Chinese Film Stars

This volume of original essays fills a significant research gap in Chinese film studies by offering an interdisciplinary, comparative examination of ethnic Chinese film stars from the silent period to the era of globalization. Whereas studies of stars and stardom have developed considerably in the West over the past two decades, there is no single book in English that critically addresses issues related to stars and stardom in Chinese culture.

Chinese Film Stars offers exemplary readings of historically, geographically and aesthetically multifaceted star phenomena. An international lineup of contributors test a variety of approaches in making sense of discourses of stars and stardom in China and the United States, explore historical contexts in which Chinese film stars are constructed and transformed in relation to changing sociopolitical conditions, and consider issues of performance and identity specific to individual stars through chapter-by-chapter case studies. The essays explore a wide range of topics such as star performance, character type, media construction, political propaganda, online discourses, autobiographic narration, as well as issues of gender, genre, memory and identity.

Including 15 case studies of individual Chinese stars and illustrated with film stills throughout, this book is an essential read for students of Chinese film, media and cultural studies.

Mary Farquhar is a Professor at Griffith University, Australia. She studied at Beijing University and specializes in China studies.

Yingjin Zhang is Director of Chinese Studies Program and Professor of Comparative Literature and Film Studies at University of California, San Diego, USA.

Routledge Contemporary China Series

Chinese Film Stars

Edited by
Mary Farquhar and Yingjin Zhang

Routledge
Taylor & Francis Group

LONDON AND NEW YORK

First published 2010
by Routledge
2 Park Square, Milton Park, Abingdon, Oxon OX14 5RN

Simultaneously published in the USA and Canada
by Routledge
270 Madison Ave, New York, NY 10016

Routledge is an imprint of the Taylor & Francis Group, an informa business

Typeset in Times New Roman by Glyph International Ltd.
Printed and bound in Great Britain by CPI Antony Rowe, Chippenham,
Wiltshire

British Library Cataloguing in Publication Data
A catalogue record for this book is available from the British Library

Library of Congress Cataloging-in-Publication Data
 Chinese film stars/edited by Mary Farquhar and Yingjin Zhang.
 p. cm.
 1. Motion picture actors and actresses–China. 2. Motion picture actors
 and actresses–Taiwan. 3. Motion picture actors and
 actresses–China–Hong Kong. 4. Motion pictures–China. 5. Motion
 pictures–Taiwan. 6. Motion pictures–China–Hong Kong. I. Farquhar,
 Mary Ann, 1949– II. Zhang, Yingjin.
 PN1993.5.C4C4425 2010
 791.4302′8092351–dc22
 [B] 2009039716

ISBN 10: 0-415-57390-4 (hbk)
ISBN 10: 0-203-85485-3 (ebk)

ISBN 13: 978-0-415-57390-0 (hbk)
ISBN 13: 978-0-203-85485-3 (ebk)

For Vishal, Mimi and Alex

Contents

Figures

Acknowledgements

We first acknowledge Richard Dyer's pioneering work in star studies. We are grateful to our contributors for their expertise, cooperation and patience; to Maureen Todhunter for her superb editorial work and to Robyn White of Griffith University for formatting the manuscript for submission; to Song Hwee Lim and Julian Ward for their support of a special issue of *Journal of Chinese Cinemas* on Chinese stars in 2008; to Intellect Ltd, United Kingdom, for permission to use the previously published works; and to Stephanie Rogers, Leanne Hinves and their Routledge colleagues for their efficient work in the production of this book. Yingjin Zhang is thankful for a research grant from the Academic Senate at the University of California, San Diego in 2009. All previously published materials have been revised for inclusion in this book.

<div style="text-align: right;">

Mary Farquhar, Griffith University, Queensland, Australia
Yingjin Zhang, University of California, San Diego, USA

</div>

- An earlier version of Chapter 2 by Yiman Wang was published as 'Anna May Wong: A Border-crossing "Minor" Star Mediating Performance', *Journal of Chinese Cinemas* (United Kingdom) 2: 2 (2008): 91–102. © Intellect Ltd, The Mill, Parnall Road, Bristol BS16 3JG, United Kingdom. Reproduced with permission of the publisher.
- An earlier version of Chapter 6 by Yingjin Zhang was published as 'Zhao Dan: Spectrality of Martyrdom and Stardom', *Journal of Chinese Cinemas* (United Kingdom) 2: 2 (2008): 103–11. © Intellect Ltd, The Mill, Parnall Road, Bristol BS16 3JG, United Kingdom. Reproduced with permission of the publisher.
- An earlier version of Chapter 7 by Xiaoning Lu was published as 'Zhang Ruifang: Modelling the Socialist Red Star', *Journal of Chinese Cinemas* (United Kingdom) 2: 2 (2008): 113–22. © Intellect Ltd, The Mill, Parnall Road, Bristol BS16 3JG, United Kingdom. Reproduced with permission of the publisher.
- An earlier version of Chapter 10 by Tony Williams was published as 'Brigitte Lin Ching Hsia: Last Eastern Star of the Late Twentieth Century', *Journal of Chinese Cinemas* (United Kingdom) 2: 2 (2008): 147–57. © Intellect Ltd,

The Mill, Parnall Road, Bristol BS16 3JG, United Kingdom. Reproduced with permission of the publisher.

- An earlier version of Chapter 12 by Brian Hu was published as 'A Life in Conjectures: "Bruce Lee" after Bruce Lee', *Journal of Chinese Cinemas* (United Kingdom) 2: 2 (2008): 123–35. © Intellect Ltd, The Mill, Parnall Road, Bristol BS16 3JG, United Kingdom. Reproduced with permission of the publisher.

- An earlier version of Chapter 13 by Mary Farquhar was published as 'Jackie Chan: A New Dragon for a New Generation', *Journal of Chinese Cinemas* (United Kingdom) 2: 2 (2008): 137–46. © Intellect Ltd, The Mill, Parnall Road, Bristol BS16 3JG, United Kingdom. Reproduced with permission of the publisher.

Contributors

Mary Farquhar is Professor at Griffith University, Australia. She studied at Beijing University and specializes in China studies. Her *Children's Literature in China: From Lu Xun to Mao Zedong* (M.E. Sharpe, 1999) won an International Children's Literature Association Award for the most distinguished, scholarly book. She is the co-author with Chris Berry of *China Onscreen: Cinema and Nation* (Columbia, 2006).

Lin Feng is a PhD candidate in the Institute of Film and Television Studies, the University of Nottingham, UK. Her current project is on Chinese stardom and the reception of Chinese masculinity. She also served as the editor of the conference report section of *Scope: An Online Journal of Film and Television Studies*.

Krista Van Fleit Hang is Assistant Professor of Chinese Language and Literature in the Department of Languages, Literatures and Cultures, the University of South Carolina, USA. Her research interests centre on the development and production of Chinese culture during the Maoist period.

Mette Hjort is Chair Professor and Head of Visual Studies at Lingnan University in Hong Kong and Affiliate Professor of Scandinavian Studies at the University of Washington, Seattle, USA. She is the author of *Stanley Kwan's Center Stage* (Hong Kong, 2006) and *Lone Scherfig's Italian for Beginners* (Washington, 2009); and the editor of *The Cinema of Small Nations*, with Duncan Petrie (Edingburgh, 2007) and *Dekalog 01: The Five Obstructions* (Wallflower, 2008).

Brian Hu is a PhD candidate in the Department of Film, Television and Digital Media, the University of California, Los Angeles, USA. His research interests include postwar Chinese popular culture and the diaspora, and his writings have appeared in academic journals such as *Screen*, *Continuum* and *Post Script*.

Michael Lawrence is Senior Lecturer in Film Studies at the University of the West of England, Bristol, UK. His PhD dissertation at Middlesex University deals with the films of Atom Egoyan. His current research focuses on children and screen performance.

Xiaoning Lu obtained her PhD in Comparative Literature from the Sate University of New York, Stony Brook, USA. She teaches in both the Department of Comparative Literature and the Department of Sinology at the Ludwig-Maximilians University of Munich, Germany. Her research interests include modern Chinese intellectual history and Cold War cinema.

Sean Macdonald lectures in modern Chinese literature, culture and cinema at the University of Florida, USA. He has published on modernism in Republican China in *Modernism/Modernity* and *Modern Chinese Literature and Culture*. His recent research is on the writer Zhang Ailing.

Julian Stringer is Associate Professor of Film and Television Studies at the University of Nottingham, UK, and co-ordinating editor of *Scope: An Online Journal of Film and Television Studies*. His recent edited books include *Movie Blockbusters* (Routledge, 2003); *New Korean Cinema*, with Chi-Yun Shin (Edinburgh, 2005); and *Japanese Cinema: Texts and Contexts*, with Alastair Phillips (Routledge, 2007). He is completing a monograph on Wong Kar-wai's *In the Mood for Love*.

Yiman Wang is Assistant Professor of Film and Digital Media at University of California, Santa Cruz, USA. Her research interests include early cinema, border-crossing film remakes, transnational Chinese cinemas, star studies, DV image-making in contemporary China, theories of translation, postcolonialism, race and gender. She has published with journals such as *Camera Obscura* and *Film Quarterly*.

Tony Williams is Professor and Area Chair of Film Studies in the Department of English, Southern Illinois University at Carbondale, USA. Apart from other works, he has published extensively on Asian cinema in *Cinema Journal*, *Asian Cinema* and *Asian Cult Cinema*. He published *John Woo's Bullet in the Head* (Hong Kong, 2009).

Sabrina Qiong Yu lectures in Chinese cinema and media at Newcastle University, UK. Her PhD dissertation at the University of Nottingham deals with Jet Li and his audiences. Her research focuses on stardom, gender and sexuality, audience/reception studies and transnational Chinese cinema, and her articles appeared in *EnterText* and *World Cinema's 'Dialogues' with Hollywood*, ed. Paul Cooke (Palgrave Macmillan, 2007). She launched a translation series on star studies with Peking University Press in 2010.

Yingjin Zhang is Director of the Chinese Studies Program and Professor of Comparative Literature and Film Studies at the University of California, San Diego, USA. His books include *The City in Modern Chinese Literature and Film* (Stanford, 1996), *Encyclopedia of Chinese Film* (Routledge, 1998), *China in a Polycentric World* (Stanford, 1998), *Cinema and Urban Culture in Shanghai, 1922–1943* (Stanford, 1999), *Screening China* (Michigan, 2002), *Chinese National Cinema* (Routledge, 2004), *From Underground to*

Independent (Rowman & Littlefield, 2006) and *Cinema, Space and Polylocality in a Globalizing China* (Hawaii, 2010).

Zhang Zhen is Associate Professor in Cinema Studies at New York University. She is the author of *An Amorous History of the Silver Screen: Shanghai Cinema, 1896–1937* (Chicago, 2005), and editor of *The Urban Generation: Chinese Cinema and Society at the Turn of the Twenty-first Century* (Duke, 2007). She is currently working on a new book on post-war Sinophone film history.

John Zou teaches modern Chinese literature and cinema at Arizona State University. He obtained his PhD in Comparative Literature at the University of California, Berkeley. Currently, he is working on a book manuscript that discusses spoken drama in Republican China.

1 Introduction

Chinese film stars

Yingjin Zhang and Mary Farquhar

Star power

In its 9 May 2005 issue, *Newsweek* ran a special report, 'China's Century', devoted in part to exploring questions such as 'Is China the world's next superpower?' (*Newsweek* 2005: 5). Gracing its glossy cover is a frontal pose of Zhang Ziyi (b. 1979), who greets the viewer with her charming smile and slim figure and who looms large against a background composed of the Great Wall, a symbol of ancient China and the Pearl of the Oriental (the Shanghai Television Tower), a symbol of a contemporary globalizing China. A newly risen star who became internationally known after Ang Lee (Li An, b. 1954) cast her in a scene-stealing martial arts role in *Crouching Tiger, Hidden Dragon* (2000), Zhang was endorsed by *Newsweek* as 'the face of a new China'. If the twenty-first century is indeed China's century, then why did *Newsweek* avoid choosing the face of a political leader or a business tycoon to represent China's rise as a new superpower? In response to this question, Gary Xu speculates that, in the judgement of *Newsweek*, 'Zhang's star power and beauty' might embody the merging of old and new China, simultaneously marking her as 'the quintessential Oriental woman' and a 'representative of the turn-of-the-millennium generation: youthful, energetic, confident, cosmopolitan, and entrepreneurial' (2007: 1–2).

While concealing Oriental motifs, *Newsweek* explicitly promotes Zhang Ziyi as 'the actress of the future' in a film section entitled 'Invasion of the Hot Movie Stars', which announces that 'Chinese cinema has brought new fun, glamour, humour and sex appeal to Hollywood' (*Newsweek* 2005: 37). The increasing importance of Chinese cinema to the 'future' of world cinema is elaborated this way:

> Without Chinese cinema, there would be no 'Matrix' franchise. There would be no 'Rush Hour' with Jackie Chan and no Quentin Tarantino flicks. Without Chinese filmmakers there would be no Bruce Lee movies and no Jet Li movies; there would be no 'Face/Off', no 'Ice Storm', no 'Farewell My Concubine'. Most of all, there wouldn't be some of the most thrilling martial-arts films ever made ...
>
> (*Newsweek* 2005: 37)

Newsweek predicts a return to an era of international stardom, in which Zhang Ziyi appears as the latest new face in an illustrious roster of world-famous Chinese stars in recent decades. They include, alphabetically by their surnames, female stars such as Maggie Cheung (Zhang Manyu, b. 1964), Gong Li (b. 1966), Michelle Yeoh (Yang Ziqiong, b. 1962), Zhang Ziyi and male stars such as Jackie Chan (Cheng Long, b. 1954), Chow Yun-fat (Zhou Runfa, b. 1955), Leslie Cheung (Zhang Guorong, b. 1956), Jet Li (Li Lianjie, b. 1963) and Tony Leung Chiu-Wai (Liang Chaowei, b. 1962). Not only have they won prestigious international awards and established transnational followings, but they have also made inroads in major Hollywood productions and exhibitions.[1]

Considering the importance of Chinese stars internationally, it is unexpected that we confront a sheer paucity of scholarship on the stars of Chinese cinema. Except for Jackie Chan (Fore 1997; Gallagher 2004) and Maggie Cheung (Hudson 2006; Lu 2001; Williams 2003) as well as a few recently rediscovered early stars like Ruan Lingyu (1910–35) and Li Lili (1915–2005) in the West (Hansen 2000; Meyer 2005), Chinese stars and stardom rarely receive sustained academic attention in either Chinese or English publications. To be sure, biographies, autobiographies, anecdotes and glamorous photo collections of stars abound in print venues and on the internet, but to date very few book-length studies deepen our understanding of the functions of stardom and star texts in national and transnational contexts.

This book represents a decisive step toward in-depth exploration of stars and stardom in Chinese cinema. Our contributors bring diverse interdisciplinary expertise in Chinese studies, film studies and cultural studies to engage with a variety of approaches in making sense of discourses of stars and stardom in China. While many adopt, or at least cite, analytical approaches from Western film as a starting point, our contributors also account for non-Western constructions of stardom, such as the concept of film 'worker' as star in socialist film, and specify the ways in which stardom plays out across regional, national and transnational Chinese cinemas.

Importantly, therefore, the book also explores historical contexts in which Chinese stars are constructed and transformed in relation to changing socio-political conditions. These conditions may differ across Chinese-language communities (in both Asia and the West) with local responses to war, revolution and globalization, including changing technologies. These local responses shape and modify local cinemas and star images, whether it is through the call for patriotic heroes during wartime China, the rise of kung fu 'dragons' in Hong Kong cinema, or the growth of transnational Chinese cinema.

Also importantly, the book considers issues of gender, identity, performance and politics specific to individual stars through chapter-by-chapter case studies. Performance, for example, is a crucial determinant of stardom, and styles of performance may substantially converge with, or diverge from, those in the West. Culturally specific examples of divergence include older Chinese theatrical traditions (such as Peking opera), favourite genres (such as martial arts) and gender-bending performance codes (such as cross-dressing and gender-crossing) that are embedded in star discourses across the Chinese-speaking world.

As editors, we attempted to offer a balanced selection of individual Chinese stars in terms of geo-cultural, historical, performance and other issues. We consider megastars, such as Bruce Lee (Li Xiaolong, 1940–73) and Jet Li, but we also introduce stars lesser known to Western readers. We include, for example, an early Chinese–American movie star Anna May Wong (Huang Liushuang, 1905–61), who achieved her reputation on the American silent screen and enjoyed a measure of stardom in China in the 1930s. We also feature Mei Lanfang (1894–1961), an internationally renowned Peking opera star in the twentieth century who nonetheless left an indelible mark on early Chinese cinema. The relatively small share of primarily Taiwan stars in our selection reflects the local nature of stardom in Taiwan cinema between the end of World War II and the birth of a New Cinema in the early 1980s that thrived on experimental art films and favoured non-professional acting more than engineering star vehicles.

Before introducing chapters on individual stars in this book, a brief discussion of English- and Chinese-language scholarship on stars and stardom is in order.

Scholarship: star production and reception

Movie stars exert an enduring appeal to the general public. To quote Edgar Morin: 'The star participates in all the world's joys, pities all its misfortunes, [and] intervenes constantly in its destiny' (2005: 4). However, as in Chinese scholarship, the subject of stars and stardom entered Western film studies on a relatively late stage. Karen Hollinger is right in her observation: 'Star studies have always been a poor second cousin within the family of film studies' (2006: 35). Jeremy Butler attributes the lack of scholarly attention to stars and stardom to two factors specific to the development of film studies in the West (1998: 342–3): first, early writings on cinema emphasized the technical aspects of filmmaking (e.g. camerawork and lighting) in an effort to establish film as an art form distinct from literature and theatre;[2] second, the majority of early film scholars came from related humanities disciplines and preferred to analyze narratives and characters more than actors and performance, thus contributing to the dominance of genre and authorship studies from the 1940s to the 1960s. Not until Richard Dyer's ground-breaking work, *Stars* (1979), did stardom and star texts become a legitimate subject in film studies, although it would take another 12 years before such scholarship reached a critical mass (Butler 1991; Gledhill 1991). Little wonder that many of the contributors to this volume refer to Dyer's scholarship. We have called this volume *Chinese Film Stars* as a tribute to his seminal work in the field.

Dyer develops a 'sociosemiotic approach' (Hollinger 2006: 35), which, in Christine Gledhill's characterization, works by 'combing semiotics and sociology' and 'analyzes the star image as an intertextual construct produced across a range of media and cultural practices, capable of intervening in the working of particular films, but also demanding analysis as a text in its own right Thus study of stars becomes an issue in the social production and circulation of meaning, linking industry and text, films and society' (1991: xiv). The key here is that the production, circulation and reception of meanings embodied by stars constitute a

text – *star text* – of rich ideological valence. 'From the perspective of ideology', Dyer writes,

> analyses of stars, as images existing in films and other media texts, stress their *structured polysemy*, that is, the finite multiplicity of meanings and affects they embody and the attempt so to structure them that some meanings and affects are foregrounded and others are masked or displaced.
>
> (Dyer 1979: 3, added emphasis)

What demands critical attention, therefore, are diverse contradictions and ambivalences structured around star texts.

Dyer's sociosemiotic approach departs decisively from 'star hagiography' in popular biographies and autobiographies and from 'anecdotal and impressionistic star adoration' in fan magazines and trade publications (Hollinger 2006: 35). He directs attention away from an obsession with issues of truth and authenticity behind a fabricated, mediated façade of the star image and encourages studies of the discursive manipulation and ideological functions of star texts in specific historical contexts. Jeremy Butler enumerates three interlocking elements crucial to our understanding of the star system in Hollywood:

1. star production: economic and discursive structures;
2. star reception: social structure and the theory of the subject; and
3. star semiotics: intertextuality and structured polysemy.

(Butler 1998: 344)

Admittedly, economic structures of the star system in Chinese cinema do not receive examination in this book, in part because our chapters are structured around individual stars, and in part because Chinese film history is marked by a conspicuous absence of the star system as we know it in some key periods, such as socialist cinema of the 1950s to 1970s and new Taiwan cinema of the 1980s to 1990s.[3] Historically, early Chinese cinema resembled early Western cinema in that film actors initially came from the theatre world: 'while performing ... at night they pick up a few dollars playing day times in a moving picture studio' (deCordova 1991: 19). Likewise, Zheng Zhengqiu (1888–1935) relied on stage actors when he and collaborator Zhang Shichuan (1889–1953) posted two signs in front of their makeshift studio in Shanghai, 'Xinmin New Theatre Research Society' and 'Asia Shadowplay Co'. (Z. Zhang 2005: 100), and proceeded to produce their first short feature, *The Difficult Couple* (Zhang Shichuan, 1913). Again, as in the West, early Chinese shorts did not publicize actors' names, and film acting was a concept that would emerge only a decade later in China.

Richard deCordova traces the emergence of the star in the United States to 1914 when 'the question of the player's existence outside his/her work in films entered discourse' and when the private lives of the stars became a 'new site of knowledge and truth' (1991: 26). Studies of British and French cinemas confirm the emergence of the star around the same time (Macnab 2000; Vincendeau 2000).

In China, the discursive structures of star production were not instituted until the early 1920s, when newspapers and magazines started to run reviews on Chinese film productions. Not surprisingly, a *Shenbao* (*Shanghai daily*) review would reference Hollywood actresses like Mary Pickford (1892–1979) when describing the debut screen performance of Yin Minzhu (Pearl Yin, 1904–89) in *Sea Oath* (Dan Diuyu, 1921), one of China's earliest full-length features (Dai 1996: 1079). By the mid-1920s, film magazines and trade publications regularly featured comments on screen acting. 'Female Movie Stars', an article in Tianyi Company's 1926 special promotional magazine (*tekan*), specifically listed tabloid publicity (*xiaobao* or literary 'mosquito press') and personal networking as two popular means by which an unknown actress was introduced to the public, although the writer still acknowledged the elegance of the 'bright star' (*mingxing*) as a concept (Dai 1996: 927–8).[4] In China, as in the West, the popular press continued to feed a growing consumer fascination with film celebrities, publishing magazines such as *Star Focus* (*Mingxing tekan*, 1925–28), *Star Monthly* (*Mingxing yuebao*, 1933–35), *Star Families* (*Mingxing jiating*, 1933) and *Stars* (*Mingxing*, 1935–37, 1938), all promoting 'bright stars' as key attractions.

Dyer's statement that 'Stars/films sell meanings and affects' (Gledhill 1991: 215) brings us to Jeremy Butler's second element, the social structure of star reception. In the realm of material culture, Chinese as well as Western female stars were prominently featured in glossy pictorials like *The Young Companion* (*Liangyou*) from 1927 to 1937 to market the latest fashions, hairdos, lifestyles, domestic products and interior designs (Y. Zhang 2007a: 137–8). In terms of ideology, Michael Chang's study of 'three generations' of early Chinese female stars – Wang Hanlun (1903–78) and Yang Naimei (1904–60) from the first, Hu Die (Butterfly Wu, 1908–89) and Ruan Lingyu from the second, Li Lili and Wang Renmei (1914–87) from the third – reveals shifting social values within two decades: whereas in the 1920s a negative discourse delegitimized movie actresses' upward social mobility, which represented an apparent threat to Chinese patriarchy at the time, in the 1930s a positive discourse promoted a new standard of *bense* (naturalist) acting and valued professional training, especially in song and dance (Chang 1999). As illustrated by Sean Macdonald's chapter in this book (Chapter 4), *bense* acting appealed to a growing awareness of athletic beauty, national health and urban modernity before China's war with Japan would drastically change the socio-political conditions in coastal and hinterland regions. During the war, star texts were frequently appropriated to propagate ideologies of nationalism and colonialism. Shelley Stephenson's work demonstrates that the discursive construct of Li Xianglan (Yamaguchi Yoshiko, b. 1920), an elusive China-educated Japanese female actor who passed as a Chinese star in the press, paralleled the Japan-sanctioned ideology of 'the Greater East Asian Co-prosperity Sphere' (Stephenson 1999). The mysterious wartime star text of Li Xianglan, in other words, worked specifically to sell Japanese colonial ideology in Japan, Manchuria, Taiwan and much of occupied China.[5]

On the other side of the gender divide, male stars like Jackie Chan and Chow Yun-fat are studied in terms of masculinity in Hong Kong action films of the 1980s

to 1990s, typically from John Woo (Wu Yusen, b. 1946) and Tsui Hark (Xu Ke, b. 1951), and screen violence and identity crisis are often linked to Hong Kong's anxiety in anticipation of return to China's sovereignty in 1997 (Gallagher 1997; Stringer 1997). In such cases of critical reception, the focus is placed not so much on star construction as on altered or alternative geopolitical discourses. Yet, to what extent film audiences identify with critical readings on Hong Kong's 1997 anxiety remains a question.[6] For similar reasons, issues of audience identification in other reception contexts are complicated in this book by Sabrina Yu's work on incongruous online receptions of Jet Li's screen personae and Krista van Fleit Hang's study of Zhong Xinghuo (b. 1924) as an amiable middle character who provided an alternative identification route in socialist cinema.

Jeremy Butler's third element – star semiotics as encoded/decoded through intertextuality and structured polysemy – reminds us of screen performance as a core component of star studies. As early as the mid-1920s, Chinese commentators already paid attention to the technicality of screen acting, down to such nuances as hand gestures, bodily postures and facial expressions of internal feelings (Dai 1996: 45). By the centennial celebration of Chinese film in 2005, a long history of Chinese screen acting has been written, although such works tend to recall screen roles rather than star performances (Liu 2005). A significant recent shift of attention from screen acting to performance studies is noteworthy. Katherine Chou's book on performance culture and visual politics explores the imbrication of gender biopolitics and revolutionary ideology during the 1920s to 1940s, and her analysis of discourses on early stars like Ai Xia (1912–34), Chen Boer (1907–51) and Ruan Lingyu (the first and third committed suicides and generated sensational publicity) teases out layers of complexity and contradiction involved in variegated gendered performances of modern girls, new women and revolutionary fighters (Chou 2004).

From the perspective of performance studies, Dyer's 'structured polysemy' of star texts may be reconceptualized as an assemble of polysemy not so much structured as *conjunctural*, for the simple reason that star performance, like performance in general, 'isn't "in" anything, but "between"'' (Schechner 2002: 24). While performance studies' emphasis on actions, interactions and relationships adequately matches star studies' focus on contextuality and intertextuality, the former's conjunctural vision directs attention less to a stable structure of meaning and signification than to its glaring cracks and fissures. The centrifugal or anti-establishment tendency in performance studies is captured in Richard Schechner's characterization:

> As a field, performance studies is sympathetic to the avant-garde, the marginal, the offbeat, the minoritarian, the subversive, the twisted, the queer, people of colour, and the formerly colonized. Projects within performance studies often act on or act against strictly ordered or settled hierarchies of ideas, organizations, or people.
>
> (Schechner's 2000: 3)

Following the conjunctural vision of performance studies, we may re-examine various levels of star performance as sociosemiotic texts. For one thing, stars are frequently cast into biographically fitting roles and therefore deliver some kind of self-performance onscreen. Such examples include Chow Yun-fat as successful local Hong Kong hero in his much-neglected television career, or Ling Bo (Ivy Ling Po, b. 1934) as a phenomenal Sinophone orphan negotiating Cold War political divides and rediscovering her lost 'homeland' in Taiwan, or Zhao Dan (1915–80) as a masochistic martyr repeatedly sacrificing himself for a glorified cause on the Chinese screen both before and after 1949. Performance studies also compel us to explore less obvious aspects of star performance: costume and voice, makeup and typesetting, as well as afterimages and clones.

Of course, mere reference to chapters in this book does not do justice to the richness of our contributors' work, so we now turn to a summary of the remaining chapters below. Each chapter showcases one individual star, concentrating on one or two crucial aspects rather than offering an all-round, developmental picture of the star's entire career. A filmography follows each chapter, but it is not a comprehensive list of all a star's films but a list of works mentioned in the chapter.

Chapters: star studies in four parts

This book is divided into four parts. Part I, 'Early Cinema: Crossing Race and Class Divides', studies three actresses who are very different from each other: Chinese-American icon Anna May Wong, tragic silent star Ruan Lingyu and lively athletic performer Li Lili. Their varied star texts provide a rich entry point to investigate the complexity of stardom in intercultural and transregional contexts. In Chapter 2, 'Anna May Wong: A Border-Crossing "Minor" Star Mediating Performance', Yiman Wang shows how Anna May Wong, as an exotic Chinese star in the United States, was constrained by racial typecasting. She mediated Western Orientalism and Chinese nationalism by adopting visual and vocal techniques of embodied performance: makeup, dresses, hairstyle, language and bodily movement. Using these techniques, she carved out her own space of resistance as a 'foreign' and female actor mediating between two worlds in the 1930s: the United States and China. In the process, her image transcends the feminine stereotypes of both cultures to become consciously 'minor' within the dominant society.

In Chapter 3, 'Ruan Lingyu: Reflections on an Individual Performance Style', Mette Hjort discusses one of the great stars of the Chinese silent film era. The focus is on questions of performance, essential to analyses of film stardom. In this context, Hjort connects Ruan's films with the important research questions that have been put on the cinematic agenda by Alan Lovell and Peter Krämer's *Screen Acting* (1999). By focusing on the film that is most widely available to viewers, namely *The Goddess* (1934) directed by Wu Yonggang (1907–82), as well as on *Center Stage* (1992), a bio pic from Stanley Kwan (Guan Jinpeng, b. 1957) that includes a number of sequences from Ruan's other films, the chapter sets the stage for a discussion of performance with a biographical account of Ruan's short life

(drawing on the excellent existing research on actresses, class, social mobility, and the dynamics of social discourse in the late 1920s and early 1930s in China). The discussion breaks new ground by looking carefully at Ruan as an onscreen presence. A wide range of issues is considered: the implications of Ruan's lack of formal training; Shanghai cinema's acceptance of the continuity framework; the 'pantomime' tradition of cinematic performance and its repertoire of gestures; and, most importantly, the concept of individual style. Here, the author draws on the thoughtful, yet largely overlooked, research by aestheticians working in the analytic tradition.

In Chapter 4, 'Li Lili: Acting a Lively *Jianmei* Type', Sean Macdonald contends that actors, like authors of texts, constitute an important focal point for cinematic messages. As actors are watched on the screen, a separate existence develops off-screen, constructed especially through the actor's biography. From her first screen role, Li Lili is positioned as a performer, and this resulted in roles in which she addressed the audience. Li and others have described early film performance in China as 'naturalistic acting style' (*bense pai*), a term applied to account for the links between the on-screen and off-screen existence of the actor in early Chinese cinema. The actor's constructed persona affected the type of roles she played, and the roles were in turn affected by the persona of the actor. In the 1930s, Li represented a lively, *jianmei* type and often played young women from the countryside, whose images enhanced her persona as a young, athletic and hardworking performer on the screen. As such, she stands as an unprecedented type for early cinema and early twentieth-century China.

Part II, 'Socialist Cinema: From Film Star to Model Worker', investigates the radical transformation of stardom from the Republican era to the socialist period, when veteran as well as emergent stars underwent a new process of construction through mandatory self-modelling that would fundamentally change the public persona of a star from a celebrity to a model worker. In Chapter 5, 'Mei Lanfang: Facial Signature and Political Performance in Opera Film', John Zou explores the mediating function of stardom and examines the social and political underpinning of Mei Lanfang's cinematic prominence. Zou notices that, in the sizeable literature on Mei's prominence in Chinese popular culture in the twentieth century and beyond, his presence in Chinese society as a film star, especially in the genre of opera film, has invited little sustained attention. Zou's chapter therefore addresses Mei's role in mediating a public space in mid-twentieth century China, in which the representation of feminine grievance serves to limit the effects of the state. With reference to established practices of registering grievance in traditional Chinese opera and poetics, Zou argues that it is the cinematic moment of the cross-dressed actor's face that signifies a discursive compromise between Mei's articulation of grievances and his reconciliation with the state.

In Chapter 6, 'Zhao Dan: Spectrality of Martyrdom and Stardom', Yingjin Zhang argues that Zhao Dan's stardom involved an uncanny martyrdom, which glorified the idea of self-sacrifice for a just cause while exposing graphic details of suffering. Since his early stardom derived in part from 'I play myself' in *Cross-roads* (Shen Xiling, 1937), Zhao voluntarily and involuntarily played himself over

and over again, to the point where his self-performance became locked in a fated process of self-othering in socialist cinema, culminating in his incessant writing of self-confessions in prison during the Cultural Revolution. A spectre of martyrdom haunted Zhao's stardom.

In Chapter 7, 'Zhang Ruifang: Modelling the Socialist Red Star', Xiaoning Lu approaches Zhang Ruifang (b. 1918), a popular female actor who had co-starred with Zhao Dan in 1959, as an exemplary 'Red Star', who embodies collective socialist ideals explicitly at odds with bourgeois star ideology. Stars in Mao's China were called 'film workers' to emphasize filmmaking as a collective social practice. Lu discusses Zhang in the context of the 'model person' on and off screen. In the transplanted Stanislavski system of naturalistic acting, actor and character are fused so that, in Zhang Ruifang's words, 'I feel the character is in me'. Performance, then, is a process of moulding one's desire or self-moulding according to socialist templates of the model citizen in an idealized society.

In Chapter 8, 'Zhong Xinghuo: Communist Film Worker', Krista Van Fleit Hang further explores the implication of film workers for socialist stardom by showing how star images were produced as part of the systematic creation of 'socialist realist' desire and identification in the Maoist period. In her reading, photos of Zhong Xinghuo working in the fields alongside peasants in preparation for his upcoming role in *Li Shuangshuang* (Lu Ren, 1962) – co-starred with Zhang Ruifang – are similar to those of classical Hollywood film stars playing sports or modelling extensive wardrobes: they give fans an image of the star's off-screen life that projects and reinforces mainstream social values. Zhong's characters are fallible though amiable; as such they differ from the muscled, iron heroes often associated with Communist propaganda. Zhong's characters arose because of the necessity of a film star to be both extraordinary and ordinary – somebody with whom viewers could identify – while simultaneously functioning as the object of desire. The combination of extraordinary and ordinary is well-suited to a socialist realist aesthetic, in which viewers were exposed to a particular kind of 'real life' on screen – certain elements of which they would recognize, and others which they would strive to create in their work for socialism.

Part III, 'Taiwan Cinema: Diaspora, Transvestism, Non-professionalism', discovers hidden Taiwan connections in the dominant star discourse that privileges mainstream ideology and overlooks marginality and luminality, and through such a discovery the authors raise challenging questions through alternative readings of stardom based on the ideas of diaspora, transvestism and non-professionalism. In Chapter 9, 'Ling Bo: Orphanhood and Post-war Sinophone Film History', Zhen Zhang traces the long melodramatic career of postwar movie star Ling Bo across the Sinophone world. She investigates the intricate relationships between the star's biography, her screen iconography, in particular that of orphanhood, and its reception, and related gender implications within the Cold War context. Ling Bo's long career as movie actress and singer, which traversed Amoy (*xiayu*), Cantonese (*yueyu*) and Mandarin (*guoyu*) film and appealed to fans in Hong Kong, Taiwan and the diaspora, has made her a Sinophone star par excellence. Her legend continues to this day as the dramas of her life and career further intertwine, serving

as both embodiment of, and witness to, the vicissitudes in a half-century long Sinophone film history.

In Chapter 10, 'Brigitte Lin Ching Hsia: Last Eastern Star of the Late Twentieth Century', Tony Williams explores the gender-bending roles of Brigitte Lin (Lin Qingxia, b. 1954) as central to both her star persona and the differential audience uptake, in this case Lin's gay fans. Williams invokes Dyer's notion that stars embody the cultural contradictions of a particular society, arguing that Lin represents a complex cultural version of Eastern stardom, a movie goddess who is 'the last Eastern star of the late twentieth century'. He traces Lin's diverse roles leading to her defining star performance as Invincible Asia (*Dongfang bubai*). In the process, she develops a sexual fluidity that owes much to the performing and viewing conventions of Chinese opera, even as her star persona exhibits the same qualities that Dyer separately attributes to Marilyn Monroe, Paul Robeson and Judy Garland: glamorous sexuality, crossing-over to ethnically diverse audiences, and a gay following.

In Chapter 11, 'Lee Kang-sheng: Non-professional Star', Michael Lawrence examines the work of the Taiwanese actor Lee Kang-sheng (Li Kangsheng, b. 1968), who has achieved international recognition through his work with Tsai Ming-liang (Cai Mingliang, b. 1958). The chapter addresses his creative collaboration with Tsai, and considers his performance style, in which his bodily being is foregrounded, in relation to European ideas concerning the neorealist or non-professional actor, in order to argue that Lee represents an important alternative to the dominant images of the Asian male action body in contemporary transnational circulation. Lee is, paradoxically, a non-professional star.

Part IV, 'Hong Kong and Transnational Cinema: Action, Gender, Emotion', returns to the popular subject of Hong Kong cinema but concentrates on neglected aspects such as early and posthumous constructions of Hong Kong martial arts superstars, the impact of the Hong Kong television industry and the proliferating internet fansites on stars and stardom. In Chapter 12, ' "Bruce Lee" after Bruce Lee: A Life in Conjectures', Brian Hu borrows the concept of star function, which Celia Lury has developed on the basis of Michel Foucault's author function, as a kind of product branding, and separates Lee's stardom from a discrete body to a 'discourse spanning multiple bodies' in an industry based on 'Bruceploitation'. Yet the industry is more than imitation. Hu concludes with convincing evidence that the ' "Bruce Lee" after Bruce Lee' industry disrupts and critiques the constrained representations of Asian Americans in Hollywood film and beyond.

In Chapter 13, 'Jackie Chan: Star Work as Pain and Triumph', Mary Farquhar revisits Jackie Chan's star vehicle, *Drunken Master* (Yuen Wo-ping, 1978) and his autobiography of the same period written 20 years later, to discuss stardom as labour. She shows how Chan's early onscreen image of star work relies on bodily performance based on his actual childhood training as an opera actor. Here, stardom *is* the body, undergoing rites-of-passage trials that involve hard labour and physical pain, trials that are re-performed in film after film and remembered retrospectively again and again as 'torture' in his personal story. This operatic training

grounds his early comic performances, including gender-crossing so common in opera and so familiar to local audiences.

In Chapter 14, 'Chow Yun-fat: Hong Kong's Modern TV *Xiaosheng*', Lin Feng departs from conventional reading of Chow Yun-fat in terms of masculinity and postmodernity (e.g. Baron 2004) and draws attention to Chow's typecasting as modern *xiaosheng* (i.e. handsome young man) in Hong Kong's television industry. In Hong Kong, many film actors begin their acting career and achieve initial stardom through the television industry. As a television-studio-trained actor, Chow spent nearly 14 years in the television industry before moving his career completely to the film industry. Feng argues that Chow's early star image as a romantic urban young man was the result of a negotiation between Hong Kong audiences' perceptions of local social changes and the television industry's conventional typecasting practice. After investigating the initial construction of Chow's television star image, Feng moves to examine how Chow's cross-media career and his star image were integrated into the perception of local identity.

In Chapter 15, 'Leslie Cheung: Star as Autosexual', Julian Stringer discusses Hong Kong icon Leslie Cheung, an all-round public entertainer and perennial media presence whose stellar popularity, and ability to connect with a diverse audience, was in part based upon his androgynous identity and ambivalent or 'queer' sexuality. While Cheung's star image has thus usually been discussed in terms of the twin themes of narcissism and ambisexuality, this chapter argues that it may also be identified with yet another 'perversion': autosexuality. Defined literally as somebody who finds sexual gratification in his or her own body through self-love and masturbation, the autosexual indulges in self-regard of a rare order. Across films, television appearances and music videos produced between 1978 and 2003, the 'symbolic autosexuality' of Cheung's image is ever-present, and it feeds into discourses of privacy, secrecy, sexuality and theatricality that circulated around the actor. Most importantly, the 'increased charisma' that Cheung has accrued since his death is also dependent upon aesthetic sensitivities associated with his image as autosexual. The chapter concludes with the suggestion that an autosexual dimension underpins the entire film star phenomenon and that part of Leslie Cheung's significance lies in his ability to express this dimension with confidence and conviction.

In Chapter 16, 'Jet Li: Star Construction and Fan Discourse on the Internet', Sabrina Qiong Yu proceeds with the premise that it is the duality of image that makes a star – a duality composed of on-screen performance and off-screen personality. From there she contends that when it comes to constructing the star's off-screen persona, fans' access to, and engagement with, intimate information from a variety of sources about the star's 'real' life are particularly important. Using the Official Jet Li website as a case study, Yu examines the construction of Jet Li's star persona through his off-screen publicity and the way in which his fans make sense of it and then effectively participate in its construction. By looking closely at four sections on the site (Li's answers to fan questions, Li's essays, his fan forum and his blog entries and discussion), Yu notices that three recurring issues – authenticity,

sexuality and cross-cultural identity – visibly exist in or even dominate Li's off-screen construction. She argues that Li's star persona is built upon both consistency and contradiction between his on-screen and off-screen images. Exactly through this correspondence and conflict, such opposed terms as 'superhero/normal guy', 'shy man/sexy idol', 'fighter/preacher of non-violence' unify perfectly in Li and constitute his multiple meanings for a new generation of North American Jet Li fans. Yu suggests that due to the popularity of the internet, stars themselves, along with their fans, now play an increasingly significant role in the process of star-making.

Conclusion: from stars to celebrities

Sabrina Qiong Yu's chapter demonstrates the importance of audience in star studies, but unfortunately, audience research has largely remained as an underdeveloped area in Chinese film studies and the situation demands immediate attention (Y. Zhang 2007b: 30–33). In Chinese film history, the importance of audience to stardom was evident as early as November 1932, when *Diansheng (Cinema Voice)* teamed up with two Shanghai magazines to launch a public election of top ten Chinese stars. Many fans were eager to cast their votes, and on the closing day in March 1933, all votes were counted, and Hu Die was crowned 'Movie Queen' with 13,582 votes, and Ruan Lingyu slightly behind as runner-up with 13,490 votes (Dai 1996: 1338–9).[7] Even during the socialist period, audiences were mobilized to vote for best male and female actors when *Dazhong dianying (Mass Cinema)* inaugurated the Hundred Flowers Awards in 1962. Although the operation was suspended after its second year in 1963 and was not resumed until 1981, 5 years after the end of the Cultural Revolution, the imbrication between audience and stardom is a significant topic worthy of further exploration. In connection to audience's impact on stardom, we should remember that viewer uptake of stars has always been culturally specific: to genre, for example, in the case of martial arts superstars Bruce Lee and Jackie Chan, or to gender, in the case of Brigitte Lin's and Ling Bo's cross-dressing performances.

Chinese stardom is multifaceted, long-lived and complicated by history, spectatorship, gender and politics. It is richly endowed with cult icons and subversive figures. As this book suggests, stars in China and elsewhere embody multiple meanings that encapsulate the private and public, the ordinary and extraordinary, off-screen and on-screen personas, as well as the individual within the contemporary world. As a core institution of the cinema worldwide, stars personalize social meaning, cultural identity and ideology for different audiences, at different times, and in different locations (Geraghty 2000; McDonald 1998). Nonetheless, stardom as a system necessarily transcends the individual. All stars are discursive practices beyond the star body, and they speak more generally to cinema as an industry that operates within and across specific societies and territories.

This book spotlights merely a small group from a galaxy of Chinese film stars. Issues of stardom clearly intersect with other issues in Chinese film studies, such as audience, gender, locality, performance and politics, and several key new areas

of development in star studies await future research. We may refer to the development of stardom in the new Hollywood and examine whether any parallels exist between Hollywood and Chinese cinema in such new post-Dyer categories as stars and independent production, special effects as 'stars', directors as stars and stars as directors (Austin and Barker 2003: 7–11). While canvassing recent work arising outside the film domain, Thomas Austin and Martin Barker specifically point to the relevance of celebrity studies to film studies, the former extending the scope to television, sport, fashion and modelling, as well as exceptional cases in everyday life where people seek or achieve celebrity on 'bizarre grounds' (2003: 13–14).

The institution of stardom, in China as in the West, is now part of a celebrity culture that is appropriated to sell 'China' itself, whether star film director Zhang Yimou (b. 1951) as chief conductor of the greatest show on earth, the opening ceremony of the 2008 Beijing Olympics, or Zhang Ziyi as the alluring face of the twenty-first century as 'China's century' on the cover of *Newsweek* in 2005. In these instances, Zhang Yimou and Zhang Ziyi are internationally recognized celebrities recruited to represent China's future. We only have to remember Zhang Ziyi's performance as the rebellious and cross-dressing Jen in *Crouching Tiger, Hidden Dragon*, along with other star performances discussed or referenced in this book, to realize that star images and star work are complex, contradictory, subversive and always renegotiable in various reception contexts. After all, in China as in Hollywood and elsewhere, stardom is an 'industry of desire' (Gledhill 1991) involving capital, politics, art and audience participation.

Notes

1 To list just a few top international film festival awards for Chinese stars: Maggie Cheung received a Silver Bear (Best Actress) at Berlin for *Center Stage* (Stanley Kwan, 1992) and the Best Actress Award at Cannes for *Clean* (Olivier Assayas, 2004); Tony Leung Chiu Wai received the Best Actor Award at Cannes for *In the Mood for Love* (Wong Kar-wai, 2000). For the prominent presence of Chinese stars in Asia and North America in recent decades, see Stringer (2003: 230–2).

2 Similarly, as one of the earliest film magazines in China, *Yingxi zazhi* (*Film Magazine*) elaborated the importance of film in three categories (literature, techniques, science) in its inaugural issue in 1921, and the last two categories fall in technical areas (Dai 1996: 214–18).

3 A system of stardom was instituted in Hollywood by the mid-1920s and was characterized by the studios' stringent measures, such as offering vastly unequal contracts to actors of varied reputation, controlling every aspect of their public and private lives, and penalizing those who violated contract terms. This old star system survived the times of the Depression but came to an end in 1948, and in the 1950s agents and agencies gradually took over the management of star images (Austin and Barker 2003: 4; see also McDonald 2000).

4 Understandably, 'Mingxing' was used as the name of the most important Chinese film company founded by Zhang Shichuan, Zheng Zhengqiu and others in 1922. The company ran a screen acting school from 1922 to 1924.

5 Li Xianglan appeared in *Eternity* (Bu Wancang et al., 1943), set in Canton prior to the Opium War of the mid-nineteenth century, and *Sayon's Bell* (Shimizu Hiroshi, 1943), set in Taiwan's aboriginal tribal villages during World War II. In these two star vehicles

showcasing her singing talents, Li is cast as an innocent, lower-class native young woman who either denounces Western imperialism or supports Japanese colonialism.
6 Writing in the late 1990s, Jenny Lau challenged the prevalent critical reception at the time: 'This "1997 reading" for every contemporary film coming from Hong Kong ran the risk of reducing the understanding of Hong Kong culture in general, and film in particular, to the narrow spheres of economics and politics' (2000: 162).
7 Li Lili was ranked tenth with 9,960 votes in that election.

Works cited

Austin, Thomas and Martin, Barker (eds) (2003), *Contemporary Hollywood Stardom*, London: Arnold.

Baron, Cynthia (2004), 'Suiting Up for Postmodern Performance in John Woo's *The Killer*', in *More Than a Method: Trends and Traditions in Contemporary Film Performance* (eds Cynthia Baron, Diane Carson and Frank Thomasulo), Detroit: Wayne State University Press, pp. 297–329.

Butler, Jeremy (ed.) (1991), *Star Texts: Image and Performance Film and Television*, Detroit: Wayne State University Press.

Butler, Jeremy (1998), 'The Star System and Hollywood', in *The Oxford Guide to Film Studies* (eds John Hill and Pamela Church Gibson), New York: Oxford University Press, pp. 342–53.

Chang, Michael G. (1999), 'The Good, the Bad and the Beautiful: Movie Actresses and Public Discourse in Shanghai, 1920s–1930s', in *Cinema and Urban Culture in Shanghai* (ed. Yingjin Zhang), Stanford, CA: Stanford University Press, pp. 128–59.

Chou, Katherine Hui-ling 周慧玲 (2004), *Biaoyan Zhongguo: numingxing, biaoyan wenhua, shijue zhengzhi, 1910–1945* 表演中国: 女明星, 表演文化, 视觉政治, 1910–1945 (Performing China: actresses, performance culture, visual politics, 1910–1945), Taibei: Maitian.

Dai, Xiaolan 戴小兰(ed.) (1996), *Zhongguo wusheng dianying* 中国无声电影(Chinese silent film), Beijing: Zhongguo dianying chubanshe.

deCordova, Richard (1991), 'The Emergence of the Star System in America', in *Stardom: Industry of Desire* (ed. Christine Gledhill), London: Routledge, pp. 17–29.

Dyer, Richard (1979), *Stars*, London: British Film Institute.

Fore, Steve (1997), 'Jackie Chan and the Cultural Dynamics of Global Entertainment', in *Transnational Chinese Cinemas: Identity, Nationhood, Gender* (ed. Sheldon H. Lu), Honolulu: University of Hawaii Press, pp. 239–62.

Gallagher, Mark (1997), 'Masculinity in Translation: Jackie Chan's Transcultural Star Text', *The Velvet Light Trap*, 39 (Spring), pp. 23–41.

Gallagher, Mark (2004), 'Rumble in the USA: Jackie Chan in Translation', *Film Stars: Hollywood and Beyond* (ed. Andy Willis), Manchester, UK: Manchester University Press, pp. 113–39.

Geraghty, Christine (2000), 'Re-examining Stardom: Question of Texts, Bodies and Performance', in *Reinventing Film Studies* (eds Christine Gledhill and Linda Williams), New York: Oxford University Press, pp. 183–200.

Gledhill, Christine (ed.) (1991), *Stardom: Industry of Desire*. London: Routledge.

Hansen, Miriam Bratu (2000), 'Fallen Women, Rising Stars, New Horizons: Shanghai Silent Film as Vernacular Modernism', *Film Quarterly*, 54: 1, pp. 10–22.

Hollinger, Karen (2006), *The Actress: Hollywood Acting and the Female Star*, London: Routledge.

Hudson, Dale (2006), 'Just Play Yourself, "Maggie Cheung": *Irma Vep*, Rethinking Transnational Stardom and Unthinking National Cinemas', *Screen*, 47: 2, pp. 213–32.

Lau, Jenny (2000), 'Besides Fists and Blood: Michael Hui and Cantonese Comedy', *The Cinema of Hong Kong: History, Arts, Identity* (eds Poshek Fu and David Desser), New York: Cambridge University Press, pp. 158–75.

Liu, Shibing 刘诗兵 (2005), *Zhongguo dianying biaoyan bainian shihua* 中国电影表演百年史话 (A 100 years of film acting in China), Beijing: Zhongguo dianying chubanshe.

Lu, Sheldon H. (2001), *China, Transnational Visuality, Global Postmodernity*, Stanford, CA: Stanford University Press, pp. 122–38.

McDonald, Paul (1998), 'Supplementary Chapter, Reconceptualising Stardom', in Richard Dyer, *Stars*, new edition, London: British Film Institute, pp. 177–200.

McDonald, Paul (2000), *The Star System: Hollywood's Production of Popular Identities*, London: Wallflower Press.

Macnab, Geoffrey (2000), *Searching for Stars: Stardom and Screen Acting in British Cinema*, London: Cassell.

Meyer, Richard J. (2005), *Ruan Ling-yu: The Goddess of Shanghai*, Hong Kong: Hong Kong University Press.

Morin, Edgar (2005), *The Stars*, trans. Richard Howard, Minneapolis: University of Minnesota Press.

Newsweek (2005), 'China's Century', a special report, *Newsweek* (9 May), pp. 26–47.

Schechner, Richard (2002), *Performance Studies: An Introduction*, London: Routledge.

Stephenson, Shelley (1999), ' "Her Traces Are Found Everywhere": Shanghai, Li Xianglan, and the "Greater East Asia Film Sphere" ', in *Cinema and Urban Culture in Shanghai* (ed. Yingjin Zhang), Stanford, CA: Stanford University Press, pp. 222–48.

Stringer, Julian (1997), ' "Your Tender Smiles Give Me Strength": Paradigms of Masculinity in John Woo's *A Better Tomorrow* and *The Killer*', *Screen*, 38: 1, pp. 25–41.

Stringer, Julian (2003), 'Scrambling Hollywood: Asian Stars/Asian American Star Cultures', in *Contemporary Hollywood Stardom* (eds Thomas Austin and Martin Barker), London: Arnold, pp. 229–42.

Vincendeau, Ginette (2000), *Stars and Stardom in French Cinema*, New York: Continuum.

Williams, Tony (2003), 'Transnational Stardom: The Case of Maggie Cheung Man-yuk', *Asian Cinema*, 14: 2, pp. 180–90.

Xu, Gary G. (2007), *Sinascape: Contemporary Chinese Cinema*, Lanham: Rowman & Littlefield.

Zhang, Yingjin (2007a), 'Artwork, Commodity, Event: Representations of the Female Body in Modern Chinese Pictorials', in *Shanghai Visual Culture, 1850s–1930s* (ed. Jason Kuo), Washington, DC: New Academia Publishing, pp. 121–61.

Zhang, Yingjin (2007b), 'Comparative Film Studies, Transnational Film Studies: Interdisciplinarity, Crossmediality, and Transcultural Visuality in Chinese Cinema', *Journal of Chinese Cinemas*, 1: 1, pp. 27–40.

Zhang, Zhen (2005), *An Amorous History of the Silver Screen: Shanghai Cinema, 1896–1937*, Chicago: University of Chicago Press.

Filmography

Center Stage (Ruan Lingyu 阮玲玉), d. Stanley Kwan 关锦鹏, Hong Kong: Golden Way, 1992.

Crossroads (Shizi jietou 十字街头), d. Shen Xiling 沈西苓, Shanghai: Mingxing, 1937.

Crouching Tiger, Hidden Dragon (Wohu canglong 卧虎藏龙), d. Ang Lee 李安, USA: Columbia Pictures, Good Machine/Taipei: Zoom Hunt/Beijing: China Film Coproduction, 2000.

The Difficult Couple (Nanfu nanqi 难夫难妻), d. Zhang Shichuan 张石川, Shanghai: Asia, 1913.

Drunken Master (Zuiquan 醉拳), d. Yuen Wo-ping 袁和平, Hong Kong: Seasonal Films, 1978.

Eternity (Wanshi liufang 万世流芳), d. Bu Wancang 卜万苍, Zhu Shilin 朱石霖, Maxu Weibang 马徐维邦 and Yang Xiaozhong 杨小仲, Shanghai: Zhonglian, 1943.

In the Mood for Love (Huayang nianhua 花样年华), d. Wong Kar-wai 王家卫, Hong Kong: Jet Tone, 2000.

Li Shuangshuang (Li Shuangshuang 李双双), d. Lu Ren 鲁韧, Shanghai: Haiyan, 1962.

Sayon's Bell (Sayon no kane 沙鸯之钟), d. Shimizu Hiroshi 清水宏, Japan: Shōchiku, 1943.

Sea Oath (Haishi 海誓), d. Dan Diuyu 旦杜宇, Shanghai: Shanghai Shadowplay, 1921.

Part I
Early cinema
Crossing race and class divides

2 Anna May Wong

A border-crossing 'minor' star mediating performance

Yiman Wang

Introduction

Anna May Wong blazed a trail for Asian American actors in Hollywood. Yet titles of writings about her, such as 'Right Place, Wong Time' (Okrent 1990: 84), 'From Laundryman's Daughter to Hollywood Legend' (Hodges 2004), and 'Caught between the Past and the Future' (Rich 2004), conjure an Anna May Wong who also embodied the temporal–spatial and ideological misplacement that undermines any assumption of individual agency. Her success thus doubled as failure, as three more descriptions commonly associated with Wong illustrate: to become 'perpetually cool' (Chan 2003), the 'China doll' (Wong 1996) has to first die a thousand deaths (*Los Angeles Times*).

B. Ruby Rich diagnosed Wong's dilemma: 'The great tragedy of Wong's life was that she sought to break free of her tradition-bound community and join the world of modernity that the cinema represented, only to find herself lashed by that very industry to constraining racial stereotypes' (2004). Caught between inheritance and aspiration, authenticity and fantasy, Western Orientalism and Chinese nationalism, Wong suffered dual misrecognitions. These were conflated with her Orientalist characters on the one hand, and being taken as a Chinese who disgraced China on the other. Rich (2004) succinctly summarizes Wong's dilemma as 'identity theft'. The crisscrossing expectations based on reified racial and cultural categories leave no room for an interstitial position, resulting in a perceptual and representational conundrum.

This conundrum by no means started or ended with Wong. Indeed, its survival into the new millennium is illustrated amply in the controversial discourses on China's 'new international face', Zhang Ziyi, following her feature role in the 2005 Hollywood production, *Memoirs of a Geisha* (Rob Marshal, 2005). It challenges us to develop alternative frameworks and vocabulary to describe tactics of producing and practicing minor and migratory identity positions.[1]

In my previous study of Wong's (self-)presentation in relation to Art Deco and nationalist ideologies, I propose 'yellow yellowface' performance as a mode of screen passing, or ironic ethnic masquerade, which allows her to simultaneously exploit and undermine the mimetic, Orientalist assumptions. Wong's legacy thus invites us to explore 'paranational and postethnic identity formations' (Wang 2005: 181–2).

In this chapter, I continue to explore the aporia or representational blockage that characterizes Wong's star discourses. Rich's description of Wong's body as a 'mask' is suggestive in this context. The image of the mask and masquerade is crucial to my analysis of Wong's minor/minority identity position. However, instead of assuming the surface–depth, mask–authenticity binary, I propose that the depth is embedded in, and produced precisely by, the mask. Wong developed her tactics of vacillation precisely by manipulating the 'masking' effect. Specifically, the 'masking' effect was inscribed in Wong's body and voice – the two major venues of (re-)cognition and (re-)presentation. For Zizek, these two venues have to be sutured in order to produce 'the illusion of the metaphysics of presence'. That is, only by short circuiting 'hearing oneself speaking' and 'seeing oneself looking', or ' "seeing oneself looking" *in the mode of* "*hearing oneself speaking*" can a gaze regain the immediacy of the vocal self-affection' (Zizek 1996: 95; original emphasis). Once we introduce the notion of performance or masquerade, the illusion of immediacy and unity is ruptured.

Perceived as a racial, gender, national and cultural Other in her multiple 'worlds' (America, Europe and China), Wong necessarily deployed visual and vocal performance. Such 'masking' effect in a broad range of media platforms suggests, as I argue below, that difference is not binary, but gradational and performative. This perspective will enable better understanding of the subaltern tactics that may emerge from Wong's visual and vocal performance for the audiences of her multiple 'worlds'.

Costumed performance

Wong's acting, according to her self-account, began with a 'thrilling' face-off experience. Hired as an extra (her debut role) in *Red Lantern* (Albert Capellani, 1919), the 14-year-old Chinese girl, Wong Liu Tsong, was poised to make up her own face. She used her mother's white solid cake powder for face, touched up her cheeks with red paper used for wrapping lucky money, and finished with black crayon for eyebrows. This 'mask', however, was soon removed and replaced by something that suited the make-up man's 'own taste'. Wong's reaction, interestingly, was a quick switch from resentment to 'thrill' (thinking she was important enough to have a make-up man). This, in retrospect, suggested to her, 'my childish dreams of stardom were beginning to materialize, and that at last I had made a step in the right direction' (Wong 1933: 6). Wong's 'face-off' serves as a trope for the tension between racialized misrecognition and self-construction that Wong experienced for the rest of her life.

On the surface, the story posits the opposition between the Chinese mask-like make-up and the Hollywood make-up conventions. Wong's switch from resentment to thrill can be easily interpreted as her submission to Hollywood's racism. This critique fails to consider the dual perspective – the 14-year-old Wong experiencing the 'face-off' and the adult Wong recounting the experience – that entails a significant process of self-reconstruction and negotiation. Indeed, Wong was thrilled with the *full knowledge* that her new face was constructed according to the

make-up man's 'own taste'. She was fully aware of Hollywood as not just a dream but also a factory with a repertoire of stock characters. To allow herself to be transformed into a stereotype means to actively look for a meeting point between her 'childish dream of stardom' and the Hollywood brand of dream. Thus, her 'thrill' had to do with obtaining a transformer who could facilitate the merging, or gradational difference.

Furthermore, this transformation did not suggest her self-erasure in that her own make-up did not signify an authentic Chinese 'self' that ended up being repressed by the industry. Rather, her 'original' make-up was no less than a 'mask' produced out of an assemblage of colours found at home; and the goal was simply to highlight generic features such as white complexion, red cheeks and black eyebrows. This make-up suggested a young girl's experiment with her face for an imaginary audience more than any serious concern with 'authenticity'. The fact that both her own make-up and her new face emphasized appearance and performance reinforced the possibility of 'thrilling' merging of personal and institutional practices. This does not mean that Hollywood racism, sexism and Orientalism did not jeopardize Wong's career and life (which ultimately constituted the working environment she negotiated tactfully). Rather, I emphasize that her negotiation and tactics did not aim at ideological resistance,[2] and that her Otherness was not essential, but performative, not categorical, but gradational. This is manifested in her physical embodiment and vocal presentation.[3] In this section, I focus on her embodied costuming in the late 1930s B movies.

Costuming is one key venue for Wong's performance of exotic foreignness. Depending on the China–America relationship at a specific historical conjuncture, which determined whether her 'Chineseness' was viewed as a liability or asset, her 'Chinese' costuming varied. When China became a US ally against both Japan and international Nazism between the mid-1930s and mid-1940s, Wong exhibited increasing engagement with the 'real' China. She participated in the China relief fund-raising campaigns by modelling and auctioning off her wardrobe, including the *qipao* dresses she acquired in China.[4] She also starred in three Paramount B movies in the late 1930s – namely, *The Daughter of Shanghai* (Robert Florey, 1937), *King of Chinatown* (Nick Grinde, 1939) and *Island of Lost Men* (Kurt Neumann, 1939) – which bespeak what Karen Leong calls the 'China mystique', or 'the gendered embodiment of American Orientalism' (Leong 2003: 5). Other scholars have discussed the importance of Wong's leading roles in fashioning Asian American identity, 'cultural citizenship' and ethnic spectatorship (Chung 2005; Lim 2006; Metzger 2006). Sean Metzger specifically argues that Wong's display of *qipao* dresses 'resonate[s] with specific moments of "liberation" in a national context and with particular icons (Madame Jiang)'; for Metzger (2006: 10, 11), Wong managed to:

> fabricate a vision of China that was, at times, wholly consonant with the U.S. drive for capital gain and the racial inequities such a drive might entail, while simultaneously articulating a pattern of resistance to the hegemonic system that so often abused her.[5]

Undoubtedly, Wong's engagement with the 'real' China since the mid-1930s coincided with her adoption of *qipao* dresses on and off the screen. Nevertheless, this does not automatically indicate her growing Chinese identity. Nor did she make *qipao* her only clothing style. In fact, all three films feature her in Western-style, shimmy and sweeping long dresses designed by Edith Head, who herself, parenthetically, adopted and kept Wong's China Doll hairdo for decades. These dresses are especially highlighted in scenes where Wong's character poises at the grand stairs, as if inviting the male protagonist and the audience to gaze and marvel at her meticulously fashioned body in the *mise en scène* that she temporarily inhabits.[6]

Her writing about *qipao* for American readers emitted fascination bordering on Orientalism. Her third instalment of the China 'travelogue' during her 1936 trip vividly and voyeuristically described Shanghai women's *qipao*, worn with 'stockings topped by a few inches of creamy skin' (Wong 1936b: 6). Her own acquisition of such dresses was depicted as an act of going 'native' doubled as curio-hunting. The Hearst documentary footages of her Shanghai trip show her arriving at the port in Western coat and deciding to 'go native' after hearing Chinese people commenting, 'Look at the foreign-looking, or Chinese-looking lady, shall I say, wearing foreign dress'. The rest of the footages document her in different *qipao* dresses at various occasions, sometimes coordinated with black leather gloves.[7] Wong's exhibition of sartorial 'Chineseness' in 'real' China not only responded to what she perceived as the Chinese people's confusion with her misfit but also exhibited a new type of Oriental exotica for her American audience. It suggested a form of performative difference that teased the recognition/misrecognition mechanism and titillated the crisscrossing gazes from the Chinese and the American sides. Wong's alternative embodiment of Chinese and Western fashions made the differences between them commensurable, consumable and confounding.

Wong's performance of dresses can be understood in the historical context of the Chinese–American entertainment culture from the 1850s to the 1920s. According to Krystyn Moon, Chinese performers achieved paradoxical agency by blending Chinese elements with American stereotypes to 'give white audiences what they wanted and expected while simultaneously challenging those stereotypes' (Moon 2005: 145). They deployed Chinese-inspired costumes, props and backdrops as well as pidgin English, yet they also played in blackface, impersonated Irish or Scottish characters, and sang in several European languages, omitting specific racial and ethnic references (Moon 2005: 145). Given the context of impersonation, Chinese-style costumes necessarily served as a dramatic curio displayed to tease and gratify the white audience while facilitating the re-fabrication of Chinese culture in the border-crossing context.

To place Wong's costumed performance in this context, we may argue that to don a dress on the screen or the stage, however 'authentic' or realistic it may seem, means to adopt a particular body language. For Wong, an interstitial actress and celebrity 'suspended between two [or more] worlds' (Wong 1936a: 1), ever conscious of her subjection to and reliance on the crisscrossing gazes, and actively

engaging with various forms of media publicity, the performative body permeated all levels of her life and career. Her body was not just a vehicle of actions, but more importantly, the very content of her performance.

Phillip B. Zarrilli's phenomenological model of an actor's embodied modes of experience is instructive for our analysis of Wong's relationship with her body via costuming. To describe the phenomenological body, or ' "embodied" body in its material resistance' (Garner in Zarrilli 2004: 654, note 5), Zarrilli develops four modes of embodiment: the surface body, the recessive body, the aesthetic 'inner' bodymind and an aesthetic 'outer' body. This model theorizes the ways the body comes to be felt in its 'materials resistance' or dematerialized in the process of acquiring a new skill. The last mode of embodiment, 'constituted by actions/tasks in performance, ... offered for the gaze of the audience', is particularly pertinent to my analysis (2004: 657). An actor comes to encounter his/her body's materiality and become more conscious of it through performance.

To take advantage of her exotic difference from Western mainstream, while demonstrating her versatility and assimilability, Wong strove to constantly monitor her physical appearance *vis-à-vis* other characters. Costumed in Chinese-styled dresses, Wong cued her body to deliver what was presumed by Western audience as Chinese women's body language – slouching shoulders while dancing, giving a submissive look, closed eyes suggesting an inscrutable Oriental,[8] swaying body hinting at illicit sexuality, and kneeling body conveying voluntary enslavement. Importantly, Wong's understanding of Chinese femininity was intertwined with discourses of exoticism. Describing to her American readers the ideal Chinese feminine beauty, presumably based on her conversation with a Chinese man she met en route to China, Wong writes of:

> a complexion the tint of mutton-fat jade, eyebrows like a moth's antennae and a walk that reminded one of a swaying willow ... the lady's neck should not be rigid; her head should swing as if set on her shoulders by a thin copper wire.
>
> (Wong 1936a: 6)

Thus, the stake in imitating and staging some of these physical features and postures was clearly not 'authenticity', but rather fashioning her body in accordance with a potentially attractive exotic image to strategize her minority position in Hollywood.

Wong's studied Oriental body deportment could lead to ironic consequences. What was originally intended to distinguish her from yellowface acting ended up making her a coach of Oriental mannerism, even when she was losing the role to a Caucasian actress. She was, for instance, hired to coach Dorothy Lamour for a Eurasian role in *Disputed Passage* (1939). Elizabeth Wong dramatized the irony in her play by showing a fictional Wong teaching a blond actress to die an Oriental death:

> Arms here! Legs here! ... Now, when your leading man sweeps you up and gathers you in his arms ... you die a little. Like so. Just a small turn of the

head. … This is how they want to see a Chinese girl in a man's arms. You die beautifully.

(Wong 1996: 86)

The playwright effectively decries Hollywood's exploitative racism through such dramatization. Nevertheless, the historical Wong's costumed performance far exceeded faking and coaching Oriental death.

The Paramount B movies demonstrate that Wong's body, dressed in Western costumes, blends easily into the *mise en scène* and the larger social environment. Western fashion experts also acknowledged her protean quality cued by different costumes. Comparing Wong's differing fashion cues and codes, costume designer Travis Banton, representing the style arbiters group from Hollywood, New York, London and Paris, remarked:

I think Miss Wong looks superb in her colourful, exotic, Oriental costumes. But for the role of a dangerous, ultra-sophisticated adventuress it is obvious that her gowns should be those of a reckless, expensively-groomed woman of the world. The Chinese gowns stress a decorative quality, whereas the American gowns which Edith Head is designing for Miss Wong in the film provide the sex appeal men of today look for in women.

(Lim 2006: 82)

This observation perpetuated the East–West power imbalance by binarizing Wong's performance into the antique Chinese decorativeness versus modern Western sex appeal and sophistication. Nonetheless, it did underscore Wong's performative malleability achieved through variant costumed embodiment geared toward audiences' divergent desires.

Such ideologically problematic yet surprisingly multivalent discourses on Wong challenge us to think beyond the recognition/misrecognition deadlock, and to refocus on the productive potential of Wong's constant management and (self-)scrutinization in various media forms. Zarrilli (2004: 664) suggests that the actor's body forms 'a site through which representation and experience are generated for *both self and other*. The actor undergoes an experience that is one's own, and is therefore constitutive of one's being-in-the-world, and simultaneously constitutes a world for the other'. It constitutes the 'irreducible *twinness* of a field that is simultaneously inhabited and seen' [added emphases]. This analysis underscores the imbrications between an actor's introverted, embodied performance and extroverted performance subjected to the audience's gaze. Their twinness resembles a Möbius strip that conflates the internal and the external, surface and depth. As the strip twists 180 degrees and winds back to itself, the internal and the external flip into each other. The Möbius strip metaphor enables us to transcend value judgement on 'misrecognition' and begin to re-recognize its implications.

In Wong's case, instead of assuming a stabilized internal–external structure, with the internal being misrecognized, we may refocus on the 'twinness' of the internal and the external, and understand the actor's subjectivity as being 'engaged

continually in a process of its own play with the "to's" and "from's" which are characteristic of each mode of embodiment' (Zarrilli 2004: 666). The 'to's' and 'from's' constitute the multiple axes of relating the actor's body to the audience. They are directional without being hierarchical, crisscrossing without being contradictory. By experimenting with various modes of embodiment and actively engaging the audiences' gazes, Wong's difference becomes performative and generative. Importantly, the energy triggered by Wong's embodied performance often transcends the Orientalist narrative frame. As the close-up shots guide the audience to gaze at Wong in her photographic as well as filmic representation, it does more than subject her body (or character) to racist and sexist consumption; it also anchors her as the centre of fascination, the node that congcals corporeal enactments of dynamic tension. This does not mean that Wong could become immune from the circumscribing ideological context. Rather, her mannerist bodily performance, even when stemming from her marginalized position, generated a high level of intensity that demands our attention to the surface and the affect.

Vocal performance

With Wong, not only her body but also her voice enacted performative difference. Unlike most stereotypical Hollywood Chinese roles that are stigmatized by pidgin English, Wong and her characters not only spoke English with no 'trace of the sing-song Chinese accent', to her American friends' surprise (Wong 1926), but also acquired the most desirable British accent. Moreover, she used French, German, mandarin Chinese and her ancestral Taishan dialect in various films, stage and vaudeville shows. In this section, I examine her commitment to the British accent, and ask what kind of vocal performance it gave rise to and how it shaped her star discourse. I address these questions by analysing the ways she framed her linguistic choice and her role in a 1939 radio play *The Patriot* (Orson Welle).

Returning from her first European trip in 1931, Wong wowed the American journalists with her newly acquired British English.[9] Such reaction had to do with the perceived incongruity between a 'pure' language and an Oriental foreigner. From the American perspective, Wong left as a foreign object (an Oriental), yet returned as a foreign subject (a Europeanized Oriental). Wong's metamorphosis rendered her foreignness uncanny in that it forced the American audience to encounter a seemingly familiar self (i.e. Western sophistication) in the Oriental Other. The presumed (linguistic) purity was thus revealed as an object that could be acquired (thus divested).

Furthermore, Wong's relationship to her British English explicitly positioned it as a commodity. Responding to media interest in her British accent, Wong observed, with her characteristic wry humour, that she decided to *buy* this accent with 200 guineas (hiring a coach) to avoid offending the critics' ears (with her 'guttural and uncultivated' American accent) (Roberts 1997); and that having made the 'investment', she had to protect it by retaining the accent (Carroll 1931: 1). In another interview, Wong described retaining the accent as 'tak[ing] whatever becomes you and mak[ing] it part of yourself' (Leong 2003: 187, note 86).

Both comments emphasized her calculation and self-packaging based on the logic of commercial exchange and capital investment. Wong's reference to money (the exchange value attached to the status symbol, British English) further suggested the imbrications between her cosmopolitan buy power and her migratory labour power.

Under the cover of glamour, one detects an ethnic actress who travelled extensively in America, Europe and China, mining for work opportunities on stage and in vaudeville, as well as in the film industry. Her investment in British English, German, French, some other European languages and at a later point, mandarin Chinese, was connected with the labour economy underlying the star discourses. To become a cosmopolitan star meant to demonstrate her international currency or exchange value that both originated from, yet also concealed, Wong's labour input.[10]

Wong's vocal performance thus simultaneously enacted and deconstructed the business of star production, without invalidating it or making it unattractive. On the contrary, her humorous use of the business discourse underscored her sophistication. Wong's performance of British English was not reducible to total alignment with Euro–American interpellation, nor did it become a site of abstract autonomy. Like her initial 'face-off' and shifting costuming, the linguistic transformation (from American to British) through commercial exchange demonstrated performative difference. Its implications remained over-determined by the 'structured polysemy' of her star discourses (Dyer 1979: 3) and the specific context in which it occurred.

Such a unique context in which Wong's vocal performance came to the fore was *The Patriot*, a radio play produced by Orson Wells for the Campbell Playhouse on 14 April 1939. One may expect that the medium of radio play would make Wong's ethnicity irrelevant by removing visuality, thus allowing her British English to transcend typecasting. But this did not happen. Wong's character in the play was a Chinese maid speaking in British English. Originally written by Pearl Buck, the play depicts the emergence of New China in its war against Japan. It elaborates the interracial marriage between a Chinese revolutionary and a Japanese woman, narrated from the revolutionary's perspective (portrayed by Wells). Wong's foray into radio entertainment drew star billing but her role was minor: the revolutionary's maid who later marries another revolutionary and experiences the ordeal of the Long March.

As a maid, Wong's vocal presence reproduced her supporting roles in films that used her to authenticate the Orientalist narrative while starring Caucasian actors in yellowface. Interestingly, contrary to her screen performance characterized by her meticulously crafted fashions and body languages, Wong's vocal performance was surprisingly flawed despite her impeccable British accent. She pronounced the male protagonist's name inconsistently and stammered on two lines ('Oh I'm not used – not used to – oh I'm used to serving, not sitting down with the others'; 'Tell me more, En-lan – En-lan – tell me more about this revolution'). Whereas it is hard to explain exactly what caused her apparent disinterest in this role, we may speculate the absence of visuality in the radio show undermined the opportunity for her to perform with her body, making her vocal presence less spirited. In other

words, the new medium offered Wong an old (subservient) role without allow-ing her the old venue of embodied visual performance. Consequently, instead of acquiring transcendent value unfettered by her ethnicity, Wong's British English became resistant materiality, out of place and unwieldy.

On the other hand, Wong's Chinese heritage also failed to give her any advantage over Buck. In the post-show conversation, Wong and Buck met in the broadcasting room, but had little interaction except polite greeting and Wong's complimentary yet poignant remark, 'As a Chinese I naturally have been intensely interested in your books on China'. Nor did Wong have a chance to interact with the audience. Instead, Buck assumed the authoritative voice in speaking about wartime China and her play. Wong certainly could not automatically speak for China on account of her heritage alone. Nevertheless, the explicit Wong–Buck hierarchy bespoke American public media's desire to portray a new, positive China as America's wartime ally – a China represented by an American woman who derived her authority from growing up in China as a missionary's daughter. The rise of Buck's China signalled the phasing-out of Wong.

Being aware of America's expectations for a new media image of China and the increasingly limited currency of her British English, Wong turned to Mandarin Chinese. At the beginning of *Bombs Over Burma* (Joseph H. Lewis, 1943), as a teacher she teaches Chinese schoolchildren Mandarin Chinese. Brief and awkward as this sequence is, her new language demonstrates her efforts to address the new political sentiment by continuously refashioning her vocal performance.

Becoming 'minor'

Throughout her career, on and off the screen, Wong consistently engaged with self-conscious visual and vocal performance. Her performative difference underscored an outsider position that defied any essentialist national or cultural categorization. Hovering between the minority social position and the racialized fictional personae, this performative body constitutes the third term that disrupts the assumption of the actor–character mimeticism.

Here Eli Rozik's triadic structure is instructive. Contrary to the dyadic actor–character correspondence, Rozik proposes a triad of actor–producer (producer of signs), actor–text and character (2002: 122). In this structure, ' "acting" means a producer of signs (W0) [real world] inscribes on matter a description or "text" [actor–text] that enacts or refers to and describes a character (W1) [fictional world]' (2002: 12). By inserting an ambivalent space of actor–text or perfor-mance between the realms of reality and fiction, this triadic structure underscores the materiality of the actor's body as non-coterminous with the roles it plays. Also importantly, this structure refocuses from external coding to the actor's generation of embodied performance. Viewed as such an actor–producer, Wong performed her differences in ways that appropriated, critiqued or bracketed exter-nal coding systems. By devising various actor–texts and performance, her body came to be experienced as material existence. Conversely, this conception of her body allows us to reassess the significance of her performative difference or actor–texts.

This triadic structure also sheds new light on Wong's vocal performance. Instead of equating it with Wong's self-expression or confining it to the characters' dialogues, we can view its multi-accented variability that often stresses out-of-place-ness (rather than assimilation) as constituting the third term between the actor–producer and the character – the site of the performative text. This vocal performance allows the actor–producer and the characters to simultaneously address and cross-address the audiences in the historical and fictional domains. Such multiple modes of address demonstrate Wong's ability to reposition herself in various contexts.

Like other actors and actresses, Wong relies upon performative versatility for sustainable public interest and star effect. Unlike mainstream actresses, however, Wong's performative difference consistently highlights her interstitial position as a cultural or ethnic 'foreigner', 'suspended between two worlds' (Wong 1936a: 1), constantly vacillating between crisscrossing external gazes and her self-perception. Her 'foreign' performance signifies not simply literal re-enactment of her actual social status, but more a conceptual frame that allows her to design positions at variant distances from the mainstream ideological interpellations. It entails complicated identity management involving sliding and morphing as well as control. As such, it counters reductive representationalism and suggests new ways of conceptualizing difference and alternative politics.

One way to pursue this is to go beyond the antithetical Self–Other deadlock, and to see racial and cultural differences as gradational, morphing and subjected to constant monitoring and readjustment from multiple perspectives. Wong's minority status and migration experiences allowed her to shuttle between, weave together and perform differences. She adopted European *haute couture* fashions and British accent to raise her cultural capital. Yet at the same time, she poked fun at her 200 guineas worth of English pronunciation, while continuing to display and adjust her 'Chinese' markers. By enacting a 'foreign' position from within the dominant matrix, Wong's performative difference was not simply opportunistic. More importantly, it indicated a de-territorializing tactic of 'becoming minor', as theorized by Deleuze and Guattari.[11]

The result, however, was not Deleuze and Guattari's 'line of flight', which seeks to 'blow apart strata, cut roots, and make new connections', thereby producing a 'smooth' space where the 'becoming' occurs (2004: 16, 537). This smooth space, even though continuous with the striated space, indicates the possibility of a boundary-free space and a libratory trajectory that hardly resonated with Wong's experiences as a migrant star-cum-worker. On the contrary, Wong's travelling both on and off the screen constantly evoked the inescapable border politics and body politics. Her 'becoming minor' was intertwined with negotiating the border and performatively inscribing it on her visual and vocal body.

Therefore, instead of seeing her mobility as manifesting the smooth space of 'lines of flight', I argue it should be more appropriately described as a space traversed by lines of suspension. These traversing lines of suspension produce relative ambiguity and flexibility while calling attention to the striation inherent in all geopolitical spaces. They do not posit liberation, yet they also defy

peremptory discourses derived from Orientalism and nationalism. As a migrational and *minor* star-cum-worker, Anna May Wong performed her differences and situated agency within this suspended space of frictions and crossings, through various media platforms. By studying Wong's performative tactics of 'becoming minor', i.e. becoming different from within the dominant matrix, we open up a flexible structure of minority positioning in today's global-scapes.

Notes

1 I follow Michel de Certeau's distinction between tactics and strategy. Whereas strategy presumes the status of authority and works toward homogenization, tactics arise from necessity and are practiced on the everyday level by individuals or fragmented groups (de Certeau 1984).

2 One-sided emphasis on resistance may end up reinforcing Orientalism, as demonstrated in a publicity article published by Paramount. This article claimed that Wong refused to be de-Orientalized and defied the studio's attempt to modernize her into a role with bobbed hair. Wong's defence, according to the article, was that her exotic roles required the *correct* Oriental demeanour, including long hair (Lim 2006: 83). As Lim suggests, this article succeeded less in establishing a fact than in constructing Wong as defiant. Yet the image of defiance could exist paradoxically because it was associated with Oriental Otherness that Hollywood readily embraced as just another commodity.

3 Cynthia W. Liu (2000: 33) argues that despite Wong's participation in shaping her star discourse, a 'space of reserve' or 'membrane' separates Wong's roles from her subjectivity. This separation unsettles the audience's scopophilia. I follow Liu's emphasis on distinguishing Wong from her roles, but not because an untainted subjectivity was reserved for Wong the person. Rather, the distinction is to underscore her performative existence to understand her public personae as resulting from self-conscious masking, rather than from natural self-expression.

4 She also wrote the Foreword for *New Chinese Recipes for the American Family* in 1942. This recipe book includes a photograph of an orphaned Chinese girl 'looking wistfully to you for help – and for hope' (see Wing 1942). Money from sales of the book was donated to the United China Relief. Wong's 'Foreword', signed in both Chinese and English, demonstrates her role as a cultural mediator, a Cantonese heritage person endorsing Cantonese–American cuisine, explaining the difference between Chinese intuition and Western science, yet promoting the possibility and desirability of bridging the barrier.

5 Some publicity photographs, entitled 'Strictly Chinese', show Wong in *qipao* dresses from her own wardrobe, featured in *Dangerous to Know* (Robert Florey, 1938) and *The Daughter of Shanghai* (Robert Florey, 1937).

6 In a *King of Chinatown* sequence, as Wong's doctor character descends a staircase in a long white, shiny dress, her patient, the 'king of Chinatown', stops her in order (for the audience) to examine her beauty. Another example is a 1937 publicity photograph for *Dangerous to Know*, showing Wong in a trend-setting dress: a black and white dinner gown with bold leaf motif, long sleeves and high neckline, adhering to moulded silhouette, and a long scarf that can be arranged in different ways or draped around the head. A similar *haute couture* Western fashion could also be found in a 1936 issue of a Shanghai film magazine, *Dianying huabao*. The photos were taken by a famous Shanghai photography studio, Hu Jiang; the captions underscore the dress as the most recent Euro–American fashion.

7 See *Anna May Wong Visits Shanghai* (1 May 1936) and *Bold Journey: Native Land* (14 February 1957), ABC travel-adventure documentary programs stored at UCLA Film and TV archive.

8 See the first shot of Wong's character in *Limehouse Blues* (Alexander Hall, 1934).
9 A news report dated 2 June 1931 spoke of Wong: 'Oriental actress, came back to Hollywood yesterday with an English accent and memories of a series of triumphs on the stage of European countries during her 4 years absence' (see 'Wong Returns after Triumph Abroad').
10 An example of Wong's aspiration for international currency is her travelling vaudeville performance in Europe. One of her repertoire shows was a song called 'The Chinese Girl', which was readily adapted into 'A Swedish Girl' and 'A Norwegian Girl', performed respectively in Swedish and Norwegian languages when she visited those countries.
11 According to Deleuze and Guattari (1986: 26), a minor literature is written in the *major* language from a marginalized or minoritarian position with the effect of de-territorializing the major language. The writer of minor literature always assumes the position of 'a sort of stranger within his own language'.

Works cited

Carroll, Harrison (1931), 'Oriental Girl Crashes Gates via Footlights', *Herald Express* (6 June), p. 1.

Chan, Anthony B. (2003), *Perpetually Cool: The Many Lives of Anna May Wong (1905–1961)*, Lanham, MD: Scarecrow Press.

Chung, Hye Seung (2005), 'Between Yellowphilia and Yellowphobia: Ethnic Stardom and the (Dis)Orientalized Romantic Couple in Daughter of Shanghai and King of Chinatown', *East Main Street: Asian American Popular Culture* (eds Shilpa Dave, LeiLani Nishime and Tasha G. Oren), New York: New York University Press, 2005, pp. 154–82.

de Certeau, Michel (1984), *The Practice of Everyday Life* (trans. Steven Rendall), Berkeley, CA: University of California Press.

Deleuze, Gilles and Felix Guattari (1986), *Kafka: Towards a Minor Literature*, Minneapolis, MN: University of Minnesota Press.

Deleuze, Gilles and Felix Guattari (2004), *A Thousand Plateaus*: Capitalism and Schizophrenia (*trans. Brian Massumi*), London: Continuum.

Dianying huabao 电影画报 (Film pictorial) (1936), 27, p. 5.

Dyer, Richard (1979), *Stars*, London: British Film Institute.

Hodges, Graham Russell Gao (2004), *Anna May Wong: From Laundryman's Daughter To Hollywood Legend*, New York: Palgrave Macmillan.

Leong, Karen J. (2003), *The China Mystique: Pearl S. Buck, Anna May Wong, Mayling Soong, and the Transformation of American Orientalism*, Berkeley: University of California Press.

Lim, Shirley J. (2006), ' "I Protest". Anna May Wong and the Performance of Modernity', in *A Feeling of Belonging: Asian American Women's Public Culture, 1930–1960* (ed. Shirley Lim), New York: New York University Press, pp. 47–86.

Liu, Cynthia W. (2000), 'When Dragon Ladies Die, Do They Come Back as Butterflies? Re-Imagining Anna May Wong', in *Countervisions: Asian American Film Criticism* (eds Darrell Y. Hamamoto and Sandra Liu), Philadelphia, PA: Temple University Press, pp. 23–56.

Metzger, Sean (2006), 'Patterns of Resistance? Anna May Wong and the Fabrication of China in American Cinema of the Late 30s', *Quarterly Review of Film and Video*, 23, pp. 1–11.

Moon, Krystyn R. (2005), *Yellowface: Creating the Chinese in American Popular Music and Performance, 1850s–1920s*, New Brunswick, NJ: Rutgers University Press.

Okrent, Neil (1990), 'Right Place, Wong Time: Why Hollywood's First Asian Star, Anna May Wong, Died a Thousand Movie Deaths', *Los Angeles Magazine* (May), pp. 84–96.

Rich, B. Ruby (2004), 'The Price of Modernity. Will Movie Legend Anna May Wong, Caught between the Past and the Future, Find Her Moment?', *Guardian* (3 March). http://www.sfbg.com/38/23/cover_annamaywong.html. Accessed 13 April 2004.

Roberts, Barrie (1997), 'Anna May Wong: Daughter of the Orient'. http://www. classicimages.com/1997/december97/wong.html. Accessed 10 December 2007.

Rozik, Eli (2002), 'Acting: The Quintessence of Theatricality', *SubStance*, 31: 2/3, pp. 110–24.

Wang, Yiman (2005), 'The Art of Screen Passing: Anna May Wong's Yellow Yellowface Performance in the Art Deco Era', *Camera Obscura*, 60, pp. 159–91.

Wing, Fred (1942), *New Chinese Recipes for the American Family: Cantonese Style Recipes Using Only Ingredients that Can be Bought in Neighborhood Stores*, New York: Edelmuth Co.

Wong, Anna May (1926), 'The True Life Story of a Chinese Girl', Part 2, *Pictures* (September). http://www.mdle.com/ClassicFilms/FeaturedStar/star49e2.htm. Accessed 21 March 2001.

Wong, Anna May (1933), 'My Film Thrills', *Film Pictorial* (London) (11 November), p. 6.

Wong, Anna May (1936a), 'Anna May Wong Tells of Voyage on 1st Trip to China', *New York Herald Tribune* (17 May), pp. 1, 6.

Wong, Anna May (1936b), 'Anna May Wong Recalls Shanghai's Enthusiastic Reception on First Visit', *New York Herald Tribune* (31 May), pp. 2, 6.

Wong, Elizabeth (1996), *China Doll: The Imagined Life of an American Actress*, a play presented by Jason Fogelson of William Morris Agency, New York.

'Wong Returns after Triumph Abroad' (2 June 1931), Anna May Wong microfiche housed in Margaret Herrick Library.

'Anna May Wong Dies at 56' (1961), *New York Herald Tribune* (5 February).

Zarrilli, Phillip B. (2004), 'Toward a Phenomenological Model of the Actor's Embodied Modes of Experience', *Theatre Journal*, 56, pp. 653–66.

Zizek, Slavoj (1996), ' "I Hear You with My Eyes": Or, the Visible Master', in *Gaze and Voice as Love Objects* (eds Renata Salecl and Slavoj Zizek), Durham, NC: Duke University Press, pp. 90–126.

Filmography

Bombs over Burma, d. Joseph H. Lewis, Alexander-Stern Productions, 1943.

Dangerous to Know, d. Robert Florey, Paramount Pictures, 1938.

The Daughter of Shanghai, d. Robert Florey, Paramount Pictures, 1937.

Island of Lost Men, d. Kurt Neumann, Paramount Pictures, 1939.

King of Chinatown, d. Nick Grinde, Paramount Pictures, 1939.

Limehouse Blues, d. Alexander Hall, Paramount Pictures, 1934.

Memoirs of a Geisha, d. Rob Marshal, Columbia, 2005.

The Patriot, d. Orson Wells, Campbell Playhouse, 14 April 1939.

Red Lantern, d. Albert Capellani, Metro Pictures Corporation, 1919.

3　Ruan Lingyu

Reflections on an individual performance style

Mette Hjort

Approach

Ruan Lingyu (1910–35), the greatest star of the Chinese silent film era and arguably
of Chinese cinema *tout court*, has prompted a number of confessional statements.
In the only English-language monograph devoted to Ruan, Richard Meyer (2004:
xiii) recalls his first encounter with this Chinese star at the Pordenone International
Silent Film Festival in 1995: 'it was love at first sight'. And in his foreword to
Meyer's book, Leo Ou-fan Lee reflects on this statement by remembering his
own responses to Ruan's most famous film, *The Goddess* (Wu Yonggang, 1934);
'I never bothered to recall its story-line, but I was haunted again and again by a
few scenes of Ruan Ling-yu's face with all her subtle and nuanced expressions.
Thus I, too, became obsessed with Ruan Ling-yu' (Lee 2004: xiv). In the opening
moments of Stanley Kwan's innovative homage to the Lianhua star, *Center Stage*,
aka *Actress* (1991), the Hong Kong director similarly reflects on the haunting
nature of his first sustained encounter with her films: 'After having seen all her
six movies she struck me as outstanding and life-like. … I found in her something
special'.

These deeply personal declarations by two scholars and a film director evoke
what is clearly viewed as an acting style with highly individualized features. They
also testify to the ways in which the individual style of an actor affects a given
viewer. Together these utterances point to what is, surprisingly, relatively unex-
plored terrain. As Leo Lee points out, while 'the narrative weight of Chinese films
[from the era in question] is carried for a large part by acting', there has been
a tendency in the critical literature to dismiss acting as 'irrelevant' to the films'
formal qualities (Lee 1999: 89–90). Yet acting or performance style is crucial to
star studies (Dyer 1998: 132–50).

In the following discussion I attempt to contribute to the existing scholarship
on Chinese film stars by drawing attention to questions of performance. The aim,
in brief, is to connect Ruan's films with some of the probing research questions
put on the scholarly agenda by Alan Lovell and Peter Krämer's *Screen Acting*
(1999). An important motivation for this excellent edited volume is a perceived
need to grasp the reasons why film acting, for the most part, has been precisely
the kind of neglected area that Leo Lee describes above with particular reference

to the Golden Age of Chinese cinema. For Lovell and Krämer the challenge is not simply to make the case for film acting as a legitimate focus for research, but to ensure that the right kinds of questions are asked: 'Too much writing in Film Studies works on a high level of abstraction without paying sufficient attention to the concrete and practical dimensions of film making' (Lovell and Krämer 1999: 8). Taking issue with the kind of theory-driven approach targeted explicitly by David Bordwell and Noël Carroll in their polemical intervention *Post-Theory* (1996), Lovell and Krämer advocate a mode of research that is hospitable to both empirical description and intentional analysis. They argue convincingly that key questions that need to be asked are: 'What do actors do to create a performance? What are their specific skills? What arc the general ideas which inform the use of those skills?' (1999: 1).

Yet in the case of Ruan, how are such questions best pursued? After all, many of the films on which her legendary status is based are either lost or very difficult to access. While recognizing the limitations of a less than comprehensive picture, I propose to focus here on the Ruan Lingyu film that is readily available to viewers, thanks to the efforts of Richard Meyer, who worked with the Beijing Film Archive to restore and release it in a digital format: Wu Yonggang's *The Goddess*. Another precious resource is Stanley Kwan's award-winning tribute to Ruan, *Center Stage*. This complex film, which is both a biopic and a documentary (with a dual focus on Ruan's contributions as an actress and on the making of Kwan's film), includes a number of sequences not only from *The Goddess* but also from other key films, such as *The Peach Blossom Weeps Tears of Blood* (Bu Wancang, 1931), Sun Yu's *Little Toys* (Sun Yu, 1933) and *New Woman* (Cai Chusheng, 1934). *Center Stage* thus provides a welcome opportunity to engage in the inductive work of drawing inferences about the features that might legitimately be identified as constituting elements of a distinctive and particularly moving individual performance style. In the present context, however, this film by one of Hong Kong's most significant independent filmmakers will be cited primarily in connection with the more analytic commentaries it provides on Ruan's work as a canonized actress.

Any attempt to provide a descriptive and explanatory account of Ruan's on-screen presence – her star image – must necessarily encompass a number of contextual issues, some biographical, others more properly social or institutional. Thus, for example, it is relevant to consider the implications of Ruan's lack of formal training as an actress, to evoke the 'pantomime' tradition of silent cinema's performance styles and its repertoire of gestures, and to note early Chinese cinema's acceptance of the continuity framework. On this last question, Bordwell rightly remarks that, 'distinctive as Ruan Lingyu's radiant performances are, they are predicated on a standardized system of shooting and cutting that could set off her expressions and postures' (2005: 145).

The significant point here is that while Ruan's legendary status as the Greta Garbo or Marlene Dietrich of China relies on powerful intuitions about individual style, her performances necessarily involve elements of what analytic aesthetician Richard Wollheim refers to as 'general style', which he takes to encompass 'school style', 'period style' and 'universal style' (1995: 40). The task at hand is

therefore to relate Ruan's contributions, at least briefly, to a specific instance of general style – the *types* of films, for example, with which the Lianhua studio is associated. However even more important is the task of pinpointing some of the special capacities and practices that are reflected in Ruan's performances. Ruan's enduring reputation as one of China's greatest stars rests, in short, on elements of both general and individual style, although the latter is clearly decisive.

Understanding Ruan's life and her suicide

Before taking up specific performance issues, it is necessary briefly to discuss who Ruan Lingyu was, to reconstruct some of the key events in this tragic figure's short life and to situate these events in relation to the excellent research on actresses, class affiliation, social mobility and the dynamics of social discourse in China in the late 1920s and early 1930s. Let us begin by recalling the names, dates and crucial actions that are so central to the discourse that surrounds Ruan, then and now. We will also try to understand how public attitudes towards Ruan, many of them focused on matters of gender and profession, helped to provoke the tragedy by which the star's life, and thus recollection of it, are marked.

Ruan Lingyu was born on 26 April 1910, to Cantonese-speaking parents from Guangdong who had settled in Shanghai. She died almost 25 years later, on 8 March 1935, succeeding finally, after three earlier failed attempts, to take her own life. Ruan's death on International Women's Day prompted a global outpouring of grief, and in Shanghai her funereal procession is said to have drawn as many as 100,000 mourners (Harris 1997: 277). The intensity of the grief expressed at Ruan's death says something about the level of her achievements as an actress, but it also raises the question as to why she chose to end her life.

At the time of her death Ruan had made 29 films, more than half of them socially engaged films that in some way represented the 'suffering women of China' (Meyer 2004: 1). Targeting heightened emotions, the narratives in these so-called 'left-wing' films drew clear contrasts between good and evil in the manner often associated with melodrama. Ruan began her career with the Mingxing Film Company and the Da Zonghua-Baihe Film Company, and found herself working for Lianhua some 4 years later as a result of a company merger. Speaking to Maggie Cheung (who plays Ruan in the biopic sequences that constitute a significant narrative thread in *Center Stage*), Kwan points out that Ruan's career as an actress divides neatly into two parts:

> These are movie stills from when she was 16. Some of the prints are no longer available. Most of the film genres were folklore, romance, supernatural or martial arts. They say she was mostly given casual roles, or wallflowers, as we call them now. Only after joining Lianhua in 1929 did she have a chance to be in serious films.

Following Maggie Cheung's laughing response, which evokes parallels between the two careers – 'We have similar fates then' – Kwan immerses the viewer in

reconstructions of the Lianhua milieu, including the imagined production of classic films, all punctuated at key moments by excerpts from some of the still extant films. Thus, for example, viewers are introduced to Maggie Cheung as Ruan in Kwan's reconstruction of the studio shooting of Sun Yu's *Memories of the Old Capital* (1930), Ruan's first film with the Lianhua studio. Kwan's decision to focus on Ruan's years with the Lianhua studio reflects the extent to which the star's legacy rests on her work with many of the most significant directors of the Golden Age of Chinese cinema: Sun Yu, as mentioned, but also Fei Mu, Wu Yonggang, Bu Wancang, Zhu Shilin, Cai Chusheng and Luo Mingyou. The Lianhua studio, an interesting topic of research in its own right,[1] is typically viewed as having involved a strong, yet by no means debilitating tension between a number of left-leaning directors with a clear sense of social mission, on the one hand, and various supporters of Kuomintang-style policies and ideas, mostly at management and board level, on the other. As Kwan's film effectively argues throughout, Ruan was unproblematically aligned with the left-wing directors whose 'Golden Age' films established her as a star.

It is not easy to determine why Ruan decided to end her life at the height of her career. Attempts to explain her actions tend to point not to any single causal chain, but to the tragic synergy among a number of factors: Ruan's involvement with two abusive men, Zhang Damin and Tang Jishan; her strong identification with the many tragic roles that she played during her years at Lianhua; and the tension between the virtuous nature of her screen roles and the deviations from pervasive moral norms that her decisions as a woman and private person manifested. To this already toxic mix, it is necessary to add at least two punctuating events. One is Zhang Damin's decision to pursue Ruan and her new lover, Tang Jishan, through a court case that was designed to exploit the media's taste for gossip. Another is the media's intense hostility towards Cai Chusheng's *New Woman* (1934) and thus towards its star, Ruan, who was quickly perceived as a convenient scapegoat. Let me expand on some of these points.

Ruan's father died when she was aged six, and one consequence of his premature death was that her mother sought employment as a domestic servant with a wealthy family that, like Ruan's, was originally from Guangdong. Zhang Damin, the youngest of the family's children, is rumoured to have raped Ruan, and to have prompted her decision to leave school and seek employment with Mingxing, in an effort to support both herself and her mother (Meyer 2004: 12). Citing family objections as his reason, Zhang Damin would never marry Ruan, but he did become her common law husband, leading a dissolute life very much at her expense (Meyer 2004: 19). Ruan's repeated attempts to distance herself from Zhang were largely unsuccessful and he eventually brought strategically publicized charges against Ruan and Tang Jishan.

Tang, a wealthy tea merchant with a reputation for courting prominent actresses, responded with violence, blaming and beating his lover hours before she killed herself (Meyer 2004: 55). Richard Meyer argues that Tang's concern for his own image played a crucial role in Ruan's death. When it became clear that Ruan had consumed a large quantity of sleeping pills, Tang wasted precious time driving

to a remote hospital, staffed by Japanese medics who were unlikely to recognize either of them (Meyer 2004: 59). Following Ruan's death, Tang produced two suicide notes that pointed the finger of blame not at him, but at Zhang Damin and at society's hunger for gossip. Later revealed to be forgeries, these notes replaced authentic documents that clearly implicated Tang Jishan in the tragic event:

> Jishan: If you're not infatuated with 'xx', if you didn't beat me that night and beat me again tonight, I might not have done such a thing! After my death, in future people will certainly call you a devil who dallies with women.
>
> (Meyer 2004: 66)

As Jean-Noël Kapferer insightfully suggests in his influential study on the dynamics of gossip, 'every collectivity and social group has its preferred, virtually institutionalized, scapegoats' (1990: 91). Republican China in the 1930s was a context of warring ideologies and dramatic change affecting social roles and relationships, particularly those of women. While revolutionary efforts created new opportunities for women, regressive energies easily cast women who pursued the new opportunities as ready targets for social opprobrium.

As an actress, Ruan belonged to a group that in many ways recalls Kapferer's remarks about institutionalized scapegoats. In a fascinating article entitled 'The Good, the Bad, and the Beautiful: Movie Actresses and Public Discourse in Shanghai, 1920s–1930s', Michael Chang persuasively argues that the classificatory system serving to categorize courtesans and prostitutes during the late Qing dynasty and early Republican years to varying degrees informed attitudes towards China's first and second generation of film actresses. Chang suggests that it was possible to escape censure and notoriety as a screen actress, but only if one was widely perceived as properly conforming to norms of authenticity that were clearly articulated in the very first writings in Chinese on screen acting (1999: 129). That is, actresses were rewarded not for 'acting well', but for 'acting good and acting like "themselves"' (Chang 1999: 136). In Ruan's case, however, what was titillating and scandalous, and thus grist for the mills of the tabloid press, was the discrepancy between the virtue she embodied on the screen and the depravity that her personal life could be seen to express when viewed in the light of traditional patriarchal values.

As an actress, and one who saw her profession as creating the conditions for independence and social mobility, Ruan was a convenient and easy target when journalists writing for the popular press decided to seek revenge for Cai Chusheng's condemnation of their ethically dubious practices in *New Woman*. This film was based on the real-life tragedy of the actress Ai Xia, an actress and scriptwriter who committed suicide when the popular press exploited her desperate attempt, through a single act of prostitution, to raise money for the medical treatment of her sick daughter. As the exchange between Maggie Cheung and Tony Leung Ka-fei (who plays Cai Chusheng) in *Center Stage* suggests, Cai is understood to have been involved with Ai Xia and thus to have made *New Woman* for deeply personal reasons. *New Woman*, and especially Ruan (playing Wei Ming, the character

based on Ai Xia), were viciously attacked by the press when the film was released in 1934. As script writer Shen Ji recalls in a documented exchange with Kwan in *Center Stage*, members of the press turned on Ruan when their efforts to censor the film's central message failed. At the time of her death, then, Ruan was the object of various types of abuse, some private, much of it highly public, and she had just finished playing a role with which she identified to an unusually high degree: that of an actress who chooses death to escape from the vicious effects of evil-minded gossip.

Ruan's performance style

Let us now turn to consider Ruan's performance style and what makes it so unique and memorable. Whereas the appeal of some stars is limited to particular national contexts or specific historical periods, Ruan's on-screen presence is arguably as mesmerizing for viewers today as it was for filmgoers in the 1930s, and as fascinating to international audiences as to Chinese audiences. I propose to begin the task of understanding why this may be so through a two-step process. First, I examine what film practitioners – directors and actors in particular – have said about the features that may be seen to define Ruan's performance style. Second, I look closely at a number of sequences from Wu Yonggang's *The Goddess*. Here I make a case for seeing Ruan's performance style as departing from the pantomime tradition of exaggerated and clearly codified gestures, and as contributing instead to the development of the performance modes that James Naremore identifies in terms of 'psychological realism' (1988: 38). I focus on three areas in which Ruan can be shown to have excelled consistently as a performer: the expression of emotional *complexity*; the communication of *intent* through *carefully modulated* facial expressions and bodily movements; and the articulation of *complex characterization* as a result of *versatility* and *range*.

As Lovell and Krämer point out, 'acting is an elusive art', involving 'a large number of actions, gestures, facial and vocal expressions' (1999: 5). In the present context, then, we do well to consider the discourse that has emerged around Ruan, paying careful attention to the terms used to pinpoint distinguishing features of an individual style, or elements of a group style that appear to have been taken to a new level of competence. The documentary sequences in *Center Stage*, in which viewers witness exchanges between Kwan and his cast about Ruan and her milieu, are a useful place to start. After all, these film practitioners are well versed in the history of screen acting and its techniques, and have something at stake in trying to understand the basis for Ruan's legendary status.

During the opening sequences of *Center Stage*, the viewer is shown a number of still images from Ruan's pre-Lianhua years. These still images are followed by a sequence documenting a conversation between Kwan and Cheung that speaks directly to the question of Ruan's specificity as an actress:

Stanley Kwan: Ruan's favourite expressions. Looking up to the heavens in forlorn wordlessness. … They had movies then. It all comes

down to expression and motion. I found in her … something
sexy.

Maggie Cheung: Not superficially sexy. It exuded from within. She could be
all wrapped up, up to here [she gestures to her neck], but you
could feel her coquettish charm. I don't know how to put it
exactly. The way she smiled was most enchanting. Remember
that village girl in *Weeping Peach Blossoms*?

Stanley Kwan: Yes.

Maggie Cheung: [miming the sequence, her hands covering her ears and head
moving from side to side] It really is soul consuming.

The exchange is brief and anything but an in-depth analysis, yet it is hard to
dispute the pertinence of the comments. Ruan's performances are indeed contri-
butions to the *silent cinema* and thus rely heavily on 'expression and motion'.
They are characterized by a series of *preferred* expressions, many of them cap-
tured, we might add, through close-ups of the face designed to create what Carl
Plantinga insightfully refers to as a 'scene of empathy' (1999: 239–55). Inasmuch
as Ruan's roles were those of suffering women, it is entirely appropriate to focus
on the characteristic ways in which she succeeded in communicating a range of
negative emotions (despair, anger, sadness), systematically aligning viewers with
her character's fate and thus prompting a sympathetic or empathetic engagement
with this character's plight.

Another key thread in the Kwan/Cheung conversation concerns Ruan's sexual-
ity, and in this regard the discussion is quite suggestive. What is remarkable about
Ruan's performances is that they combine the representation of lived experiences
of tragedy with a certain muted yet pervasive sexual charge. Ruan's sexuality, we
are told, is never 'superficial', a term that might be glossed as 'loud', 'explicit',
'flagrant', or 'vulgar'. A slightly less obvious, but nonetheless compelling gloss
for 'superficial' would be visibly 'self conscious' or 'self aware'. Cheung's view
that Ruan's sexuality is 'enchanting' and 'soul consuming', exuding somehow
'from within', suggests a projection and perception of innocence, the absence of
a self-aware appropriation of sexualized expressions aimed at achieving specific
effects. Ruan's on-screen presence has an erotic tenor, Cheung implies, whether
she is playing a role that explicitly requires it – a prostitute, for example – or a
role that does not depend on a sexualized mode of bodily expression.

The theme of Ruan's erotic attractiveness is also the subject of an exchange
between Maggie Cheung (as Ruan) and Tony Leung Ka-fai (as Cai Chusheng)
in one of Kwan's fictionalized reconstructions of Ruan's life. The scene occurs
towards the end of *Center Stage*, as Kwan sets the stage for Ruan's tragic suicide:

Cai: Marlene Dietrich. She's a born decadent star. You look healthier than her.
I can't imagine how she'd look as a housewife, a factory worker or a woman
in distress. But why's everyone saying that you look like her?

Ruan: Let me tell you why. Because I'm sexy playing a woman in distress.

Cai: Don't be too sexy playing my New Woman.

Ruan: Fei Mu doesn't mind my playing a sexy nun for him [in *A Sea of Fragrant Snow/Xiang xue hai*, 1934].

Cai: Fei Mu is too capitalist. Don't compare me with him.

Given its status as a fictionalized reconstruction, this exchange tells us little about what Ruan or Cai actually believed, providing further evidence instead of Kwan's views on the specificity of Ruan's performance style. It is, of course, quite possible that aspects of the sexual charge that Kwan attributes to Ruan should be considered not only in terms of performance styles but also in relation to what Lovell and Krämer refer to quite simply as 'physical attractiveness'. Lovell and Krämer usefully point out that 'there is no doubt that [physical attractiveness] forms an important part of an audience's response to an actor, both in the cinema and the theatre' (1999: 6). They acknowledge the need for further work in this area, but also highlight the difficulties involved in undertaking the relevant kind of research. Here it seems reasonable to assume that Ruan's legacy as a performer is linked to the expression of a subtle, never vulgar, yet consistently present sexual energy. The expressivity in question is no doubt the result of physical traits deemed attractive by audiences then and now, as well as of a performance style that works to make these traits salient, but always in a muted or restrained way.

Ruan, as remarked above, did not have formal training as an actress, and a commonly held view is that her approach was to 'live' her various roles by identifying fully with them, often through the intense recollection of situations from her own life. This kind of memory work allowed Ruan to stimulate the emotional states by which the interior life of a given character would be defined under certain circumstances. The important parallels to be drawn between Ruan's approach and the methods advocated by Constantin Stanislavski (1986) through his work with the Moscow Art Company have been widely recognized. Kwan does in fact acknowledge the connection in *Center Stage*, where reference is made to Stanislavski in a stairwell scene at the imagined Lianhua studio. Whereas Stanislavski advocated living the role by accessing a storehouse of emotional memories in a disciplined and often indirect way, the consensus view is that Ruan not only relived many of her own painful experiences through her acting, but also tended to become wholly absorbed by the tragic roles in which she found parallels to her own life.[2]

In a moving piece entitled 'La légende de Ruan Lingyu', Shu Kei, a Hong Kong filmmaker and dean at the Hong Kong Academy of Performing Arts, posits a direct connection between Ruan's *lack* of formal training as an actress, and her tragic fate:

She was imprisoned twice. In other films she suffered from melancholy or madness; in one she was assassinated and in another she died of illness. My sense is that every time she played these tragic scenes, she experienced a series of emotional shocks, and very often she proved incapable of drawing a distinction between the film and reality.

(Shu Kei 1984: 152–4)

More to the point, however, are the views of actress Li Lili, who attributed the sensitivity and depth by which Ruan's performances are characterized to Ruan's emotional states, many of them involving a two-fold process of powerful recollection and identification. As an observer on the set during the shooting of Wei Ming's suicide scene in *New Woman*, Li Lili described Ruan's performance as Wei Ming:

> ... she went very silent for a while and quickly went into character: tears started to fall from her eyes, and while she was crying she took the sleeping pills. What appeared on the screen was a close-up of her face: she didn't show much expression, she just gazed as she swallowed one pill after another. However, *the look in her eyes underwent a subtle change, showing all the contradictory emotions of a suicide* [emphasis added] at the moment when her life hangs in the balance, and expressing her thirst for life and dread of death, her indignation and her sorrow ... she couldn't stop crying for most of the day.
>
> (Meyer 2004: 50)

As Meyer points out, a subsequent conversation between Li and Ruan confirmed that Ruan relived her own suicide attempts during the shoot. It seems beyond doubt that Ruan's capacity to recapture relevant personal memories and to become wholly absorbed by her roles helped to produce the subtlety and complexity that are features of her performance. Indeed, established Asian film scholar Bérénice Reynaud does not hesitate to identify Ruan's practice of 'living' her roles as a decisive factor with clear implications for the particularly memorable and unique qualities of her performances:

> Ruan – who started her film career as a teenager to avoid the abuse and humiliation of her situation as a maidservant's daughter – did not 'act', but really experienced the feelings she projected on screen. *Hence the unaffected emotional charge, poignancy and feistiness of her performance* – unable to separate acting from reality, she was consumed by the tragic dimension of her roles.
>
> (Reynaud 1993: 25; added emphasis)

If we ask what enables someone to access a rich and deep emotional life, 'sensitivity' is a highly plausible response. Someone living in a brutish and insensitive way is unlikely to be able to draw on a web of intricately connected emotional experiences, all vividly recorded at the level of deep personal memory. To claim that Ruan's performances are remarkable on account of the sensitivity they exhibit is unlikely to be controversial. The sensitivity in question is no doubt the result of recollections of a life lived with awareness and feeling, and of a natural gift for entering very fully into a series of imagined fictional worlds. Indeed, director Wu Yonggang chose to refer to Ruan's imagination as well as to

her sensitivity when trying to explain the sense of uniqueness that is so central to her star status, and the unshakeable belief that this status is wholly deserved and unassailable:

> Ruan is like some *sensitive* photo paper. Whatever you want from her, she acts out at once, no more, no less, just right. *Sometimes my imagination and requirement of her roles are not as delicate and profound as what she experienced.* During shooting, her emotion is so undisturbed by anything outside and her representation is always so lucid and real.
>
> <div align="right">(Meyer 2004: 46; added emphasis)</div>

Discussions of Ruan's life and achievements have emphasized the untutored nature of her talent, but it is worth noting that Wu concluded his comments above with the following suggestive words, 'just like a water tap – you want it on, it's on, you want it off, it's off' (cited in Meyer 2004: 46). The suggestion here is that Ruan had, in fact, taught herself a series of techniques, many of them no doubt similar to those advocated by Stanislavski, for accessing emotional memory and controlling the expression of its effects in the context of a given role.

Let me turn now to *The Goddess* to discuss a few selected scenes that provide concrete visual evidence of the remarkable emotional complexity and sensitivity that are generally viewed as constituting Ruan's distinctive individual style. *The Goddess* tells a story about a prostitute, played by Ruan, who is also an utterly dutiful and loving mother. This prostitute falls into the hands of a vicious gambler, who regularly steals her earnings and thereby thwarts her attempts to educate her son. Despised by the community on account of her profession, the prostitute is eventually jailed for murdering this gambler. The film concludes with a kind-hearted school principal visiting the prostitute in jail. This principal, who unsuccessfully pleaded the case of the prostitute and her son when 'upright' patrons of the school demanded that the young boy be removed, informs the jailed mother that he wishes to adopt her child. The prostitute expresses great happiness at this turn of events and begs the principal to tell her son, as he grows up, that she is dead, thereby ensuring that her son's life will cease to be contaminated by the stigma of her profession. As Yingjin Zhang remarks, *The Goddess* is 'a film full of the pathos of unrewarded virtue' (1999: 168). What is more, '*Goddess* participates in a male discourse on prostitution typical in Republican China, which dictates that sexual dangers be contained, public disorder be reduced, and male offspring be legitimately adopted'(Zhang 1999: 168).

It is important to remember that Ruan's acting style, as we perceive it, is the result of collective efforts, with cinematography and editing playing a key role. Indeed, as anyone familiar with the famous Kuleshov experiments will know, 'a wide range of meanings or nuances, none of them intended by the script, the playing, or the *découpage*, can be produced through the cutting' (Naremore 1988: 24). Yet we have only the finished film to work with, and this edited sequence of images thus necessarily becomes the basis for attributions of talent and skill. While the

sensitivity or the emotional tenor that is detected in a given image may in some cases be the effect of editing rather than of gifted acting, there is no reason to assume that this should mostly be the case.

Kwan, we will recall, points out that Ruan's films are silent films, and as such depend on 'expression and motion'. Yet, important distinctions are to be made when it comes to the silent cinema. Whereas 'a rudimentary sign language' involving a system of 'codified' gestures characterized, for example, the Hollywood cinema until around 1908, silent cinema directors subsequently favoured a psychological realism made possible by, among other things, 'shorten[ing] the distance between the actors and camera' (Naremore 1988: 38). There are moments when Ruan clearly draws on the kind of pantomime tradition that Naremore associates with Western figures such as François Delsarte, a Parisian elocutionist, or Steele MacKaye, the Madison Square Theater manager who imported the Frenchman's techniques to the United States (1988: 52). On the whole, however, Ruan's performance style is striking in the degree to which it manifests a subtle, nuanced and seemingly individualized mode of expression, the very antithesis of the convention-driven articulations of a more 'primitive' silent cinema.

Let us look at three groups of images, each illustrating a noteworthy aspect of Ruan's performance style. The first (Figures 3.1(a) to 3.1(j)) is from the earlier moments of the film and the interest of these images here concerns the evidence they provide of Ruan's ability to communicate a high degree of emotional complexity. The sequence begins with the prostitute reacting to a policeman's negative attentions. With the policeman in pursuit, the prostitute hides in a stairwell and then enters an apartment, knowing nothing about whom or what she will find there. It happens to be the dwelling of the gambler, who immediately recognizes the woman's vulnerability and the opportunities she represents for him to make easy money. Grinning broadly and greedily, the man proposes that she spend the night with him, and the prostitute reacts with a truly memorable defiance to which Kwan would later draw attention in *Center Stage*, where the unforgettable scene with Ruan defiantly blowing smoke in the gambler's face is both excerpted from the original film and reconstructed with Cheung as Ruan.

This sequence of images shows Ruan communicating a series of emotions, and thus an emotional flow, with a clarity of expression, or lucidity, as Wu would have it, that is truly remarkable. Registering a sense of worry in Figure 3.1(a) (Ruan expresses worry) and a sense of clear threat in Figure 3.1(b) (Ruan registers a new threat), Ruan begins to flee in Figure 3.1(c) (The prostitute flees). Figure 3.1(d) and Figure 3.1(e) (Ruan expresses attentiveness) show her listening carefully and in Figure 3.1(f) (Exhausted and relieved, the prostitute believes herself to have escaped her pursuer) we see an expression of exhausted relief. Figure 3.1(g) (The prostitute registers the presence of another person in the room) shows surprise and Figure 3.1(h) (The prostitute recognizes the morally dubious intentions of her new acquaintance) shows anger, as a new threat becomes apparent. In Figure 3.1(i) (Ruan expresses defiance) the focus is on defiant feistiness, and Figure 3.1(j) (Ruan uses a cigarette to enact resistance to unwanted advances) foregrounds a stubborn resistance to domination through self-assertive movement.

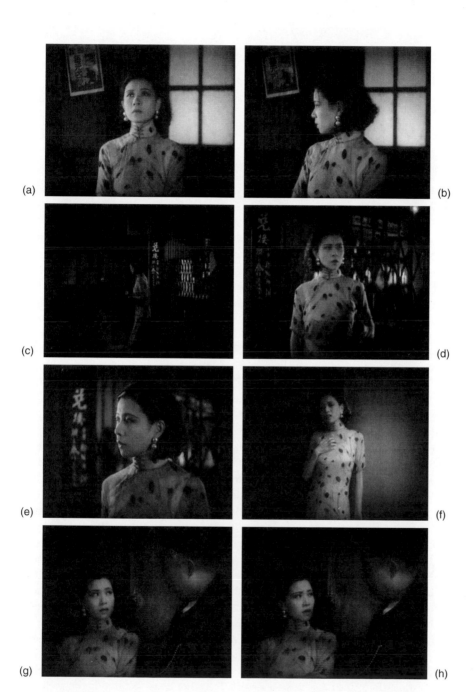

Figure 3.1 Stills from a sequence in *The Goddess* – registering emotional complexity.

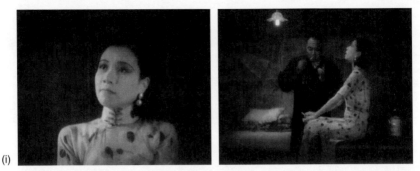

(i) (j)

Figure 3.1 Continued

Threat is the dominant theme throughout this sequence, in the form first of a hostile policeman and then an exploitative low-life male. Cognitive theorists of emotion have argued persuasively that emotions are made up of judgements and beliefs, which allow us to distinguish between different kinds of emotions. Fear, for example, is prompted by the view that a given situation is threatening, whereas disgust is generated by an assessment of some situation as somehow impure. If we bring these intuitions about emotion to bear on the sequence of images under discussion, we note that Ruan has not simply expressed fear, an appropriate reaction to each of the two types of threat that she faces. Rather, she has found a way to convey a wholly plausible *mix* of emotions, including, very crucially, the defiance that comes from construing the second threat as wholly unfair and unacceptable.

It is not difficult to imagine a lesser actress playing this entire scene with fear, and only fear, communicated through facial and other gestures. Ruan's genius is evident in her ability to show us, through body language alone, the difference between two emotional episodes involving the same intentional object – threat – but entirely different empirical objects – a policeman and a low-life type. The capacity to articulate the subjective interiorities of her characters with this degree of nuance is without a doubt one of the defining features of Ruan's individual style.

The second set of images for analysis here provides evidence of Ruan's capacity, again without the use of words, to articulate her *plans* or *intentions*. Narrative films focus on characters whose desires and thwarted desires help to propel the plot forward, while complicating it in ways that create various forms of audience involvement. The history of silent cinema includes many examples of characters clearly articulating, through exaggerated gestures, their conception of a plan and then its execution. Ruan's approach is quite different from that, for once again room is made for emotional nuance, complexity and development.

The sequence I use to illustrate this point begins with Ruan discovering a hole in the wall where she can hide her money from her abusive pimp and concludes with Ruan successfully negotiating the admission of her son to his new school. Figure 3.2(a) (The prostitute conceives of a plan) shows Ruan concentrating with incredible intensity on the loose brick in the wall, her plan articulated for us through

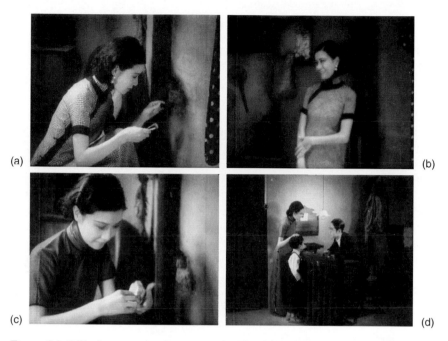

Figure 3.2 Stills from a second sequence in *The Goddess* – performing a plan and its execution.

her focused attention on a particular prop. In Figure 3.2(b) (The prostitute uses obsequiousness to draw the pimp's attention away from her secret hiding place), Ruan expresses an obsequious desire to please, the underlying reason being that she fears the pimp, who has just entered the room, might have noticed her interest in the particular brick in question. Her nervousness is conveyed, as throughout the film, through her hands. Figure 3.2(c) (Anticipating success) foregrounds the pleasure that accompanies the anticipation of the successful execution of an action plan, and Figure 3.2(d) (The prostitute successfully negotiates her child's admission to a good school) focuses on the prostitute's ability to 'pass' as a perfectly respectable mother.

Instead of 'broadcasting' the character's plans through exaggerated facial expressions, Ruan directs her attention towards props, thereby reserving the expressivity of the face and body for the emotions that might actually accompany the actions in question. This is, I believe, a crucial point, and one that and one that deserves to be developed well beyond what is possible here. As Gianluca Sergi remarks insightfully in his contribution to the Lovell and Krämer volume, 'The ability to interact creatively with props ... can be identified as a further important skill which a good actor needs to master' (1999: 131). Ruan, I contend, masters this particular skill to an exceptionally high standard, and this ability to work so creatively and expressively with props – lipsticks, chopsticks, a child's toy, among many other objects in *The Goddess* – enables her to communicate emotions and intentions with precision, and without ever being obvious or 'loud'.

My final images from Wu's film provide evidence of Ruan's versatility and range and they come from a variety of scenes and sequences. Ruan's role in *The Goddess* requires considerable range, for it encompasses quite a number of social roles and situations, and thus a corresponding range of bodily and facial expressions. In Wu's film, Ruan is not only a prostitute plying her trade and balancing its obligations with those of being a struggling, single mother but also a genuinely devoted and loving mother seeking to give her son the opportunities that she herself never had. She negotiates with her clients, contends with the police and defends herself as best she can from her pimp and his lowlife friends. She builds friendships with her neighbours, on whose neighbourliness she often relies when leaving her son alone at home. She plays with her child, helps him with his homework and generally nurtures him. She is also eventually driven to murder, and the time she spends inhabiting her various social roles is punctuated by intense emotions that in various ways signal the difficulties involved in having to resort to prostitution in order to care for one's child.

Images that clearly demonstrate Ruan's expressive range in relation to the spectrum of social roles just evoked are Figure 3.3(a) (The prostitute entices a client); Figure 3.3(b) (Physically exhausted, the prostitute returns home after a long night's work); Figure 3.3(c) (Thwarted yet again, the prostitute expresses a resigned sadness at her fate); Figure 3.3(d) (With almost childlike glee, the prostitute anticipates her child's pleasure at a gift); Figure 3.3(e) (Threatened yet again, the prostitute's clutched arms express her nervousness); and Figure 3.3(f) (The prostitute, wholly focused on her son's attentions, beams with pride and joy). As she slips from one social role to another, or as she confronts the obstacles that continuously thwart her ability to be the kind of mother she wishes to be, the prostitute is transformed again and again. Few actresses are capable of performing transformations like these with such lucidity and clarity.

I conclude by adding my own confessional statement to those cited at the beginning of this chapter: Ruan's performance in *The Goddess* is unforgettable and in some ways life-changing. A working-class student at Lingnan University in Hong Kong once put it as follows: 'You may not quite know why, but you cannot for a second doubt that your life is better and somehow richer after you have seen *The Goddess*'. To which another student responded: 'The sense of having been enriched by Ruan's talent becomes all the more acute when one knows something about the tragedy of her personal life'. Ruan's cinematic legacy is indeed a gift, and it is to be hoped that others will step forward to do for her extant films what Richard Meyer has done for *The Goddess*: make them available to the hundreds of thousands of cinephiles and ordinary viewers who are unlikely ever to make their way to the archives in Beijing or Taipei.

Notes

1 While Richard Meyer sees Lianhua as pursuing many of the goals of the May Fourth movement (Meyer 2004: 3), Yingjin Zhang (1999: 21) makes a case for examining the studio in connection with far less 'monumental historical events'. Thus, for example,

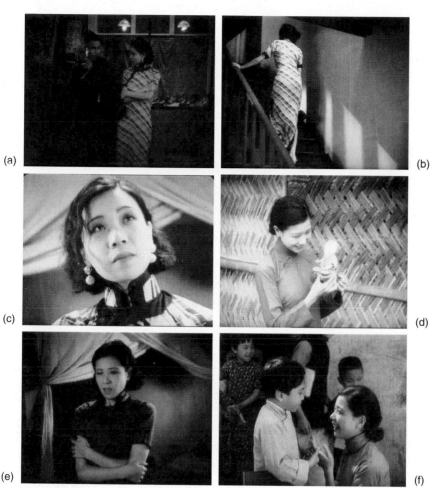

Figure 3.3 Stills from *The Goddess* – Ruan's emotional range.

Leo Ou-fan Lee (1999: 74) argues that Lianhua's activities should be seen as a response to 'the demand for leisure and entertainment (rather than [as] an extension of the May Fourth project of intellectual enlightenment)'.
2 For an approach to acting that disputes the value of 'living' the role, see Diderot (1994).

Works cited

Bordwell, David (2005), 'Transcultural Spaces: Towards a Poetics of Chinese Film', in *Chinese-Language Film: Historiography, Poetics, Politics* (eds Sheldon Lu and Emilie Yueh-Yu Yeh), Honolulu: University of Hawaii Press, pp. 141–62.

48 Mette Hjort

Bordwell, David and Noël Carroll (eds) (1996), Post-Theory: Reconstructing Film Studies, Madison: University of Wisconsin Press.
Chang, Michael G. (1999), 'The Good, the Bad and the Beautiful: Movie Actresses and Public Discourse in Shanghai, 1920s–1930s', in Cinema and Urban Culture in Shanghai, 1922–1943 (ed. Yingjin Zhang), Stanford: Stanford University Press, 128–59.
Diderot, Denis (1994), Paradoxe sur le comedien, Paris: Editions du Seuil.
Dyer, Richard (1998), Stars, Supplementary chapter by Paul McDonald, 2nd edn, London: British Film Institute. First edition 1979.
Harris, Kristine (1997), 'The New Woman Incident: Cinema, Scandal and Spectacle in 1935 Shanghai', in Transnational Chinese Cinemas (ed. Sheldon Hsiao-peng Lu), Honolulu: University of Hawaii Press, pp. 277–302.
Kapferer, Jean-Noël (1990), Rumors: Uses, Interpretations and Images, New Brunswick: Transaction Publishers.
Lee, Leo Ou-fan (1999), 'The Urban Milieu of Shanghai Cinema, 1930–40: Some Explorations of Film Audience, Film Culture and Narrative Conventions', in Cinema and Urban Culture in Shanghai, 1922–1943 (ed. Yingjin Zhang), Stanford: Stanford University Press, pp. 74–96.
Lee, Leo Ou-fan (2004), 'Foreword', in Richard Meyer, Ruan Ling-yu: The Goddess of Shanghai, Hong Kong: Hong Kong University Press, pp. xii–xiv.
Lovell, Alan and Peter Krämer (eds) (1999), Screen Acting, London: Routledge.
Meyer, Richard (2004), Ruan Ling-Yu: The Goddess of Shanghai, Hong Kong: Hong Kong University Press.
Naremore, James (1988), Acting in the Cinema, London: University of California Press.
Plantinga, Carl (1999), 'The Scene of Empathy and the Human Face on Film', in Passionate Views: Film, Cognition and Emotion (eds Carl Plantinga and Greg M. Smith), Baltimore: Johns Hopkins University Press, pp. 239–55.
Reynaud, Bérénice (1993), 'Glamour and Suffering: Gong Li and the History of Chinese Stars', in Women and Film: A Sight and Sound Reader (eds Pam Cook and Philip Dodd), London: British Film Institute, pp. 21–9.
Sergi, Gianluca (1999), 'Acting and the Sound Gang', in Screen Acting (eds Alan Lovell and Peter Krämer), London: Routledge, pp. 126–37.
Shu Kei (1984), 'La légende de Ruan Lingyu', in Le Cinéma chinois (eds Magoli Reclus and Marie-Claire Quiquemelle), Paris: Centre Georges Pompidou, pp. 149–54.
Stanislavski, Constantin (1986), An Actor Prepares, trans. Elizabeth Reynolds Hapgood, London: Methuen.
Wollheim, Richard (1995), 'Style in Painting', in The Question of Style in Philosophy and the Arts (eds Caroline van Eck, James McAllister and Renée van de Vall), Cambridge: Cambridge University Press, pp. 37–49.
Zhang, Yingjin (1999), 'Prostitution and Urban Imagination: Negotiating the Public and the Private in Chinese Films of the 1930s', in Cinema and Urban Culture in Shanghai, 1922–1943 (ed. Yingjin Zhang), Stanford, CA: Stanford University Press, pp. 160–80.

Filmography

Amorous Lesson (Qingyu baojian 情欲宝鉴鉴), d. Li Pingqian 李萍倩, Shanghai: Da Zhonghua-Baihe, 1929.
The Burning of Nine-Dragon Mountain (Huoshao jiulong shan 火烧九龙山), d. Zhu Shouju 朱瘦菊, Shanghai: Da Zhonghua-Baihe, 1929.

Center Stage aka *The Actress* (Ruan Lingyu 阮玲玉), d. Stanley Kwan 声锦鹏, Hong Kong:
Golden Harvest/Golden Way, 1991.

City Nights (Chengshi zhi ye 城市之夜), d. Fei Mu 费穆, Shanghai: Lianhua, 1933.

Coming Back (Guilai 归来), d. Zhu Shilin 朱石麟 Shanghai: Lianhua, 1934.

Flower of the Screen (Yinmu zhi hua 银幕之花), d. Zheng Jiduo 郑基铎, Shanghai: Da
Zhonghua-Baihe, 1929.

The Goddess (Shennü 神女), d. Wu Yonggang 吴永刚, Shanghai: Lianhua, 1934.

Goodbye, Shanghai (Zaihui ba, Shanghai 再会吧, 上海), d. Zheng Yunbo 郑云波,
Shanghai: Lianhua, 1934.

Husband and Wife in Name (Guaming de fuqi 挂名的夫妻), d. Bu Wancang 卜万苍,
Shanghai: Mingxing, 1927.

Life (Rensheng 人生), d. Fei Mu, Shanghai: Lianhua, 1934.

Little Toys (Xiao wanyi 小玩意), d. Sun Yu 孙瑜, Shanghai: Lianhua, 1933.

Love and Duty (Lianai yu yiwu 恋爱与义务), d. Bu Wancang, Shanghai: Lianhua, 1931.

Luoyang Bridge (Cai zhuangyuan jianzao Luoyang qiao 蔡状元建造洛阳桥), d. Zhang
Shichuan 张石川, Shanghai: Mingxing, 1928.

Memories of the Old Capital (Gudu chunmeng 故都春梦), d. Sun Yu, Shanghai: Lianhua,
1930.

Monument to Blood and Tears (Xuelei bei 血泪碑), d. Zheng Zhengqiu 郑正秋, Shanghai:
Mingxing, 1927.

National Style (Guofeng 国风), d. Luo Mingyou 罗明佑 and Zhu Shilin, Shanghai: Lianhua,
1935.

New Woman (Xin nüxing 新女性), d. Cai Chusheng 蔡楚生, Shanghai: Lianhua, 1934.

The Peach Blossom Weeps Tears of Blood (Taohua qi xue ji 桃花泣血記), d. Bu Wancang,
Shanghai: Lianhua, 1931.

Pearl Hat (Zhenzhu guan 珍珠冠), d. Zhu Shouju, Shanghai: Da Zhonghua-Baihe, 1929.

A Sea of Fragrant Snow (Xiang xue hai 香雪海), d. Fei Mu, Shanghai: Lianhua, 1934.

Sequel of Memories of the Old Capital (Xu gudu chunmeng 续故都春梦), d. Bu Wancang,
Shanghai: Lianhua, 1932.

Solitary Survivor of a Disaster (Jiehou guhong 劫后孤鸿), d. Zhu Shouju, Shanghai: Da
Zhonghua-Baihe, 1930.

A Spray of Plum Blossoms (Yi jian mei 一剪梅), d. Bu Wancang, Shanghai: Lianhua, 1931.

Spring in the Jade Hall (Yutang chun 玉堂春), d. Zhuang Guojun 庄国钧, Shanghai:
Lianhua, 1931.

Suicide Contract (Zisha hetong 自杀合同), d. Zhu Shilin, Shanghai: Lianhua, 1930.

Three Modern Women (Sange modeng nüxing 三个摩登女性), d. Bu Wancang, Shanghai:
Lianhua, 1933.

Total Defeat of the Nine-Dragon King (Dapo jiulong wang 打破九龙王), d. Zhu Shouju,
Shanghai: Da Zhonghua-Baihe, 1929.

White Cloud Pagoda (Baiyun ta 白云塔), d. Zhang Shichuan and Zheng Zhengqiu,
Shanghai: Mingxing, 1928.

Wild Flower (Yecao xianhua 野草闲花), d. Sun Yu, Shanghai: Lianhua, 1930.

Yang Xiaozhen (Yang Xiaozhen 杨小镇), d. Zheng Zhengqiu, Shanghai: Mingxing, 1927.

4 Li Lili

Acting a lively *jianmei* type

Sean Macdonald

Star discourse and early cinema in China

The Republican period in China (1911–49) still holds many surprises, and the actor Li Lili (1915–2005) is one of them. Li Lili was one of the biggest stars of silent and sound film of the 1930s and 1940s in China. This chapter focuses on her film career at Lianhua Film Company from 1932 to 1937 through discussion of the films she acted in, the attention she received in popular media and memoirs from her later life. From her first films with Sun Yu, Li's on-screen persona presents a combination of two qualities, lively (*huopo*) and *jianmei*, literally 'healthy and beautiful', a term with significant links to government social policy and emerging popular conceptions of female beauty. For early cinema, Li Lili represents an unprecedented type with links to female roles in traditional opera in China, song and dance performance, and emergent concepts about autonomy for women in society.

Richard Dyer's *Stars* remains one of the most comprehensive studies of the movie star, observing how 'Stars as images are constructed in all kinds of media texts other than films, but nonetheless, films remain ... privileged instances of the star's image' (Dyer 1979: 99). The conceptual approach to Li Lili's stardom in this chapter is Dyer's notion of 'stars as types'. As Dyer notes, 'what is important about the stars, especially in their particularity, is their typicality or representativeness. Stars, in other words, relate to the social types of a society' (Dyer 1979: 53). Dyer acknowledged at the time that there were limits to star types for women. Nevertheless, the types to which Dyer alludes have relevance in my discussion of Li. The 'pin-up' was a type that existed 'primarily in media representation' and there were certainly aspects of 'woman as sexual spectacle and sex object' (Dyer 1979: 57) in Li's career as a star because she was filmed, and photographed, in clothing that drew attention to her body. However, Li's star image may also be read in the context of what Dyer described as a subcategory of 'alternative or subversive types': namely, 'the independent woman', whose independence 'is expressed both in the characters they play and in what was reported about them in magazines' (Dyer 1979: 64).

Equally as important in the case of Li Lili was the type of performance she delivered. In this chapter I argue that Li's star image and performance style on screen

was heavily determined by her early training in Li Jinhui's (1891–1967) Bright Moon Song and Dance Troupe (*Mingyue gewutuan*). In Dyer (1979: 155), one minor type of performance that closely corresponds to Li's is 'vaudeville and music hall', styles that 'operate chiefly in the realm of comedy'. The status of the star comes into play through performance. As Dyer notes, 'Performance is defined as what the performer does, and whether s/he, the director or some other person is authorially responsible for this is a different question altogether' (Dyer 1979: 165). Nevertheless, while it may be problematic to assign 'authorial responsibility' to the actor, the importance of the star's role in film can hardly be denied. In his historical reading of the appearance of film stars, Richard deCordova points out that no single historical narrative can account for the origin of the star. As deCordova notes: 'The actor – like the author – cannot be viewed simply as a real individual. It is a category produced by a particular institution and given a particular function within that institution' (1990: 19). The history of cinema as an institution is also the history of the star 'in which the spectator regarded the actor as the primary source of aesthetic effect. It is the identity of the actor as subject that would be elaborated as the star system developed' (deCordova 1990: 46). The value of reading 'the star' as a way of reading cinema production and cinema culture is the possibility of reading film with the actor as one central factor in the production of meaning in film.

DeCordova notes that the models for acting in cinema were imported from theatre, including a discourse on acting that differentiated between theatre and film styles of acting (deCordova 1990: 23–46). Recent research into early cinema in China also shows an intimate connection between theatre and early cinema; the first films were filmed performances of stage actors and productions, including popular spoken dramas (Chou 1997: 110–11; Zhang 2005: 89–117). In addition, Katherine Hui-ling Chou (2004: 56–67) notes a discourse on Chinese stars, apparently from the 1920s, that distinguished between acting for film and for theatre. Perhaps one of the most important types of writing for star discourse is the biography. In her discussion of the early actor Wang Hanlun, Chou (2004: 62–3) notes that despite the changing film company employers, and despite her demure roles in early film, the biographical description constructed a thoroughly modern off-screen persona through publicity.

Recent histories have done much to resuscitate China's early cinema, yet there is little discussion of the actors who appeared on the early cinema screen. Laikwan Pang's 2002 study presents important work on preconceptions of left-wing cinema in the 1930s. Zhen Zhang (2002) returns to the beginnings of cinema at the turn of the nineteenth century for a reading of early cinema in China as a type of vernacular modernism, a concept first applied to early Chinese cinema by Miriam Hansen (2000). But as for the actual films from this time, most discussion is framed within the concept of the director's authorship.[1]

The 'authorship' concept is also evident in star discourse for the early period. Chou's (2004: 45–113) discussion of actor Ai Xia fixes the focus on this performer/screenwriter as an author, a producer of written text. Anne Kerlan-Stephens' (2007) exploration of the making of 'modern icons' focuses on three

performers at the Lianhua Film Company: Wang Renmei and Chen Yanyan (1916–99) as well as Li Lili. While Kerlan-Stephens examines these women as performers, she concentrates on studio-controlled publicity as the source of their iconic status.

Song-and-dance performance and early cinema

A few years before she died, Li Lili produced for publication a large, illustrated volume called *Free and Easy Writings*, a collection of short pieces that included autobiographical information, production notes on movies in which she acted, and short articles and interviews on film acting (Li 2001). These texts constitute very moving testaments of one of the most important actors of early Chinese cinema, who chose to present her life as an intelligent, articulate and contemporary author. Her writings reveal the lively persona intrinsic to her stardom.

Li was born Qian Zhenzhen in Beijing. Her parents, Qian Zhuangfei and Zhang Zhenhua, were medical doctors and underground members of the Chinese Communist Party (CCP). For career and political reasons, Li was separated from them when she was still a child.[2] Li was at one point sent to a work–study reformatory for orphans, a real-life episode linking with a theme that recurs throughout her acting career, her autobiographical narratives and the discourse about Li in the film press in the 1930s. Li herself attaches a regime of work–study (*bangong bandu*) to her years as an actor and after, a pattern that partially defines the persona of Li Lili in her memoirs and the discussions of her off-screen life in the press. She first experienced formal training in performance when she studied Peking opera for a short time, but for various reasons, including possible harassment by an instructor, this training seems to have been short-lived.[3]

Two of Li's anecdotes in particular blur the distinction between filmed action and fictional acting. Although Li's stardom began at Lianhua in the 1930s, Li's first film role was in the martial arts film *The Hero Hidden in Yan Mountain* (Xu Guanghua, 1926) when she was just 11 years old. Li's mother acted the mother, while Li's father acted the son with Li acting the part of the little sister. Unable to pretend her real father was her screen brother, she laughed when she was supposed to cry: 'In anger, my mother struck me, I really cried, and finally the scene was filmed' (Li 2001: 10). The second anecdote recounts an experience on the set of *National Style* (Luo Mingyou, Zhu Shilin, 1935) in which Li co-starred with the great silent star Ruan Lingyu, playing Ruan's younger sister.[4] In one crucial scene around the middle of the film, Ruan scolds Li for her irresponsibility, ordering Li to end her relationship with her lover to honour her marriage. After a shouting match (exclamation points in the intertitles), Li shoves Ruan, who slaps Li across the face: 'She boxed me in the ear, and at this moment I should have cried and made a scene, but listening to her scolding me with her Cantonese: "You good-for-nothing", I couldn't help snickering. We shot this scene several times unsuccessfully'. After Ruan conferred with one of the directors, Zhu Shilin (1899–1967), they shot the scene again: 'Her slaps were harder. My ear started

ringing, and it seemed as if I lost my temper' (Li 2001: 140). The scene was completed.

The implications of such anecdotes should not be underestimated in the context of performance in early cinema and of Li Lili as actor and star. One of the key factors in the emergence of stars in the USA and Europe was the recognition of the distinction between a filmed action, and an action performed for the screen, 'the filmed body as a site of fictional production' as deCordova phrases it (1990: 33). The inability Li admits in these anecdotes – of laughing when she should be crying – and the subsequent resolution to this problem – hitting the actor to elicit a proper response to suit the context of the scene – remind us of both the limits of the filmed body and the fine line between a filmed action and intentional acting for the screen. These anecdotes also highlight an acting technique that helped establish a style of performance that was important to Li's rise to stardom.

One of the best known aspects of Li's career is her early work as a stage performer in the Bright Moon Song and Dance Troupe led by Li Jinhui.[5] After a tour of Southeast Asia in 1929, Li Jinhui sojourned in Singapore and some members of the troupe, including Li Lili, remained there with him. According to Li, legal requirements in Singapore stipulated that only people sharing the same family name could share the same residence, so Li Jinhui adopted Qian Zhenzhen, who changed her family name from Qian to Li.[6]

But her name change is only one aspect of a very significant moment in the rise of Li Lili's stardom. Schools geared towards training actors for screen performance appear in the early 1920s in China (Zhang 2005: 130–31). However, Li would derive her training from the song and dance troupe. With the arrival of sound films from Hollywood, Andrew Jones notes that Lianhua Film Studio 'annexed the Bright Moon Song and Dance Troupe as a means of competing with this tide' (2001: 97).[7] Li first meets Sun Yu when members of the Bright Moon Song and Dance Troupe are absorbed by the Lianhua Film Company's Song and Dance Troupe in 1931 (Li 2001: 86). This would be the defining moment for Li Lili, and a transition from the stage to the screen, with stage presence to remain a defining factor in her on-screen roles.

Biography of a type

Li claimed that the naturalistic acting style (*bense pai*) was predominant in the 1930s (Wang and Li 1983: 132). This term seems to have been attached to 1930s film acting partly in hindsight, and partly by the actors themselves. 'Naturalistic acting' describes their positions as untrained actors, as actors who had not mastered a particular method (Wang and Li 1983: 132).[8] Li also notes actors were linked by their screen names and the names of the roles in the film to attract the audience to a particular picture (Li 2001: 146). In this way 'the roles and/or the performances of a star in a film were taken as revealing the personality of the star (which was corroborated by the stories in the magazines, etc.)' (Dyer 1979: 22). This connection between the actor on-screen and off-screen begins in the early years of cinema: 'With the emergence of the star, the question of the player's

existence outside his or her own work in film became the primary focus of discourse' (deCordova 1990: 98). The name Li Lili signifies an actress linked to roles on screen and off. Although Li's stardom would be built around her cinema roles, her stardom was not confined to the screen. Moreover, the roles she played on the screen referenced and refracted her off-screen life. Li Lili is associated to a type of woman described with a strikingly consistent vocabulary.

Better known for his advocacy of artistically entertaining 'soft-cinema' over message-driven 'hard-cinema', the writer Jia Mo,[9] in an article published in *Modern Cinema*, divides women stars into five types: the tragic female role, the lively young girl, the drifting young girl, the seductive woman and the expressive female role (1933: 7).[10] The examples he names are mostly from the USA, but one type certainly applies to Li Lili, the 'lively young girl', linked to physical movement (running and jumping) and singing and dancing. This 'lively young girl' type forms a chain of words and images in the press linked to Li Lili. In a short biographical note published in the film magazine *Qingqing dianying*, Li's career is traced from Li Jinhui's Bright Moon Song and Dance Troupe to her films with Sun Yu, and her marriage to Luo Jingyu in 1938 (supposedly dispelling rumours about her relationship to Sun Yu). The note claims that Li Lili's first part in Sun Yu's *Blood of the Volcano* (1932) was actually the principal role in that film, 'that lively individuality, that healthy and beautiful (*jianmei*) physique'.[11]

A silent film, *Blood of the Volcano* has been described as perhaps the most fantastic of Sun's films.[12] *Blood* combines melodrama, gritty violence and romance in a revenge tale that culminates in action at the mouth of an erupting volcano. The film highlights traits of Li Lili's performance that remain throughout her work with Sun Yu, and after. *Blood* is the story of Song Ke (Zheng Junli, 1911–69) who, after losing his family because of the local warlord's nephew, leaves China to live an embittered life in an unspecified part of Southeast Asia. Intertitles introduce a young woman dancing on a beach, a moonlit ocean in the background framed by palm trees: '3 years later, in that faraway overseas place ... the great ocean ... the volcano ... women ... red wine ... healthy and beautiful bodies ... naked hearts ... that's overseas'. And as the audience soon sees, the body standing in for 'that faraway overseas place' is none other than Li Lili.

Li first appears in a long shot on the beach performing a strange 'native' dance, raising her arms up and down as she dances in a circle. Then the first close-up of Li appears, of her pelvis and legs gyrating and swaying. Before her face appears and she is introduced as a character, Li is set up through images of the lower half of her body and as a 'healthy and beautiful body' (*jianmei de ti*), a type and role that establish her and her roles with Sun Yu in the film. About 10 minutes later (or 40 minutes into the film) Li's character enters, and roughly the next 10 minutes of film set up her character, Liu Hua, a sort of itinerant burlesque dancer. Although *Blood* is a silent film, Li sings while she dances, accompanied by musicians strumming ukuleles and guitars. Like her character Liu Hua, Li Lili had links with Southeast Asia through her tour with Li Jinhui's troupe in 1928 and later while enrolled as a part-time student in the Southeast Asian Superior Commercial School in Shanghai as part of her work–study regime.

The role of performer

These biographical details contributed to the construction of Li Lili's persona, functioning as a template for her on-screen roles. After addressing a cockatoo in her room, Li walks to a dressing table where she smothers herself in sprayed perfume, then stands and raises her dress to powder her shapely and muscular legs in the type of leg shot that will be associated with *Queen of Sports* (Sun Yu, 1934) 2 years later. It seems that more than any other actor in China at this time, Li was filmed *à sa toilette*, either dressing or in a partial state of undress, in an apartment, bedroom, or dormitory room. Li's family name and biography linked her to Li Jinhui's troupes of singing and dancing children and teens. If Sun Yu was drawing on Li's associations as a singer and dancer who had toured Southeast Asia with Li Jinhui to add authenticity to the character Liu Hua, such associations would have included morally problematic insinuations as well.[13] Still, Li's Liu Hua is very much in control as she winks at the mostly leering males who comprise the audience. Objectification of Li's character through the spectators' gaze is problematized by the confidence of her returning gaze, which Jeffrey Smith (1991: 49) notes as part of a stage performer's negotiation with her spectators in burlesque.

Li's screen performance represents a performance within a performance. Her characters often directly address the audience, looking straight into the camera. Although this may be attributed to early cinema's acting styles and stable camera (at least compared to later film), Li's performances emphasize direct audience addresses because of her well-known association with stage performance.[14] Chris Berry (1988: 68) notes that Li's Moli in *The Big Road* (Sun Yu, 1934) was once a flower-drum girl: 'a form of street entertainer ... a marginal group in traditional society, including also slaves and prostitutes'. In *Big Road* Li sings one of the film's songs in a 'classic shot reverse-shot exchange' with a primarily male audience, and interspersed with images of famines and floods, highlighting the themes of her song (Berry 1988: 71). Moli's engagement with her on-screen audience represents an engagement with the cinema spectator and reaffirms Li Lili's place as an actor who performs as a performer. Li returns the gaze of her male on-screen audience members, and of the cinema spectators watching her on the screen.

The lively, *jianmei* type as history

A strong example of Li's lively *jianmei* type on-screen is her starring role in *Queen of Sports*, a story of sports success and social temptations, and one of her most popular films. In *Queen of Sports*, Li plays Lin Ying, an irrepressible athlete from the countryside who travels to Shanghai to study at a women's sports college. In Shanghai she discovers the nature of competition and love. While she begins to dress glamorously and to navigate between the stadium and the dance hall, through disciplined training she excels at the National Sports Games. Li's ingenuous Lin Ying is a comic character, deflating the class and modernistic pretensions of the city. Her naïve straightforwardness towards her physicality

parallels her perspective of the modern metropolis. But she also epitomizes the healthy and beautiful (*jianmei*) and sports (*tiyu*) features associated with young women and their ideal types in China in the 1930s.

'For women, *tiyu*, or the cultivation of muscle strength, was a necessary tool to cultivate a *jianmei* body' in 1930s China (Gao 2006: 551). The state played a key role in promoting physical fitness during this time, with state policy implemented in educational institutions through physical education programmes. Nevertheless, the full import of the state's message was inconsistent, calling for women to pursue a form of natural beauty and physicality, but one that they should keep demurely hidden from the public eye (Gao 2006: 548); a healthy and beautiful body, but with modesty, and without explicit sexual appeal. Government intervention in the universities in China began by the mid-1920s (W. Yeh 1990: 173–6), and the trope of physical fitness in *Queen of Sports* is obviously contiguous to government policies during the 1930s.

Yet no policy should delete the active participation and agency of the people involved. Sun Yu, the director, and Li Lili, both took an interest in physical fitness. The name of the college 'Jing Hua' sounds like an unaspirated 'Qing Hua' where Sun Yu studied for 4 years.[15] Sun Yu wrote this script in the lead-up to the fifth National Games in 1933, yet *Queen of Sports* was obviously a vehicle for Li and, as in the case of *Blood of the Volcano*, there are obvious links to Li's off-screen life. Just as the main character, Lin Ying, goes on to be a top 50-meter sprinter, Li claimed to have come in first in the 50-meter sprint at Southeast Asian Superior Commercial School (Li 2001: 19). Government policy certainly affected film production during this time, but this should not obscure the originality of *Queen of Sports*, which had an unusual theme for China (and for films outside China).[16]

Reading *Queen of Sports* in the juxtaposed contexts of spiritual pollution and a new body politics for women, Paul Pickowicz noted Sun Yu's use of sexual suggestion in *Queen of Sports*: 'All the necessary ingredients are there, but the message gets lost. *Queen of Sports* titillates rather than educates' (1991: 51). Perhaps such a contradictory message could be read as an encapsulation of popular responses to the government promotion of *jianmei*. But more importantly, can the message of a film be limited to political policy? If the popular press is any indication, stardom itself was an important message of Republican era films.

In other words, a significant 'message' of the film *Queen of Sports* is its star Li Lili, a celebrity figure that epitomized the lively, *jianmei* spirit of the times. In *Queen of Sports* Li acts the part of a sprinter, with close-ups of her athletic legs as metonyms for national competition and the sexuality of a young actress. But in the press she is linked to swimming, with a striking number of photographs of Li in bathing suits. Li appeared in a 1935 special 'Swimming' issue of *Dianying shenghuo* (*Screen life*) that contained photographs of women actors from the USA and China, and she is the only one linked to organized sports, specifically swimming, in her off-screen life. The article (as playfully loaded with superlatives as any Hollywood fan magazine) declares, 'Lili's lively attitude (*huopo de zitai*) and agile movement (*linglong de dongzuo*) caught the notice of her admiring spectators

right from the start'. The title of the piece, 'The Sweet Sister and the Mermaid', combined the 'Sweet Sister' appellation for Li in the press, with the 'Mermaid' appellation for Yang Xiuqiong (1918–82), a well-known competitive Chinese swimmer. In the enthusiastic flow of the piece, Li Lili possesses 'a classic, time-less healthy and beautiful female figure (*jianmei nüxing de tige*), lively (*huopo*) dark eyes, a pair of beautiful legs, the thick hair of a Southern girl, incredible ability ...' (Anonymous 1935b).[17]

This magazine was not the only periodical to pair Li Lili and Yang Xiuqiong. The cover of a 1934 issue of the women's journal *Linglong* features a photograph of Yang Xiuqiong.[18] Inside, the 'Movies' section features a biography of Li Lili, following a review of a film entitled *Woman* (Shi Dongshan, 1934) critiquing representations of women in film. But whereas the article in the film magazine talks up Li's lively nubile qualities, in this proto-feminist women's journal Li is cast as 'the most innocent and sincere of celebrity actresses'. Readers are given Li's family background: that her father is a doctor, and that she supports her mother and brother while paying for her own tuition and living expenses at Southeast Asian Superior Commercial School on a salary of around 130 yuan a month: '[Li's] lifestyle is very modest, she gladly puts up with hardships, [she] isn't thinking of ways to generate more income, this is truly worthy of praise!'.[19]

Were such aspects of Li's off-screen life merely consistent with state-sanctioned model womanhood?[20] Anne Kerlan-Stephens (2007: 63) claims that '[Lianhua studios] was not completely at ease with [Li's] real personality and in particu-lar with her physical capacities'. Weikun Cheng (1996: 197) points out that by the early twentieth century, stage actresses in Tianjin and Beijing had attained 'professional knowledge and skills, financial independence, and an active social life'.[21] But this didn't mean complete social acceptance. Attitudes towards the social and professional autonomy for women were at best ambiguous at this time. Perhaps *Linglong* was projecting a model with implications beyond Republican government policy. *Linglong*'s twin concerns revolved around physical fitness and celebrity, with celebrities sometimes serving as models for modern women in China (Gao 2007), and Li Lili appeared regularly in this journal. In a 1936 special 'Swimming' issue, Li Lili takes the cover and inside cover photo, with a photo and article on Yang Xiuqiong, 'After watching Yang Xiuqiong perform'. The cautionary article warns about women in the public eye like 'movie stars, stage actresses, and taxi-dancers' who 'in this pornography-mad society, beneath the "watching big sister take a shower" attitude', fall victims to a sort of unconscious male aggression towards women. The article collapses sports celebrity and other types of celebrity by linking both to the position of women in society under the gaze of men (Jing Zi 1936: 1888–91).[22]

Change and continuity in Li's later roles

The 'lively, *jianmei* type' that Li Lili epitomized was sustained in her on-screen roles in her six films directed by Sun Yu from 1932 to 1936. After playing in her final film with Sun Yu in 1936, *Back to Nature* (Sun Yu, 1936),[23] Li Lili continued

to address the camera with other directors, often singing or dancing, but her 'lively, *jianmei* type' sheds some of the on-screen liveliness. No longer could she use her constructed persona to shape the type of roles she played with exuberance. The national defence film *Bloodbath on Wolf Mountain* (Fei Mu, 1936) exemplifies Li's lost liveliness. Most of the story is told through Li's character, a young peasant woman named Xiaoyu, often with full face reverse-shot exchanges. Although her father refers to her as a 'mischievous child', Li's character is a protagonist who represents a segment of her village's people and their response to an outside threat. The role does not draw and cannot accommodate the charm, seduction and playful engagement with viewers that typified her parts in Sun Yu's films.

In *Orphan Island Paradise* (Cai Chusheng, 1939), Li plays a young taxi-dancer in occupied Shanghai, working with a group of assassins who target Chinese collaborationists with the Japanese invaders. Li sings the opening duet, and one scene focuses on her. Her eyes fill with tears as she lies on the bed and flips though an album of photographs from home, singing one of the most mournful renditions of 'My Home is in the Northeast' (*Wo jia zai dongbei*) ever committed to celluloid. Here Li's altered 'type' is integrated into the story, leaving less room for her constructed off-screen persona to shape the role, and so muting the focus on her as performer and 'star'. In *Storm on the Border* (Ying Yunwei, 1940), an important early CCP minority propaganda film, Li plays a young Mongolian woman Jin Hua, performing what is presumably a local dance. Li's final moments, glaring into the camera after she is shot by the villain, dominate the film's denouement.

But Li's trademark jauntiness and vivacity are overpowered by the tragedy of the scene. Li's roles in these three films differ significantly from her roles in earlier films with Sun Yu, such as *Little Toys* (1933). In *Little Toys*, Li's Zhu'er leads a group of children in the countryside through a series of comic calisthenics, the cart on which she stands functioning like an impromptu stage. Addressing the audience, Li's heroic character dies bravely after foreign bombardment. Li's character is linked to youth (in this case, children), physical fitness and performance. Even with her characteristic heroism and *jianmei*, it is analytically useful to separate Li's roles between those she played in films with Sun Yu and the roles she played with subsequent directors. Although the persona that emerges in the films she made with Sun Yu may be seen as a template for Li Lili's type, after the beginning of the Sino–Japanese war in 1937, the charmingly playful scenes of *Little Toys*, *Big Road* and *Queen of Sports* are all but gone.

Nevertheless, some continuity runs through Li Lili's roles with Sun Yu and with other directors. Kerlan-Stephens notes how 'in many of [Li's] performances her character goes through a series of transformations reflected in the clothes she wears' (2007: 69). Irrespective of director, the characters Li played were often young women who journey from a somewhat innocent rural setting to somewhere else like the city or a battlefield, or the 'journey' may be through a shift in the characters' attitudes rather than their location.

Some of Li's most salient changes in costume are in *Daybreak*, where she transforms from an innocent young peasant woman into a street-wise prostitute and revolutionary.[24] However, such costume changes were metonymic of the

lively *jianmei* type as a persona, and a character. The scene I allude to above, in which Li's character loses her temper in *National Style*, is a good example. Costume change was the external signifier for personality. Changes in costume clearly signalled audience expectations about the personality traits tied to Li's lively, *jianmei* persona. At the end of *Queen of Sports*, in an abrupt turnaround of character and plot, Li's Lin Ying purposely loses the race that would have sealed her title of 'Queen of Sports'.

Richard Dyer (1979: 113) noted that in early cinema character 'consistency may be sacrificed in the interests of a concise and dynamic narrative'.[25] I would disagree with Dyer somewhat here. Can character and narrative be so easily separated? In the roles she played on-screen, Li Lili's persona reveals the complementarity of character and plot. The sudden shifts in mood that Li projects into her roles are part and parcel of the lively, *jianmei* type she embodied. Some of the initial credit could go to Sun Yu, who aimed for a certain amount of individualization in his casting and directing.[26] But, Li's performances are what enabled the lively, *jianmei* type to travel from the screen into the popular imagination as a gendered social type to be reckoned with, as she is described in a 1935 issue of *Linglong*: 'Li Lili has a very strange temper, one moment loudly crying, the next madly laughing, at times irritable as a raging bull, at other times gentle as a lamb' (*Linglong* 182: 949).

In her discussion of *bense pai*, the naturalistic acting style of the 1930s, Katherine Chou claims it was the predominant style for actresses like Ai Xia, Wang Ying (1913–74), Wang Renmei and Li Lili. But I would contend that Li's persona was distinguished by a certain stability. Despite what Dyer (1979: 57) noted in the 'media representation' of the 'pin-up', the *jianmei* aspect (with a slight emphasis on health beside beauty) of Li's photo shoots in swimsuit and shorts seem to prevent them from becoming a type of exclusive sexual spectacle. Although it would be difficult to deny that Li's persona exuded a type of sexuality, she did not attract the same sort of epithets as 'sexy wildcat' (*xinggan de yemao*) for Ai Xia, or 'wildcat' (*yemao*) for Wang Renmei. And her private life certainly never put her career in jeopardy, as was the case in Wang Renmei's marriage to Jin Yan (1910–83) in 1933. Indeed, Li Lili seems to have maintained a relatively stable private life.[27] Perhaps maintaining a restrained personal life enabled her to take on more risky on-screen roles.

Two roles Li played in 1937 with other directors starkly encapsulate the Li Lili type. Both roles dichotomize the lively, *jianmei* type by putting into contrast already established aspects of Li's persona. In both films, Li Lili's roles are constructed through juxtaposed images and personality traits that reference her earlier roles. In *Ghost* (*Gui*, Zhu Shilin, 1937), a segment from *Lianhua Symphony* (*Lianhua jiaoxiangqu*, Situ Huimin *et al.*, 1937), Li plays a young girl in the countryside, frightened by neighbours discussing ghosts. With her mother out playing *majiang*, the young woman is alone in her house, the very house she has been told contains ghosts. That night, the man who told her the ghost stories returns and rapes her as she lies frozen in fear in her room. The next morning, unaware of what happened, the girl's mother finds her in a state of shock yelling about ghosts. On the advice of the girl's attacker, the girl's mother asks a Daoist priest to perform

a service when the girl, in a sudden flash of realization, denounces the priest and his helpers, as well as her attacker, declaring ghosts a lie to trick people.

Li's face fills the frame, then cuts to a long shot as she chases the Daoist priest and his helpers out of the room. She then attacks her attacker, shouting from the doorway before collapsing. The narrative is inscribed with a modern anti-superstition structure of feeling that brings together official and unofficial discourses of twentieth-century attitudes towards popular religion (Duara 1991). *Ghost* is also clearly a critique of patriarchy. Li's performance is very strong as she transforms, abruptly and violently, from an innocent and naïve young peasant woman to a self-aware and raving young woman who denounces the cultural system of ghosts and, by extension, her rapist.

Acting the young woman from the countryside in her earlier films with Sun Yu probably had links to historical attitudes about rural culture in China. But Li Lili's persona as modern young stage performer refocuses these roles, problematizing the link between the on-screen role and the off-screen persona. Her other 1937 film, *Such Luxury* (*Ruci fanhua*, Ouyang Yuqian, 1937) ends with Li 'playing' a peasant or, rather, she plays a character who, in an ironically reversed costume change, puts on peasant clothing to catch up with her lover Zhang Yucheng (Mei Xi, 1914–83), who has left on a train. The story concerns the Li couple, who move in with the wealthy Zhang's. Li plays a dual role. As Mrs Li, she performs for the bourgeois world. There is even a bedroom scene with Li in girdle and nylons. As Mrs Li, she sings the film's eponymous title at a dinner for a local military commander. In contrast, with her lover she attends a nationalist–revolutionary rally and sings 'I Love Freedom' (*Wo ai ziyou*) to a rural crowd. Ouyang Yuqian is screenwriter and director, and the film is a brilliant critique of the moneyed classes in wartime China. Dialogue is bitingly satirical. One of the most telling moments is a shot in which Li's Mrs Li is being criticized by her husband for possibly implicating him by making contributions to the national cause. As her husband wags his finger and rebukes her, she leans on a pillar, giving a long stare into the camera that ends with a smirk.

Despite her husband's remonstrances, Li does worse than enlist his name in the revolutionary cause. She steals from Mrs Zhang, the wife of their host, passing the money onto her lover, their host's younger brother. This time Li's legs are cast as metonyms for the act of theft, the camera following them up and down the stairs to the room above, where the money is kept. Ouyang Yuqian and Li Lili seem complicit in this use of Li's earlier, tantalizing persona. Mrs Li's marriage is clearly in trouble by the time she goes for a motorcycle ride with her lover, an obvious allusion to the motorcycle scenes in *Queen of Sports*.

Conclusion

As I noted in my introduction, within Richard Dyer's star typology, Li Lili would certainly have met criteria for the 'independent woman', a subcategory of the 'alternative or subversive types'. According to Dyer (1979: 61–6), this type is problematic because she throws certain expectations of gender into disarray.

Li Lili's links to sports may have made her a 'tomboy' type in Hollywood, but Susan Brownell contends the hard and fast links between gender and sports would not have held in China at this time, where sports were not the 'male preserve' they were in Europe and the United States.[28] Reading Li's type means rethinking certain preconceptions about the roles women play in society, as well as historical preconceptions about the Republican period.

Chris Berry's suggestions about the 'oddball figure' of Li Lili's Moli character in *Big Road* are relevant to Li Lili's character in *Such Luxury*. Li's Moli can be read as a partly unprecedented type, as well as a re-inscription of types like the *wudan*, the female warrior of opera in China (Berry 1988: 47–8). At the same time, it is worthwhile recalling Li's association to song and dance performance, a relatively new type of performance in China at this time with links to 'vaudeville and music hall', performance styles from 'the realm of comedy' (Dyer 1979: 155). Li's lively, *jianmei* type, filtered through a song and dance performance style, has historical links to the musical as a form of pure entertainment. The healthy and heroic positivity projected by Li's type hints at the utopian aspect of musical entertainment, or as Dyer (2002: 20) puts it: 'utopianism is contained in the feelings [entertainment] embodies'. If anything, Li Lili embodied feeling.

In her autobiographical volume, Li understandably focuses on the roles she acted with Sun Yu. But she also devotes whole chapters to two later politically charged films, *Bloodbath on Wolf Mountain* and *Storm on the Border*, the latter a significant film in the history of cultural production by the Chinese Communist Party (CCP), 'a precursor to the PRC's national minority genre' (Kuoshu 1999: 96).[29] This revolutionary strand lends Li's career, and the films she acted in, a political aura linked to the historical emergence of the CCP and the People's Republic of China.[30]

Nevertheless, it could be said that the 'leftist' revolutionary strand in Li's acting career begins with her films with Sun Yu, and the construction of an individualistic type. But Li's capricious 'lively, *jianmei* type' also has another resonance, a second 'revolutionary' strand, exemplified in her films with Sun Yu, and later films like *Ghost* and *Such Luxury*, that represent an internal critique of Chinese culture, associated to discourses of gender, nation and individualism, in a manner recalling the May Fourth period. In *Such Luxury*, Li Lili's Mrs Li is subversive of middle-class morality, a case of Sun Yu's *Queen of Sports* meeting an unrepentant *Pan Jinlian*, with a pilfering wife to stand in for the famous nationalist *Mulan*.[31] Li's Mrs Li is a satirical addition to theatrical and cinematic New Women of early twentieth-century China. The lively, *jianmei* type might have become, under different historical circumstances, the Nora who would finally leave.[32] In conclusion, Li Lili embodies an unprecedented, even revolutionary, star type in early Chinese cinema.

Notes

1 For discussions of Li Lili films that focus on the director authorship of Sun Yu, see Pang (2002: 73–107), Shi Chuan (2004) and Zhang (2005: 289–92).

2 Since Li herself does not explain, we are left to wonder if or how her parent's political affiliation may have influenced her career and rise to stardom.

3 Li is not specific about when she studied opera. Her memoir refers to this period after mention of her attending a Catholic girls school ('I hadn't turned seven yet', Li 2001: 4), and before mention that she had appeared in her first film in 1926 (Li 2001: 6–8).

4 Li also co-starred with Ruan as her daughter in *Little Toys* (*Xiao wanyi*, Sun Yu, 1933). Although Ruan committed suicide before filming was complete, *National Style* was Ruan's last film and is dedicated to her memory.

5 Li is not specific about timing but says that her father enrolled her in Li Jinhui's troupe after the 12 April Incident in 1927, when Chiang Kai-shek began a purge of Communist members from his governing party, the Guomindang (Li 2001: 45).

6 Li claims she did not really use her adoptive name until she enrolled in 1930 in the Southeast Asian Superior Commercial School, a vocational training school in Shanghai, using the formal school name 'Li Keling' (Li 2001: 16). Andrew Jones (2001: 93) notes that Li Jinhui, his daughter Minghui and his new wife Xu Lai were in Singapore at this time, and it would seem Li Jinhui married Xu Lai in the same year he 'adopted' Li Lili.

7 See also Chang (1999: 145–7). However, production of talkies in large numbers in China did not really begin until 1934 when sound equipment could be built locally (Pang 2002: 54). Although the largest film company at the time, Mingxing, had produced the first talkie in 1931, *The Songstress Red Peony* (*Genü hong mudan*, Zhang Shichuan, 1931), the soundtrack was recorded on wax and had to be properly synchronized to the film. The same process was still in use in Sun Yu's 1934 film *The Big Road*. Still, as Yueh-yu Yeh (2002: 87) notes, 'sound production in the early 1930s meant filling the movie mainly with songs'.

8 For Li this is particularly relevant, since she would be asked to take formal acting classes when she worked at the Beijing Film Studio in the early 1950s, and by the late 1950s she began her post-acting career as an acting instructor at the Beijing Film Academy. Michael G. Chang (1999: 153) discusses *bense pai* as 'true character', which he links to 'socially constructed ideals of women' in the 1930s. Chou claims *bense pai* as a style of performance in cinema in the 1930s in which actresses 'acted roles similar to themselves' (2004: 69).

9 Jia Mo's biographical details are unclear. For a discussion of hard and soft cinema, see Pang (2002: 50–2).

10 Articles from early cinema periodicals, including *Modern Cinema* (*Xiandai dianying*), were republished in *Zhongguo zaoqi dianying huakan* (Early Cinema Periodicals in China). Unless otherwise indicated, references to film periodicals are to this republished edition, abbreviated as *ZZDH*. The quote from this article appeared in *ZZDH* (5: 555).

11 *Qingqing dianying*, 4: 11(1939), p. 6 (*ZZDH*, 10: 486).

12 An alternative title to this film is *Loving Blood of the Volcano*.

13 While Li Jinhui's troupes were not burlesque, by the 1930s, the press had given the music and troupe performances attached to Li Jinhui the aura of being a sort of lewd music and performance (Jones 2001: 90–104).

14 Li claims that she herself asked the directors and camera people to take frontal face shots over profiles because she had a round face that did not look pleasing in profile. According to Li, during the filming of *Bloodbath on Wolf Mountain* (*Langshan diexue*, Fei Mu, 1936), the director insisted that she not limit the angles of her shots, in order to achieve a more complete performance (Li 2001: 105).

15 The school name may be an intentionally unsubtle name which could be translated as 'Competitive China' College. From its early years as a preparatory school for studies in the USA, Qinghua University had a physical fitness component that included qualifying tests in swimming and track and field (Wen-hsin Yeh 1991: 213–14).

16 Li mentions the uniqueness of the sports theme in *Queen of Sports* (Li 2001: 19). Susan Brownell traces the participation of women in public sporting events during the Republican period and before (Brownell 1995: 223–8).

17 Gao (2007: 553, 556) notes a discourse around women's legs in the journal *Linglong*, a fetishizing discourse that seems to have existed beyond the pages of *Linglong* (Gao 2006: 562).

18 *Linglong* was a popular women's magazine published in Shanghai from 1931 to 1937. All references to *Linglong* are to the excellent Columbia University collection of this journal at: http://www.columbia.edu/cu/lweb/digital/collections/linglong/. Accessed 10 December 2007.

19 See Anonymous (1934: 1641). Kerlan-Stephens (2007: 61) notes that Li 'started with a relatively low salary (50 yuan per month) and kept climbing the ladder of success (she was earning up to 1,000 yuan a month by 1937)'.

20 Li confirms the significance of these details while recounting how she enrolled at college as part of her work–study regime, shooting pictures while studying (Li 2007: 18–22).

21 Jonathan P.J. Stock (2002: 3) evidences the rise of female performers in Shanghai at this time as well.

22 While the article is a discussion of Yang Xiuqiong, the phrasing reminded me of the shower scene in *Queen of Sports*, which combined sports, personal hygiene and sexuality.

23 From the synopsis for this film, about a group of people who become stranded on a deserted island, and selected stills I have seen, this film has its share of 'swimsuit' shots of Li and other women (Li 2001: 96).

24 Kerlan-Stephens (2007: 70) calls *Daybreak* 'the matrix for this pattern' of costume transformation.

25 Here Dyer is discussing films in which 'the plot is most important (which according to conventional wisdom is up to the late 1950s)'.

26 Sun Yu claimed the difficulty for a director in choosing an actor was in merging the individuality (*gexing*) of the actor with the individuality of the character in the script (Sun 1992: 171).

27 Chou (2004: 67–85) discusses *bense pai* and Ai Xia in the context of 1930s cinema culture. Kerlan-Stephens (2007: 53–7) discusses Wang's marriage and its aftermath. For Kerlan-Stephens, 'instability' was Li's only 'stable characteristic' (2007: 69). Most of the gossip I found on Li was mundane reports of her studies, marriage and travel. However, one story reports a love triangle, tame by today's standards (Anonymous 1935a). Another incident supposedly occurred on the set of *Blood of the Volcano*, in which Li Lili and Chen Yanyan playfully compete for the attention of child actor Li Keng (1928–65), who says of Li: 'I like your white, fat thighs'. See Cui Niao (1935).

28 Brownell (1995: 216–28) claims it was the Western organizers who prevented women from participating when Western-style sport meets were being introduced to China in the early twentieth century.

29 Li's discussion of *Bloodbath* is a detailed narrative describing the process of production and Fei Mu's method of constructing her character's psychology, and her excellent discussion of *Storm* reads this film as allegorical of the conditions of its production (2001: 99–108, 114–28).

30 Such a reading is confirmed in a recent pictorial biography (Shi Man 2007). It would be problematic to describe this tendency as 'Maoist', since these films precede the dominance of Maoist theory and policy in China.

31 I am referring to *Pan Jinlian* (1928), a play based on the famous narrative of an adulteress in *Outlaws of the Marsh* (*Shuihu zhuan*), and *Hua Mulan Joins the Army* (*Mulan congjun*, Bu Wancang, 1939), a screenplay about the folk hero Hua Mulan, both written by Ouyang Yuqian.

32 Nora is a character in Henrik Ibsen's (1828–1906) *A Doll's House* (1879). The plot
 revolves around the couple, Nora and Torvald Helmer. After a series of events that bring
 their marriage into doubt, the play ends with Nora's decision to leave her husband. An
 international figure for woman's emancipation, Nora was also a very important figure
 in China in the first half of the twentieth century.

Works cited

Anonymous (1934), 'Li Lili de shenghuo' 黎莉莉的生活 (Li Lili's life), *Linglong* 玲珑,
 150, p. 1641. http://www.columbia.edu/cu/lweb/digital/collections/linglong/. Accessed
 10 December 2007.

Anonymous (1935a), 'Li Lili xian yu sanjiao lian'ai' 黎莉莉陷于三角恋爱 (Li Lili caught
 in a love triangle), *Linglong*, 206, pp. 3365–70.

Anonymous (1935b), 'Tian jie'er yu meirenyu' 甜姐儿与美人鱼 (The sweet sister and the
 mermaid), *Dianying shenghuo* (Film life), special swimming issue (August), no page;
 rpt in ZZDH, 6, pp. 204–5.

Berry, Chris (1988), 'The Sublimative Text: Sex and Revolution in Big Road', *East West
 Film Journal*, 2: 2 (June), pp. 66–85.

Brownell, Susan (1995), *Training the Body for China: Sports in the Moral Order of the
 People's Republic*, Chicago: University of Chicago Press.

Chang, Michael G. (1999), 'The Good, the Bad and the Beautiful: Movie Actresses and
 Public Discourse in Shanghai, 1920–1930s', in *Cinema and Urban Culture, 1922–1943*
 (ed. Yinjing Zhang), Stanford, CA: Stanford University Press, pp. 128–59.

Cheng, Weikun (1996), 'The Challenge of the Actresses: Female Performers and Cul-
 tural Alternatives in Early Twentieth Century Beijing and Tianjin', *Modern China*, 22:
 2 (April), pp. 197–233.

Chou, Katherine Hui-ling (1997), Staging Revolution: Actresses, Realism and the New
 Woman Movement in Chinese Spoken Drama and Film, 1919–1949, PhD Thesis,
 New York University.

Chou, Katherine Hui-ling 周慧玲 (2004), *Biaoyan Zhongguo: nü mingxing,
 biaoyan wenhua, shijue zhengzhi, 1910–1945* 表演中国: 女明星, 表演文化, 视觉政治,
 1910–1945 (Performing China: actresses, performance culture, visual politics, 1910–
 1945), Taibei: Maitian.

Cui Niao 翠鸟 (1935), 'Yanyan de zhi yu Lili de da tui dou shi Xiao Li de enwu' 燕燕的
 痣与莉莉的大腿都是小黎的恩物 (Yanyan's mole and Lili's big legs are playthings for
 Xiao Li), *Dianying xinwen* (Film news), 1: 3, p. 13; rpt in ZZDH, 6, p. 279.

deCordova, Richard (1990), *Picture Personalities: The Emergence of the Star System in
 America*, Urbana: University of Illinois Press.

Duara, Prasenjit (1991), 'Knowledge and Power in the Discourse of Modernity: The Cam-
 paigns against Popular Religion in Early Twentieth-Century China', *The Journal of Asian
 Studies*, 50: 1 (February), pp. 67–83.

Dyer, Richard (1979), *Stars*, London: British Film Institute.

Dyer, Richard (2002), 'Entertainment and Utopia', in *Only Entertainment*, London:
 Routledge, pp. 19–35.

Gao, Yunxiang (2006), 'Nationalist and Feminist Discourses on Jianmei (Robust
 Beauty) during China's "National Crisis" in the 1930s', *Gender and History*, 18: 3,
 pp. 546–73.

Hansen, Miriam Bratu (2000), 'Fallen Women, Rising Stars, New Horizons: Shanghai
 Silent Film As Vernacular Modernism', *Film Quarterly*, 54: 1 (Autumn), pp. 10–22.

Jia Mo 嘉谟 (1933), 'Dianying nümingxing zuofeng de fenxi' 电影女明星的分析 (An analysis of the styles of female movie stars), *Xiandai dianying* 现代电影 (Modern Cinema), 1: 2 (April), p. 7.

Jing Zi 静子 (1936), 'Guan Yang Xiuqiong biaoyan hou' 观杨秀琼表演后 (After watching Yang Xiuqiong perform), *Linglong*, 243, pp. 1888–91.

Jones, Andrew F. (2001), *Yellow Music: Media Culture and Colonial Modernity in the Chinese Jazz Age*, Durham: Duke University Press.

Kerlan-Stephens, Anne (2007), 'The Making of Modern Icons: Three Actresses of the Lianhua Film Company', *European Journal of East Asian Studies*, 6: 1, pp. 43–73.

Kuoshu, Harry H. (1999), *Lightness of Being in China: Adaptation and Discursive Figuration in Cinema and Theater*, New York: Peter Lang.

Li, Lili 黎莉莉 (2001), *Xingyun liushui pian: huiyi, zhuinian, yingcun* 行云流水篇: 回忆, 追念, 影存 (Free and easy writings: reminiscences, recollections, images), Beijing: Zhongguo dianying chubanshe.

Linglong, originally published in Shanghai; Columbia University collection. http://www.columbia.edu/cu/lweb/digital/collections/linglong/. Accessed 10 December 2007.

Pang, Laikwan (2002), *Building a New China in Cinema: The Chinese Left-wing Cinema Movement, 1932–1937*, Lanham, MD: Rowman & Littlefield.

Pickowicz, Paul G. (1991), 'The Theme of Spiritual Pollution in Chinese Films of the 1930s', *Modern China*, 17: 1 (January), pp. 38–75.

Shi Chuan 石川 (2004), 'Sun Yu dianying zuozhexing biaozheng ji qi neizai chongtu' 孙瑜电影的作者性表征及其内在冲突 (The auteur sign of Sun Yu's films and its inner conflicts), *Dangdai dianying* 当代电影 (Contemporary Cinema), 6, pp. 52–6.

Shi Man 石曼 (2007), *Zhongguo 20 shiji 30–50 niandai zhuming yingju ren huazhuan – Li Lili*, 中国 20 世纪 30–50 年代著名影剧人画传 – 黎莉莉 (Picture biographies of famous people in China, 1930s–50s – Li Lili), Chongqing: Chongqing chuban jituan.

Smith, Jeffrey P. (1991), '"It Does Something to a Girl. I Don't Know What": The Problem of Female Sexuality in "Applause"', *Cinema Journal*, 30: 2 (Winter), pp. 47–60.

Stock, Jonathan P.J. (2002), 'Learning "Huju" in Shanghai, 1900–1950: Apprenticeship and the Acquisition of Expertise in a Chinese Local Opera Tradition', *Asian Music*, 33: 2 (Spring–Summer), pp. 1–42.

Sun, Yu 孙瑜 (1993), 'Dianying daoyan lun' 电影导演论 (On film directing), in *Zhongguo dianying lilun wenxuan (20–80 niandai)* 中国电影理论文选 (20–80 年代) (A selection of Chinese film theory: 1920s–80s) (eds Li Jinsheng 李晋生, Xu Hong 徐虹 and Luo Yijun 罗艺军), Beijing: Wenhua yishu chubanshe, pp. 168–77.

Wang, Renmei 王人美 and Li Lili 黎莉莉 (1983), Fangwenji: Mingyue gewutuan yu bense pai yan ji' 访问记: 明月歌舞团本色派技 (An interview: Mingyue song and dance troupe and the naturalistic acting technique), *Zhongguo dianying yanjiu* 中国电影研究 (Chinese cinema research), 1: 1, pp. 129–35.

Yeh, Wen-hsin (1990), *The Alienated Academy: Culture and Politics in Republican China, 1919–1937*, Cambridge, MA: Council on East Asian Studies, Harvard University Press.

Yeh, Yueh-yu (2002), 'Historiography and Sinification: Music in Chinese Cinema of the 1930s', *Cinema Journal*, 41: 3 (Spring), pp. 78–97.

Zhang, Zhen (2005), *An Amorous History of the Silver Screen: Shanghai Cinema, 1896–1937*, Chicago: University of Chicago Press.

ZZDH = *Zhongguo zaoqi dianying huakan* 中国早期电影画刊 (Early cinema periodicals in China) (eds Jiang Yasha 姜亚沙, Jing Li 经莉 and Chen Zhanqi 陈湛绮), 12 vols, Beijing: Quanguo tushuguan wenxian suowei fuzhi zhongxin, 2004.

Filmography

Back to Nature (Dao ziran qu 到自然去), d. Sun Yu 孙瑜, Shanghai: Lianhua, 1936.

The Big Road (Dalu 大路), d. Sun Yu, Shanghai: Lianhua, 1934.

Blood of the Volcano (Huoshan qingxue 火山情血), d. Sun Yu, Shanghai: Lianhua, 1932.

Bloodbath on Wolf Mountain (Langshan diexue 狼山喋血), d. Fei Mu 费穆, Shanghai: Lianhua, 1936.

Daybreak (Tianming 天明), d. Sun Yu, Shanghai: Lianhua, 1933.

Ghost (Gui 鬼), d. Zhu Shilin 朱石麟 Shanghai: Lianhua, 1937.

The Hero Hidden in Yan Mountain (Yanshan yinxia 燕山隐侠), d. Xu Guanghua, 徐光华 Beijing: Guanghua, 1926.

Hua Mulan Joins the Army (Mulan congjun 木兰从军), d. Bu Wancang 卜万苍, Shanghai: Huacheng, 1939.

Lianhua Symphony (Lianhua jiaoxiangqu 联华交响曲), d. Cai Chusheng 蔡楚生, Fei Mu, He Mengfu 贺孟斧, Shen Fun 沈浮, Situ Huimin 司徒慧敏, Sun Yu, Tan Youliu 谭友六, and Zhu Shilin, Shanghai: Lianhua, 1937.

Little Toys (Xiao wanyi 小玩意), d. Sun Yu, Shanghai: Lianhua, 1933.

National Style (Guofeng 国风), d. Luo Mingyou 罗明佑 and Zhu Shilin, Shanghai: Lianhua, 1935.

Orphan Island Paradise (Gudao Tiantang 孤岛天堂), d. Cai Chusheng, Hong Kong: Dadi, 1939.

Queen of Sports (Tiyu huanghou 体育皇后), d. Sun Yu, Shanghai: Lianhua, 1934.

The Songstress Red Peony (歌女红牡丹 *Genü hong mudan*), d. Zhang Shichuan 张石川, Shanghai: Mingxing, 1931.

Storm on the Border (Saishang fengyun 塞上风云), d. Ying Yunwei 应云卫, Beijing: China Film Company, 1940.

Such Luxury (Ruci fanhua 如此繁华), d. Ouyang Yuqian 欧阳予倩, Shanghai: Lianhua, 1937.

Woman (Nüren 女人), d. Shi Dongshan 史东山, Shanghai: Lianhua, 1934.

Part II
Socialist cinema
From film star to model worker

5 Mei Lanfang

Facial signature and political performance in opera film

John Zou

Introduction

From the early 1920s to his death, Mei Lanfang (1894–1961) was a dominant figure in Peking opera. Specialized in female roles, he asserted great influence over Chinese opera and Chinese popular culture during this time. Images of his theatrical personae appeared on a wide variety of domestically circulated objects, from matchboxes and magazine covers to postage stamps. His tours in the United States and the former Soviet Union made his success international. Even in death, he accrued unprecedented honour as an actor. Premier Zhou Enlai personally instructed that Mei's body be buried in the grand, unused coffin originally constructed for the 1924 state funeral of Dr Sun Yat-sen, founder of the Republic of China. Since the early 1990s, when Peking opera returned to public attention in China as a part of national culture, the maestro's posthumous career has rebounded. Today, celebrations are staged extensively; his residence in Beijing has been turned into a national museum; and publication on his life and work has become a mid-size cultural industry. *Forever Enthralled* (2008), a big-budget biopic directed by Chen Kaige – famous for *Farewell My Concubine* (1993) – and featuring the Hong Kong megastar Leon Lai (Li Ming, b. 1966), has rekindled public fascination with the star.

However, whereas Mei's operatic legacy in Chinese society is observed in a sizeable literature, his presence as a film star, especially via the popular genre of opera film and in distinction from his successful stage career, has invited little sustained attention. Since 1920, the maestro had been filmed numerous times and his *A Wedding in the Dream* (Fei Mu, 1948) was honoured as the first colour film made in China. This chapter studies the discursive and institutional configuration of Mei's screen stardom, particularly as demonstrated in *Mei Lanfang's Thespian Art* (Wu Zuguang, 1955), the most elaborately made Chinese biopic documentary in the 1950s. It addresses Mei's role in mediating a limited public space in mid-twentieth century China, in which representation of feminine grievance serves to negotiate the effects of the state. Referring to established practices of grievance registration in traditional Chinese opera and poetics, I argue that the cinematic moment of *the cross-dressed actor's face* signifies a discursive compromise between Mei's negative articulations and his reconciliation with political authority.

One of earliest and most ambitious film projects of the early People's Republic of China (PRC) government, *Mei Lanfang's Thespian Art* features four of Mei's most celebrated operas, in which he acts in roles of 'traditional Chinese women'. *The Yuzhou Blade* (*Yuzhou feng*), *Farewell My Concubine* (*Bawang bieji*) and *Intoxication of an Imperial Consort* (*Guifei zuijiu*) are major works in Peking opera that helped consolidate his reputation as its ultimate interpreter. The fourth, *Broken Bridge* (*Duanqiao*), is from his repertoire of Kun opera, the alleged classical precursor to Peking opera, and showcases the authenticity of the singer's artistic pedigree and his synthesis of China's performative traditions. In the maestro's career, the film represents a pinnacle of his successes, where his performances, already billed as the most coveted public entertainment, now reached an unprecedented nationwide audience. As a result of intervention by a publicly minded new state, theoretically, every citizen of the country could feast cinematically upon the legendary actor's mediated but still lively presence. Given all the attention the movie received from the government, press, academy and public at large, in the mid-1950s, Mei was almost China's greatest film star.

What gives his performance a measure of oddity is, however, that opera after opera in *Mei Lanfang's Thespian Art*, the audience finds Mei in roles of grieved women. Even to an untrained eye, the performance of traditional womanhood may come across as almost inseparable from articulations of profound unhappiness: the theatre of the maestro is a theatre of negativity. *The Yuzhou Blade* features a righteous daughter's anger at her evil father, who turns out to be the culprit of her husband's unjust destruction. In *Farewell My Concubine*, the leading female character puts herself to the sword because Xiang Yu, military strong man and her lord, is losing his last battle. Unrequited longing informs the performance of *Intoxication of an Imperial Consort*. But the most versatile configuration of grievance through the embodiment of a 'traditional woman' may be found in *Broken Bridge*, an act from the epic Kun opera, *The Story of White Snake* (Figure 5.1). The narrative of this play is often dated back to a lost *chuanqi* text of the Ming theatre, *Thunder Blade Pagoda* (*Leifeng ta*), and two existing Qing works bearing the same title. Set during the Song Dynasty, it is about the extraordinary White Snake who, after extended mystic self-cultivation, assumes human form. She falls in love with a local young man Xu Xuan and establishes a family with him. Discovering her animal traces, Fahai, a clairvoyant and overly zealous Buddhist monk in the city, informs the skittish husband and makes him believe in her fatal effect. The two men seek to abolish White Snake forever through the monk's Buddhist magic. Mei's performance addresses an episode after White Snake has temporarily foiled the monk's scheme, when she catches up with her 'unfaithful' husband, only to manifest to him her unchanging love despite his injustice.

At a moment of consolidation of political alliance between state and Peking opera, why would the powerful makers of *Mei Lanfang's Thespian Art*, particularly Mei himself, throw their clout behind works filled with such anxiety and dissatisfaction? Before any answers may be furnished, it has to be pointed out that negativity in men's performative evocation of womanhood and femininity has been a consistent phenomenon in China's cultural history. In literary studies

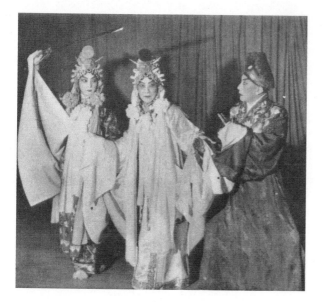

Figure 5.1 Mei in *The Story of White Snake.*

it has been claimed repeatedly that performative unhappiness centred on female figures often constitutes a metaphor of controlled political grievance in Confucian China's high literary canon, from Qu Yuan's famous *Encountering Sorrow* (Lisao, approximately fourth century BC) onwards. Following the same line of thought, this chapter makes a case that the figure of female discontent, which becomes increasingly prominent in opera film under the Republic and early PRC takes on a similar function in Chinese popular culture, including Mei's films. In particular, I argue that this grievance against the state is manifest in Mei's acquisition of film stardom in tandem with what I call his cross-faced performances.

Cross-faced stardom

The existing scholarship on stars has two prominent strands. First, Richard Dyer's founding project, *Stars* (1979; 1998), has been followed by other lines of enquiry emphasizing the sociology of stardom. Among key concerns here are crucial analytical questions directed toward the commodification of stardom, such as the star–audience dynamic and the star's position in film production. The drawback of this approach is that it tells us precious little about specific conditions from which stars arise, once scholarly attention is distanced from the typical scenarios of modern Western social history. As the presence of stars is sometimes said to conceal social tensions highlighted in the narrative event, Dyer's sociosemiotics of stardom also directs critical attention away from the specific historical complexes in non-Western societies in its grand narrative of capitalism and

commercial society. Second, in contrast to Dyer's institutionally centred project, is the Foucaultian agenda, which receives exemplary illustration in Joseph Roach's 2007 book, *It*. Roach's study is located in a stylized historical context in which the glamour of public actors is reiterated from eighteenth century English court to twenty-first century Hollywood. But this performance-centred project capitalizes on moments where the historical coincides with the performative. The insight that the star's glamour is an embodiment of opposing forces makes no serious reference to social and political forces that inform the making of the star's social influence. I situate the following discussion of Mei Lanfang in a space between these two well-argued positions. It centres on the specific circumstances of grievance representation in the early PRC, relating the performative to the political. More specifically, Mei's film stardom is read in reference to the singularity of a political modality, i.e. sustaining a weak public space *vis-à-vis* an authoritarian state.

Western scholarship usually views the 1950s as a decade of little political originality in modern Chinese history. Among the political processes under way then, the restraint of public spaces, systematic annexation of institutional structures that once existed outside the state censorship of social behaviour and cultural expression, and the relentless persecution of dissent had all happened elsewhere before. These circumstances are often taken for granted as necessary accompaniments to a quaint form of high communist state-making. The historical presence of vehicles to represent political disagreement remains by and large under-theorized. Examining these phenomena in the study of film stars brings forth a lively perspective that emphasizes configuration of social influence at a level that has yet to draw much attention.

Given all that is said of public spaces in the early PRC, Mei's enormous presence indicates a type of social influence that was inconsistent with dominant political interests, and thus the need for its co-option. But if we follow Dyer and attribute the star's formative origin to the capitalist mode of production and market exploitation, the star becomes almost by definition an oxymoron within the early PRC context of state penetration into society. As a commodity that conceals the relationship of production and manipulates its own demand through a doctored supply system, the star seems to have lost its essential social relevance under high communism, where the purpose of the new social order was to de-commodify objects, labour and interpersonal relations. The star's dynamic purpose to supply satisfaction to the individual becomes obsolete when the individual is rejected as an ideological fiction. Furthermore, under an unlimited state such as the early PRC, where social influence is increasingly interwoven with political sway, the institutional consequence of the star also becomes suspicious. No more a figure of the market and thus a force of heterogeneous quality *vis-à-vis* the bureaucratic state, the star takes on an aspect ever so similar to the propagandist icon, whose function is emphatically to ensure the consistency and extension of the state, rather than voicing social difference and political discontent.

For Mei Lanfang, then, a central question is how stardom is still possible within a political environment where the 'star' is generically transformed into a propagandist icon. If Mei, or any other cross-dressed leading man in these opera films of

the early PRC, is not a star in the classical Hollywood sense, how should we come to terms with such enormous personal influence? Whereas the genre of opera films boomed in the early PRC, what followed during the Cultural Revolution was the so-called Model Operas (*yangbanxi*), which tend to be much less complicated in their discursive position and political functionality. Morally uplifting and polit- ically consenting, the Model Operas usually featured leading actors with a type of propagandist iconography more accountable to established practices of staging than to 'personality'. Even though Mei's glamour is abundantly aided by make-up, costume, lighting, stage routines and so forth, his signature style, which constitutes the core attraction for the audience, is usually unmistakable. To see a Mei film in the 1950s was not to see a film, but to see Mei. It is simply unthinkable that in the star's absence, the performance could still achieve the same effect.

Since Bela Balazs' (1971) analysis of film language, the close-up on the actor's face has been a key term by which the film discourse is distinguished from other representational schemes such as the theatre. Never before had the audience been able to witness another human being's emotional states at such exaggerated prox- imity, nor had a performer acquired a means of representation with such expressive finesse. It may be said that to some extent the actor's face so delineated in cinema mediates a stage that is unavailable in opera itself. In Mei's later career, when he devoted increasing resources to filmmaking, the face was precisely the ele- ment that received concentrated attention. Of course, since around the mid-1920s and even after Mei's death, Mei's image had played as much a role as his sound recordings in spreading his fame and cultivating a national following via mediated representation. During his early success as an opera performer in the 1910s, his photographed face was already circulated widely in event promotions, commer- cial advertisements and fan collections. But it may be said that it was through association with film projects in his later career that his facial image was turned into the centrepiece of his mediated presence to the public.

A Wedding in the Dream, for instance, produced a poster shot of Mei that became one of his most familiar images in the media (Figure 5.2). In his cinema of the early PRC, public endorsement and Mei's personal exploration of his facial composition were redoubled. This may be partly because of the mundane fact that while approaching old age, his cross-dressed body developed in a way that was increasingly incapable of rendering youthful, feminine glamour. Yet the maestro also tried actively to exploit film to advance unprecedented possibilities in psy- chological interpretation and virtual bonding with the audience. Commenting on *Peony Pavilion* (Xu Ke, 1961), Mei describes his rumination over performing Du Liniang, an aristocratic young woman bothered by erotic fantasies, after she retires to her chamber following a tour in the garden.

The monologue used to be delivered when she sits alone on stage. The depiction of the

> fatigue from her recent tour, and feelings of sentimentalism and solitude are all dependent upon her facial expressions and a few small movements of the hand. [In] the film, however, [I may] walk and talk, and take positions

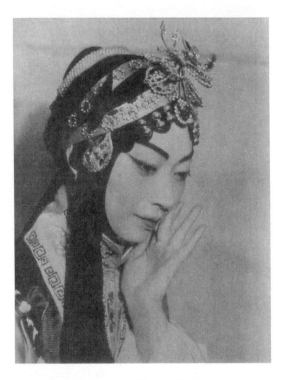

Figure 5.2 Mei in *A Wedding in the Dream.*

such as drawing window curtains, looking out from the window, etc. It gives me additional means to develop [the character]. It also helps me arrive at the idea that [I] need to convey the animated experiences of the time by way of the details in performance, so that the audience may understand how Du Liniang, as created by Tang Xianzu 300 years ago, lived in that feudal society.

(Mei 1962: 232)

Although Mei does not comment specifically on the close-up, he makes quite clear that the virtuosity of the discourse of opera film has much expanded the per-formative scope of the face. Whereas singing and dialogue are often accompanied with limited action when delivered on stage, the tracking shot makes possible a more kinetic and intimate presentation of emotional details. To the extent that the space associated with facial presentation is limited in theatre, the movement of the camera allows the actor freer access to directions to which the face may turn, and thus increased latitude to employ props to stage the face. But ultimately, such ren-ditions of the face strengthen a connection between the star and his audience. They motivate the audience to grant authority to the actor's interpretation of Du Liniang and also, to a degree, China's legendary past. As Mei's face conveys the depths of

passion in his character, it apparently also keeps creating the audience's need for it by inducing a certain psychological dependence. The fan letters cited in Mei's autobiography speak of audience members who return to his performances again and again, between opera and cinema, simply to experience his execution of the same arias and performative moves.

In treatment of what he terms 'the abnormally interesting people', Joseph Roach locates the key to their attraction or 'It', in:

> the power of apparently effortless embodiment of contradictory qualities simultaneously: strength *and* vulnerability, innocence *and* experience, and singularity *and* typicality among them. The possessor of It keeps a precarious balance between such mutually exclusive alternatives, suspended at the tipping point like a tightrope dancer on one foot; and the emphatic tension of waiting for the apparently inevitable fall makes for breathless spectatorship ... [original emphasis].
>
> (Roach 2007: 8)

Roach goes on to explain that '[i]n classical European theater, such oppositions and hence resistance are suggested by the term *contraposto* [sic], which describes a pose in which the performer turns in different directions simultaneously at the knees, the hips, the shoulders, and the head, making an interesting line of the body' (2007: 8).

In Mei Lanfang's star performances, comparable, physically mediated oppositions may be observed, but if we want to attribute them to a performative archetype, we may have to look toward an established practice in Chinese theatre, i.e. cross-dressed acting, instead of the Greek-originated idea of *contrapposto*. That is, we may need to begin with the oppositions and resistance between two different gender identities the maestro inhabits, and particularly the performative events by which his male face signifies as that of a woman. To extend Roach's discussion of 'It', I suggest that whereas Mei's charismatic facial performance may convincingly convey female psychology and behavioural economy, it is also simultaneously oriented to two mutually exclusive identities. In his films, his attraction does not come exclusively from either the male body, or the female persona, but from occupying both these genders, from the fact that he is a man acting as woman.

In modern Chinese polities, especially the party state regimes in the late Republic and early PRC, manhood and womanhood were socially endorsed identities. Man acting as woman, especially in its sexual implications, was therefore a precarious business fraught with possibilities of scandal and monstrosity. Although in the PRC the state has until recently disallowed discussion of sexuality in popular entertainment, and thus afforded Mei and his cross-dressed colleagues a degree of protection, sexual readings of his transgendered acting were common in both Republican mosquito newspapers and theatre-related memoirs from Taiwan in the 1950s and 1960s. The edge in Mei's performance then was his gift not only to follow established routines to look and sound like a woman but also to resist the

possibility of scandal that lurked behind his every syllable and move, to keep his work, and by his example cross-dressed opera and cinema, as legitimate as they were entertaining.

This said, it has to be also pointed out that transgendered performances do not automatically generate 'abnormal' attractions. Given the popularity of traditional opera in modern China, not only were many actors trained in female roles, but across the country numerous fans and fan clubs attempted to imitate the cross-dressed stars in their singing and acting. Professional actors and amateurs who had the composure to gracefully pull off the daunting task of cross-gender performance were not rare, but other than Mei and a very small number of his colleagues, none had acquired star status in the so-called *dan*, or male to female transgendered roles. In Peking opera, the so-called four greatly renowned *dan* actors (*sida mingdan*), of whom Mei is the most celebrated, followed the patriarchs of the past such as Cheng Changgeng (1811–80) and Tan Xinpei (1847–1917) to become superstars in the trade. But in public ranking during the years of the Republic, right beside these four greatly renowned *dan* actors, one sometimes found the four greatly unfortunate *dan* actors (*sida meidan*) who included such respected members of the opera community as Xu Biyun (1903–67) and Huang Guifen (1906–78). The difference between the two groups was that members of the latter group did not quite make it at the stage box office to prove themselves commercially viable.

Associated with the stars' influence, then, is a highly recognizable and individualized set of vocal, gesticulated and facial processes in the context of interpreting established stage routines, which come together more or less coherently under a personal name. These processes often recur across the boundaries of individual performances in opera and film by the same actor, so that they constitute the core of what is sometimes described as an individual actor's performing style and star value. For commercial exploitation, it is usually such packaged processes bearing the actor's name that sell the ticket. In discussing facial performance, I tentatively name the relevant processes occurring with Mei's acting as his 'facial signature', which distinguishes his work not only from that of his imitators but also from the facial stylistics of his renowned colleagues in theatre and film. The following are two examples of Mei's possession by 'It' as may be respectively perceived in the social and stylistic perspectives.

First, comparisons between Mei and his contemporaries who trained in cross-dressed opera often note the maestro's mesmerizing suavity. Although he began as something of a social pariah because of opera's association with male prostitution under the late Qing, he received generous patronage very early in his career from powerful Republican leaders and the politically retired Confucian literati. His close and continuing association with them, financed by his sizeable personal wealth, is said to have cultivated in him an understated manner and personal carriage of the quasi-Confucian polite society during the early Republic. His poor understanding of money, generosity to friends, tendency to accommodate unreasonable requests and abstract loyalty to his country aptly described an aristocrat of a pampered upbringing in popular lore rather than a former catamite typically endowed with

extraordinary survival instinct and street smarts. Among opera professionals who usually have very little formal education outside their acting and music, Mei was exposed to some of the most sophisticated traditional *belles-lettres* and art works of his time by mixing in the company of such literary and artistic figures as Fan Zengxian (1846–1931) and Qi Baishi (1863–1957). As a result, his hand in calligraphy and ink painting and knowledge of classical literature were both considered respectable. Such extraordinary coexistence in his personal life of traces of both prince and pauper is often forgotten in discussions of his performative work, yet the extremity in his reversal of fortune certainly informs the public construction of his extraordinary personality and stardom.

Second, Mei's success in interpreting traditional Chinese womanhood is often praised for its flowing ease and stylistic inclusiveness (Figure 5.3). Even his most prominent colleagues tended to develop in one area of technicality such as singing or acting,[1] or excel in one type of *dan* character such as the righteous, suffering woman or the martial maiden. Yet the maestro's talent is recognized as universal across *dan* roles. In an extraordinarily long career of around 50 years, he played and made famous more women characters than any of his rivals in the opera. Achieving such an extensive presence required him to push his envelope hard, and time and

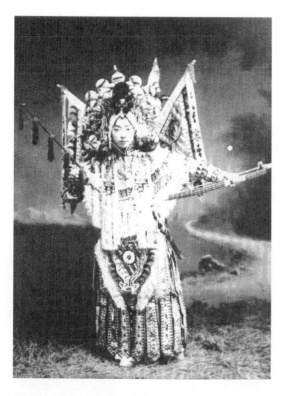

Figure 5.3 Mei as the martial maiden Mu Guiying.

again he assumed considerable risk. One of his earliest and bravest experiments after his tours of Shanghai in the early 1910s was an attempt to bring together two strictly divided performative types within the female or *dan* role of Peking opera, namely, the blue gown (*qingyi*) and the flowery maiden (*huadan*). Traditionally, the former is identified as primarily a singing role that usually depicts cultured female characters; the latter is an acting role that portrays low-class womanhood and engages mostly in witty dialogue and sometimes acrobatic stage routines. Whereas Mei's risky performances were extremely profitable and greatly expanded his name recognition and fan base, the conservative audience and opera critics of the time saw the attempt as a major violation of opera codes, and negative press followed him for quite some time. To register the sheer monstrosity of his *dan* combinations, which Mei and his advisors named the flowery gown (*huashan*), and its irresistible appeal to the opera-going public, his impact on the public was coined *Meidu*, the Chinese term for syphilis, which may be literally rendered as 'Mei's poison'.

Playing against the state

For a cross-dressed film star, Mei's facial signature is thus marked by exceptional dualism: man and woman, prince and pauper, refined lady and sassy young girl. Yet the performative suture of Mei's facial split does not always champion men's performance of femininity as a vehicle to represent political grievance. Historically, his public significance may be said to have developed through three different 'faces'. The aplomb and eclecticism that later rewarded him so handsomely tended to look somewhat forced in the youthful visage that crowned his successes under the warlord government of the early Republic, as he struggled to find a position in the opera and society at large. For all the glamour and edginess it brought to the stage, his face hardly conveyed public opinion. Instead, more often than not, it stood for a scandal that grievance was mobilized against: an emblem of a form of decadence typical of the *ancien régime*, especially when the face invited readings in tandem with his stigmatized body that constituted an explicit sex object under the fallen Qing. Maybe because of the connections he cultivated diligently with the high and mighty, in the press Mei often gave a face to an ineffective and indifferent state in political disarray and institutional impasse, generally defaulting on its responsibility to society.

With consolidation of his success in the opera and his rising international fame, Mei found himself in a different relationship with the burgeoning Nationalist party state. Instead of merely being an extraordinary phenomenon, he now participated more regularly in a social order not only fascinated by his stardom but also supportive of his cultural leadership. He systematically changed his repertoire, abandoning many early experimental plays to concentrate on reinterpreting the classics of Peking opera and developing programmes in Kun opera. He also moved to Shanghai after the Nationalists chose neighbouring Nanjing as their seat of government. A photograph of his off-stage, moustached face during the Japanese occupation

indicated his adamant refusal to collaborate. Even though still primarily associated with the theatre, by now he assumed nationalist significance, particularly as a widely travelled symbol of China's determined resistance during World War II.

Mei's social and political circumstances were altered again in the early PRC. Even though he was an accidental adornment of corrupt politics under the warlord government and an honorary cultural ambassador for the Nationalists, the Communist polity initiated his full integration into the new political system. He was invited back to Beijing from Shanghai, given a prominent seat at the rubber-seal national representative body in Beijing, asked to assume the top position in traditional theatre administration and education, and motivated to join the Party. Whereas in earlier times it indicated the warlord state's inadequacy and provided gestalt to a Nationalist state in crisis, now in its old age, Mei's face was invited to play Chinese society under a young Communist state. For someone who was always politically aware but never intentionally political, the role of playing loyal opposition to the Communists in power was bestowed rather than actively acquired. It is well observed that, unlike the experimental works that accompanied his early influence and the classicism of his middle period, works of feminine unhappiness dominated his later performances, especially in the cinema. A good portion of such negativity was, no doubt, a factor by default, but the government's active courtship of Mei's support indicated its awareness that the maestro had potential to influence a heterogeneous constituency, beyond those whose allegiance it had secured. With regard to Roach's 'breathless spectatorship', Mei's 'power of an apparently effortless embodiment of contradictory qualities simultaneously' is to bring about, in the political context, something of a soft landing for public grievance without stressing the government's bottom line.

A central aspect in the potency of the star's facial signature is, therefore, that it not only makes the performer 'abnormally interesting' but also may induce social consent by providing extraordinary glamour and attraction to objects, locations and social processes when it is brought to bear upon them, i.e. when the latter take on the signatory structures and details of the star's exceedingly interesting face. Herein are the star's influence and citational value. But we cannot conclude automatically that this transferability of the star effect by facial signature is simply a matter of freak idiosyncrasy, or reduce it to mysterious resonance between the stars and the objects, actions, and so forth that they choose to endorse. Just as Frederic Jameson argues in his discussion of Levi-Strauss, where the Caduveo Indians' facial decorations employ 'a design which is symmetrical but yet lies across an oblique axis', so too Mei's facial signature invented 'imaginary or formal "solutions" to unresolvable social contradictions' (Jameson 1981: 78–9). Although modern stars in the entertainment industry are not the shamanistic figures from tribal societies, they are nevertheless charismatic makers of facial decorations or public identities for their contemporaries. The face of the star is not a receiving but a giving process. The close-up that Balazs speaks of, pulling the audience ever so close to the star's face, ultimately enables acquisition of that face – that imaginary solution, balanced at Roach's 'tipping point', to irresolvable social contradictions. Yet at the same time the star's facial signature also incurs a reversal to its own

aggressive self-rendition and social penetration. Emmanuel Levinas, for instance, suggests that:

> [t]he face is present in its refusal to be contained. In this sense, it cannot be comprehended, that is, encompassed. It is neither seen nor touched – for in the visual or tactile sensation the identity of the I envelops the alterity of the object, which becomes precisely a content.
>
> (Levinas 1979: 194)

In this second instance, the face of the star, though extensively available, may never be sufficiently incorporated or 'encompassed' because of its sheer exteriority to the audience's self. It is a terminus that sets up a boundary against the continuous sameness to which the self is identified. It is the ultimate Other that the self cannot tolerate and feels compelled to negate, banish and destroy. But with its sheer otherness to the *I*, such a face also evokes a sense of otherness in the *I*. Insofar as the star's face remains an exteriority to the audience, the audience takes on the same exteriority to that face. In other words, as long as the face always faces, when evoking itself in terms of a signifying surface, it tends to call forth or generate a similar signifying surface oriented toward it in that which it faces. The face that must be destroyed also marks the limit to destruction. For the audience, it is a reminder of its own existence.

In light of such a dialectic of the face, I conclude this chapter with three connected accounts of the discursive finesse in Mei's grievance registration and containment via cross-faced cinematic performance in the 1950s. The character type Mei played to facilitate state–society coordination in the early PRC is the so-called 'traditional Chinese woman'. The term is broad and oftentimes misleading, yet includes three ideological motifs that provide an initial lead to examine the discursive underpinning of Mei's negotiation with the state. I draw from *The Story of White Snake* to illustrate this point.

Women

In *The Story of White Snake*, Mei's face is staged with elaborate headdress, exaggerated make-up, stylized hand gestures and body positions. Conversation and soliloquy, whether in music or otherwise, are in a high-pitched falsetto and a linguistic register seldom visited by average female speakers of the day. *White Snake* is typically presented in cited spaces of archaic architecture, adorned with structural curves and enclosures, and an abundant supply of textiles in exotic fabric and strong colours. In sartorial, verbal, somatic and spatial terms, it conveys a set of conventions specifically developed to facilitate the male performance of womanhood. These conventions had a long history of development but received systematic enforcement in the 1910s and 1920s, when Peking opera was transformed into a theatre centred on female personae and faced the almost inevitable induction of female actors into the profession.

Under this regime of acting, women were disciplined to articulate their body in a feminine gender that was set up through men's examples. Women were therefore

often the sex without a gender of its own. They register a sexual distinction whose relationship with the gender code was 'denaturalized'. Insofar as men's female personae were advanced as a dominant prototype of femininity, woman's access to the feminine was subject to the litmus test of agreement with their ideology and stylistics before receiving professional and social endorsement. Men became mediators between women and femininity. The unhappiness articulated in Mei's facial registration, then, was not open-ended. It may be understood as balanced between female discontent regarding male colonization of the feminine gender and men's anxiety over women's increasing presence in the theatre, which menaced men's time-honoured monopoly over the performance of femininity as a major platform to deliver political opinions.

Tradition

Parallel to Mei's facial rendition in the representation of women, his construction of a certain traditionalism or classicism also became poignant. This was so as long as China's traditional culture, to which Peking opera was often allocated, faced a modern state under the paternal Communist government, whose revolutionary founding principle was to salvage China from its failed traditions. In Mei's rendition, tradition was not only feminized but also submissive. As we see in *The Story of White Snake*, the good woman who gives face and personality to tradition ultimately capitulates to men's terms of peace. She does show her strength and make her case, but she also surrenders to Fahai, the busy steward of 'human' rule over the 'beastly', places her husband's interest ahead of her own, and only receives vindication through her son. Tradition, like the maestro in action, was cross-faced. It articulated grief but conformed politically. One may say that its articulation of grievance was purchased at the price of political conformism. Tradition was revealed in Mei's face as the White Snake willingly throws herself into her husband's embrace, Fahai's magic prison, and her son's salvation. But as a modern man, Mei's subscription to tradition was quite dubious. If the femininity of tradition helped configure tradition's unhappiness under the early PRC, it also determined tradition's passivity and vulnerability.

After his middle career, the maestro was a powerful spokesperson for tradition in modern China. Yet in practice he paid tradition very little respect. Indeed, Mei probably violated more rules, trampled more taboos, and crossed more lines than any other opera actor of that generation of greats who ended up in opera films. He cannibalized traditional performance schemes, narrative traditions and the like to serve his own commercial and artistic agenda, thus making tradition look like a helpless woman to be endlessly exploited with impunity. For instance, to hardcore conservatives, a Peking opera singer acting in the lead of the Kun opera performance was a joke. But as White Snake, he took over the latter's performative legacy regardless, when figuring tradition as a mistreated woman unfailingly devoted to her husband, who might overlook her virtues and good housekeeping only at his own peril. Here Mei was the misleading traditionalist with modern designs, who seemed to advocate a quite collaborationist position for traditional culture under the modernist state. For all the display of anger and

power in *White Snake*, a case was no doubt made for tradition. But to be true to its love and responsibility, tradition-as-woman was willing to disregard the injustices it had received.

The Chinese

Last but not least, Mei in the 1950s was more than a face of woman and tradition in China. Even though both constituted important dimensions of society at large, the maestro's unparalleled influence in popular culture allowed him to take on a much more consequential project: to give face to 'the Chinese'. In Chinese Communist ideology, the idea of 'the Chinese' has long been contested, most crucially because its mobilization model was socially cathartic and divisive, as well as drastically opposed to the Nationalists' somewhat more reconciliatory and inclusive social vision. But even with the Korean War raging, the early 1950s was still a time of domestic reconciliation. The revolution was won. In its wake, a politically neutral face of the Chinese may have helped to heal the trauma of the bloody Civil War (1946–49) and close the gap between winners and losers. Mei Lanfang, the king of entertainment, was indisputably the best choice for such a 'neutral' face that might conceal lingering social oppositions through opera performances and particularly opera films.

From Mei's perspective, representing China and the Chinese, and lending his facial signature to various configurations of Chineseness, were a part of what he had done since the Nationalists triumphed in the late-1920s, when he began to draw an international audience. But never before had he taken on the task of representing Chinese to the Chinese. It may be said that his position in the domestic cultural market until then generally implied smaller profiles such as Chinese womanhood and Chinese tradition, especially in contrast to the image he established internationally. From the position of playing for the state at international arenas, he moved to playing against the state in front of a domestic audience. In the context of a society–state tug of war in the early PRC, grievance took on a degree of negativity incomparable to what had taken place in the women vs state or tradition vs state relationships. In these earlier scenarios, the particular social group that Mei represented always needed to enlist the help of the state in its rivalry with another, e.g. the men or the modernists. In the 1950s, however, the Chinese society that Mei embodied found itself facing the state not only as a higher source of arbitration but also as an immediate rival. Therefore, if Mei appeared in the earlier years as a small-minded professional leader engaged in an institutional turf war, or a collaborationist willingly subjecting his constituency to the yoke of the state, when he faced the state at the pinnacle of his career, one may observe a radicalism and impatience seldom observed in his previous work.

While he had effectively discharged such politically motivated containment of grievance before the 1950s, in cinema of the early PRC, grievance became a much more exposed and confrontational figure in his performance. Indeed his death in 1961 largely coincided with the government's closure of what remained of public space supported by traditional opera and opera film. The scholar and

beauty scheme of representation was now said to be inadequate for addressing the new society of workers, peasants and soldiers. The Cultural Revolution was in the works and a new form of opera film was on the horizon. In would come the Model Operas, replacing grievance with a semi-religious euphoria, where all pains of the past would justify the political status quo. Remarkably, China's unique historical configuration would bequeath Mei his greatest role to play postmortem. Of all prominent social activists, it was up to Mei to forcefully stake society's fortune against an overwhelming state. Memory and film of Mei, the extraordinary figure of a cross-faced star, made a last stand for a public space that would be closed for at least the next 20 years.

Forever enthralled

Of the figural and metaphorical aspects of *contrapposto* in Mei Lanfang and indeed any mega star, one additional observation that can be made is of the star's biographical suspense between fact and fiction. Late Qing literati records of the theatre were mostly rumour-mills in themselves. Zeng Pu's *A Flower in the Sea of Sins* (Niehai hua, 1905), for instance, intensifies political satire by fabricating quite a number of salacious details about cross-dressed actors. In the early Republic, in addition to diligent dirt-digging among theatre journalists, Bao Tianxiao, a popular writer of sentimental fiction in the so-called Mandarin Duck and Butterfly school, also wrote a scandalous novel of Mei's various rumoured encounters, entitled *Traces of Fragrance* (Liu fangji, 1919). 'Fragrance' is by the way the Chinese character that forms part of the star's given name. Other than exploiting commercial values of the star's ambivalent social presence, it seems that such prototypical paparazzi also served society's spontaneous tendency to problematize, though not always in the reasoned manner, the star's strange and inordinate social influence.

More recently, Mei's career and life story received another semi-fictional account in Chen Kaige's *Forever Enthralled*, a movie that claimed to trace the maestro's personal development up until his return to theatre after a hiatus of retirement during the Japanese occupation of Shanghai. For its lack of representation of authentic stage performance and its enthusiastic fabrication of Mei's psychology, this film rhetorically complements *Mei Lanfang's Thespian Art* in that the latter, in a high Communist mode of film discourse, stayed strictly away from the uniquely personal. Of course, to the critic's fault-finding eye, many of the theatre shots may look simply too tidy and there is a general lack of understanding of the maestro's warm, busy, crowded household and overall lifestyle. What the film does offer is a story of Mei's private, moral motivation behind his grand achievements. Leon Lai, who did mesmerizing work in Hong Kong films, such as *Fallen Angels* (Wong Kar-wai, 1995), here appears in his best as a middle-class character brimming with inhibited expression. In the Chen-Lai interpretation, Mei comes across indeed quite convincingly as a cornered man, by his stage role, his social position, his friends, and even his wife, a star whose only channel of authentic self-representation was the stage, and whose focal endeavour was not to engage the society, but to speak the self.

As historical account, what this story misses is obviously forces in the maestro and his society that constituted his exceptional, extra-individual, 'superhuman' charisma. In presenting a character whose personal psychology is so transparent and fault free, the film communicates a contemporary bourgeois vision of the romantic artist, with a most reassuringly sadistic equilibrium by which the latter's every achievement is accounted for in some part of his personal suffering. In contemporary China, this bourgeois mobilization of the psychological individual certainly counteracts the celebratory state discourses on Mei's national symbolism. But at the same time, it may be said that by resolving a social phenomenon in absolutely personal terms, the nascent Chinese bourgeoisie, whose ideology receives unreserved elaboration in the movie, seems quite ready to follow their predecessors in industrialized societies to disengage from a social understanding that necessitates political confrontation as its constitutive responsibility toward the state. If there is an authentic connection between this film and the maestro who lived at the beginning of the PRC, it is in the reiteration of Mei's successful curbing of negativity and discontent, though given the amount of grievance to be witnessed in the earlier film, *Forever Enthralled* tends to be much more reconciliatory. The film does not simply pay kudos to traditional culture, but also corners such politically mercuric issues as artistic expression, stardom and social influence in the intimate portraiture of a bourgeois artist as a young(ish) man.

It is no surprise then that the current Chinese state bestows upon it generous endorsement. On 30 December 2008, Chen Zhili, the Chinese Communist Party (CCP) point woman in culture and education, led a team of lesser national leaders from the National People's Congress and People's Consultative Conference to visit the State Administration of Radio, Film and Television for an early screening of the film. Given the state's interest in a sancationable reading of Mei's life and influence, it is apparent his ghost still has to be tamed. Now, nearly 50 years after his death, it is still sound political investment to corner the forever enthralling Mei as one of the capitulated demons, now with a personal story, beaming obligingly as a harmless god on China's national Olympus.

Note

1 In the professional lingo of Peking opera, singing (*chang*), delivery of dialogue (*nian*), acting (*zuo*) and martial performance (*da*) form four basic skills and essential orientations of stage work. 'Acting' in this context means specifically the performance of physically challenging, often acrobatic, stage routines.

Works consulted

Balazs, Bela (1971), *Theory of the Film; Character and Growth of a New Art*, trans. Edith Bone, New York: Dover Publications.

Berry, Chris and Mary Farquhar (2006), *China on Screen*, New York: Columbia University Press.

Dyer, Richard (1979), *Stars*, London: British Film Institute.

Dyer, Richard (1986), *Heavenly Bodies: Film Stars and Society*, London: Macmillan Education Ltd.

Gao Xiaojian 高小健 （2005）, Zhongguo xiqu dianying shi 中国戏曲电影史 (A history of Chinese opera films), Beijing: Wenhua yishu chubanshe.

Gledhill, Christine (1991), *Stardom: Industry of Desire*, London: Routledge.

Habermas, Jurgen (1989), *The Structural Transformation of the Public Sphere: An Inquiry into a Category of Bourgeois Society*, trans. Thomas Burger, Cambridge, MA: MIT Press.

Jameson, Frederic (1981), *The Political Unconscious*, Ithaca: Cornell University Press.

Levinas, Emmanuel (1979), *Totality and Infinity: An Essay on Exteriority*, trans. Alphonso Lingis, The Hague: Martinus Nijhoff Publishers.

Mci Lanfang 梅兰芳 (1954), *Wutai shenghuo sishi nian* 舞台生活四十年 (40 years of stage life), Beijing: Renmin wenxue chubanshe.

Mei Lanfang 梅兰芳 (1962), *Wo de dianying shenghuo* 我的电影生活 (My film life), Beijing: Zhongguo dianying chubanshe.

Roach, Joseph (2007), *It*, Ann Arbor: University of Michigan Press.

Filmography

Fallen Angels (Duoluo tianshi 墮落天使), d. Wong Kar-wai 王家卫, Hong Kong: Jet Tone Production, 1995.

Farewell My Concubine (Bawang bieji 霸王別姬), d. Chen Kaige 陈凯歌, Hong Kong: Tomson, 1993.

Forever Enthralled (Mei Lanfang 梅蘭芳), d. Chen Kaige, Beijing: China Film Group, 2008.

Mei Lanfang's Thespian Art (Mei Lanfang wutai yishu 梅兰芳舞台艺术), d. Wu Zuguang 吴祖光, Beijing: Beijing Studio, 1955–56.

Peony Pavilion (Youyuan jingmeng 游园惊梦), d. Xu Ke 许珂, Beijing: Beijing Studio, 1961.

A Wedding in the Dream (Shengsi hcn 生死恨), d. Fei Mu 费穆, Shanghai: Lianhua, 1948.

6 Zhao Dan

Spectrality of martyrdom and stardom

Yingjin Zhang

'I play myself'

Two events in Zhao Dan's life (1915–80) carry uncanny associations. First, when he took the role of Lao Zhao in *Crossroads* (Shen Xiling, 1937), he was delighted by the opportunity of 'I play myself' (*wo yan wo*) and flaunted a passionate self-performance that would constitute a centrepiece of his decades-long star image (D. Zhao 2005: 87–91). Second, when he was incarcerated in a single cell in a Shanghai prison in 1967, Zhao found himself in the same location as for shooting his performance of a patriot tortured by Japanese in *Female Fighters* (Chen Liting, 1949) 20 years earlier (D. Zhao 2003: 97). Equally uncanny is that his five-year incarceration by the Communist 'Gang of Four' from 1967 to 1973 is roughly of the same length as his previous incarceration by a Nationalist warlord in Xinjiang from 1940 to 1945. Such creepy historical and fictional coincidences abound in Zhao Dan's eventful life (Gu 2000). This chapter aims to demonstrate that the eerie spectrality linking Zhao's martyrdom and stardom reveals as much about the peculiar nature of socialist stardom as about the anxiety of Chinese artists in a new regime of total ideological control, the latter documented by Paul Clark (1987: 25–87).

One of the most famous stars in Chinese cinema from the 1930s through the 1960s, Zhao Dan started screen acting at the age of 18. However, an ominous *déjà vu* haunted his otherwise stellar career of 40 films and dozens of stage dramas (Q. Zhao 2005: 322–30). In his debut film, *Spring Sorrows* (Li Pingqian, 1933), Zhao played a young tuberculosis patient struggling for life on his death bed, and his expressive eyes and facial expressions subtly conveyed a minor role's feelings of desolation and desperation (Xiao 1987: 252).[1] In his final film, *Red Crag* (Shui Hua, 1965), Zhao played a heroic Communist martyr who refused to escape by himself and chose to sacrifice his life on the eve of the Communist victory over the Nationalists. As if engineered by uncanny spectrality, martyrdom framed Zhao's entire career, and he became a star who specialized in a variety of martyr's roles.

The term 'martyr' refers to a person who

1. willingly suffers death rather than renounces his or her religion;
2. is put to death or endures great suffering on behalf of any belief, principle, or cause;

3. undergoes severe or constant suffering; and/or
4. seeks sympathy or attention by feigning or exaggerating pain, deprivation and so forth.

Eerily, Zhao Dan's screen roles cover the full etymological spectrum of martyrdom: as a star, he feigned and exaggerated pain and suffering on screen; as a screen martyr, he repeatedly endured suffering and death for a glorified cause of Communism, Nationalism, or social justice; and as a real-life martyr, he periodically suffered criticism, deprivation, betrayal and incarceration. Zhao's stardom is therefore structured precariously through martyrdom on and off screen. Significantly, the root meaning of 'martyr' (to witness, derived from the Greek *mártys*) foregrounds a disturbingly sinister underside of Zhao's brilliant stardom, which is a *martyr complex* – an exaggerated, almost masochistic desire for self-sacrifice and suffering structurally embedded in socialist cinema and widely propagated to constitute a prevalent pathos in socialist life. Zhao's life thus establishes an unusual logic according to which martyring oneself – that is, having one's self-sacrifice and suffering 'witnessed' in public – became a prerequisite to stardom.

Following the 'sociosemiotic' (Hollinger 2006: 35) research pioneered by Richard Dyer (1979), this chapter approaches stardom as 'an intertextual construct produced across a range of media and cultural practices, capable of intervening in the working of particular films, but also demanding analysis as a text in its own right' (Gledhill 1991: xiv). Reading Zhao Dan's stardom as a text of rich complexity and irony, this chapter brings together the otherwise scattered traces of his lifetime performance and demonstrates that spectrality, which had emerged to define some of his pre-1950 films, would function as an obscure logic that forcefully integrated stardom with martyrdom in socialist China on and off screen.

Martyrdom: incarceration on and off screen

Zhao Dan is an icon of martyrdom. His stardom is saturated with scenes of his incarceration and images of his sufferings endured for, and necessitated by, radical or revolutionary ideas. In *Female Fighters*, Zhao played Zhang Yuliang, a resistance fighter who visits his ex-wife and estranged daughter in occupied Shanghai and who endures Japanese incarceration without compromising his patriotic belief. In one graphic scene, Zhang is suspended in the air with his hands tied behind him, and the dark shadows of his tortured body are projected on the wall. After he refuses to tell secrets of the underground resistance, his Japanese captor starts whipping him and calls in military dogs to attack him. An extreme close-up of Zhang's face highlights his agonizing pain. In another emotionally charged scene, Zhang's young daughter, who has not seen him for years, visits him in the prison and cries out behind the metal bars, 'Daddy, you have suffered so much!' Perhaps unintended in the original script, this phrase would become a perfect description of Zhao's subsequent life on and off screen.

For Zhao, playing a tortured patriot in *Female Fighters* was excruciatingly painful, as it brought back fresh memories of his real-life incarceration in Xinjiang

from August 1940 to February 1945. Similar to Zhang Yuliang in the film, Zhao left his 11-month-old daughter Zhao Qing in Shanghai at the outbreak of the resistance war in 1937 and travelled with a patriotic drama troupe to China's hinterland. In 1939 he was attracted by the promise of a new democratic region in Xingjiang, China's northwestern border province, but the Nationalist warlord Sheng Shicai soon turned against Communists and arrested Zhao and fellow leftist artists. Zhao was interrogated and tortured, and denied contact with the outside world. Disinformed that he had died, his wife was persuaded to give up her second child with Zhao to an orphanage and to marry a Communist in the hinterland. Not surprisingly, Zhao's biographic materials found screen incarnations in *Female Fighters* as well as in *For Peace* (Huang Zuolin, 1955), where he plays Jiang Hao, a patriotic professor incarcerated by the Japanese during the war and assassinated by the Nationalists after the war.

Among dozens of Zhao's screen images, patriots Zhang Yuliang and Jiang Hao are by no means as memorable as Xu Yunfeng, the Communist martyr Zhao played in an epic revolutionary film, *Red Crag*. Betrayed by a traitor, Xu and Jiang Jie (Yu Lan, b. 1921), another high-ranking underground Communist in Chongqing, are arrested by the Nationalist agents and incarcerated in a concentration camp, but they refuse to surrender and heroically suffer rounds of severe torture. In the climactic execution scene on the eve of the Communist liberation, Xu and Jiang defy their executors and walk side by side, hand-cuffed and in shackles, to the hillside flanked by upright pine trees, accompanied by a solemn, upbeat soundtrack of the Internationale. After a few cross-cutting shots of their comrades shouting behind the bars and affirming their solidarity in the Communist cause, a low-angle shot intensifies Xu and Jiang's glorified martyr images, and the camera's panning of the pine trees – punctuated by off-screen slogans and gunshots – suggests their soaring immortal spirit.

As with *Female Fighters*, shooting *Red Crag* reminded Zhao Dan of his real-life 'experience in blood and tears' during his Xinjiang incarceration. What Zhao and his fellow filmmakers did not anticipate, however, was the immediate dismissal of the film as a 'thoroughly bad', 'poisonous weed', a negative example awaiting mass criticism masterminded by Jiang Qing (1914–91) (Huang 1984: 59).[2] Through a sardonic ruse of history, the heroic moment of Xu's execution in *Red Crag* in martyrdom for the Communist cause, symbolically – albeit unexpectedly – marked the terminal point of Zhao Dan's screen stardom/martyrdom, as he would be incarcerated in 1967 and would never again star in a new film for the remaining 15 years of his life.

Apart from patriotic and Communist heroes, Zhao had portrayed other types of martyrs. Zhao once admitted – to the surprise of his family members – that he felt his best screen role was neither a Communist nor a patriot but Wu Xun in *The Life of Wu Xun* (Sun Yu, 1950). The Wu character was an uncultivated rural beggar based on a real historical figure who suffers all kinds of humiliation to raise sufficient funds for three local schools he establishes to educate village children free of charge (Q. Zhao 2005: 67).[3] The two-part biography was produced by the private studio Kunlun (a postwar Shanghai powerhouse of former leftist filmmakers) and released

initially to enthusiastic audiences and rave reviews. However, party chairman Mao Zedong was offended by the film's 'erroneous' historical vision and personally penned a critique published in *Renmin ribao* (*People's daily*), the leading party organ, in May 1951. The nationwide campaign against *The Life of Wu Xun* sent a chilling message to artists and intellectuals that they had no choice but to toe the party line, and all Shanghai private studios were forced to merge with the state enterprises a year or two after the campaign (Y. Zhang 2004: 94–9). Historically, Wu Xun might be a folk martyr venerated by local villagers and commended by modern reformers, but the socialist screen reserved no room for ideologically dubious figures like him and cared even less about Zhao Dan's outstanding star performance in the film.

Just as socialist cinema had excluded Wu Xun from its strictly censored list of historical heroes, so the Communist Party treated Zhao Dan with prolonged suspicion, even after he was admitted as its member in 1957. To be sure, in the late 1950s, Zhao was allowed to play a few heroic martyrs, but Zhao's disillusionment with the party reached its height during his second incarceration in the late 1960s. Rather than fortifying his political capital, Zhao's incarceration in the early 1940s was recognized as a black spot in his personnel record and became a major source of his continuous troubles during the Cultural Revolution. No longer treated as a martyr suffering for a just cause, Zhao was interrogated as a 'traitor' who had abandoned the Communists for the Nationalists before his 1945 release in Xinjiang. Designated as 'Inmate 139', he was ordered to write confessions day in and day out and to recount every trace of his thought, ultimately to incriminate himself in a nationwide political struggle.

In a written confession dated 29 March 1968, Zhao blamed himself for scribbling in slips of paper and hiding them from army soldiers who served as prison guards. In another confession dated 13 December 1968, Zhao reveals he could not remember where he obtained two pennies and ends by pleading for clemency for his crime. In yet another, dated 22 November 1969, Zhao invited criticism and struggle against himself, claiming he had secretly peered through windows looking for anyone he knew when he returned to his cell after a day of labour. Crime confession from 1967 to 1973 (D. Zhao 2003: 110–206) steered Zhao's stardom into a sinister phase of self-tortured martyrdom in which he delivered a solitary performance of a troubled self caught in a ruthless game of *perpetual othering*.

The result of such othering was astounding. Shortly after his death in 1980, the party investigation group visited Zhao's family and returned two huge bags of his confessions handwritten during the five-year incarceration. Huang Zongying (b. 1925), Zhao's wife from the late 1940s, refused to sign an acknowledgment of the party's decision – 'All untrue words are to be revoked' – on Zhao's behalf, for she felt that she had no right to fill in a 15-year blank page of an outstanding Communist artist.[4] Faced with the monstrosity of two bags of Zhao's confessions marked for 'self-disposal' (*zixing xiaohui*) by the family, his youngest daughter wrote in her diary: 'What is it? Is it a person? Is it the entire life of a person?' (D. Zhao 2003: 90).[5]

Stardom: performance of self as others

Ostensibly, the image of Zhao Dan that emerged from his enforced self-incriminating confessions differs drastically from his signature star image as a passionate youngster full of energy and idealism. Back in the mid-1930s, *Crossroads* gave him a perfect chance: 'it was all about "I play myself", about exhibiting myself, about overacting and catching every single shot of me' (D. Zhao 2005: 89). Decades later, Zhao would question his overacting in *Crossroads* – which he believed had paradoxically expressed and alienated him at the same time – and traced the cause of the problem to imitating Hollywood styles fashionable in the 1930s. Indeed, in the beginning sequence of *Street Angel* (Yuan Muzhi, 1937), in which Zhao's character plays the trumpet in a wedding parade through a narrow street, Zhao sustained his contagious, exuberant acting, but he would later credit the director Yuan Muzhi (1909–78) for constraining him, thereby creating a balanced realist style of acting in that film (D. Zhao 1980: 23–5, 33–4). By now, film scholars tend to characterize Zhao's 'naturalistic' (*shenghuohua*) acting style as 'enthusiastic, uninhibited, emotional and slightly humorous' (Liu 2005: 24, 33).

Nonetheless, Zhao's inclination to overacting was still visible in *Nie Er* (Zheng Junli, 1959), a biographical film of a canonized Communist composer who happened to be Zhao's beloved friend from the mid-1930s.[6] The *déjà vu* experience of 'I play myself' returned in Zhao's performance of *Nie Er* (1912–35) as he believed he and Nie shared similar personality traits – elsewhere described as 'childish, impulsive, restless, passionate, talented, and humorous' (B. Wang 1997: 147). Playing Nie was therefore like playing himself, only that he was already 20 years older than the Nie he last knew. Nonetheless, Zhao sometimes appears quite lost in *Nie Er*, as if he were unsure whether his self-performance as a martyred Communist would satisfy the party's changing expectations due to its internal factional tensions. The metaphor of 'I play myself' became doubly significant when Zhao playing Nie was informed on-screen that his admission to the party had been approved: a close-up of Nie's radiant face reveals his teary eyes, and his gratitude to the party is palpable as he wipes away tears and dedicates himself to composing more revolutionary songs in the film. Given that Zhao had been admitted to the party two years before the film was made, one would assume that Nie's screen tears were Zhao's genuine tears of joy and gratitude as well. The integration of Nie and Zhao into one symbolic image created a martyr complex so deeply ingrained in Zhao that decades later he would instruct in his will that, after his death, half of his ashes be buried beside Nie's tomb in Japan (Huang 1984: 5).

For some critics, the scene of Nie's admission to the party illustrates 'a darker, more sinister aspect' of the revolutionary film, 'in which the individual can be made to feel more authentically his own self and experience an ecstatic self-enforcement precisely at the moment when he is at the bidding of the party' (B. Wang 1997: 151) – that is, at the moment of his *submission* to the party's ideological interpellation. In other words, one would become truly oneself only when one had submitted oneself to the party's process of othering so that one could re-emerge

as a new 'authentic' self sanctioned by the party. As a star, Zhao/Nie diligently performed such a dialectic process of self as others and others as self on screen, and his stardom would ideally function as a source of identification whereby the audience could emulate the screen martyrdom and transform themselves in accordance with the party's interpellation.

Nevertheless, not all viewers would experience the same imaginary identification with the screen martyr as stipulated by the psychoanalytic reading outlined above. For example, Jay Leyda, an American scholar who had othered himself enough to be a China supporter and worked as a foreign film expert in Beijing from 1959 to 1962 (Y. Zhang 2002: 48), was 'quite unprepared for the nonsense and uselessness of *Nie Er*', in which Zhao Dan appeared to him as 'a constant embarrassment': 'To the bouncing youngster he had played in *Crossroads* he added the furrowed brow, open mouth and poised pen required of any composer shown in a film, and the combination was as unreal as the film's story' (Leyda 1973: 260–1).

Leyda's judgement might be biased by his disaffection with the China–Soviet fallout in the early 1960s, but most critics now admit 'some truth in the view that the revolutionary film is formulaic and schematic' (B. Wang 1997: 146). However, formulaic narratives and schematic ideas alone did not determine the success or failure of a screen performance in socialist cinema. Not surprisingly, as Pickowicz observed of Zhao Dan's role as the titular character in *Lin Zexu* (Zheng Junli, 1959), 'Zhao Dan's performance as Lin Zexu was unforgettable' (Figure 6.1); it marked a high point in his career as the film 'generated a veritable avalanche of enthusiasm' (Pickowicz 2006: 1060–1). Arguably, Zhao had much to identify with Lin Zexu, a celebrated late Qing official who became a national hero when he ordered the historical burning of opium in Canton in 1839 but whose loyalty to the country was mistreated by the imperial court as he was exiled for his radical

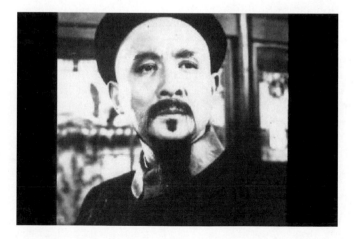

Figure 6.1 Zhao Dan as Lin Zexu.

measures against the foreign power. As in *Nie Er*, playing Lin Zexu must have evoked a *déjà vu* feeling of 'I play myself' to some extent. As part of the daily programme to immerse himself in Lin's life, Zhao took up calligraphy and ink-and-wash painting in which he had been professionally trained decades before (Liu 2005: 74). Zhao was proud of his performance in *Lin Zexu*, in particular his first appearance: Lin is summoned to meet the emperor, and when he looks up, a close-up captures his eyes shining with honesty, courage and wisdom (Zhongguo dianying chubanshe 1979).

For Zhao, as for his critics and fans, his eyes were extremely expressive. By the early 1960s, Zhao was ready to promote his system of three-step screen acting: 'proceed from the self and enter the role; live as the role does and experience the role's ideas and emotions; develop techniques and means of expressing the role's personality and complete the task of constructing the role's image' (D. Zhao 2005: 188). Zhao's outstanding construction of Lin Zexu is one excellent example of the 'Zhaoist system of acting' (*Zhaoshi biaoyan tixi*), which bears a visible resemblance to 'Method acting' in that both require actors to experience the role's emotions and motives and to 'give up their personalities to become someone else' (Hollinger 2006: 48).[7] Nonetheless, as indicated above, a fundamental problem in socialist China was the thin line between acting and reality: the self was always already othered, and the othering of the self was an absolute prerequisite for an artist to be recognized and accepted by the party. In Zhao's case, therefore, 'I play myself' was inevitably translated into *witnessing* the torturous process whereby his self had to be othered or 'martyred' – voluntarily or otherwise – by the all-powerful ideological and historical forces.

Spectrality: stardom as martyrdom in socialist cinema

The spectrality of stardom and martyrdom implicated a large number of veteran filmmakers in socialist China, especially during the Anti-Rightist Campaign in 1957 and the Cultural Revolution from 1966 to 1976, and not all stars survived their political mistreatments by the party.[8] For instance, Shi Hui (1915–57), a famous film star and director of the 1940s and 1950s, endured similar sufferings on and off screen, but his outcome was more tragic – albeit lesser known – than Zhao's. Shi was condemned as a bourgeois rightist and committed suicide in 1957 at the age of 42, in a surreal manner that, again, blurred the lines between art and life, fiction and reality, stardom and martyrdom, self and other in socialist life. After a mass meeting of criticism when no friend dared to come to his defence, Shi boarded a ship where he had intentionally 'experienced life' (*tiyan shenghuo*) for the last film he scripted and directed, *Night Voyage on a Foggy Sea* (Shi Hui, 1957), threw himself into the sea and drowned. Unlike Zhao Dan, Shi Hui has remained a martyr denied martyrdom – no published source in China has acknowledged his suicide to date (Pickowicz 2007: 287) – and a spectre of faded stardom.

Although not as tragic as Shi Hui's life, Zhao Dan's life had moments of frustration and desperation, particularly when he failed to secure the two film roles that most endeared him. First, he volunteered to play Lu Xun (officially hailed as

'father of modern Chinese literature') in *Life of Lu Xun*, a major project endorsed by the Ministry of Culture, and he began to wear a bushy moustache and live his imagining of Lu Xun's life in his daily routines. Begun in 1960, the project unfortunately went nowhere for various political reasons. Second, after the Cultural Revolution, Zhao was nominated to play Premier Zhou Enlai in *The River Surges On* (Xie Tieli, 1978), but he was denied the opportunity due to his by-then unsettled political case and, more outrageous to him, allegations that he had conducted a relationship with Jiang Qing in the 1930s (D. Zhao 2005: 181–6, 265–78).

In lieu of films, only photographs of Zhao Dan made-up as Lu Xun and Zhou Enlai have survived. In an eerie way, these photographic images serve as a ghostly reminder of those chapters of Zhao's past deemed problematic by different factions of the Party. In spite of his numerous popular screen portrayals of Communist martyrs (Nie Er, Xu Yunfeng) and folk heroes (Lin Zexu, Wu Xun), Zhao was still seen by the Party as an artist not eligible for passing on screen as truly great historical figures such as Lu Xun and Zhou Enlai. Most devastating to Zhao in the late 1970s was his inability to appear in a single film. This zero record was all the more devastating because, besides Lun Xun and Zhou Enlai, he had dreamed of playing other heroes and martyrs such as Jing Ke (an ancient assassin who failed to kill the First Emperor), Wen Yiduo (a modern poet and scholar assassinated by the Nationalists), Qi Baishi (a famous modern ink-and-wash painter) and Li Bai (a legendary free-spirited poet from the Tang dynasty) (Huang 1984: 95–7).

There is little doubt that Zhao had wilfully intended himself as a martyr on and off screen, but *for what cause* really did he construct his illuminating martyrdom? The clue can be found in an article Zhao dictated from his hospital bed, 'No Hope for the Arts if Regulated Too Specifically', which appeared in *Renmin ribao* on 8 October 1980, two days before he would die of cancer at the age of 65. The article questioned how the party had regulated the arts in China and called for creative freedom: 'The arts are the artists' own business; the arts would have no hope whatsoever and would perish if the party regulated them too specifically' (D. Zhao 2005: 227). In particular, Zhao criticized the party-instituted system in which incompetent cadres had interfered with artistic work, and he lamented that for 20 years he had failed to play Lu Xun on screen and that there was not a single film about Lu Xun before 1980. 'I am not afraid of anything anymore', he uttered as his dying words, 'but enough of my babbling, what is the use? ...' (D. Zhao 2005: 230).

Nevertheless, despite his lingering scepticism, Zhao's swansong performance of stardom was extremely useful, and his heroic martyrdom was subjected to various interpretations at a historical transition period in post-Mao China. Cultural dignitaries and fellow artists lost no time in decorating Zhao with glowing eulogies. Ba Jin (a famous fiction writer) called Zhao 'the first person to speak truth ... and to sacrifice himself for the arts'; Xia Yan (1900–95, a ranking cultural leader and a screenwriter) emphasized Zhao's belief in 'democracy of the arts'; Yang Hansheng (1902–93, another cultural leader and screenwriter) commended Zhao's demand for 'creative freedom'; and Bai Yang (1920–96, a female co-star in *Crossroads*)

respected Zhao's screen images, his courage and his pursuit of beauty (D. Zhao 2005: 294–6). Judging from these eulogies, Zhao became a martyr who dared to speak truth and who endured incarceration and suffered injustices for the causes of freedom and democracy. Significantly, upon his death, Zhao's martyred stardom was not directly linked to the otherwise glorified cause of Communism or Nationalism embodied by his screen images.

At the juncture of 1980, terms such as 'truth', 'freedom' and 'justice' all hovered like spectres in a country that had barely recovered from the traumatic decade of the Cultural Revolution. For Zhao Dan, the posthumous attribution to him of the image of a fighter for freedom and democracy in the arts only testifies to their conspicuous absence during his life. Incarcerated and tortured multiple times on and off screen, Zhao has left two contradictory star images: on the one hand, an energetic, apparently carefree youngster full of idealism and passions; on the other, a sombre martyr enduring pains, suffering mistreatments and oftentimes sacrificing his life for a glorified cause. If we accept his self-characterization 'I play myself', then his dynamic self had been fundamentally othered after the fiasco of *The Life of Wu Xun* and would return to haunt his martyred images from time to time. Indeed, after the Cultural Revolution, the star images of his martyrdom became spectral, as they foreshadowed his deprivation of screen roles and his untimely death in bitter regret. An eerie kind of spectrality has never failed to integrate Zhao Dan's stardom with martyrdom.

Notes

1 Zhao played a similar role in *A Bible for Girls* (Zhang Shichuan *et al.*, 1934) as a tuberculosis patient who is unemployed, financially dependent on his wife, and dies in utter desperation (Q. Zhao 2005: 324).
2 Jiang Qing was Mao Zedong's wife from the early 1940s on and was popularly described as the most evil top leader during the Cultural Revolution who persecuted a large number of artists and cadres to death. She was briefly active in Shanghai's performing arts circle in the mid-1930s and appeared in four films under the name of Lan Ping. She was arrested in 1976, expelled from the party in 1977, and sentenced to death in 1981; her sentence was reduced to life in prison in 1983, but she committed suicide in 1991.
3 The director Sun Yun concurs with several critics' assessment that Wu Xun was Zhao Dan's best screen role; for Sun, Zhao's performance moved audiences to tears and etched in their memories the image of an old beggar pleading for the cause of impoverished rural children (Sun 1990: 198).
4 Huang Zongying was a film actor from the late 1940s to the 1950s and co-starred with Zhao Dan in *Rhapsody of Happiness* (Chen Liting, 1947) and *Female Fighters*. She became a non-fiction writer in the socialist period.
5 Zhao's family did not destroy his confessions. Instead, Huang Zongying selected sections that she believed would not harm anybody and had them published in slightly redacted form in a collection (D. Zhao 2003: 110–206).
6 Nie Er emerged as a popular patriotic songwriter during the early 1930s and was martyred as a Communist composer after his death by accidental drowning in Japan on his way to professional training in the Soviet Union.
7 Method acting refers to the ensemble of exercises Lee Strasberg developed for actor training and rehearsal, which was in part derived from Constantin Stanislavski's system of acting (Hollinger 2006: 10–16).

8 Veteran filmmakers who became victims in the Anti-Rightist Campaign include Lü Ban (1913–76) and Sha Meng (1907–64), both starring in *Crossroads*, as well as Wu Yin (1909–91) and Wu Yonggang. Filmmakers who were persecuted to death in the early years of the Cultural Revolution include Cai Chusheng (1906–68), Shangguan Yuzhu (1922–68), Tian Han (1898–1968), Ying Yunwei (1904–67) and Zheng Junli.

Works cited

Clark, Paul (1987), *Chinese Cinema: Culture and Politics since 1949*, New York: Cambridge University Press.

Dyer, Richard (1979), *Stars*, London: British Film Institute.

Gledhill, Christine (ed.) (1991), *Stardom: Industry of Desire*, London: Routledge.

Gu, Weili 顾伟丽(2000), *Zhao Dan: Diyu tiantang suo yizhu* 赵丹: 地狱天堂索艺珠 (Zhao Dan: searching for artistic pearls in hell and heaven), Shanghai: Shanghai jiaoyu chubanshe.

Hollinger, Karen (2006), *The Actress: Hollywood Acting and the Female Star*, London: Routledge.

Huang, Zongying 黄宗英 (1984), *Ta huozhe: yi Zhao Dao* 他活着：忆赵丹 (He is alive: reminiscences of Zhao Dan), Beijing: Zhongguo dianying chubanshe.

Leyda, Jay (1972), *Dianying: An Account of Films and the Film Audience in China*, Cambridge, Mass.: MIT Press.

Liu, Shibing 刘诗兵 (2005), *Zhongguo dianying biaoyan bainian shihua* 中国电影表演百年史话 (A 100 years of film acting in China), Beijing: Zhongguo dianying chubanshe.

Pickowicz, Paul (2006), 'Zheng Junli, Complicity and the Cultural History of Socialist China, 1949–1976', *China Quarterly*, 188, pp. 1048–69.

Pickowicz, Paul (2007), 'Acting Like Revolutionaries: Shi Hui, the Wenhua Studio, and Private-Sector Filmmaking, 1949–52', *Dilemmas of Victory: The Early Years of the People's Republic of China* (eds Jeremy Brown and Paul G. Pickowicz), Cambridge, MA: Harvard University Press, pp. 256–87.

Sun, Yu 孙瑜 (1990), *Dalu zhige* 大路之歌 (Song of the big road), Taipei: Yuanliu.

Wang, Ban (1997), *Sublime Figure of History: Aesthetics and Politics in Twentieth-Century China*, Stanford, CA: Stanford University Press.

Xiao, Guo 肖果(ed.) (1987), *Zhongguo zaoqi yingxing* 中国早期影星 (Early Chinese film stars), Guangzhou: Guangdong renmin chubanshe.

Zhang, Yingjin (2002), *Screening China: Critical Interventions, Cinematic Reconfigurations, and the Transnational Imaginary in Contemporary Chinese Cinema*, Ann Arbor: Center for Chinese Studies, University of Michigan.

Kzhang, Yingjin 赵丹(2004), *Chinese National Cinema*, London: Routledge.

Zhao, Dan 赵丹(1980), *Yinmu xingxiang chuangzao* 银幕形象创造 (Constructing screen images), Beijing: Zhongguo dianying chubanshe.

Zhao, Dan 赵丹(2003), *Zhao Dan zishu* 赵丹自述 (Self-narration by Zhao Dan) (ed. Li Hui 李辉), Zhengzhou: Daxiang chubanshe.

Zhao, Dan 赵丹 (2005), *Diyu zhi men* 地狱之门 (Gate of hell), expanded edition (eds. Zhao Qing 赵青and Ming Yuan 明远), Shanghai: Wenhui chubanshe.

Zhao, Qing 赵青(2005), *Wo he diedie Zhao Dan: Zhao Qing huiyi* 我和爹爹赵丹：赵青回忆 (Daddy Zhao Dan and me: Zhao Qing's reminiscences), Beijing: Zhongguo dianying chubanshe.

Zhongguo dianying chubanshe 中国电影出版社 (ed.) (1979), *Lin Zexu: cong juben dao dianying* 林则徐：从剧本到电影 (Lin Zexu: from the screenplay to the film), Beijing: Zhongguo dianying chubanshe.

Filmography

A Bible for Girls (Nüer jing 女儿经), d. Zhang Shichuan 张石川 et al., Shanghai: Mingxing, 1934.

Crossroads (Shizi jietou 十字街头), d. Shen Xiling 沈西苓, Shanghai: Mingxing, 1937.

Female Fighters (Liren xing 丽人行), d. Chen Liting 陈鲤庭, Shanghai: Kunlun, 1949.

For Peace (Weile heping 为了和平), d. Huang Zuolin 黄佐临, Shanghai: Shanghai Studio, 1955.

The Life of Wu Xun (Wu Xun zhuan 武训传), 2 parts, d. Sun Yu 孙, Shanghai: Kunlun, 1950.

Lin Zexu (Lin Zexu 林则徐), d. Zheng Junli 郑君里, Cen Fan 岑范, Shanghai: Haiyan, 1959.

Nie Er (Nie Er 聂耳), d. Zheng Junli, Shanghai: Haiyan, 1959.

Night Voyage on a Foggy Sea (Wuhai yehang 雾海夜航), d. Shi Hui 石挥, Shanghai: Tianma, 1957.

Red Crag (Liehuo zhong yongsheng 烈火中永生), d. Shui Hua 水华, Beijing: Beijing Studio, 1965.

Rhapsody of Happiness (Xingfu kuangxiangqu 幸福狂想曲), d. Chen Liting, Shanghai: Zhongdian Studio 2, 1947.

The River Surges On (Dahe benliu 大河奔流), 2 parts, d. Xie Tieli 谢铁骊, Beijing: Beijing Studio, 1978.

Spring Sorrows (Bipa chunyuan 琵琶春怨), d. Li Pingqian 李萍倩, Shanghai: Mingxing, 1933.

Street Angel (Malu tianshi 马路天使), d. Yuan Muzhi 袁牧之, Shanghai: Mingxing, 1937.

7 Zhang Ruifang

Modelling the socialist Red Star

Xiaoning Lu

Introduction

From the 1970s onward, with the re-evaluation of popular culture and theoretical shifts in film studies, stardom has become an important subject in cultural and cinema studies. The study of stardom not only offers us the possibility of examining the whole cinematic process, as the movie star ties production, film and spectator together, but also allows us to explore how star making is organized and understood in a certain society, and more importantly, how a society produces certain notions of personhood through its star making.

Within Chinese cinema, a few film stars unfailingly excite scholarly interest, because they are not only iconic national figures but also serve as a site where discourses of nation and modernity blend. For instance, the tragic silent-movie star Ruan Lingyu in 1930s metropolitan Shanghai is an allegory of China trapped between semi-colonialism, semi-feudalism and capitalism (Cui 2003), as well as a symbol, agent and victim of Chinese modernity (Harris 1997). The muscular star Bruce Lee not only reinvigorated 1970s Hong Kong martial arts cinema through fusing patriotic messages with his dazzling performance of martial arts but also excited Chinese cultural nationalism worldwide. As for Gong Li, the best-known Chinese star in today's global cinema market, her international stardom, concomitant with the popularity of the Fifth Generation films, has both capitalized on the essentialist idea of Chineseness and symbolized China's struggle in the globalizing marketplace (Berry and Farquhar 2006: 128).

In contrast, film stars in Chinese socialist cinema (1949–66) have gone unnoticed, even though they were iconic figures at the stage of socialist modernization and they constituted mass culture in the Mao era. The uneven topology of star studies in Chinese cinema manifests an unquestioned assumption: movie stars are by-products of industrial practices of Hollywood and the like. It also indicates uneasiness toward detaching the star from an analytical framework of commercial culture. The importance of the study of stardom in Chinese socialist cinema cannot be overstated. Such studies are useful to understanding both a film industry and a film culture that seek an alternative path to that set out by Hollywood. In addition, stardom encapsulates issues such as the paradoxical coexistence of individualism

and collectivism in the socialist state and the dynamic relationship between the public figure and the masses.

This chapter uses the concept of the Red Star, stars who gave excellent screen performances and social performances, to examine the propagandistic construction of stardom in Chinese socialist cinema (1949–66). It illustrates with a case study of a particular female film star, Zhang Ruifang (b. 1918). Adopting a perspective that acknowledges the dialogic relations within a national cinema, and between social mobilization and cultural production, this chapter seeks a conceptualization of the Red Star that accounts for the socio-historical specificity of stardom during the Mao era.

Problematizing 'the star'

During the Mao era, Zhang Ruifang was a well-known actor in Chinese socialist cinema, especially famous for her on-screen persona of the progressive woman activist who keeps abreast with the times. Throughout the 1950s, Zhang was cast for major positive female roles, as a woman militia leader in a classic revolutionary film *Conquer South, Victory North* (Cheng Yin and Tang Xiaodan, 1951), as an underground female communist in a biopic *Nie Er* (Zheng Junli, 1959), and as an urban housewife who actively participates in a Mutual Aid Team in *Everywhere is Spring* (Shen Fu, 1959).

However, Zhang was best known for her title role in a rural film *Li Shuangshuang* (Lu Ren, 1962). The film tells of a young peasant couple in a people's commune. Li Shuangshuang, the wife, is presented as a model commune member, forthright in character, selfless at heart and quick in unmasking others' selfish demeanours. Her husband Sun Xiwang, a mild character who harbours patriarchal habits and conservative attitudes, often feels embarrassed by Shuangshuang's activism and holds her back from taking public responsibilities. After several mini-dramas of quarrels and splits between the peasant couple, the film ends with the couple's reunion. Xiwang, sincerely convinced of Shuangshuang's merits, reconciles with his wife, learns from her and develops into a good commune member. With the film's phenomenal success, audiences began to identify Zhang endearingly with her character Shuangshuang. Zhang's stardom peaked in 1963, when she won the Best Actress Award of One Hundred Flowers, a readers' choice award sponsored by the film magazine, *Dazhong dianying* (*Mass Cinema*).

Yet, to call Zhang a star is problematic. In the Mao era when the socialist ideology prevailed, the very word 'star' fell out of fashion in everyday speech. 'Star' carried a spectrum of negative connotations: corrupted lifestyles, loftiness, individualism and liberalism, all of which originate from the same source, capitalism. Specific to cinema, 'star' immediately evoked images of glamorous and fashionable movie stars in Hollywood as well as in the cosmopolitan Shanghai, which are the most sensual symbols of commercial culture. The film star culture, as a site where the spectator's engagement with film is predominant, and hence film's impact on social life most tangible, became a battlefront of 'People's Cinema', a new Chinese cinema that the Chinese Communist Party (CCP) aimed

to build. Not surprisingly, the CCP made great endeavours to transform film star culture. It launched criticisms of Hollywood cinema and 'harmful' domestic films (Leyda 1972).[1] Well aware of print culture's role in perpetuating memorable star images and breeding blind idolizations of individuals, it cleared away fan magazines which were popular in Republican China, such as *Mingxing huabao* (*Star pictorial*), *Mingxing jiating* (*Star family*), *Mingxing texie* (*Star feature*), *Yingxing zhuan ji* (*Movie star collection*) and *Yingmi julebu* (*Fans club*). As a number of film magazines on stars rapidly disappeared, film magazines that adopted strong nationalistic titles, including *Dazhong dianying*, *Renmin dianying* (*People's cinema*) and *Zhongguo dianying* (*Chinese cinema*), quickly took their place.

It comes as no surprise that movie actors, even the stellar ones, along with film directors, scriptwriters, cinematographers and other personnel in Chinese socialist cinema, began to share one common designation: 'the film worker'. This appellation may bluntly call attention to stars as primarily labourers, who utilize natural attributes, gifts and acquired crafts to perform or to work. It nevertheless demonstrates a particular socialist ethic – to work is glorious – and reveals a deep-seated egalitarian understanding. Since socialists in the Mao era believed that work cultivated proletarian consciousness and defined class boundary, stellar actors were endearing not because they possessed exceptional, mysterious and ethereal qualities, but because they were self-supporting and accomplished workers, to whom the masses could relate. To say the least, the designation of film workers helped re-conceptualize the relation between the star and the spectator: encouraging intimate camaraderie between the star and the spectator rather than spectators' craze for the star.

For these reasons, I use the Red Star as an analytical concept to examine Mao-era film workers who embodied socialist values. Zhang's stardom provides an intriguing case. As a model socialist on-screen and good worker off-screen, Zhang attracted identification and emulation. Her case problematizes a dominant understanding of female star informed by psychoanalytic film theory.

Laura Mulvey's famous argument about visual pleasure in cinema – that man is doing the looking and woman is being looked at – not only generates further discussions of spectatorship and visual pleasure but also has great ramifications for studies of female stars. Female star, as the extension of her body on-screen, is still a fetish. She is the object of desire but not the subject of identification (Mulvey 1975). Star studies that consider race, class and ethnicity have questioned and complicated the Mulvian model (Dyer 1984; Stacey 1994). Recent media studies of audiences, and in particular of fandom, also offer an exciting new direction. By highlighting the productivity of audiences, these studies inform us of the importance of audiences as producers in reproducing and reinventing star image and relevant discourses (Hills 2002; Jenkins 1992). Nevertheless, these approaches do not provide a satisfactory model to explain the Red Star. Considering the socio-historical specificity, Chinese audiences in the Mao era hardly formed an autonomous interpretive community. Audiences' responses to film and star were highly visible in newspapers, magazines and journals. However, these responses were mediated

by the then popular socio-political discourses and selected in accordance with editorial directives of specific state media.

My use of the analytical concept of Red Star concerns the relationship between a wider management of propaganda and cultural production in socialist China. In particular, I relate the star phenomenon to model people who emerged from industry, agriculture and the military in Mao's China. Mao Zedong once pointed out that the significance of model people lay in their functionality in the entire social structure. Model people, as activists devoted to the socialist cause, set up good examples for the ordinary people. As the advanced elements among the masses, they were the people on whom the party could count. Ultimately, they were the link between the party and the masses (Mao 1950). Hence, I propose a theoretical paradigm of modelling to comprehend the Red Star in general, and Zhang's stardom in particular. To conceptualize the Red Star through modelling is to foreground the intricate relation between the construction of the star and the socialist ideology. While admitting the centrality of the Red Star to the entire social structure, this paradigm opens a space for a deconstructionist reading of the Red Star. The model is the original, the ideal and the centre. It shapes the masses into desired citizens. However, the question arises: does this centre have certitude, immobility and essence?

Star image

Zhang Ruifang's star image as a model socialist person was stabilized over the course of the years 1962 and 1963, as her publicity image was visually modified and subsidiary discourses accrued.

In June 1962, 3 months before the release of *Li Shuangshuang*, the film magazine *Shanghai Cinema* published a few publicity pictures of the film. These include a half page of downsized black and white film stills of *Li Shuangshuang*, and a centrefold featuring portraits of two protagonists set against a watercolour background of serene countryside. The latter, with its bright colour and full-scale size, accentuates the film's leading male and female actors, who appear as their screen roles. There is no doubt that Chinese folk art lends essential conceptual ideas and formalist expressions to the publicity picture of the rural film *Li Shuangshuang*. Use of popular folk art certainly helps prepare audiences for this relatively new film genre, regulates viewers' expectation of *Li Shuangshuang*, and facilitates the popularization of the film.

More importantly, the centrefold draws attention to a particular kind of femininity imagined within folk tradition. The left side of the centrefold features a tainted colour picture of Xiwang, who is attentively playing a flute. The depiction of Xiwang is so detailed that wrinkles in his forehead and the folds of his off-white peasant garment are clearly visible. Yet his image is dwarfed by an even bigger portrait of Shuangshuang, which nearly occupies the entire right half of the centrefold. In her portrait, the pink flower patterned shirt, softened facial outline, bashful smile and flushed cheekbones, which are commonly used formalist elements in the folk painting of female characters, serve as visual cues of the feminine quality

of Shuangshuang. Overall, Shuangshuang's image is sedentary. Resting her chin in her right hand, Shuangshuang wears a carefree smile. Her bangs rest serenely on her forehead, and her eyes seem to express sincere longing for the happy days to come. She is pretty yet passive. Ironically, although Zhang's publicity was framed within the publicity of the film, it relied heavily on what contradicts her screen persona. The image of the highly conventional and anonymous woman in the watercolour provides a good point of reference to understand the drastic change in the construction of Zhang's star image within that one year.

In June 1963, immediately after Zhang Ruifang won the Best Actress award, the fifth and sixth issue of *Mass Cinema* published the most famous and widely circulated publicity picture of Zhang on its cover: a painted colour portrait of Zhang as her screen role Li Shuangshuang. This painting presents us a neatly dressed peasant woman wearing a beaming smile and sunburnt complexion. With her right hand lifted up close to her open mouth, and with her eyes looking diagonally out of the frame, Shuangshuang seems to be calling out for her companions in the distance. Far different from the above-mentioned idyllic watercolour, the portrait is filled with dynamism, at both levels of composition and feeling. With Zhang's face positioned in a diagonal axis of the frame, this low-angle portrait avoids the conventional and static front-view portrait of a single character. Corresponding to composition, details of the portrait relegate the figure's feminine qualities and instead emphasize her strength, energy and spirit. A blue and white check patterned garment, northern woman's hairstyle, healthy suntanned complexion, clear facial outline, thick black eyebrows and bright eyes beaming with enthusiasm all help to transform a tender and loving woman into a determined and energetic socialist activist. Dispensing with any concrete background, including supplementary characters and countryside landscape, makes the image more prominent and suggests that the public space where the peasant woman plays an active role is vast and infinite. With its quasi-realist depiction, bright colour schemes and masculinization of a female character, this cover picture highlights distinctive physiological features and physical action of Zhang/Shuangshuang, a woman activist. It thus created a memorable icon of the new socialist person, and presaged the dominant aesthetics in revolutionary visual culture, an aesthetics that aims to bring proletarian heroes to great visual prominence.

The transition from the idyllic folk painting to this socialist realist picture illustrates the propagandistic construction of Zhang's stardom: an exemplary woman socialist. The very process of stabilizing Zhang's stardom bespeaks contesting ideas contained within the reception of *Li Shuangshuang*. The state media's intentional suppression of heterogeneous discourses surrounding Zhang also revealed the party's need to project and eventually to construct a stable identity for its citizens.

Subsidiary discourses, including journalistic and critical discourses and everyday speech, further contributed to making Zhang a Red Star. These discourses evaded explorations of Zhang's private life, including her divorce and second marriage, despite the centrality of the married life of the peasant couple to the film narrative. Instead, the discourses showed an intense interest in exploring the

connection between the model heroine and the actress herself through various discussions of Zhang's performance.

Many professional actors marvelled at Zhang's natural and realistic film acting. Whether Shuangshuang is quarrelling with a self-centred commune member in public or bickering with Xiwang, Zhang accurately and appropriately portrays her character in accordance with different situations. They further explored why Zhang was capable of such a compelling performance. Huang Zongying's comment crystallizes the general view on this issue. In her view, Zhang's performing style was closely linked with her self-cultivation, world outlook, artistic training, life experience, and her attitudes toward people and matters. Zhang was such a warm-hearted, candid, determined and selfless person in real life that she could transcend her intelligentsia class background, and naturally and skilfully play the peasant character. As Huang (1962: 10) observes, '[Ruifang] did not just hold onto her professional work. Whenever the party needs her, she spares no effort to work for the party's cause'. These words demonstrated the most salient feature of the star discourse in socialist China: it highlighted the star's socialist subjectivity. Rather than delineating ethereal qualities of the star, discussions of the star frame the actor's superb performing skill within his/her various social roles and political responsibilities, and ultimately make him/her a model person with both admirable skills and respectful socialist ethics.

Huang further affirms Zhang's realistic performing style by delineating the process involved:

> Ruifang performs in a simple way. When you watch her performance, you feel that she does not use much technique. In actuality, as soon as she gets the film script, she actively enters her role. The spirit of the role attaches itself to her. In daily life, you can detect subtle changes in her mood and spirit. In her behaviours and manners, you find traces of the character. Through experiencing real life and attending numerous rehearsals, she fuses herself and the character into one. This actor's charm does not come from showing herself off, but from immersing herself in the character.
>
> (Huang 1962: 10)

As Huang observes, self-overcoming and self-transforming, rather than spontaneous overflow of true feelings, contribute to Zhang Ruifang's vivid depiction of her character. Huang's comment is significant not merely as a professional observation. It is emblematic to a set of interpretive strategies used in the film star culture in the new China, which counteracted discursive patterns in commercially oriented star culture in Republican China. The analytical vocabularies that permeate her comment, such as the fusion of actors and characters, and experiencing life, are reminiscent of the Stanislavski System, an approach to acting developed by the Russian theatre director Konstantin Stanislavski.

Examination of the Chinese appropriation of the Stanislavski System is crucial to understanding the Red Star. The System not only enabled Zhang to render

outstanding on-screen performance but also proved to be a regulatory force that melded her into a model socialist.

The Stanislavski System and modelling the Red Star

The system created by Konstantin Stanislavski is a set of rules that help actors to achieve natural and complex acting. The term 'system' not only identifies what the actor does when s/he plays correctly but also indicates acting as *process* rather than imitation. Central to this system are the following conceptions. First, Stanislavski differentiates formalist acting from realistic acting. He dismisses formalist acting as imitative performance and promotes realistic acting as truly theatrical and artistic. He emphasizes that to achieve realistic acting the actor should experience his/her part. Second, Stanislavski proposes psycho-physical techniques as effective ways to help the actor to merge her/himself with their character, and in the end to best embody the character. Specifically, a psychological technique enables the actor 'to put himself, when the need arises, in the creative state, which invites the coming of inspiration'. The physical technique 'consists in preparing his bodily apparatus to express the role physically and to translate his inner life into stage terms' (Benedetti 2000: 75).

Ever since it was introduced to China in the late 1930s, the Stanislavski System has generated transcultural passion in Chinese-spoken drama production, drama performance, and drama theory exploration (Tong 1992). The 1950s and early 1960s saw a renewed interest in translating and introducing Stanislavski's works, with a stronger intensity and a wider scope. In 1952, the Beijing People's Art Theatre was modelled after the Moscow Art Theatre with which Stanislavski had close engagement. In 1955 and 1956, the journal *Dianying yishu yi cong* (*Film art translation series*) ran a column named 'Xuexi Sitannisilafusiji tixi' (Study the Stanislavski system). The column constantly carried Chinese translations of Soviet essays on the Stanislavski System, including several articles by Stanislavski's collaborator, the Russian playwright Vladimir Nemirovich-Danchenko. More impressively, by 1963 the Chinese film press had published the first four volumes of *The Collected Works of Stanislavski*, which include *An Actor's Self-Cultivation* (Parts I and II) and *Creating a Role*. In the meantime, film actors actively applied the system to practice. Zhang Ruifang's performance in *Li Shuangshuang* is an example. She brilliantly chose a loud voice and infectious laughter as physical expressions for her forthright character; she accurately enacted northern peasants' chores; she also delicately handled a spectrum of emotions ranging through pride and courage to attentiveness and tenderness. The cinematic apparatus, with lighting and close-ups, rightly captures the nuance of her expressions and enhances the effect of her performance.

However, the transcultural practice of the Stanislavski System in China was never a pure and transparent transmission of the Russian system. It was entangled with various artistic and social missions, and was infused with Chinese artists' creative readings. In fact, the translingual practice of Stanislavski's works effaced

concrete performing techniques and the importance of creativity. For Chinese practitioners in the Mao era, the significance of the Stanislavski System went far beyond offering a pragmatic method for truthful acting. It provided a discursive pattern for performance critique, as evidenced by the above-mentioned comments on Zhang's performance.

What is more revealing about the Chinese appropriation of the Stanislavski System is that the actors' artistic pursuit of Stanislavskian performance proved to be a regulatory force in transforming actors into good socialists. The system not only ruled stage but also regulated individuals. Stanislavski's 'fusion of actor and character' is particularly central to this regulatory process. In Stanislavski's theory, the fusion occurs when the actor learns how to align her/his psyche with the imagined psyche of the dramatic character. Once the actor attains this fusion, not only does s/he make the spectator forget that s/he has a lived identity other than the character but also creates the conditions in which intuitive creation can ensue. For Stanislavski, the actor's merging with his/her character is crucial in healing the rift between the actor as human being and as performer and, consequently, in creating truthful and affective performance on stage. In the Russian context, the concept of fusion was significant because it propelled actors to perfect their performing skills; in the Chinese context, it was significant primarily because it became a driving force for actors to engage in self-transformation in accordance with socialist ideology.

Chinese actors' pursuit of professional perfection accidentally collaborated with the party's effort to build ideal socialists. Zhang's ideal performance is clearly Stanislavskian. When contemplating her acting experience in *Li Shuangshuang*, Zhang said,

> I wish to pursue such a spiritual state: my own mental outlook can reveal the character's mental attitude. I should feel the character is in me. I can use her eyes to see, her logic to think. I can play episodes that are not penned down in the screenplay. I always believe that the actor's mental attitude can be moulded. ... Playing different roles is similar to attending different schools and getting on with different classmates. By immersing ourselves in different life ambiences, consciously and attentively observing, experiencing, and approximating, we can have our temperament changed toward that of the character. Therefore, I particularly approve of the idea that we should finalize the location where filming takes place first. This way, the environment in which the character lives would gradually exert influence on the actor.
>
> (Zhang 1963: 19)

Her faith in the fusion of the actor and character, as well as in the constructiveness of the actor's temperament, in a way echoes Stanislavski's view that the actor needs to cultivate her/himself into a superbly conditioned instrument in order to create eloquent truthfulness on the stage. Despite her belief in the need for the actor to restructure her/himself, Zhang's understanding of the premise of 'experiencing

the part' obviously differs from Stanislavski's. Based on a conception of universal human nature and a deep affirmation of individuality, the Stanislavski System holds that the actor's personal experience provides a sufficient arsenal for her/him to perform the character, who is her/his fellow humankind. For Chinese actors who assumed the new role of film workers in the newly established People's Republic of China (PRC), one lesson they learned was that as history marched, a new subject emerged. Since the gap between actual actors and socialist heroes is wide, Zhang believes that the actor's self-transformation is the precondition for his/her vivid depiction of the character, in both form and spirit.

Hence, unlike American followers of the Stanislavski System who favoured the method acting school, Zhang and her fellow film workers downplayed the role of the unconscious in 'experiencing the part'. Perhaps Chinese practitioners at that time found the unconscious too unreliable. Contaminated by historical debris, how could the unconscious lend support to actors performing workers, peasants and soldiers in the new China? Instead, they adopted a common and pragmatic practice of going to the countryside or factories to 'experience life', to prepare themselves for their roles.

As Zhang recalled, experiencing life in the countryside was instrumental to her performance of Shuangshuang, a typical character in the new circumstances. In Lin County in Henan Province, where the film was made, she worked in the field with peasants, made friends with them, and tried to find traces of Shuangshuang among them. Together with reading literary works on rural life and the screenplay of *Li Shuangshuang*, these experiences helped her to visualize Shuangshuang, particularly her appearance and disposition, and later to play this part (Zhang 1963). The practice of experiencing other ways of life introduced actors to new sensory events and familiarized them with workers/peasants' lives. In this process, actors not only had opportunities to learn new gestures, grimaces and other physical movements for performance but also found new visualization techniques. More important was the potential of this practice for transforming the actor. As Zhang implied, this long-term practice helped her to forge new habits, such as social routines, and to develop a new perception of being-in-relationship with others and with the environment. The unconscious was rewritten by the socialist culture at the depth of habit, and consequently, a radical change in perception and disposition was effected.

Indeed, the actor's performance and self-transformation were interconnected. Zhang's off-screen performance, such as being a good cadre in the film studio, exchanging her experience with fellow film workers, and imparting her understanding of playing new film characters to young actors, was equally as impressive as her on-screen performance. It is a relay of her Stanislavskian performance in cinema. Suffice to say, performance was no longer just a matter of an actor bringing out their own creativity in representing their character, nor was it a problem-solving process involving the tension between the actor as human being and as a professional. Performance on-screen converged with social performance in real life, thus blurring the distinction between the representational and the actual. For the Red Star, performance was at once a process of finding a correct way

to approach the character and of reforming him/herself into a good socialist. Consequently, the actor's embodiment of the character involves the questions of representation and of experiencing one's capacity to do right things in the socialist state. Whether on-screen or off-screen, Zhang's conscious and consistent effort to mould herself into the mould of the model socialist was striking and instructive. This effort was a practice of reiteration, with the performer's psychological and physical involvements. Not only did this reiteration reflect Zhang's professionalism but also it became the normative force that made Zhang a good socialist.

Conclusion

Seemingly paradoxical, the rise of Zhang Ruifang as a Red Star in Chinese socialist cinema was a result of the restructuring of Chinese cinema, the state's propagandistic construct and the confluence of the actor's cinematic performance and social performance. Because of visual prominence and being related to various extra-cinematic discourses, the Red Star was perhaps the most effective model person. The Red Star crystallizes the socialist ideas and moulds the masses. Nevertheless, the Red Star demystifies the power of the model. As Zhang's case illustrates, being at the centre of the social structure, the Red Star is constantly de-centred. The Red Star is at once an object of emulation and an object being remodelled by the socialist ideology.

Note

1 Hollywood cinema was popular among the urban Chinese audience in Republican China. According to Jay Leyda (1972), approximately 75 per cent of all moviegoers in Shanghai went to see American films before 1949.

Works cited

Benedetti, Jane (2000), *Stanislavski: An Introduction*, London: Routledge.
Berry, Chris and Mary Farquhar (2006), *China on Screen: Cinema and Nation*, New York: Columbia University Press.
Cui, Shuqin (2003), *Women through the Lens: Gender and Nation in a Century of Chinese Cinema*, Honolulu: University of Hawaii Press.
Dyer, Richard (1984), *Heavenly Bodies*, London: Routledge.
Harris, Kristine (1997), 'The New Women Incident', in *Transnational Chinese Cinemas* (ed. Sheldon Hsiao-peng Lu), Honolulu: University of Hawaii Press, pp. 277–302.
Hills, Matt (2002), *Fan Cultures*, London: Routledge.
Huang, Zongying 黄宗英 (1962), 'Xi kan Li Shuangshuang' 喜看李双双 (Watch Li Shuangshuang with pleasure), *Wenyi bao* 文艺报 (Newspaper on arts and literature), 11, pp. 7–10.
Jenkins, Henry (1992), *Textual Poachers*, London: Routledge.
Leyda, Jay (1972), *Dianying/Electric Shadow: An Account of Films and Film Audience in China*, Cambridge; MA: MIT Press, 1972.

Mao, Zedong (1950), 'Speech Delivered at the National Conferences of Combat Heroes and of Model Workers in Industry, Agriculture and the Army', Marxist. org. http://www.marxists.org/reference/archive/mao/selected-works/volume-5/mswv5_09.htm. Accessed 11 July 2006.

Mulvey, Laura (1975), 'Visual Pleasure and Narrative Cinema', *Screen*, 16: 3, pp. 6–18.

Stacey, Jackie (1994), *Star Gazing: Hollywood Cinema and Female Spectatorship*, London: Routledge.

Tong, Daoming 童道明 (1992), 'Jiao Juyin he Sitannisilafusiji' 焦菊隐和斯坦尼斯拉夫斯基 (Jiao Juyin and Stanislavsky), *Wenyi yanjiu* 文艺研究 (Study of literature and art), 5, pp. 87–95.

Zhang, Ruifang 张瑞芳 (1963), 'Banyan Li Shuangshuang de ji dian tihui' 扮演李双双的几点体会 (A few thoughts on playing Li Shuangshuang), *Dianying yishu* 电影艺术 (Film art), 2, pp. 14–29.

Filmography

Conquer South, Victory North (Nan zheng bei zhan 南征北战), d. Cheng Yin 成荫 and Tang Xiaodan 汤晓丹, Shanghai: Shanghai Studio, 1951.

Everywhere Is Spring (Wan zi qian hong zong shi chun 万紫千红总是春), d. Shen Fu 沈浮, Shanghai: Haiyan, 1959.

Li Shuangshuang (李双双), d. Lu Ren 鲁韧, Shanghai: Haiyan, 1962.

Nie Er (聂耳), d. Zheng Junli 郑君里, Shanghai: Haiyan, 1959.

8 Zhong Xinghuo

Communist film worker

Krista Van Fleit Hang

Introduction

The term 'film star' conjures up associations of luxury, fame and leisure that seem to contradict much of communist ideology. Perhaps to guard against capitalist connotations, mainland Chinese actors and actresses in the 1950s and 1960s were not referred to as film stars (*dianying mingxing*); like most professionals in the Maoist period they were called workers, more specifically, film workers (*dianying gongzuozhe*). Zhong Xinghuo (b. 1924), a film worker known best for his comic roles in *Today's My Day Off* (Lu Ren, 1959) and *Li Shuangshuang* (Lu Ren, 1962), is an apt figure through which to interpret the meaning of stardom in this period.

Examining the emphasis on his public life over his private life in promotional materials elucidates the direct influence of politics in the construction of Zhong Xinghuo's image. Another important feature of filmmaking in early communist China was the connection between the ordinary and the extraordinary in the creation of film-worker images, an element of stardom also seen in other cultures. It was given new meaning in the People's Republic of China (PRC) as actors played ordinary people living extraordinary lives in accordance with communist ideals, differentiating them from both Cultural Revolution superheroes and Hollywood superstars. In his frequent appearances as middle character, Zhong Xinghuo used humour to stimulate a comic identification in the audience that, when combined with the representation of acting as labour in promotional materials, was meant to encourage filmgoers to emulate him by performing their own labour to help push society forward on the path to socialist utopia.

Hollywood film stars, Chinese film workers

Zhong Xinghuo acted in films that were popular because of his ability to speak to the audience through humour. Thus he was able to accomplish a main goal of the cultural establishment in the late 1950s and early 1960s – the promotion of communist ideology – by simultaneously educating and entertaining film audiences. The usage of 'film worker' rather than 'film star' alerted to fans that the jobs of people engaged in film production were similar to those of farmers in the fields or

workers in heavy industry. All 'workers' were to propel the country forward on its path to socialist utopia, whether they laid bricks, paved roads, or produced cultural works that would represent life in a communist country. Against the background of this particular function of the actor in society, Zhong Xinghuo's image can be contrasted fruitfully with the images of his counterparts in different cultural contexts, providing for a deeper understanding of the meaning of stardom in socialist realist film production.

Attention to the construction of Zhong Xinghuo's image shows that underlying the effort to represent film work as just another kind of labour remained an understanding of the power of the star image from pre-revolutionary times. The cultural establishment recognized these images could be harnessed to engage in work that was paradoxically quite similar to that from the Hollywood tradition: using the star image to 'sell'. In this case it was not cigarettes or face cream, it was communist ideology. While cultural producers endeavoured to distance themselves from pre-1949 artistic production, they still relied on some of those traditions to make their works more popular.[1] This usage of star images was not invented with communist victory; critics have compared the use of ideology in the 1930s with the marketing of products for sale. In an article on promotion of the ideology of the Greater East Asia Co-Prosperity Sphere through the image of film star Li Xianglan, Shelley Stephenson writes:

> While the Chinese star system mirrors Hollywood in its use of film personalities as sellers of a product (in 1930s and 40s Shanghai, star images were used to sell everything from face lotion to cigarettes, from raincoats to herbal medicines), the product here is the idea: a unified Asia through the medium of film.
>
> (Stephenson 1999: 226)

Film workers of the 1950s and 1960s would also sell ideology, though during this period the ideological significance of the actor's image was even more central than in the war period. The films I focus on in this chapter fall into the period of Chinese cinema that Yingjin Zhang describes as 'the phase of socialist realism (1953–65), [during which] the CCP deployed film as an effective weapon of propaganda and expanded its film operations ...' (Zhang 2004: 190). Many of Zhong Xinghuo's films should be further classified as light comedies, produced in a short-lived period in socialist realist cinema in which filmmakers were encouraged to take up light-hearted issues such as everyday life in the rural villages or the work unit. These films often featured the conversion of a middle character – a person who starts the narrative with an incorrect political orientation, but who is transformed into a more productive member of society through the lessons he or she learns in the story. This conversion often happens with much humour and kind-hearted teasing of the middle character. I return to this discussion after a more general examination of the star system in the communist period.

During the phase of socialist realist cinema, actors were no longer associated with commercial products; their images were fixed solidly on the level of

political discourse. When analysing the communist film system, we must take into account the intimate connections between the film industry and state media apparatus. Both the film studios and the magazines carrying the articles, advertisements and reviews of the films were state-owned. This meant that gaps between the perceived public reception of the films and the studio's creation of the actors' images were not as substantial as they could be in Hollywood cinema. As Richard Taylor argues in his study of Soviet film stars, 'Red stars were in the final analysis the property of the state, the Party, and ultimately of the leader' (Taylor 1993: 83). Richard Dyer maps four aspects of the star-making process in classical Hollywood: publicity, promotion, films and critical commentary. He analyses the ways in which each of these four elements works to produce the image of the star, emphasizing the connection of each of the four elements to the actual actor, society at large and the Hollywood film industry. In the study of a Chinese communist film worker we must remain mindful of the connections between publicity and promotion. Whereas in Hollywood, promotion was under the control of the studios while publicity was multifaceted – through the press, the star him or herself, fan clubs and so forth – in China during the Maoist period, publicity focused on the professional image of the actor and was guarded closely by the cultural establishment.

Film star images are often comments on the ideals of the society in which the film stars function. In the communist system, the close connections between the cultural establishment's promotion and publicity of an actor ensured a tightly packaged image. Robert Allen argues in his study of Joan Crawford, 'the individual star image – ostensibly a single member of society – provides a convenient focus for a set of issues that reverberate within the society as a whole: success, wealth, romance, "acceptable" social behaviour, and consumption, among others' (Allen and Gomery 1985: 174). Of course, the issues that reverberate in Zhong Xinghuo's image are very different from those of an American film star; we might posit collective labour, the smooth concurrence of national and family ideals, patriotism and commitment to duty as some of the issues he signifies.

Because the representation of life in communist China overwhelmingly focused on public activity, the social ideals that actors represented spoke to public rather than private desires. A focus on romances or personal wealth would be eschewed for further representations of the actor's participation in collective work and commitment to duty – even in images of the actor's life off-screen. The focus on the public and avoidance of the private lives of actors marks a significant difference in the construction of the star image in communist China and the Hollywood system. Whereas fan magazines in other places and time periods might print exposés of stars' love affairs or shots of them in leisure activities, in China of the 1950s and 1960s the private lives of film workers were not seen as a worthy focus of the attention of fans and would thus not be given space in the magazines. The focused nature of image construction, securely in the hands of the state cultural establishment, meant that there was little slippage between the actor's persona off-screen and the characters he or she played on-camera. If, as John Ellis argues, the actor's image was completed in the film, then that complete image would be of a productive member of society (Ellis 1982: 93).

Finding the extraordinary in the ordinary

Zhong Xinghuo began his acting career in the late 1940s when he participated in plays as part of his college career at Shandong University.[2] He moved to Shanghai in 1949, and was assigned to work in the Shanghai Film Studio at the end of that year. He quickly developed a flair for the comic. In the 1959 film *New Story of an Old Soldier* (Shen Fu) he plays a lazy man who is unwilling to go to the Northeast and establish a commune. His resistance is the subject of many jokes, but by the end he is converted to become a productive member of the commune. Similarly, in the 1962 film *Li Shuangshuang*, he and his screen wife Li Shuangshuang reflect the struggle between those who oppose and those who advocate a people's commune. In this light comedy written by Li Zhun, set in the countryside in the late 1950s, Zhong develops this character type from a small part to supporting lead. In both films he acts as a middle character – a backward, somewhat bumbling man who has a good heart that simply needs to be moulded by the party.

Zhong Xinghuo's most significant lead came in the character of Ma Tianmin in the 1959 film *Today's My Day Off*, for which he is still remembered.[3] Ma Tianmin is somewhat different from these other two characters; he is a policeman committed to duty who experiences problems in his personal life because of his devotion to public work. Ma Tianmin has a different political orientation from the characters Zhong Xinghuo plays in *Li Shuangshuang* and *New Story of an Old Soldier*; he is an upright policeman who will help to convert middle characters. Nonetheless, in this film Zhong Xinghuo's comic skills are similarly well employed as his character struggles with conflicts between duty and family. *Li Shuangshuang* was his most critically acclaimed film. Zhong Xinghuo and his co-worker Zhang Ruifang both won Hundred Flowers Awards for their performances in the film, and the film itself won the top award for a feature film. Understanding reception in the Maoist period is a difficult task since all venues of expression about films, including the magazines that published letters from fans, were under state control. Since the Hundred Flowers was awarded to films based on numbers of votes from fans after a call in the magazine *Dazhong dianying* (*Mass Cinema*), this award is one way to judge the popularity of a film within this limited scope.

Off-screen, Zhong Xinghuo's image as constructed in fan magazines was meant to reinforce communist ideology. With its commercial feel, *Mass Cinema* is one of the best sites to examine promotion and publicity of film stars in the 1950s and 1960s. This magazine was a vehicle for promoting recent films, and carrying stories about the lives and work of film workers, fan letters, data on audience statistics, as well as critical articles about the function of film in society and strategies for producing films that would better express communist goals while reaching a wide audience.[4] While there were many contributions from film critics, more serious film criticism was reserved for journals such as *Dianying yishu* (*Film Art*). *Mass Cinema*'s orientation is primarily towards interested audience members, rather than solely industry people. This magazine brings to light many of the paradoxical connections between the Hollywood film industry and the Chinese communist film industry. The look and feel of the magazine, while different from other fan

magazines in terms of content, is strikingly similar to them in displaying actors' lives, promoting films and publishing viewers' responses to film.

Publicity and promotion of a film overlapped widely in *Mass Cinema*. In the months surrounding the release of a film that had gained some success with critics, the magazine would carry numerous photo spreads devoted to the film. These promotional materials would feature stills from the film, with captions discussing the plot and listing the cast of characters. The overwhelming majority of space in the magazine was devoted to either critical commentary or these promotional materials; however, there is some publicity, especially in features about the creation of a film. There was much publicity around the associated project of delving into life (*shenru shenghuo*) during the filming of *Li Shuangshuang*, which focused on the time the full film crew spent in the countryside during filming. In August 1961, a group comprising the actors, their director, screenwriter and other members of the film crew from Shanghai's Haiyan Studio descended upon a small village in the Lin District of Henan province. They wanted, in the words of director Lu Ren, to 'go into life' so they could make a film that realistically portrayed the daily lives and struggles of new peasants (Lu Ren 1964: 227). To accomplish this goal, the cast, Lu Ren, screenwriter Li Zhun, and others, spent a month in Henan filming the outdoor scenes and getting to know the local people.

Delving into life to faithfully portray the lives of the peasants was a contemporary approach to artistic creation that was described by the participants in their memoirs, received publicity in magazines, and even resulted in a book titled *Li Shuangshuang: cong xiaoshuo dao dianying* (Li Shuangshuang: From Story to Film). Almost all of the film's participants wrote articles about the time they spent in the village, in which they describe rehearsing, interacting with peasants, studying the folk traditions of Henan, and reading the entire corpus of Li Zhun's work. The actors participated in village meetings, did small performances to entertain the villagers, and worked alongside villagers in the fields. They spent much of their time simply observing the peasants, trying to imitate the way peasants performed tasks of daily life such as making noodles, washing clothes in the river, or even carrying shovels and other farming tools. This project is documented with a commercial feeling in photographs in *Mass Cinema*. The magazine's December 1962 issue contains a two-page spread of photographs of people from a few films spending time in the countryside. The first two showcase Zhong Xinghuo chatting with peasants as he works alongside them to collect the harvest.

Richard Dyer finds that lives of stars were often put on display as evidence of the fabulousness of Hollywood. Dyer decodes the images of stars in fur coats and diamonds or playing sports for leisure to show that these images were instrumental in perpetuating the ideal of the American dream (Dyer 1979: 39–43). The images of Zhong Xinghuo and his fellow film workers in the countryside function in much the same way, though conspicuous consumption and leisure are replaced with frugality and a commitment to labour that come from the emphasis on displaying the public lives of the stars over their private lives. The two-page spread of film workers, titled 'Visit, Study, Observe: On Film Workers' Visits to the People's Communes', shows Zhong Xinghuo out of character. But while fans of a

Hollywood star might be treated to a glimpse of the glamorous life of stars playing tennis or otherwise enjoying their leisure time, here the focus is still on the work of acting. Fan magazines in the American tradition conversely de-emphasized the labour involved in being a film star. Making a movie was fun and glamorous; never work (Dyer 1979: 39). In China, the conception that filmmaking was another kind of labour received a high proportion of the publicity surrounding the film.

The captions for the two photographs of Zhong Xinghuo read:

1. Zhong Xinghuo, who plays the role of Sun Xiwang in *Li Shuangshuang*, with commune members, chatting as they thresh grain.
2. Soliciting opinions on their roles for *Li Shuangshuang*, actors Zhong Xinghuo and Cao Duo converse intimately with commune members.

(Dazhong dianying 1962: 2)

These publicity shots give fans an image of the actors' off-screen lives that projects and reinforces mainstream social values. An image of Zhong Xinghuo the film worker threshing grain is meant to give the viewer a feeling of excitement. Zhong Xinghuo has a huge smile on his face and his labour, displayed before the viewer in a photograph, appears exciting and meaningful. The very mundane nature of the job he is performing, and the inclusion of a village woman in the photograph with him, gives viewers the sense of the ordinary. Here is an extraordinary man performing an ordinary activity familiar to many Chinese citizens living in the countryside, thus infusing that labour with an element of excitement. The intended message is that the viewer of the photograph, or indeed of his films, could also attain this excitement by performing the same labour.

Film stars are often characterized as being simultaneously ordinary and extraordinary, accessible to the viewer as object of desire, but just outside the viewer's reach. As John Ellis writes,

> The star is ordinary, and hence leads a life like other people, is close to them, shares their hopes and fears; in short, the star is present in the same social universe as the potential film viewer. At the same time the star is extraordinary, removed from the life of mere mortals, has rarefied and magnified emotions, is separate from the world of the potential film viewer.

(Ellis 1982: 97)

Ellis argues that this paradoxical image of the star works to enhance the viewing experience, acting as an 'invitation to the cinema'.

Under the dictates of socialist realist cinema, the social universe depicted in 'everyday life films' of the 1950s and 1960s contains elements of both the extraordinary and the ordinary. Creators of the socialist realist films strove to compose a realistic portrait of the life they were representing, whether in the rural villages or in an urban setting, while infusing the narratives with scenes of collective action that lifted them on to the level of the lyrical. Audience members were supposed to recognize how much more exciting their own lives could be if they emulated the

characters in the film, applying communist ideology to their own daily lives. The combination of extraordinary and ordinary is quite well suited to a socialist realist aesthetic, which imagines ordinary citizens moved to commit themselves to the socialist cause after being stirred by an artistic experience. The insertion of extraordinary commitment into ordinary labour was a theme emphasized by numerous members of the cultural establishment. In Zhong Xinghuo's recent nostalgic recollection of delving into life to prepare for the role of Ma Tianmin he repeats this language, saying that the policemen he observed were engaged in ordinary acts of daily life, but 'in the ordinary one can witness greatness' (Zhang Li 2007).

Labour and comic identification

Li Shuangshuang presents an image of the ideal new village that would be a model for Chinese peasants. In this audience-friendly film we see a form of comic identification achieved through the display of the trials and tribulations of a couple, one of whom must transform himself so the two can have a successful relationship. Ban Wang argues that cinematic experiments in revolutionary China aestheticized politics by cultivating audience desire, which was then sublimated onto a revolutionary ideal that transformed individual love into love of nation (Wang 1997: 123–32). Wang focuses on two films that narrate the story of the revolution and are quite different from the 'everyday life films' in which Zhong Xinghuo usually acts. Zhong Xinghuo's characters are typically contemporaries of the audience, not those performing heroic acts in the Sino–Japanese War or the Civil War. The films do not attempt to convince viewers to dedicate their lives to the national cause; instead, they teach viewers how to live well and be productive members of a society already committed to communist ideals. The flaws in Zhong Xinghuo's characters give viewers the sense that they are ordinary men trying to live in an extraordinary time, and therefore these characters are accessible to the contemporary audience in a way different from the heroic identification Wang has so aptly described.

While aiming to further clarify the idea of comic identification, I focus discussion on the film *Li Shuangshuang*. The main character Li Shuangshuang is constructed as naturally connected to the land and her fellow villagers, without the need for change. It is her husband Sun Xiwang who, as the middle character, must be transformed in the course of the story. In this contemporary rural film that is governed by 'the internal contradictions of the people' (*renmin neibu maodun*), society itself does not need to change; it is ready and waiting for the labour of housewives like Li Shuangshuang and her friends. Their families need to change, and to do that they must learn a new meaning of labour. As a prominent scholar of Soviet history states, 'It was work ... that usually allowed men to be remade. Work under Soviet conditions was regarded as a transformative experience because it was collective and imbued with a sense of purpose' (Fitzpatrick 1999: 75). Throughout the film, Sun Xiwang must learn this new meaning of labour, which he does while watching the labour of other people, much the way the audience members watch the labour of the characters on screen.

Li Shuangshuang fights to change Xiwang's attitude towards labour and communal life so they can have a better present. In this way the film creates an idyllic village that has already realized the goals of socialism – a view of the future common to many work of socialist realist literature.[5] Xiwang evolves into a man who appreciates the entry of his wife into the public sphere, and he also evolves into somebody who recognizes the true value of labour. He must learn to appreciate that Shuangshuang's work outside the house lets her participate in the transformative experience of communal labour. The main things that change for Xiwang are his attitude towards the work he does and a greater understanding of and appreciation for his wife. He learns this lesson not through his own labour, but by witnessing his wife's fulfilment with her new life in village society.

The most important scene of labour in the film takes place when the women are harvesting wheat, singing a folk song as they carry poles laden with the abundant harvest. The smiles on their faces and the dancing way they carry their burdens, while possibly looking staged and unrealistic to present-day audiences, were meant to enforce the sense of the joys of communal labour. The scene is so exuberant that we can see just how hard the creators of the film were working to push this message, and it is when he witnesses this scene that Xiwang begins to realize he was wrong to prevent his wife from participating in work in the fields. This scene also acts as a metaphor for the imagined power of the viewing experience to convey the message of the benefits of collective life and labour, thus transforming the viewer's relationship to his or her own labour.

In his work on viewing modes in Chinese cinema, Chris Berry develops the idea of a 'collective viewing subject' in socialist cinema, as opposed to the Hollywood form of identification with a central male character (Berry 1991: 30–9). The collective viewing subject combines with the use of mid-range long takes that are meant to display life as it is unfolding before the viewers' eyes to emphasize the completeness and self-enclosed nature of the village in *Li Shuangshuang*. The lack of close-ups on characters serves to equalize them, so while Zhang Ruifang and Zhong Xinghuo are obviously the leads of the film and have the most developed characters, in the visual language of the film they are equal to the other characters.[6] Lu Ren uses mid-takes to show that this is an everyday story of ordinary people; they are models to be looked up to, but also the potential of all Chinese peasants, who should be able to identify with them.

In the logic of socialist realism, infusing ordinary activities such as dam building and noodle making with the spirit of collectivity elevates them to the level of extraordinary, which is the lesson Zhong Xinghuo's character learns in the film and also the lesson the viewers were meant to take home and absorb into their own lives. When we interpret this film along with the publicity shots of Zhong Xinghuo in the fields, we see just how tightly packaged this narrative is. There is no slippage between the images of Zhong Xinghuo the actor and Sun Xiwang the character; rather, we see that the work of acting and the work of labouring in the fields are to be interpreted on the same level. The 'rarefied and magnified emotions' displayed on screen become an imperative for all members of the community, accessible as long as they commit themselves to the communist project.

Desire is manufactured in the cinematic experience, whether in Hollywood cinema or in Chinese revolutionary cinema. John Ellis argues that desire is cultivated and viewers identify with it because the star image is simultaneously accessible and impossible. The viewer can only satisfy his/her desire in watching the film, which is the completion of the star image cultivated in the publicity and promotional materials surrounding the actor. Ellis writes: 'Desire is both permitted and encouraged, yet knows it cannot achieve any tangible form of satisfaction, except the satisfactions of looking' (Ellis 1982: 98). In communist cinema the publicity materials that surround the actors, as we have seen in the images of Zhong Xinghuo in the fields with the peasants, all focus on the public, communal nature of the actor's work. The cinema itself is one more site for the performance of labour, evidenced in the term film worker. Viewers are thus given a means to emulate the film workers in performing their own labour. When work in the fields is aestheticized in the same way as the actors' work on screen, the ultimate completion of the viewer's desire for the film worker is not in the looking, it is in the labouring.

Much of the project of socialist realist cinema was the creation of new citizens who would be fit to live in a newly communist society.[7] Since art was seen as an essential tool in the moulding of citizens in communist China, understanding the roles available to actors leads to a better appreciation of how the communist state wanted to project its self-image. Situating an individual film worker in the system shows how the communist cultural establishment made use of many of the structures from pre-revolutionary cinema to spread its message to the people. Zhong Xinghuo played normal men who were either converted into citizens who appreciated the spirit of collective life through the course of the film narratives or presented a model for how one should enact communist ideals in everyday life. His characters were meant to speak to audience members, guiding them in their pursuit of a better life with the application of communist labour practices. The different mode of identification cultivated in the audience through these light comedies was another means by which the cultural establishment attempted to remake the Chinese people.

Notes

1 Tina Chen (2003: 164) discusses the efforts required in the cities to distance film viewing practices from the bourgeois tradition. In the countryside this tension was not a consideration; here the importance was placed on actually getting the film to the villages.
2 For a short biography of Zhong Xinghuo, see *Zhongguo dianying jia liezhuan*, Vol. 6, pp. 161–70.
3 Zhong Xinghuo recently told an interviewer from CCTV that he is frequently recognized on the streets of Shanghai as Old Ma:

> Some people can't call out my name, Zhong Xinghuo. They say Old Ma, or Ma Tianmin. I wonder how it is that it's been over 40 years but people still have such a deep impression. I don't think it's a matter of my acting. It's the entire composition of the script, how the film represented the character in that era, how he acted out

of his spirit, his behaviour, the way he served the people. That's what makes him memorable to people after such a long time.

(Zhang Li 2007)

4 For a study of the magazine, and the ways in which the cultural establishment conceptualized film on its pages, see Chen (2003).
5 See, for example, Zhao Shuli's *Sanliwan Village* (1964) or Ding Ling's *The Sun Shines over the Sanggan River* (1984). Both of these texts focus primarily on solving the problems of collectivization and getting commune members to work together.
6 Though perhaps not always to each other; see Xiaobing Tang's analysis of the ending of *Li Shuangshuang* (2003: 653).
7 For identity formation as it pertains to cinema in communist societies, see John Haynes' discussion of Soviet male film stars (2003: 2), and Ban Wang's study of Chinese revolutionary cinema (1997: 123).

Works cited

Allen, Robert and Douglas, Gomery (1985), *Film History: Theory and Practice*, New York: Alfred A Knopf.

Berry, Chris (1991), 'Sexual Difference and the Viewing Subject in *Li Shuangshuang* and *The In-Laws*', in *Perspectives on Chinese Cinema* (ed. Chris Berry), London: British Film Institute, pp. 30–9.

Chen, Tina Mai (2003), 'Propagating the Propaganda Film: The Meaning of Film in Chinese Communist Party Writings, 1949–1965', *Modern Chinese Literature and Culture*, 15: 2, pp. 154–93.

Ding Ling (1984), *The Sun Shines over the Sanggan River*, trans. Gladys Yang, Beijing: Foreign Languages Press.

Dyer, Richard (1979), *Stars*, London: British Film Institute.

Ellis, John (1982), *Visible Fictions: Cinema, Television, Video*, London: Routledge and Kegan Paul.

Fitzpatrick, Sheila (1999), *Everyday Stalinism: Ordinary Life in Extraordinary Times: Soviet Russia in the 1930s*, New York: Oxford University Press.

Haynes, John (2003), *New Soviet Man: Gender and Masculinity in Stalinist Soviet Cinema*, New York: Manchester University Press.

Lu, Ren 鲁韧 (1964), '*Li Shuangshuang* de daoyan fenxi he gousi 李双双的导演分析和构思' (Analysis and thoughts on *Li Shuangshuang* by the director), in *Li Shuangshuang: cong xiaoshuo dao dianying* 李双双: 从小说到电影(Li Shuangshuang: from story to film), Beijing: Zhongguo dianying chubanshe, pp. 217–32.

Stephenson, Shelley (1999), ' "Her Traces Are Found Everywhere": Shanghai, Li Xianglan, and the "Greater East Asia Film Sphere" ', in *Cinema and Urban Culture in Shanghai, 1922–1943* (ed. Yingjin Zhang), Stanford, CA: Stanford University Press, pp. 222–48.

Tang, Xiaobing (2003), 'Rural Change and Woman in New China Cinema: From *Li Shuangshuang* to *Ermo*', *Positions*, 11: 3, pp. 647–74.

Taylor, Richard (1993), 'Red Stars, Positive Heroes, and Personality Cults', in *Stalinism and Soviet Cinema* (ed. Richard Taylor), London: Routledge, pp. 69–89.

Wang, Ban (1997), *The Sublime Figure of History: Aesthetics and Politics in Twentieth-Century China*, Stanford, CA: Stanford University Press.

Youngblood, Denise (1992), *Movies for the Masses: Popular Cinema and Soviet Society in the 1920s*, New York: Cambridge University Press.

Zhang, Li 张丽 (2007), 'Wo yu Ma Tianmin – zhuan fang biaoyan yishujia Zhong Xinghuo 我与马天民-专访表演艺术家仲星火' (Ma Tianmin and me – an interview with the actor Zhong Xinghuo). http://www.cctv.com/special/765/-1/52196.html. Accessed 14 March 2007.

Zhang, Yingjin (2004), *Chinese National Cinema*, London: Routledge.

Zhao, Shuli (1964), *Sanliwan Village*, trans. Gladys Yang, Beijing: Foreign Languages Press.

Zhong, Xueping (2000), *Masculinity Besieged?: Issues of Modernity and Male Subjectivity in Chinese Literature of the Late Twentieth Century*, Durham: Duke University Press.

Zhongguo dianying jia liezhuan (Biographies of Chinese film people) (1986), multiple vols, Beijing: Zhongguo dianying chubanshe.

Filmography

Li Shuangshuang (Li Shuangshuang 李双双), d. Lu Ren 鲁韧, Shanghai: Haiyan, 1962.

New Story of an Old Soldier (Laobing xinzhuan 老兵新传), d. Shen Fu 沈浮, Shanghai: Haiyan, 1959.

Today's My Day Off (Jintian wo xiuxi 今天我休息), d. Lu Ren 鲁韧, Shanghai: Haiyan, 1959.

Part III

Taiwan cinema

Diaspora, transvestism, non-professionalism

9 Ling Bo

Orphanhood and post-war Sinophone film history

Zhang Zhen

A living legend

Orphan Ling Bo (Jin Chaobai, 1964) is a Taiwanese-language (*taiyu*) biopic about the eponymous legendary Hong Kong movie star. My unexpected encounter with this film at the National Film Archive in Taipei in the summer of 2006 was a moment of epiphany for me as a film historian in search of a focal point for envisaging a particular historical period. I had set out to canvass the post-1949 Mandarin-language (*guoyu*) cinema produced on the island to find grounds for comparing the two state-sponsored Mandarin-language cinemas across the Taiwan Strait during the Cold War. Encountering this film presented an opportunity for eye-opening findings, prompting me to change research directions and enabling me to make new historical connections in the Chinese-language film landscape from the intertwined perspectives of orphanhood, stardom and melodrama.

Within the broad Cold War context, the overlapping narratives of Ling Bo's dramatic orphanhood and her stardom illuminate the complex tapestry of post-war Sinophone film culture. The 'post-war' rubric in fact points to the series of staggered wars in the region. World War II and the Pacific War were ended in 1945 and marked the decolonization of Taiwan and recovery of Hong Kong as the British Crown colony from Japan; the Civil War between the Communist and the Nationalist powers resulted in the establishment of the People's Republic of China (PRC) in 1949 and the retreat of the Nationalist regime to Taiwan. Reconfiguration of the film industries in the region was characterized by the exodus of Shanghai film personnel to Hong Kong (and Taiwan, to a lesser extent) and the fierce competitions between various studios and language-based cinemas. Strikingly, the orphan figure looms large in the post-war Chinese-language cinema across the region. A thorough study of the underlying structures of feeling and ideological resonances of the celluloid orphan in this period is beyond the purview of this essay. I want to underscore here, however, that Ling Bo's portrayal of orphans is not simply an invitation for her fans to link her screen image to her life story, but accentuates the symbolic potency of the figure in this period generally and in Taiwan particularly.

Orphan Ling Bo is one of the hundreds of Taiwanese-language films produced in the 1950s and 1960s that catered to the largest ethnic population on the island,

whose mother tongue Taiwanese (Minnan hua or Hokkien) has origins in Fujian province on the mainland. A dialect largely unintelligible to people elsewhere in China, it has a certain affinity with Cantonese in using the standard written Chinese (both classical and vernacular forms), yet with a distinctive set of characters, words and expressions that capture the ethnic, colloquial and lively characteristics of the speech, evidenced sometimes in the Chinese subtitles in both cinemas. The popularity of the Taiwanese-language cinema extended to the Minnan-speaking diaspora communities in Southeast Asia, and allowed the dialect-based regional cinema to compete with the state-sponsored Mandarin-speaking cinema then on the rise, forming a pattern of what scholars have termed 'parallel cinemas' (Yeh and Davis 2005: 15–54) or 'competing cinemas' (Zhang 2004: 125–41) in Taiwan. This local cinema was also competitive with Mandarin and Cantonese films from Hong Kong, as well as imports from Hollywood and elsewhere, due to its strong foothold among the urban working-class and rural audiences with shared ethnic and linguistic heritage.

Shu-mei Shih has analysed a number of contemporary visual texts (including film, television and photography) produced by filmmakers and media artists of Chinese descent outside mainland China. She conceptualizes the arena through the texts' articulations of 'visuality and identity' in terms of the 'Sinophone: a network of places of cultural production outside China and on the margins of China and Chineseness, where a historical process of heterogenizing and localizing of continental Chinese culture has been taking place for several centuries' (Shih 2007: 4). The term productively redefines the relationships between various geopolitical and ethnic 'Chinese' entities and demographics, including the vast Chinese diaspora communities, within a long view of migration and cultural translation across the Asia-Pacific. While Shih's main focus is the current period of intensified globalization, I find the term useful as well for rethinking and remapping Chinese-language film history in a more rigorous and historically specific way, especially the post-war period when the Shanghai-centred Chinese film industry dispersed and a number of regional-dialect cinemas competed with Mandarin-language films made in China, Hong Kong and Taiwan.

The long career of Ling Bo, popularly known as Ivy Ling Po (b. 1939), as movie actress and opera singer, traversed Amoy (*xiayu*), Cantonese (*yueyu*) and Mandarin language (*guoyu*) film and appealed to fans in Hong Kong, Taiwan and the diaspora. It made her a Sinophone star *par excellence*. What intrigued me most about the neglected *Orphan Ling Bo* was not its peculiar take on 'A Star Is Born' (in the wake of George Cukor's 1954 musical starring Judy Garland), but rather the melodramatic emphasis on Ling Bo's orphanhood and her transregional and translingual appeal. Her legend continues to this day as the dramas of her life and career intertwine further, serving as both an embodiment of, and witness to, the vicissitudes in a half-century-long Sinophone film history.

The Shaw Empire presented Ling Bo as an 'Asian movie queen' (Figure 9.1) and in its heyday boasted of her as one of its crown jewels. Ling Bo's screen persona as a charismatic male impersonator was most evident in the famous Huangmei opera film *The Love Eterne* (Li Han-hsiang, 1962). In fact, Ling Bo appeared in

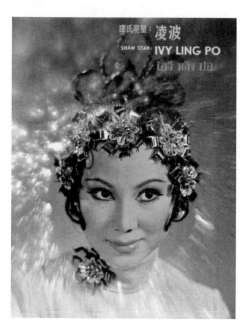

Figure 9.1 Asian movie queen Ling Bo, popularly known Ivy Ling Po.
Source: http://www.ivylingpo.com/photos_Color.html

more than 100 films, not counting her television output. These ranged from her adolescent roles in Amoy films to a brief stint in Cantonese cinema, from the genre films (including Huangmei opera, martial arts, romantic thriller and family melodrama) that she starred in during her Shaw years (1962–76) to a large score of post-Shaw films and her last screen role in *Golden Swallow* (Sing-pui O, 1988) before retiring to Canada.

In 2003, the 40th anniversary of *The Love Eterne* spurred something of a comeback in her career. Exhibition programmes at the 2003 Hong Kong International Film Festival and elsewhere, in conjunction with the digital remastering and distribution of the Shaw classics by Celestial Pictures, which made some of her films on DVD readily available to old and new fans, have fanned popular and critical interest in her.[1] She has returned to both stage and screen despite her advanced age. In a nutshell, Ling Bo is a living legend.

Heeding studio publicity and fan discourses, recent scholarly interest in Ling Bo has generally pivoted around her gender-bending performance as male impersonator or female transvestite in the context of the Huangmei opera film tradition (Chen 2006: 52–69; Tan 2007). This makes sense in view of the sensational success of *The Love Eterne*, which resulted in a cult following of Ling Bo and brought her the Golden Horse award for 'Outstanding Performing Skills'. The award was specially created to distinguish her transvestite role from the 'Best Actor' and 'Best Actress' awards; the latter was awarded to her co-star Le Di (Betty Loh Ti).[2]

Her androgynous screen persona in this peak period of the Huangmei opera film is also associated with other award-winning roles, such as the heroine in *Lady General Hua Mu-lan* (Yue Feng, 1964), which won her the coveted Best Actress award at the Eleventh Asian Film Festival, the young prince in *Grand Substitution* (Yan Jun, 1964) and the scholar in *The Mermaid* (Gao Li, 1965). *Grand Substitution* and *The Mermaid* won her the 'Most Versatile Talent' award at the Twelfth Asian Film Festival.

Ling Bo's screen persona was at times doubly transvestite – playing men, or playing women dressed as men. Much remains to be explored concerning this persona, through intertextual analysis informed by feminist and queer perspectives. I propose that an investigation of the narrative and iconographic significance of orphanhood in films starring Ling Bo as well as those about, or alluding to, her real life as an orphan-turned-star could add to the discussion and shed new light on the interplay between gender, stardom and film history. This in turn will help make better sense of the seemingly contradictory off-screen persona of Ling Bo after her marriage, constructed by publicity material and perceived by most fans now and then as an ideal image of the 'good wife and nurturing mother' (*xianqi liangmu*) and, above all, a cinema Cinderella who wedded a screen prince and lived happily ever after.

The orphan-star goes 'home' in Taiwan

The absence of an 'Oedipal dimension' in Ling Bo's Huangmei opera films, as Tan See-kam perceptively observes, is 'largely because the *caizi*-son – whether played by Ling or others – almost invariably has *no* father: he either has a widowed mother (e.g. *The Love Eterne*) or is an orphan (e.g. *The Mermaid*)' (2007: 17; original emphasis). The consistent casting of Ling Bo in such roles of powerless men on the margins of the Confucian patriarchal order certainly capitalized on the rising star's androgynous look and voice. But the overlap of a female performer's body and an 'effete' young man caught in unfavourable or even tragic circumstances does pose questions about the sources and meaning of Ling Bo's charisma within the post-war geopolitical and cultural landscape in the region.

What connects *Orphan Ling Bo* and several Ling Bo operatic vehicles in the 1960s is indeed the motif of orphanhood or quasi-orphanhood. Beside the afore-mentioned roles, the scholar Dong Yong in *A Maid from Heaven* (He Menghua and Chen Yixin, 1963) and the young prince in *Grand Substitution*, adapted from the classical play *Orphan of the Zhaos* (*Zhaoshi guer*),[3] add to the inventory of Ling Bo's orphan roles. The latter has particular interest because Ling Bo's prince role does not have a romantic function central to the narrative as in other films, and instead falls within the temporal arc between birth and coming of age marked by the avenging of his natal father and his royal restoration. Released in the same year, and if viewed concurrently, *Grand Substitution* and *Orphan Ling Bo* provide important clues to the links between Ling Bo's life prior to her stardom and her on-screen embodiments of some of the most enduring orphan figures in Chinese cultural repertoire. The emphasis in both films on a turbulent adoptive childhood

ending in the redemption of innocence and induction into the 'royal' ranks, through a dramatic reversal of fortune, reveals the melodramatic attraction of the orphan tale to audiences in the post-war Sinophone world at large. Ling Bo's contemporary fans, in particular, would have had no trouble reading her life story into the celluloid orphans she portrayed. Through this double-reading, Ling Bo's charisma overlaps with and even intensifies that of the larger-than-life historical or fictional orphan figures, triggering strong pathos as well as pleasure in the fans, who cared about Ling Bo's extraordinary life as an orphan-turned star as much as they did about those deprived orphan characters ultimately rewarded by fate.

As with many studio-fabricated stars, such as Joan Crawford (1905–77) in Hollywood and Ling Bo's co-star in *The Love Eterne*, Betty Loh Ti,[4] Ling Bo, invoking a fairy in Chinese folktale, was a new screen alias adopted by her when she ascended the Shaws' 'milky way', announcing a rebirth. According to biographical accounts in public circulation, Ling Bo was born in 1939 and grew up under the name Jun Hai-tang with her foster parents in Xiamen, the beautiful seaside city across from Taiwan. In her memoirs published in Taiwan's *Zhongyang ribao* (*Central Daily*) in 1967, she recounts with an aching longing for her haphazard origin in China:

> Xiamen, Nanyang, my childhood was rather shrouded and perplexing. The first thing that everyone remembers is their parents. But, I don't have any. Xiamen is the first place I can recall. Some people said my parents' surname was Chen and they had gone to Nanyang, or their surname was Yan and they were divorced. All of these – Chen, Yan, Nanyang – seem so remote! All I remember is Jun Hai Tang growing up at Xiamen. Dad, Mom, where are you?[5]

Her relatively carefree childhood came to an abrupt end in 1949, when her foster mother moved to Hong Kong, taking the young Ling Bo with her. Overwhelmed by isolation and poverty that befell countless refugees from the mainland, Ling Bo was coerced by her foster mother into the then popular Amoy-dialect movie industry and assumed the screen name Xiao Juan (Figure 9.2) at the age of 12. For a decade she played bits or leading child and adolescent roles in more than 50 films, followed by a stint in Cantonese cinema that was brief and unpromising due to her lack of proficiency in the language back then. She was then, as the legend goes, discovered by Li Han-hsiang (1926–96) while working as a behind-screen ghost-singer for Huangmei opera films.[6] *The Love Eterne* catapulted Ling Bo into a 'screen miracle' (Tan 2007: 10), making her a household name in Hong Kong, Taiwan and Nanyang.

More than any other place, Taiwan fell under the spell of Ling Bo. The exhibition of the film there in the summer of 1963 created an all-time high box-office record in Taiwan's history. More important than statistics, the reception was a cultural drama involving thousands of crazed fans, women particularly, who viewed the film repeatedly, and sang the film's tunes in and out of the theatres. The phenomenon was described as the landing of a 'high-grade typhoon', continuing to gain strength

Figure 9.2 Xiao Juan: Amoy film starlet.
Source: http://www.ivylingpo.com/photos_XiaoJuan.html

and cause further 'calamities' in the advent of Ling Bo's visit in October, when Taipei turned into a 'city of crazed people' (*kuangren cheng*) (Cai 1984: 259). The noted Taiwan film critic and producer Chiao Hsiong-ping, then a schoolgirl, offers her witness account of the 'crazed' welcome of the star:

> My heart was jumping for joy. What luck to run into her! Right at this moment, heaven and earth changed before me. A mob of adults had obscured the sky, and I was staggering amidst the crowd, my feet not even touching the ground. Pressed on both sides by the crowd, I was swung left and then right. I struggled to stay afloat, as if I was drowning … the whole thing happened in about two or three minutes. Suddenly the crowd dispersed, and I was lying on the ground.
>
> (Chiao 2003: 75)

Like many other Hong Kong stars who did not pledge allegiance to the Communist regime in China at the time, Ling Bo was overcome by the love the island's population poured on her as 'Liang Xiong' (Brother Liang, after Zhu Yingtai's appellation of Liang Shanbo). She referred to Taiwan as 'homeland' (*zuguo*) and her fans there as her 'compatriots' (*tongbao*). 'I felt as though the sky

and earth were spinning and it was as if I was engulfed within that boundless effusiveness'. This sensation of a lost child embraced by the maternal pleni-tude was heightened when Madame Jiang, wife of Jiang Jie-shi (Chiang Ke-shek) and popularly known as 'Mother of the State' (Guomu), greeted her 'so warmly and kindly'.[7]

Taiwan for Ling Bo was a 'homeland' in a double sense. As the base for the inter-nationally recognized sovereign nation-state of the Republic of China (in exile), Taiwan was perceived by a large population of Chinese outside the mainland (or PRC) as the legitimate 'homeland', at least until 1973 when Taiwan lost its mem-bership of the United Nations to the PRC. But Taiwan was endearing to Ling Bo also because of its large Taiwanese- or Minnan-speaking population, who shares with her the same distant or even lost origin in Fujian. Her orphanhood lends a powerful locus of identification and nostalgia for the 'homeland', while her success first in the Amoy cinema and then as a Mandarin-language movie star in the Shaw Empire with pan-Asian and global ambitions brings much pride to a diasporic community. Tellingly, in addition to receiving her special Golden Horse award, one of the main programmes during her three-day visit in Taipei was her 'corona-tion' ceremony hosted by the 'Fukkien Natives' Association at the Zhongshan Hall (Cai 1984: 260). The Taiwanese-speaking population, the demographic majority on the island, clearly saw and claimed Ling Bo as one of their own, perhaps all the more so because of her transregional and transethnic appeal. Allegedly, as many as 48 women insisted that they were Ling Bo's godmothers while several others even claimed to be her long-lost biological mother (Cai 1984: 261).

Produced in the midst of *The Love Eterne*'s sweeping popularity, *Orphan Ling Bo* rode the waves of the 'typhoon' that the Shaw production generated and answered the Taiwanese fans' craving for her melodramatic life story and desire to 'adopt' her as their own. The thematic focus on her orphanhood echoed the prevalent iconicity of the orphan in Taiwanese-language film in general. Liao Jinfon observes that the propensity for such related images of orphans, vagabonds and fragmented families in Taiwanese-language film addresses the need to account for the pain, suffering and cultural displacement caused by wars and the colonial experience (2001: 154–5). Quite different from common accounts of the star's birth and early childhood as enigma, *Orphan Ling Bo* begins, in a patently melo-dramatic fashion, in the 'space of innocence' on the brink of upheaval (Williams 1998: 65). Huang Xiaomei (the young Ling Bo) is happily studying at school when the news of her sick father's falling to death at work reaches her. Destitute after the funeral, her mother and uncle take her along begging on the way to Shantou, where they hope to join another uncle. Failing to find him, and with the mother severely ill, Huang Xiaomei offers to sell herself to cover the medical expenses. Mr Jun, a kind gentleman, pays for her mother's cure; to repay his kindness and to give the daughter a secure home and better life, the mother and the uncle leave behind Huang Xiaomei without bidding farewell. The pathos of the 'parting for life and death' (*shengli sibie*) is poignantly underscored by the *mise en scène*, wherein the mother stands behind a ruined wall and cannot hold back her tears upon hearing her daughter's cry for her.

Significantly, Ling Bo's biological family in this fictional account, which takes up almost a third of the film, is restored in a sympathetic light. She is given an identifiable native place in rural Fujian, which would connect her with most of the Minnan-speaking population. The viewers are thus absorbed in Ling Bo's life-long quest to find her mother, especially because the foster mother turns out to be calculating and even abusive. The communist takeover of mainland China is described as a major calamity, triggering a flow of countless people, including her and her foster mother, fleeing to Hong Kong. The rest of the film builds on the better-known events in her life there, including an involuntary marriage as concubine to an overseas Chinese, until her dramatic discovery by Li and the success of *The Love Eterne*. The film ends with her tearfully thanking the crew, the Shaw collective, and the audience members, who have rushed to her place to congratulate her after the first test screening. 'I have a favour to ask you all', she pleads, 'please help me to find and reunite with my biological mother!' In a frontal end shot common to many *taiyu pian*, she waves 'goodbye' to the audience. Indeed, Ling Bo returned to Taiwan in just a couple of years when she decided to spend her honeymoon there (and then Japan) in 1966, largely to show her gratitude for the Taiwan fans' tremendous support. During that visit, she hosted a charity fundraising, where she auctioned her wedding gown to finance establishment of the 'Ling Bo's Orphan Education Association' (Cai 1984: 266–7).

This biopic about Ling Bo functions as a crucial meta-commentary on Ling Bo's transregional star text. As a *taiyu pian*, it offers a 'parallel' or 'competing' universe in which the Taiwanese-speaking audience could construct a locally and ethnically specific context for their reception and consumption of Ling Bo's stardom, such as in the first third of the film. The ethno-linguistic specificity of the film also pays a tribute to Ling Bo's minor stardom as Xiao Juan in the Amoy film.[8] Although the Shaws entertained the idea of Ling Bo playing herself in her own life story, Ling Bo herself had opposed the idea, fearing it would reopen past wounds and hurt the living. Had the Shaws succeeded with their plan, the film would most likely have been Mandarin-speaking and glossy, with Huangmei opera or contemporary tunes and with quite different narrative emphasis and spectatorial address for a pan-Chinese and pan-Asian market.

The melodrama of genre-cruising and gender performance

Extending Alberonic's notion of the stars as the 'powerless elite' and Weber's conceptualization of political leaders' charisma, Richard Dyer argues that the intense or nearly supernatural qualities of a star may be best understood 'in terms of the relationships ... between stars and specific instabilities, ambiguities and contradictions in the culture (which are reproduced in the actual practice of making films and film stars)' (1991: 57–8). Ling Bo was not the only female star who cross-dressed for her parts in post-war Hong Kong cinema. Yet her orphan origin in the mainland, now beyond reach behind the iron curtain of the Cold War, along with Nanyang as the rumoured destination for her biological parents after her

abandonment, endows her stardom with loaded geopolitical meanings and extra mythic dimensions.

On a social and political level, Ling Bo's orphan personification – on and off screen – speaks volumes of the failure of both the modern Chinese nation-state and the British Commonwealth to care for disenfranchised or displaced people, particularly orphans and abused foster children without legitimate political citizenship and the protection and nurturing of a socio-ethical network. On the one hand, her story and image crystallized the abject suffering and traumatic experiences under decolonization and modernization that impacted the lives of millions of people, including the Chinese and Sinophone communities, in the Asia-Pacific during the 1940s to 1960s. On the other hand, her rebirth as a glamorous star, or what Dyer calls a 'heavenly body', is enabled by the ontological openness and biopolitical malleability of orphanhood. Gledhill's observation that 'stars function as signs in a rhetorical system which works as melodrama' (1991: 207) applies most poignantly in Ling Bo's case. It is the melodramatic excess at the centre of her orphan-stardom – on both realist and mythic registers and with both dystopic and utopic overtones – that lends insight into her drama-riddled long career. I believe this recognition helps us to better understand her tireless genre experimentation and gender performance, which went beyond the short-lived Huangmei opera film as a genre. Although mostly known for her male-impersonating roles such as the 'Liang Brother', Ling Bo has in fact left a legacy rich in diversity and complexity as her life and stardom evolved beyond the orphan-scholar phase.

During her most prolific and highly visible period in the 1960s and 1970s, her screen credits spanned several genres, types of roles and modes of production. While starring as the 'male' leads or cross-dressing female leads in about 15 Huangmei opera films, she also appeared in a score of martial arts films and contemporary films (including family melodrama and romantic thrillers). Notably, her first appearance in the martial arts film, an equally popular and more enduring genre that the Shaws cashed-in on, was as Hong Gu, the mysterious high-flying aunt of Jimmy Wang Yu's orphan hero, in *Temple of the Red Lotus* (Xu Zenghong, 1965).

Despite Ling Bo's confession that she was not keen on the genre partly due to her lack of training in the martial arts, the Shaws capitalized on the androgynous appeal cultivated in her previous award-winning films, *The Love Eterne* and *Lady General*. The pair of films, designed as her vehicles, proved that she possessed both the *wen* (literary and effeminate) qualities when playing men and the *wu* (military and masculine) qualities when playing women, and could shuttle effortlessly between genders and genres. She continued this dual gender- and genre-bending strategy through the turn of the 1970s. After playing the legendary dandy-scholar Tang Bo-hu in *Three Smiles* (Yue Feng, 1969), her last Huangmei opera film for the Shaws,[9] she starred in a number of martial arts films. In *The Crimson Charm* (Lo Wei, 1971), Ling Bo plays a one-armed heroine in male disguise, who readily invokes the famous *One-Armed Swordsman* (1967) directed by Zhang Che (Figure 9.3).

Figure 9.3 The one-armed swordswoman: Ling Bo as martial arts heroine.
Source: *Southern Screen* No. 140, October 1969

A large bulk of martial arts films privileges the orphan and the orphan condition as central narrative premises that motivate revenge: for instance, *Red Heroine* (Wen Yimin, 1929) and *Temple of the Red Lotus*, (Xu Zenghung, 1965) and *Dragon Inn* (King Hu, 1968). The casting of the orphan-star Ling Bo in this genre is even more relevant for generating the empathy and identification of the spectators, in particular the male working-class patrons devoted to the genre. It provides a 'masculine' counterpoint to her 'feminine' male impersonation, as both types of roles are often on the social margins yet ultimately redeemed or rewarded, in part or in whole. Having a female star with limited education to play prodigious scholars who are more interested in the affairs of the heart than officialdom imparts an ironic and subversive streak. Yet Ling Bo's background as orphan and refugee, who wandered a large swath of personal and geopolitical *jianghu* (the environment in which many Chinese classical martial arts hero stories are set), naturally bleeds into the ordeals of the martial heroines she portrays. The martial arts genre thus provided an effective conduit for highlighting her other virtues as an orphan-star: capacity for survival against all odds, endurance and filial piety (to her foster parents despite their unfair treatment) and loyalty (to friends, mentors and patrons).

The two genres, mobilizing Ling Bo's complementary sets of skills and virtues, together provided a fuller melodramatic spectrum for her star text, allowing the 'dialectic of pathos and action' to play out fully.[10] At the same time, the subtext of Ling Bo's orphan origin and adolescent stardom as Xiao Juan would continue to project her as a young innocent victim of dire circumstances, betrayed by both her natal and foster families and exiled from her ancestral home by the Communist state. The blurring of age and gender categories in her screen persona until the late 1960s, I believe, owes much to the mythic orphanhood ingrained in her stardom. Her roles are always caught in stages of becoming – in processes of gendering

and sexualization, and of gaining moral recognition and social acceptance. In her 1967 memoir, published in her heyday as a Shaw star, she describes her 'boyish' mannerism and hairstyle during her school years in Xiamen. 'I felt that being a boy was more relaxing and comfortable'. 'I rarely mixed with girls at all'. 'Even until today, I could not shake off this rough side of me and yet I turned out to be also a shy young woman'. These reminiscences would have served well as part of the Shaw publicity apparatus for her transvestite appeal. Yet when Ling Bo was on the crest of success after a series of 'reverse gender roles', she became a bit uneasy and expressed her desire to 'utilize my own gender to act in feminine roles'. 'Moreover, prolong[ed] performance in this [reverse gender] role also gave me some anxiety that I myself might turned "quirky" '.[11]

Notably, these remarks were made around a period when a series of events radically reshaped her star image: her marriage to Chin Han (Figure 9.4) in 1966; a stand-off with the Shaws on contractual matters; and her custody battle with her foster mother over her first son from a previous relationship.[12] She met Chin on the set when the two played 'buddies' and then lovers attaining blissful marriage in *Lady General*. In real life the two actors' union proved more arduous, as both the paternalist Shaws and Ling Bo's foster parents strongly opposed their marriage, fearing the decrease of their own economic interest. More important, Ling Bo's marriage would mark her transition into a mature, heterosexual woman, compounded by the public exposure of her custody battle and the birth of her second son in 1967. In short, she is no longer an obedient foster daughter who endured abuses and exploitation. The formation of a family of her own and her now legitimate maternal role not only enabled her to finally outgrow her orphanhood

Figure 9.4 The star-crossed lovers: Ling Bo and Chin Han after their marriage.
Source: http://www.ivylingpo.com/photos_ChinHan_Family.html

but also put pressure on the studio to recast her image by giving her new roles in other genres.

The matrimonial and maternal turn in her life and career, paradoxically, brought her a series of roles that simultaneously widened her performance range and narrowed her gender appeal. Both real-life roles put her squarely in the hetero-normative domestic realm. She appeared in films with contemporary settings as she desired, but they tended to feature her either as sacrificial wife or femmes fatale. When she played a glamorous nightclub singer who was torn by her love for a drug-addict in *Song of Tomorrow* (Tao Qin, 1967), a critic announced with delight that, 'Beside male impersonation, our Ling Bo can play women as well. Beside Hungmei opera tunes, she can sing contemporary songs (*shidai qu*), too'.[13] Subsequently, she won her first Golden Horse Best Actress award – markedly different from the previous gender-neutral award associated with her 'outstanding performance' of the 'Liang Brother' – for her role as an ill-fated wife in *Too Late For Love* (Lo Chen, 1967). In *The Young Generation* (Yue Feng, 1970), she is the devoted wife and mother who gives her soul and body to the family, which uncannily resonated with the studio's publicity of Ling Bo at the time. A young couple marries against parental disapproval and moves to a small coastal town. They have five children and endure all imaginable hardship, including downward social mobility and serious illnesses.

In two quite similar romantic thrillers involving infidelity and blackmail, Ling Bo plays a modern-day middle-class wife, yet with diametrically opposite outcomes. In *Raw Passions* (Lo Chen, 1969), Ling Bo is the virtuous wife who is almost killed for protecting her marriage despite the humiliation her husband's past dallying with a showgirl has brought her. Against the backdrop of titillating belly-dance shows and soft-core bed scenes, Ling Bo's faithful and resourceful feminine role delivers a mixed message of innocence and conservatism. Pacing the luxury sets of her modern home, she is seen as contained and lonely. More disturbingly, her image as the good wife is foiled by that of the neighbour's wife, who turns out to be the killer of the showgirl despite her docile look. Both are housewives who flaunt expensive fashions and hairdos, yet seem mere dolls locked up in their fancy hillside homes. Bored and insecure, their only vocation seems to go to any length to keep their men and homes against the omnipresent threat of sex and violence that the rapidly modernizing Hong Kong poses to their vacuous married life.

A Cause to Kill (Mu Shi-jie, 1970) seems an ominous film in view of Ling Bo's falling out of Shaws' favour and eventual disassociation from Shaw when her contract expired a few years later. She plays a movie actress whose career is on the downward turn after her marriage to a wealthy publisher cum amateur photographer (played by Kwan Shan (Guan Shan, b. 1933)). Restless and disenchanted, she grows increasingly neurotic (Figure 9.5) and jealous when she discovers her husband's past affair with a woman scriptwriter now based in Singapore. She lures the latter to Hong Kong, stages an immaculate plot of having her husband killed, only to err on the unexpected. In her confession to the hired killer, she admits that her hatred for her husband stems from the strange coincidence of their marriage

Figure 9.5 Ling Bo as the besieged and neurotic middle-class housewife.
Source: http://www.ivylingpo.com/photos_Color.html

and her career decline. 'Strangely, after marriage, none of my films did well in the box-office'. For several years, she has had no work while her suspicion of her husband's infidelity is amplified to murderous proportion. The film ends with the unravelling of her plot and her macabre suicide.

At the outset, these contemporary-themed films updated Ling Bo's star image as she dons the fashion of the era and plays roles uncannily tied to her new wifely and maternal identities. However, these roles lost the symbolic potency of orphanhood that had been infused into her earlier gender-bending roles in the costume plays of Huangmei opera and martial arts film. She is again typecast, now in a more static frame of the domestic melodrama that implicitly refers to the compromises and stagnation in her career after she married and had another child to the dismay of her employer. After she had her third son (second with Chin Han) in 1972, the Shaws reportedly 'froze' her for two years – eerily mirroring the frozen career of the movie actress in *A Cause to Kill*.

Her disappointment with the Shaws intensified to the point when she decided to disentangle herself from the empire and embark on independent production with Chin Han. It seemed the 'marriage' on the rocks was really the one with the Shaws, from which she felt estranged. Ironically, one of her last roles for the Shaws was the neglected empress Cixi in *Empress Dowager* (1975) directed by Li Han-hsiang, who had by then returned to Hong Kong from Taiwan. The small role, however, won her the Best Supporting Actress award at the Asian Film Festival. Her 14-year career at the Shaws, which paralleled her prolonged rite of passage from an orphan-star to an 'aging' movie queen, came full cycle.

Ling Bo's career did not end, however, but took a new turn toward freelance work, independent production and television. Her departure from the Shaw Empire is also indicative of changing times in the Sinophone film landscape. A feature titled 'Whatever Happened to Ivy Ling Po?' in *Hong Kong Movie News* of July 1974 reported that Ling Bo frankly voiced her resentment with the studio. 'No contemporary film roles had come her way, and she has no liking for costume swordplay dramas'.[14] Indeed, the martial arts film was still the rage at the time, especially after the induction of Chu Yuan (b. 1934) and Lau Kar-leung (Liu Jialiang, b. 1934) into the Shaws, but Ling Bo's lack of training and her 'advanced' age, not to mention her lacklustre interest in the genre, put her in a less competitive position.[15] At the same time, the kung-fu craze ignited by the meteoric rise and fall of Bruce Lee and the restructuring of the film industry in the early 1970s ushered in a new era of media production and consumption in the region. The paternalistic, vertically incorporated system of the studio era, as exemplified by the Shaws at its pinnacle, gave way to a cluster of 'independents' of varying sizes and orientations, such as the Golden Harvest (Jiahe) and the Long Bow (Changgong), established by former Shaw pillars Raymond Chow and Zhang Che (1923–2002), respectively.[16] Today (Jinri), founded by Chin Han, Ling Bo and another actor couple, was virtually a co-op style cottage industry lacking capital and other resources. The title of their first production, *Crossroad* (Chin Han, 1976), a melodrama about two working-class couples' daily strife, love and friendship, offers an apt image for the situation of the immediate post-Shaw Ling Bo, as well as for the Sinophone film industry undergoing fragmentation and transformation.

Epilogue

As Ling Bo forged ahead in the coming decades, her resilience and versatility continued to captivate and inspire her transnational fans across generations. Hardly a buried relic from the golden age of Hong Kong cinema that saw many female stars dying young,[17] Ling Bo's life and charisma proved enduring and reached a new apex when she staged *The Love Eterne 40* and toured it in Malaysia, Singapore, Taiwan and the USA in 2002 and again in Taiwan in 2004.[18] More recently, she appeared (with her husband Chin Han) in a cameo role in *Rice Rhapsody* (2005) directed by her son Kenneth Bi. In the same year, the extended melodrama of Ling Bo's orphanhood and stardom seemed to have taken on a new happy ending: she reportedly reunited with her biological brother Huang Yusheng in Shenzhen in January 2005 and learned that her given natal name was Huang Yujun (Bai 2005: 42). This revelation is certainly not too far from the name Huang Xiaomei that the young Ling Bo was called by in *Orphan Ling Bo*. But it had taken almost a lifetime for her to reconnect with her roots in the mainland.

Over the decades, Ling Bo's loyal fans everywhere – except in the mainland, which knew very little about her – have followed her from her early orphan-stardom to her recent comeback as a gracefully aging living legend, from the wide screen to the small screen, and from concert halls to online fan sites in the virtual

world. Now with her rediscovered kinship ties in the ancestral homeland and the digital incarnations of her star images widely available, would her new fans and film historians in the mainland want to reclaim Ling Bo as the long-lost daughter of Chinese cinema? More likely, her story, along with many others, would inspire new approaches to rewrite Sinophone film history in general.

Acknowledgements

I thank Xiangyang Chen and Sangjoon Lee for obtaining copies of films essential for this project, and Intan Paramaditha for being such a resourceful research assistant. Charles Leary and Shi-yan Chao lent a keen ear to my ideas and helped with technical matters. I am grateful for the comments and encouragement from Huang Ren, Amy Villarejo, Kristen Whissel, Linda Williams, Andrew Jones, Karen Beckman, Poshek Fu, Lanjun Xu, Mei Chia-ling, Shuang Shen, Mary Shuk-han Wong and Leung Ping-kwan on a larger ongoing project, from which this chapter is derived. A NEH Summer Stipend enabled me to conduct research at the National Film Archive in Taipei. Thanks also to the Shaws Organizations for the permission to use the images first appeared in their publications. Finally, I am indebted to and inspired by Ling Bo's online fans who have allowed me to access precious sources and become a fan myself.

Notes

1 The retrospective travelled to a number of locations, including the Film Archive at the University of California, Los Angeles and the Film Society at the Lincoln Centre for Performing Arts, New York. On the remastering of the Shaw classics and its aesthetic and cultural implications, see Leary (2005).
2 The film also won the Second Golden Horse awards for Best Director (Li Hang-hsiang), Best Music (Zhou Lan-ping) and Best Editing (Chiang Hsing-loong).
3 The famous Yuan-dynasty play had been adapted into a Mandarin-language film in 1961, starring Hu Die (as the widow-mother) and Hsiao Fong-fong (as the prince) and directed by Hu Peng. Both Hu Die and Chen Yanyan, who played widow-mother in two Hong Kong versions, were major stars in Shanghai back in the 1930s and 1940s.
4 On Joan Crawford, see Allen and Gomery (1985: 176–7). Loh Ti's name, for instance, was also a screen alias, derived from her nickname 'Liu Di' (the sixth brother) as she was called at home.
5 http://www.ivylingpo.com/Special_Memoires1967_01.html.
6 http://en.wikipedia.org/wiki/Ivy_Po. More recently, she traced her encounter with Li Han-hsiang to 1958 when Li heard her singing Huangmei tunes in a low-budget production for a smaller company at the Grandview Studio where he was filming *Diao Chan* (Li Han-hsiang, 1958). See the excerpt of the interview she gave to the Hong Kong Film Archive Oral History Project on 19 January 2000 (Wong 2007: 234).
7 http://www.ivylingpo.com/Special_Memoires1967_13.html.
8 The film is spoken predominantly in Minnan, but occasionally in Mandarin, such as the earlier scene at school, her later reunion with her schoolteacher and, of course, the encounter with Li and her co-star Loh Ti.
9 The popularity of the genre also waned by that point (Tan 2007).
10 See the summary of Linda Williams' definition of this and other key features of melodrama in Mercer and Shingler (2004: 93–4).

11 http://www.ivylingpo.com/Special_Memoires1967, Part 2 and Part 12.
12 'Ling Po's Diary 1981' contributed by Vinci, Anny, Kesley. http://www.ivylingpo.com/Special.Diary1981.html.
13 *Hong Kong Movie News*, June 1966, as appeared at http://sblingpo.proboards21.com/index.cgi?board=general&action=display&thread=1078375205&page=3. The same issue also carried a set of Ling Bo's wedding photos under the rubric the 'June Bride' (perhaps borrowed from Cathay's 1960 film of the same title).
14 *Hong Kong Movie News*, June 1966, as appeared at http://sblingpo.proboards21.com/index.cgi?board=general&action=display&thread=1078375205&page=3.
15 On the overall lack of power of the Shaw stars, including Ling Bo, see Jarvie (1977: 76–81).
16 For the rise of Golden Harvest in particular and the shifts in industrial structure and market in the period in general, see Fore (1994: 40–58). See also Zhong (2003: 1–14).
17 The top-ranking actresses who committed suicide in the 1960s include Lin Dai (1934–64) and Loh Ti, Ling Bo's co-star in *The Love Eterne*.
18 The success of the show also resurrected her fame as a singer, resulting in a series of concerts in Taiwan, Hong Kong, Malaysia and the USA. DVDs and CDs of the restaged film and her concerts are at the time of this writing available at http://en.wikipedia.org/wiki/Ivy_Ling_Po.

Works cited

Allen, Robert Clyde and Douglas Gomery (1985), *Film History: Theory and Practice*, New York: Knopf.
Bai, Jiang 柏姜(2005), *Shaoshi juxing: lingjuli jiechu* 邵氏巨星: 零距离接触 (Shaw's great stars: close encounters), Hong Kong: Xingdao.
Cai, Guorong 蔡国荣(1984), *Mengyuan xingxi: Zhongguo mingxing yingshi* 梦远星稀: 中国明星影史 (Vanishing dreams, distant stars: a history of Chinese movie stars), Taipei: Zhongguo yingpingren xiehui.
Chen, Yeong-Rury (2006), 'Male Impersonation and Gender Identification', Chapter 5 of *A Fantasy China: An Investigation of the Huangmei Opera Film Genre through the Documentary Film Medium*, PhD Thesis, Swinburne University, Australia.
Chiao, Hsiong Ping 焦雄屏(2003), 'Nüxing yishi, fuhao shijie he anquan de waiyu – ji *Liangshanbo yu Zh Yingtai* sishinian' 女性意识, 符号世界和安全的外遇－记《梁山伯与祝英台》四十年 (The female consciousness, the world of signification and extramarital affairs: a forty year tribute to *The Love Eterne*), *Shaoshi dianying chutan* 邵氏电影初探 (The Shaw screen: a preliminary study) (ed. Wong Ain-lin 黄爱玲), Hong Kong: Hong Kong Film Archive, pp. 63–71.
Dyer, Richard (1991), 'Charisma', in *Stardom: Industry of Desire* (ed. Christine Gledhill), London: Routledge, pp. 57–98.
Fore, Steve (1994), 'Golden Harvest Films and the Hong Kong Movie Industry in the Realm of Globalization', *The Velvet Light Trap*, 34 (Fall), pp. 40–58.
Gledhill, Christine (1991), 'Signs of Melodrama', in *Stardom: Industry of Desire* (ed. Christine Gledhill), London: Routledge, pp. 207–229.
Jarvie, I.C. (1977), *Window on Hong Kong: A Sociological Study of the Hong Kong Film Industry and Its Audience*, Hong Kong: Centre for Asian Studies, University of Hong Kong.
Leary, Charles (2005), 'Remastering Hong Kong Cinema', in *Cinephilia: Movies, Love and Memory* (eds Marijke de Valck and Malte Hagener), Amsterdam: University of Amsterdam Press, pp. 83–96.

Liao, Jinfon 廖金凤(2001), *Xiaoshi de yingxiang: Taiyu pian de dianying zaixian yu wenhua rentong* 消失的影像: 台语片的电影再与文化认同 (The disappearing images: cinematic representation and cultural identification in Taiwanese-language cinema), Taipei: Yuanliu.

Mercer, John and Martin Shingler (2004), *Melodrama: Genre, Style, Sensibility*, London: Wallflower.

Shih, Shu-mei (2007), *Visuality and Identity: Sinophone Articulations across the Pacific*, Berkeley, CA: University of California Press.

Tan, See-Kam (2007), 'Huangmei Opera Films, Shaw Brothers and Ling Bo – Chaste Love Stories, Genderless Cross-dressers, and Sexless Gender-Plays?', *Jump Cut*, 49 (Spring). http://www.ejumpcut.org/archive/jc49.2007/TanSee-Kam/index.html. Accessed 8 July 2009.

Williams, Linda (1998), 'Melodrama Revisited', in *Refiguring American Film Genres* (ed. Nick Browne), Berkeley, CA: University of California Press, pp. 42–88.

Wong Ai-Lin 黄爱玲 (2007), *Fenghua xueyue Li Han-hsiang* 风花雪月李翰祥 (Li Han-hsiang, storyteller), Hong Kong: Hong Kong Film Archive.

Yeh, Emilie Yueh-yu and David William Davis (2005), *Taiwan Film Directors: A Treasure Island*, New York: Columbia University Press.

Zhang, Yingjin (2004), *Chinese National Cinema*, London: Routledge.

Zhong, Baoxian 钟宝贤 (2003), 'Xiongdi qiye de gongye zhuanbian – Shaoshi xiongdi he Shaoshi jigou' 兄弟企业的工业转变－邵氏兄弟和邵氏机构 (The industrial change of a fraternal enterprise: the Shaw Brothers and the Shaw system), in *Shaoshi dianying chutan* 邵氏电影初探(The Shaw screen: a preliminary study) (ed. Wong Ai-Lin 黄爱玲), Hong Kong: Hong Kong Film Archive, pp. 1–13.

Filmography

The Big Boss (Tangshan daxiong 唐山大兄), d. Lo Wei 罗维, Hong Kong: Golden Harvest, 1971.

A Cause to Kill (Shaji 杀机), d. Mu Shi-jie 穆时杰, Hong Kong: Shaw Brothers, 1970.

The Crimson Charm (Xue fumen 血符门), d. Lo Wei 罗维, Hong Kong: Shaw Brothers, 1971.

Crossroad (Shizi lukou 十字路口), d. Chin Han 金汉, Hong Kong: Jingri (Today), 1976.

Diao Chan (Diaochan 貂蝉), d. Li Han-hsiang 李翰祥, Hong Kong: Shaw Brothers, 1958.

Dragon Inn (Longmen kezhang 龙门客栈), d. King Hu 胡金铨, Taiwan: Union Film, 1968.

Drunken Master (Zuiquan 醉拳), d. Yuen Wo-ping 袁和平, Hong Kong: Seasonal Films, 1978.

Empress Dowager (Qingguo qingcheng 慈禧太后), d. Li Han-hsiang, Hong Kong: Shaw Brothers, 1975.

Grand Substitution (Wanggu liufang 万古流芳), d. Yan Jun 严俊, Hong Kong: Shaw Brothers, 1964.

Golden Swallow (Jin yanzi 金燕子), d. Sing-pui O, Hong Kong : Alan & Eric Films, 1988.

Lady General Hua Mu-lan (Hua Mulan 花木兰), d. Yue Feng 岳枫, Hong Kong: Shaw Brothers, 1964.

The Love Eterne (Liang Shanbo yu Zhu Yingtai 梁山伯与祝英台), d. Li Han-hsiang 李翰祥, Hong Kong: Shaw Brothers, 1962.

The Mermaid (Yu meiren 鱼美人), d. Gao Li 高立, Hong Kong: Shaw Brothers, 1965.

A Maid from Heaven (Qi Xiannü 七仙女), d. He Menghua 何梦华 and Chen Yixin 陈一新, Hong Kong: Shaw Brothers, 1963.

One-Armed Swordsman (Dubi dao 独臂刀), d. Zhang Che 张彻, Hong Kong: Shaw Brothers, 1967.

Orphan Ling Bo (Gunü Ling Bo 孤女凌波), d. Jin Chaobai 金超白, Taiwan: Tailian, 1964.

Raw Passions (Luo xue 裸血), d. Lo Chen 罗臻, Hong Kong: Shaw Brothers, 1969.

Red Heroine (Hong xia 红侠), d. Wen Yimin 文逸民, Shanghai: Youlian, 1929.

Rice Rhapsody (Hainan jifan 海南鸡饭) d. Kenneth Bi, Singapore/Hong Kong/Australia: Kenbiroli Films, 2005.

Song of Tomorrow (Mingri zhige 明日之歌), d. Tao Qin 陶秦侠, Hong Kong: Shaw Brothers, 1967.

Temple of the Red Lotus (Jianghu qixia 江湖奇侠), d. Xu Zenghong 宏增宏, Hong Kong: Shaw Brothers, 1965.

Three Smiles (San xiao 三笑), d. Yue Feng 岳枫, Hong Kong: Shaw Brothers, 1969.

Too Late For Love (Fenghuo wangli qing 烽火万里情), d. Lo Chen 罗臻, Hong Kong: Shaw Brothers, 1967.

The Young Generation (Ernü shi womende 儿女是我们的), d. Yue Feng 岳枫, Hong Kong: Shaw Brothers, 1970.

10 Brigitte Lin Ching Hsia

Last Eastern star of the late twentieth century

Tony Williams

Introduction

The title of this chapter deliberately evokes both the only English-language book devoted to this retired star and Howard Hampton's definition of her as 'the late twentieth century's last, strangest movie goddess' (Hampton 1996: 42). But the title also attempts to make a strong case for the actress's claim to this title in terms of contemporary studies of stardom. Why Brigitte Lin Ching Hsia (Lin Qingxia, b. 1954) rather than Gong Li or Maggie Cheung Man-yuk? These competitors are highly accomplished stars who have made films in the artistic as well as the popular realms of Southeast Asian cinema. Gong Li owes much to her exotic roles in the Fifth Generation Chinese films of directors such as Chen Kaige (b. 1952) and Zhang Yimou, while the no-less accomplished Cheung has achieved notable transnational stardom after freeing herself from the glamour roles of her early career (Williams 2003).

Brigitte Lin represents a more complex and cultural version of Eastern stardom. She has never ventured into the realms of transnational stardom, nor has she exhibited the type of glamorous exoticism associated with Gong Li. She is identified with the role of 'Invincible Asia' in the last two of the *Swordsman* trilogy, produced in 1992 by Tsui Hark. His gender-bending associations attracted the attention of Western audiences, particularly in terms of gay reception that gay director Stanley Kwan explored in his 1996 documentary on Hong Kong cinema, *Yang ± Yin: Gender in Chinese Cinema*. But Lin's stardom is much more complex than these gender-bending roles suggest. It certainly owes much to cultural factors such as cross-dressing roles associated with Peking opera, as well as many films such as Li Han-hsiang's *The Love Eterne* (1962) and *The Dream of the Red Chamber* (1977). However, a case can be made for examining Brigitte Lin's star persona using the pioneering concepts of the work of Richard Dyer.

In *Stars* (1979: 183), Dyer claims the star phenomenon often represents cultural contradictions that operate in any society. Certain stars can also embody bisexual elements within their cinematic constructions that not only oppose strict gender definitions but also parallel the fluid identification mechanisms that Sigmund Freud recognized as operating within the human personality. Brigitte Lin's well-known star persona embodying male and female components, such as her breakthrough

role in *Peking Opera Blues* (Tsui Hark, 1986), illustrates this principle. But this star persona is embodied within recognizable aspects of Chinese cultural representations. For this study, I want to develop the insightful study of Akiko Tetsuya, written as a passionately dedicated self-published labour of love containing interviews with the star herself and her many collaborators, by focusing on the diverse nature of the films Lin made during her 20-year career. Distinctive though her identifiable 'Invincible Asia' star status is, it developed as a result of varied film performances, some of which anticipated what would emerge later in Hong Kong cinema. These performances are overlooked in most studies of her work and need some attention to develop a fuller picture of Brigitte Lin's star persona.

I therefore begin by focusing on key films from a time the star herself regards as her 'unhappy Taiwan period' (1972–84). Most film critics neglect this 'unhappy' phase of Lin's career, but some dedicated internet sites such as http://www.brigittelin.com provide considerable coverage. Tetsuya's film list puts in this period some 63 films, not all of which are available in DVD or VCD formats. Some are in non-subtitled versions only. Many of these films foreshadow the later trajectory of Lin's career.

During this period, Taiwanese cinema exhibited none of the stylistic and interrogative political elements that would emerge in the later era of its 'New Wave' associated with directors such as Hou Hsiao-hsien (Hou Xiaoxian, b. 1947) Edward Yang (Yang Dechang, 1947–2007) and Tsai Ming-liang. Lin's films of this era tend to be regarded as romantic escapism, but many of her performances articulate contradictions within contemporary Taiwanese society that could not be represented explicitly under Taiwan's authoritarian government of that time. Although this era sees Brigitte Lin at her most youthful and most effervescent as a performer, not all of her films from this period can, or should, be easily dismissed as escapist and trivial.

A star is born

Dyer's conceptual work reveals that certain star images express contradictions in any society at a given time and Lin's 'unhappy Taiwan' period films made between 1973 and 1984 are no exception. During the early development of her star persona, Taiwan was less democratic than it is now. Films made in Taiwan during this era appear to reflect a localized ideological version of a status quo refusing to examine explicitly the historical and political contradictions that powerfully reshaped Taiwan from the mid-twentieth century. This examination would have to wait until the work of Hou Hsiao-hsien and others. Although young Brigitte appears to resemble a Taiwanese version of Mary Pickford's 'America's sweetheart' of the 1910s and early 1920s, close examination of her more accessible films reveals the presence of contradictory elements.

While still in college, she appeared as a major star in *Outside the Window* (Song Cunshou and Yu Zhengcun, 1973). Based on a well-known 1963 Taiwanese novel by Qiong Yao (but funded from Hong Kong sources), the film displayed an accomplished performance by Lin in the role of high school student Chiang Yen-yung

who falls in love with her teacher K'ang Nang (Hu Chi), 20 years her senior. Despite the possibility of slipping easily into the realm of an adolescent puppy love weepie, the film is actually, as Stephen Teo (2000: 167) recognizes, 'a sensitive and deeply moving elegy on the destruction of innocent love by collective social pressure and the futility of adolescent dreams'. Although it focuses on individual tragedies, *Outside the Window* contains insightful images of an affluent, but dysfunctional, Taipei family and an oppressive school system. *Outside the Window* even contains a harrowing scene of marital rape, an act that Yen's unfeeling husband (played by future leading man Chin Han) dismisses by cheerfully bringing a breakfast tray to her 'the morning after'!

Lin's later Taiwanese films never reach the heights of her dramatic debut, but certain elements questioning the status quo on gender inequality are never entirely absent from the more light-hearted successors. Even their 'happily ever after' endings appear weak in terms of the presentation of certain overwhelming social obstacles that prevent positive resolutions in the first segments of each film. Some of these films implicitly suggest the need for alternative directions for female empowerment that Lin will intuitively move towards in *The Dream of the Red Chamber* (1977) and will solidify in later Hong Kong films that feature her realized dominant star status challenging rigid definitions of gender and male control.

Lin's first film was never shown in Taiwan due to the objections of Qiong Yau. But her second starring role in *Gone with the Cloud* (Liu Chia Chang, 1974) became a box-office success in Taiwan and across Southeast Asia. It led to her appearances in 50 similar romantic films, frequently co-starring Chin Han (Qin Han, b. 1946) and/or Chin Hsiang Lin (Qin Xianglin, b. 1948), before she moved to the United States for a period of 'soul searching' in 1979 (Tetsuya 2005: 1). This film also introduced a particular social dimension into the romance narrative that would dominate her later Taiwan films. Lin plays a 19-year-old high school graduate dating the son of a rich man who also dates her older sister. The father refuses to allow his son to marry Lin because of her poor background and her sister's former job as a nightclub hostess. Although *Gone with the Cloud* moves towards an obligatory happy ending, it reveals the presence of disturbing social tensions within Taiwanese society.

Ghost in the Mirror (Song Cunshou, 1974) is one of Lin's rare Taiwanese excursions into the realms of supernatural fantasy. Co-starring Shih Jien of *A Touch of Zen* (King Hu, 1971), it not only belongs to the world of Pu Songling's ghostly narratives but also features Lin as a mood-switching female ghost whose fluctuations between 'Yin' and 'Yang' anticipate her later fluid gender role in *Ashes of Time* (Wong Kar-wai, 1994).

During this period Lin also appeared in more modern light-hearted films such in *Run Lover Run* (Richard Chen Yao-chi, 1975) in which she plays a tomboyish athlete uninterested in traditional Chinese customs involving arranged marriage. Lin's androgynous appearance anticipates her later Hong Kong star persona. Co-starring Alan Tang, the film is a Taiwanese screwball transcultural 'battle of the sexes' comedy with Lin's Li Ping admiring more masculine Hollywood stars such as Charles

Bronson and Steve McQueen rather than her more gentle childhood sweetheart. The film moves towards the reconciliation of opposites not just in the role of gender but also in terms of culture, where both in-laws realize that old arranged-marriage customs are no longer relevant to contemporary Taiwan.

Pai Ching-jui's *Forever My Love* (1976) is Lin's version of *Love Story* (Arthur Hiller, 1970) with the genders reversed. Also co-starring Alan Tang, the film uses distancing devices of melodrama and romance to again reveal unwholesome class issues in contemporary Taiwanese society. Arranged marriage recurs as the theme in Richard Chen Yao-chi's *Come Fly with Me/I Am a Seagull* (1976). Lin's Liu Yen-mei shows little excitement for an arranged marriage with London-based businessman Ping-wan in contrast to her fascination with the gliding experiments of Cheng Chieh (Charlie Chin), a lower-class character who decides to achieve his dream in Taiwan rather than becoming an unemployed graduate forced to relocate overseas like so many others during this period. Like in *Run Lover Run*, the course of true love never runs smoothly; this time class barriers present another seemingly insurmountable obstacle. One of the film's hilarious scenes reveals the heroine's disdain for arranged marriage when she goes to meet her future father-in-law in a restaurant wearing a late Ching Dynasty traditional outfit.

Gao Li's *Morning Fog* (1978) presents Lin at her most beautiful and resilient, playing an independent woman who has risen from the depths of poverty to work as a tutor. Stigmatized by her illegitimate birth, she sees her romance with business man Tu Hsiao (Chin Han) destroyed by upper-class machinations until the couple reunites in the final scene with the words, 'The sun will burn away the fog and you'll forget all your unhappiness'. In Pai Ching-jui's *Poor Chasers/A Pair of Silly Birds* (1980), Lin again plays a character from a poor background and is determined to conceal her origins from rich boyfriend Chu Cheng-hsiung (Chin Han) until her virtuous mother feels obligated to reveal the truth to Chu's father. The film moves towards its optimistic conclusion with mother and daughter reunited in a modern rendition of Confucian family values where class barriers become dissolved.

Space limits here prevent examination of Lin's other Taiwan films. Overall, many of her romantic roles during this era appear to be not escapist fluff but in fact subversive works. These roles illustrate Richard Dyer's concept of stardom as attempting to resolve social contradictions within the context of a contemporary national status quo (1979: 59). They deserve further study.

Before deciding to relocate to Hong Kong, Lin made two other films worthy of notice: *The Dream of the Red Chamber* (1977) and *Love Massacre* (Patrick Tam Ka-ming, 1981). Directed by Li Han-hsiang and based on a classic Ching Dynasty novel, Lin regards *Red Chamber* as her favourite film (Tetsuya 2005: 17) where she plays her first male role: young master Bao Yu in love with Lin Daiyu (Sylvia Chang [Zhang Aijia, b. 1953]). Due to concerns over Lin Daiyu's health, Bao's parents arrange a marriage with another girl and Lin Daiyu dies of despair. Originally, the roles were reversed but Li decided to change the casting, much to Lin's delight, since it fulfilled her idea of a dream casting; 'After that, I happily became a boy' (Tetsuya 2005: 19). In 1980, Lin shot *Love Massacre* in California.

Directed by Hong Kong New Wave director Patrick Tam, Ka-ming, this was both her first thriller and the one through which she moved towards playing a more mature character by shedding her 'romantic girly look' (Tetsuya 2005: 24). Here she was influenced by production designer William Cheung, who persuaded the conservative actress not to wear a bra in the film (Tetsuya 2005: 25). Although this film is not as well-known as her later work, Lin credits *Love Massacre* as the film where she tried out many new ideas, which made this film stand out from her other films of that time (Tetsuya 2005: 26).

Transitional stardom

Following her appearance in *Love Massacre* and possible dissatisfaction with a Taiwanese cinema that was beginning its process of decline, Lin appeared in three (possibly four) films directed by the bizarrely talented Chu Yen Ping (Zhu Yanping, b. 1950). Usually dismissed as a minor force in Hong Kong and Taiwanese cinema, he is an extremely iconoclastic director whose films often break standard generic formulas and who began to 'blur boundaries' in a postmodernist manner well before Western critics invented that term (Williams 1999: 60–2). Although Lin dismisses these films, they represent the most maverick phase of her career and suggest that perhaps Chu Yen Ping, rather than Tsui Hark, may have been instrumental in initial attempts to broaden her star persona and break away from the romantic melodramas with which she was most associated.

During 1982 she appeared in Chu Yen Ping's three films, *Golden Queen's Commandos* (1982), *Pink Force Commandos* (1982) and *Fantasy Force Mission* (1983), playing a bizarre series of roles far removed from her 1970s Taiwanese star persona. In the first, as Venus Lin she plays bazooka-wielding, black-leather-costumed, red-booted heroine Lilly who helps Captain Dong (Wang Yu) rescue three Allied generals captured by the Japanese in Luxemburg located on a map of Canada! Logic is always absent from Chu Yen Ping films, especially one frequently raiding costumes from different eras, various film soundtracks, and exploiting generic references ranging from The Keystone Cops, through American horror films, to *The Alamo!* (John Wayne, 1960). At the climax, Lilly and her lover expire in a manner similar to that of Jennifer Jones and Gregory Peck in *Duel in the Sun* (King Vidor, 1947).

Her role as Black Fox in *Golden Queen's Commandos* combines the heroic roles of Yul Brynner in *The Magnificent Seven* (John Sturges, 1960) with John Wayne's Rooster Cogburn (complete with eye patch!) (*Rooster Cogburn*, Stuart Millar, 1975), involved in a mission to destroy a chemical warfare plant run by a mad scientist/James Bond villain.

Pink Force Commandos is an unofficial sequel reuniting Lin with the female stars of the earlier film now playing different roles. Again as Black Fox, Lin pays the price for betraying her female associates by having her arm cut off, like Wang Yu (b. 1944) in *The One-Armed Swordsman* (Chang Cheh, 1967). However, a blacksmith gunfighter modelled on Christopher Lee in *Hannie Caulder* (Burt Kennedy, 1971) gives her a mini-Gatling gun as a replacement. These *Commando*

films obviously influenced Quentin Tarantino (b. 1963), in Darryl Hannah's role in *Kill Bill* (2003) and the actress playing the weapon-wielding amputee heroine in the first part of *Grindhouse* (2007).

Mystery surrounds *Night Orchid*, aka *Demon Fighter* (Chu Yen Ping). Several sources give 1983 as the production year, the same as for *Zu Warriors from the Magic Mountain* (Tsui Hark, 1983). Co-starring Adam Cheng, who also appears in Tsui Hark's film, *Night Orchid* (which circulates in America only via a full screen, badly dubbed, and often inaudible version known as *Demon Fighter*) superficially appears to be influenced by *Zu*. Although the Hong Kong Movie Database supplies a 1982 date and lists Cheung Paang-Yee as director, the film strongly resembles Chu Yen Ping's bizarre work. Other internet sources give Chu director credit. What makes this film interesting is not just its use of Lin's Yin–Yang, persona already seen in *Ghost in the Mirror*, but also a bisexual dimension anticipating her later role as Invincible Asia.

As Shu Chu-chu, Lin believes that warrior Chu Liu-xiang (Adam Cheng) betrayed her sister. Masquerading under the guise of a killer clothed in black and wearing an orchid mask, she sets out to murder all of Chu's lovers. An earlier scene shows her caressing one lover with her fingers in a manner resembling a lesbian romantic gesture. When Shu's identity later becomes known, she tells Chu that she murdered the woman not only because she believed the woman to be a lover of her foe but also because of the impossibility of fulfilling the victim's demands for physical love. A brief close-up of a sinister-looking Lin during this flashback reveals her hair tied back rather than having the flowing locks that her character displays in the rest of the film. The scene anticipates her later Hong Kong bisexual roles.

Lin earlier played a male role in *The Dream of the Red Chamber* and this performance was by no means unusual in Chinese culture. But this brief scene in *Night Orchid* is far removed from the usual bizarre image found in a Chu Yen Ping film. Although it displays Shu's murderous masquerade when dressed as a man, it also suggests an explicitly sinister bisexual dimension rather than the traditional convention of females impersonating males as in Cantonese operas featuring Pal Suet-sin and Yam Kim-fai and Lin's later appearance in Tsui Hark's 1992 *Dragon Inn* (Raymond Lee). It could even be Lin's own contribution to the film. This scene also foreshadows those frustrated desires for sexual fulfilment with Invincible Asia affecting Jet Li's Ling Wu-chung and Yu Rong-guang's Koo in *Swordsman 2* (Ching Siu-tung and Stanley Tong, 1992) and *Swordsman 3: The East I Red* (Ching Siu-tung and Raymond Lee, 1993).

Night Orchid may actually precede *Zu*. It seems difficult to imagine that Lin would return to a Taiwan film industry she had decided to leave and appear in a film directed by Chu Yen Ping following her breakthrough role in Tsui Hark's *Zu Warriors from the Magic Mountain*. Lin's Hong Kong star persona from *Peking Opera Blues* onward may represent more of an equal collaboration between herself and Tsui Hark rather than being the creation of any one director. As Dyer (1979: 177) notes, casting is often 'a case of having to "exploit and organize imaginatively" pre-given material, the star image and performance capacities'.

The road to Invincible Asia

Following her decision to relocate to Hong Kong, Brigitte Lin found herself facing the problems affecting any star moving to another location: namely, re-establishing star status or finding a new identity. Cuban-born actor Tomas Milian never regained his European stardom when he moved to the United States and has continued in character roles ever since (Navarro and Zanello 1999).

By contrast, Jackie Chan achieved Hollywood success but in mediocre vehicles such as the *Rush Hour* series and *Around the World in 80 Days*, which never displayed the innovative nature of talents associated with his 1980s Hong Kong films. After her distinctive role as the Countess of the Jade Pool in *Zu Warriors from the Magic Mountain*, Brigitte Lin found herself in a similar transitional situation. She first appeared in Teddy Robin Kwan's Cinema City slapstick parody *All the Wrong Spies* (1983) combining *Casablanca* with the Marx Brothers. This film must have appeared familiar territory after her Chen Yu-ping Taiwanese films. After disappointing roles in Ringo Lam Ling-tung's *The Other Side of Gentleman* (1984) and Jackie Chan's *Police Story* (1985), where she became merely a female prop like Maggie Cheung's May, she played a kung-fu nun in Karl Maka's farce *The Thirty Million Rush* (1987). She then reunited with Tsui Hark in what would be one of her most distinctive roles: uniform-wearing, close-cropped General's daughter Tsao Wan in *Peking Opera Blues*.

This was the second of six collaborations with Tsui Hark. With the exception of his modern thriller *Web of Deception* (David Chung, 1989), all are period productions. Set in 1913, Lin's *Peking Opera Blues* character wears male attire throughout most of the film since it allows her freedom of movement within that authoritarian era. The film's title also evokes the cross-dressing performances of Peking opera that Lin had earlier employed in her role in Li Han-hsiang's *huangmei diao*-influenced *The Dream of the Red Chamber*. However, in *Peking Opera Blues*, Lin is not a cross-dressing mannequin figure. She also exhibits real acting ability in scenes where she regrets betraying her reactionary father by displaying emotions in the best manner of silent film performance.

Before her appearance as Invincible Asia in *Swordsman 2*, Lin appeared in a number of mixed films such as Kirk Wong Che-keung's remake of *Angels with Dirty Faces* (1938), *True Colours* (1986), Tony Au Ting Ping's reincarnation romantic tragedy *Dream Lovers* (1986) her only appearance with Chow Yun-fat, Sun Chung's hysterical melodrama *Lady in Black* (Sun Chung, 1987), and Yim Ho's *Red Dust* (1990), a twentieth century historical melodrama loosely based on the life of Eileen Chang where she delivers another accomplished performance. A year later, Lin became the subject of a 1991 documentary, *A Portrait of Lin Ching-hsia*, which also featured both Tsui Hark and Nanshun Shi, the former directing her dancing with a young, hirsute, Jordan Chan.

Tsui and Lin would soon begin their next key collaboration. Supervising Ching Siu-tung's direction of *Swordsman 2*, Tsui cast Lin as a man who transforms himself into a woman to gain advanced supernatural power from a sacred scroll. Like a Ming Dynasty eunuch, Asia must undergo castration to obtain political power.

Although Lin's role has been applauded by gay audiences, it actually develops recognizable cross-dressing gender performances from Peking opera. But it also appeals to the fluid, genderless nature of spectatorship that post-Laura Mulvey film theorists recognize as containing key elements of the cinematic gaze.

Lin's Invincible Asia is both modern and traditional. She manages to play convincingly a man becoming a woman whose 'feminine' side becomes strongly attracted to Jet Li's loutish hero Ling, thus displaying a diffuse type of sexuality that is socially taboo. The manner of Asia's refusal to answer Ling's anguished pleas about whether she has slept with a man or woman suggests this is a problem for the traditional hero himself and not for the hero/heroine. Tsui Hark's 1992 *Dragon Inn* remake similarly reveals sexually teasing encounters between Lin and Maggie Cheung.

Swordsman 2 also articulates another aspect of star construction, as Dyer (1979: 183) explains 'exposing precisely the uncertainty and anxiety concerning the definition of what a person is', and operating 'through the cultural and historical specificities of class, gender, race, sexuality, religion, sub-cultural formations, etc.'. In this context, Lin's Invincible Asia might be renamed as 'Universal Asia' according to certain cultural parameters within Eastern forms of representation. Tsui and Lin may have developed the idea of Invincible Asia from one scene in *Zu* where Yuen Biao and Ming Hoi encounter Lin's demonic character who wears red garments similar to those worn later by her Invincible Asia character. As Invincible Asia she also embodies the dark side of Adam Cheng's heroic character who later becomes a blood demon.

Invincible Asia was a hard act to follow but a sequel was surely inevitable. Although Lin's Invincible Asia dies in *Swordsman 2*, *Swordsman 3: The East I Red* restores her to life. Tsui and directors Ching Siu-tung (Cheng Xiaodong, b. 1953) and Raymond Lee literally pull out all the stops by making what appears to be a deliberately chaotic narrative conceived as the death of the costumed swordplay genre, making any sequel impossible. Learning that impostors have appropriated her role (including former lover Snow played by Joey Wong), Asia embarks on a destructive rampage. The sexual ambiguity of the earlier film now gives way to more explicit lesbian overtones, with several sequences evoking the bizarre authorship of Chu Yen Ping. A Japanese warship changes into a submarine. Asia flies through the air on a swordfish and breaks into song with a group of prostitutes. A powerful ninja master is actually a dwarf in disguise. The film resembles the closing episode of the 1967 British television series *The Prisoner*, where series creator Patrick McGoohan designed the final episode, 'Fall Out', to ensure that a sequel would be impossible.

By this time, Lin had found her indelible star person in the same way that John Wayne became associated with the Western hero and Vincent Price as a tormented Edgar Allen Poe icon. Kowalis (1997) explains that Lin attempted some different roles such as the theatrical Taiwanese-based 1991 production *The Peach Blossom Land* (Stan Lai) but found little opportunity for variation. Ronny Yu directed one of her striking performances in *The Bride with White Hair* (1993) as well as the final 10 minutes of the sequel, *The Bride with White Hair 2* (1993) directed by David Wu.

As Wolf Girl Ni-chang, Lin falls in love with Cho Yi-hang (Leslie Cheung) of the rival Wu Tang Clan in the last years of the Ming Dynasty. His betrayal turns her into the witch figure of the title. Clad in lavish costumes by Japanese designer Emi Wada, Lin delivers a mesmerizing performance aided by striking camerawork that emphasizes her deadly features. The sequel sees her leading an all-female cult against men in general and the Wu Tang Clan in particular until her final apocalyptic reunion with Cho. In both these films, Lin's white-haired demonic avenger presents a powerful figure reacting against a world of male betrayal and power. Despite Cho's treachery, the sequel sees Lin's Wolf Girl still trapped in the past remembering her former idyllic love, a memory that generates revenge against the Wu Tang Clan. Her female cult comprises similarly betrayed women who now become ruthless avengers.

Although the dream teaming of 'Invincible Asia meets Stephen Chow' failed to live up to its promise in Gordon Chan and Wong Jing's *Royal Tramp 2* (1992), Lin's performance in Wong's *Boys Are Easy* (1993) fulfilled expectations. Playing a butch cop significantly named after one of Hong Kong cinema's special effects masters who made her role in the *Swordsman* series so evocative, Lin effectively matched Tony Long Ka-fai's effeminate gigolo. It resulted in a different type of romantic union far removed from her early Taiwanese films. However, repetition of her familiar star persona in the 1994 films *Fire Dragon*, *The Dragon Chronicles* and *Three Swordsmen* demonstrated clearly that another change now seemed necessary.

Lin achieved this by retiring from the screen after marrying Esprit Asia Chairman Michael Ying Lee Yuen and began raising a family. She concluded her career with outstanding performances in two other 1994 films both directed by Wong Kar-wai (Wang Jiawei, b. 1958). *Ashes of Time* featured her in her familiar dual star persona as the appropriately named melancholic hero and heroine, Murong Yin and Murong Yang, set in the historical past. By contrast, *Chungking Express* (1994) returned her to a modern world where she first began her career but one different from her early Taiwanese films. During the film's first part, the mature actress appeared as a mysterious *femme fatale* wearing dark glasses and a blonde wig. The latter guise she leaves on the floor after departing from the stage. It is an apt metaphor, signifying the type of masquerade Lin performed throughout the major part of her career. The dark-haired actress exits 'stage right' from a movie screen she will no longer inhabit. By this time, she had surely achieved those three star qualities that Richard Dyer (1986) associates with Marilyn Monroe (1926–62), Paul Robeson and Judy Garland: glamorous sexuality, crossing-over to ethnically diverse audiences, and a gay following. Yet she had combined these within her own specific star persona.

Postscript

Since her retirement in 1984, Lin has never appeared in any film nor is ever likely to. According to Tetsuya's book, she seems quite happy with her new off-screen role. But Lin has not departed entirely from the industry. She has supplied the

narration to two later Hong Kong films: *Bishonen* (Yang Fan, 1998) and *Peony Pavilion* (Yang Fan, 2001). *Bishonen* is interesting because it belongs to the industry's emerging category of gay movies and obviously owes much to the influence of Lin's star persona defined by Stanley Kwan in his documentary *Yang ± Yin*. Executive-produced by Sylvia Chang, who co-starred with Lin in *The Dream of the Red Chamber* over 20 years before, *Bishonen* uses Lin's Mandarin-speaking voice-over in a Cantonese-language male-centred production. This not only intuitively represents Lin's now established gender-blurring star persona but also significantly associates her with feminist definitions concerning the role of the off-screen voice that may involve an alternative, heterogeneous element contributing to the progressive component of the cinematic discourse.

In her recent article on the role of the off-screen voice in *Gigi* (Vincente Minelli, 1958), Susan Smith (2007) suggests that far from representing the type of ideological role defined by Mary Ann Doane (1985) and Kaja Silverman (1988) in promoting narrative reassurance, the role may be actually much more progressive. A world of difference certainly exists between Minelli's 1958 musical and *Bishonen*. But Lin's new role in Hong Kong cinema as an occasional, off-screen narrator may continue the radical aspects of her star persona in new ways that neither she nor her audiences ever considered for the future. The possibilities are endless. Even if the actress will be absent from the screen as a physical presence, she may still continue as a progressive off-screen voice in future productions.

Acknowledgements

I acknowledge the very generous help of David Desser, Lisa Stokes and Akiko Tetsuya for supplying me with information about important aspects of Brigitte Lin's work. I especially thank Art Black for sending me some rare Taiwan films of Brigitte Lin.

Works cited

Doane, Mary Ann (1985), 'The Voice in Cinema: The Articulation of Body and Space', in *Film Sound: Theory and Practice* (eds Elizabeth Weis and John Belton), New York: Columbia University Press, pp. 162–76.

Dyer, Richard (1979), *Stars*, London: British Film Institute.

Dyer, Richard (1986), *Heavenly Bodies*, London: British Film Institute.

Hampton, Howard (1996), 'Venus, Armed: Brigitte Lin's Shanghai Gesture', *Film Comment*, 32: 5, pp. 42–8.

Kowalis, Jon (1997), 'The Diaspora in Postmodern Taiwan and Hong Kong Film: Framing Stan Lai's *The Peach Blossom Land* with Allen Fong's *Ah Ying*', in *Transnational Chinese Cinemas: Identity, Nationhood, Gender* (ed. Sheldon Hsiao-peng Lu), Honolulu: University of Hawaii Press, pp. 169–86.

Navarro, Giorgio and Fabio Zanello (1999), *Tomas Milian: Er Cubano de Roma*, Firenze, Italy: Igor Molino Editore.

Silverman, Kaja (1988), *The Acoustic Mirror: The Female Voice in Psychoanalysis and Cinema*, Bloomington: Indiana University Press.

Smith, Susan (2007), 'Singing Outside the Frame: The Female Voice-Off in *Gigi* (Minelli, 1958)', *cineACTION*, 72, pp. 32–41.

Teo, Stephen (2000), 'Outside the Window', in *Border Crossings in Hong Kong Cinema. The 24th Hong Kong International Cinema Retrospective* (ed. Richie Lam), Hong Kong: Hong Kong Leisure and Cultural Services Department, p. 167.

Tetsuya, Aikiko (2005), *The Last Star of the East: Brigitte Lin Ching Hsia and Her Films*, Los Angeles: private publication.

Williams, Tony (1999), 'Chu Yen Ping: Hong Kong Cinema's Neglected Bizarre Genius', *Asian Cult Cinema*, 22, pp. 60–3.

Williams, Tony (2003), 'Transnational Stardom: The Case of Maggie Cheung Man-yuk', *Asian Cinema*, 14: 2, pp. 180–90.

Filmography

All the Wrong Spies (Wo ai yelaixiang 我爱夜来香), d. Teddy Robin Kwan 泰迪罗宾, Hong Kong, 1983.

Ashes of Time (Dongxie xidu 东邪西毒), d. Wong Ka-wai 王家卫, Hong Kong, 1994.

Bishonen (Mei shaonian zhilian 美少年之恋), d. Yang Fan 杨凡, Hong Kong, 1998.

Boys are Easy (Zhui nan zi 追男仔), d. Wong Jing 王晶, Hong Kong, 1993.

The Bride with White Hair (Baifa monü zhuan 白发魔女传), d. Ronny Yu 于仁泰, Hong Kong, 1993.

The Bride with White Hair 2 (Baifa monü zhuan II 白发魔女传), d. David Wu 胡大为, Hong Kong, 1993.

Chungking Express (Chongqing senlin 重庆森林), d. Wong Kar-wai, Hong Kong, 1994.

Come Fly with Me/I am a Seagull (Wo shi yi shaou 我是一沙鸥), d. Richard Chen Yao-chi 陈耀圻, Taiwan, 1976.

Demon Fighter/Night Orchid (Wuye lanhua 午夜兰花), d. Chu Yen Ping 朱延平, Taiwan, 1982.

Dragon Inn (Xin longmen kezhan 新龙门客栈), d. Raymond Lee 李惠民, Hong Kong, 1992.

Dream Lovers (Mengzhong ren 梦中人), d. Tony Au Ting-ping 区丁平, Hong Kong, 1986.

The Dream of the Red Chamber (Jinyu liangyuan Hongloumeng 金玉良缘红楼梦), d. Li Han-hsiang 李翰祥, Hong Kong, 1977.

Fantasy Force Mission (Mini tegong dui 迷你特工队), d. Chu Yen Ping, Taiwan, 1983.

Forever My Love (Fengye qing 枫叶情), d. Pai Ching-jui 白景瑞, Taiwan, 1976.

Ghost in the Mirror (Gujing youhun 古镜幽魂), d. Song Cunshou 宋存寿, Taiwan, 1974.

Golden Queen's Commandos (Hongfen bingtuan 红粉兵团), d. Chu Yen Ping, Taiwan, 1982.

Gone with the Cloud (Yun piaopiao 云飘飘), d. Liu Chia Chang 刘家昌, Taiwan, 1974.

Lady in Black (Duoming jiaren 夺命佳人), d. Sun Chung 孙仲, Hong Kong, 1987.

The Love Eterne (Liang Shanbo yu Zhu Yingtai 梁山伯与祝英台), d. Li Han-hsiang, Hong Kong, 1962.

Love Massacre (Ai sha 爱杀), d. Patrick Tam Ka-ming 谭谭家明, Hong Kong/USA, 1981.

Morning Fog (Chenwu 晨雾), d. Gao Li 高立, Taiwan, 1978.

The Other Side of Gentleman (Junzi haoqiu 君子好逑), d. Ringo Lam Ling-tung 林岭东, Hong Kong, 1984.

Outside the Window (Chuangwai 窗外), d. Song Cunshou and Yu Zhengcun 郁正春, Taiwan, 1973.

The Peach Blossom Land (Anlian taohuayan 暗恋桃花源), d. Stan Lai 赖声川, Taiwan, 1992.

Peking Opera Blues (Daoma dan 刀马旦), d. Tsui Hark 徐克, Hong Kong, 1986.

Peony Pavilion (Youyuan jingmeng 游园惊梦), d. Yang Fan 杨凡, Hong Kong, 2001.

Pink Force Commandos (Hongfen youxia 红粉游侠), d. Chu Yen Ping, Taiwan, 1982.

Police Story (Jingcha gushi 警察故事), d. Jackie Chan 龙成, Hong Kong, 1985.

Poor Chasers/A Pair of Silly Birds (Yidui shaniao 一对傻鸟), d. Pai Ching-jui, Taiwan, 1980.

Red Dust (Gungun hongchen 滚滚红尘), d. Yim Ho 严浩, Hong Kong, 1990.

Royal Tramp 2 (Luding ji 鹿鼎记), d. Wong Jing and Gordon Chan 陈嘉上, Hong Kong, 1992.

Run Lover Run (Aiqing changpao 爱情长跑), d. Richard Chen Yao-chi 陈耀圻, Taiwan, 1975.

Swordsman 2 (Xiao ao jianghu zhi dongfang bubai 笑傲江湖之东方不败), d. Ching Siu-tung 程小东and Stanley Tong 唐季礼, Hong Kong, 1992.

Swordsman 3/The East I Red (Dongfang buba zhi fengyun zaiqi 东方不败之风远再起), d. Ching Siu-tung and Raymond Lee 李惠民, Hong Kong, 1992.

The Thirty Million Rush (Hengcai san qianwan 横财三千万), d. Karl Maka 麦嘉, Hong Kong, 1987.

True Colours (Yingxiong ouxiang 英雄偶像), d. Kirk Wong Che-keung 黄志强, Hong Kong, 1986.

Web of Deception (Jing hun ji 惊魂记), d. David Chung 钟志文, Hong Kong, 1989.

Yang ± Yin: Gender in Chinese Cinema (Nansheng nüxiang: Zhongguo dianying zhi xingbie 男生女相: 中国电影之性别), d. Stanley Kwan 关锦鹏, UK/Hong Kong: British Film Institute/Kwan's Creation Workshop, 1996.

Zu Warriors from the Magic Mountain (Xin shusan jianxia 新蜀三剑侠), d. Tsui Hark, Hong Kong, 1983.

11 Lee Kang-sheng

Non-professional star

Michael Lawrence

A different kind of action star

Taiwanese Lee Kang-sheng (Li Kangsheng, b. 1968) has been called 'art house cinema's most unlikely superstar' (Hu 2005). A highly visible Chinese actor in today's globalized film culture, Lee is associated exclusively with art cinema. It is in the context of art cinema's regular concern with the everyday that we watch his strikingly ordinary body perform predominantly ordinary actions: sleeping, smoking, drinking, eating, urinating, masturbating. His stardom demonstrates an intriguing juxtaposition between the ordinary and the extraordinary, and between the real person and the star persona.

Lee may therefore be an anomalous figure in this book, since he is a contemporary Chinese star who has achieved international recognition even though he has never appeared in the two most popular vehicles, martial arts and English-language films. The closest Lee has come on-screen to the heroic or incredible bodies of the martial arts film is as the sullen film projectionist in *Goodbye, Dragon Inn* (Tsai Ming-liang, 2003), in which his character is responsible for the screening of King Hu's classic film *Dragon Gate Inn* (1966) at a dilapidated theatre in Taipei.

Lee Kang-sheng's star image is therefore at many removes from the star images of Jackie Chan, Chow Yun-fat and Jet Li. These three actors, who are discussed in the Hong Kong and transnational section of this volume, all made films in Hollywood and achieved international success primarily for their roles in action cinema, toward and in the late twentieth century. In the new century, global 'pan-Asian' blockbusters, such as Ang Lee's *Crouching Tiger, Hidden Dragon* (2000), Zhang Yimou's trilogy *Hero* (2002), *House of Flying Daggers* (2004) and *The Curse of the Golden Flower* (2006) and Tsui Hark's *Seven Swords* (2005), have brought a pantheon of Chinese stars to international audiences. Several of these actors have also appeared in award-winning films by art-house auteurs such as Wong Kar-wai and Hou Hsiao-hsien. Yet they have undoubtedly reached their largest audiences outside Asia as the dynamic and graceful bodies of *wuxia pian* (sword-fighting films).

In contrast, Lee Kang-sheng's renown stems from a series of celebrated Chinese-language films shown at art-house cinemas and festivals throughout Europe and North America since the early 1990s. These include films by Lin Cheng-sheng

(Lin Zhengsheng, b. 1959) and Ann Hui (Xu Anhua, b. 1947), but most notably those by the Malaysian-born, Taiwan-based director Tsai Ming-liang. In this respect, Lee belongs to a tradition of art cinema stars who are associated with a particular director, such as Liv Ullman (b. 1938) with Ingmar Bergman (1918–2007), Anna Karina (b. 1940) with Jean-Luc Godard (b. 1930), Monica Vitti (b. 1931) with Michelangelo Antonioni (1912–2007) and Hanna Schygulla (b. 1943) with Rainer Werner Fassbinder (1945–82). Lee is a central character in all of Tsai's films, which have won many prizes and been the subject of several international retrospectives, including New York and London. Lee's performances in these films, the origin of his fame, are unmistakably other to those of the transnational stars mentioned above.

Lee is often referred to as Tsai Ming-liang's 'muse' or 'fetish' (Martin 2007: 84; Reynaud 2004). He literally embodies Tsai's art cinema. As Jared Rapfogel (2002) suggests, Tsai 'has found his distinctive little patch of land (whose human face is Lee Kang-Sheng)'. Volker Hummel (2004) concurs: 'If I think of Tsai Ming-liang, the first thing I see is Kang-sheng's face'. Lee thus functions metonymically for the cinema of Tsai Ming-liang: the corporeal being of Lee is integral to this director's corpus.

Lee's work in these films, however, challenges our conventional ideas about the professional actor, and the skill and labour involved in creating individual screen performances. His strange and often silent screen presence differs radically from what we typically associate with stars today. Unlike any other screen persona in recent Chinese cinema, Lee is intensely inward, passive and taciturn. On-screen he is often yearning, longing, mourning, isolated, alienated and alone. His erotic identity is complex: he desires and is desired by both men and women. His ambiguous and fluid sexuality is best understood as 'queer' (V. Lee 2007: 123). Yet since his physical and emotional encounters with others are always fleeting, or faltering, he represents 'an unexpected kind of (post)modern sexual subject that is yet to appear fully' (Martin 2003: 166). This chapter therefore explores Lee's unusual star persona by examining his performances' foregrounding of an obdurately physical being, a primarily bodily presence in which erotic being is enveloped.

Certainly, Lee is paradoxical and unique: a Chinese actor with a melancholy screen persona, neither straightforwardly heterosexual nor homosexual. He has established a global following by developing a professional commitment to an individual auteur and by sustaining a non-professional approach to, or style of, performance itself. Tsai's singular aesthetic, as I illustrate here, was influenced at an early stage by Lee's particular way of being before the camera, which the director first considered peculiar and inappropriate. Tsai's films foreground physical bodies at rest and motion rather than traditional psychologically rounded fictional characters. For this reason Lee's performances need to be understood in relation to neorealist and non-professional acting, to appreciate his unique difference as an actor and as a Chinese star.

This chapter examines Lee's difference from contemporary transnational Chinese male stars by first assessing his collaborative and creative partnership

with Tsai Ming-liang, and then addressing his screen presence in relation to ideas concerning the neorealist and non-professional performance. As an internationally acclaimed Chinese actor associated almost exclusively with neorealist or non-professional style performances in films influenced by European art cinema, Lee's stardom demonstrates an important alternative transnational mode of presenting the Chinese male body in action.

Tsai Ming-Liang and Lee Kang-Sheng: mutual discovery

As many accounts of the director's career make clear, Tsai Ming-liang discovered Lee Kang-sheng by chance outside a video arcade in Taipei's Ximending (West Gate) district and offered him a small part in a television film, *All the Corners of the World* (1989). Tsai then gave him a leading role, as a bully, in another television film, *The Kids*, aka *Youngsters* or *Boys* (1991). Tsai recalls of the beginning of their collaboration,

> I felt that there was something very special about him – at the least, something that I had never encountered before in an actor … [He] doesn't jump out at you with classic good looks, but neither is he ugly – he has a kind of average look about him while maintaining his own style.
>
> (M. Berry 2005: 378)

Tsai's descriptions of Lee point to the actor's contradictory qualities: 'very special' and 'kind of average'. Lee is simultaneously individual and typical, extraordinary and ordinary, a revelation or discovery, but one that might easily go unnoticed. He possessed 'something' that distinguished him (or would distinguish him) as a performer, something Tsai 'had never encountered before in an actor' but discovered in Lee (who was not yet an actor). When Tsai decided to make a feature film, *Rebels of the Neon God* (1992), the central character was partly based on Lee's own experiences (he had failed his college entrance exams shortly after making *The Kids*) and shared the actor's nickname, Hsiao Kang or Little Kang. Lee has since appeared in all of Tsai's eight subsequent films: *Vive L'Amour* (1994), *The River* (1997), *The Hole* (1998), *What Time Is It There?* (2001), the short film *The Sidewalk I Gone* (2002), *Goodbye, Dragon Inn*, *The Wayward Cloud* (2005) and *I Don't Want to Sleep Alone* (2006).

Tsai has admitted he cannot imagine making a film without Lee, that their cooperation is continuous (Kraicer 2000: 587). Several critics have rightly acknowledged Lee's contribution to Tsai's body of work. Bérénice Reynaud refers to an oeuvre 'created by Tsai and Lee *together*' (emphasis original) that requires 'a more fluid, more realistic vision of authorship' (2004). Referring to critics who saw Lee's own debut directorial film *The Missing* (2003) as heavily influenced by Tsai's films, Reynaud contends that Tsai's films are reciprocally influenced by Lee Kang-sheng, specifically through the director listening to the rhythm of the actor's body. Indeed, Tsai describes an important incident that took place at the beginning of their collaboration, when, during the shooting of a simple scene,

he began to get exasperated by the natural slowness of Lee's speech and physical gestures.

> We were doing an exterior shot on *The Kid*, I asked him to turn his head to look at another character. His movements were extremely slow, and I thought he looked like a robot. I kept instructing him to do it again, or to blink his eyes as he turned – I wanted him to do something so that the audience would know that he was still alive! He started to feel uncomfortable because I kept criticizing his performance. Finally he turned to me and said, "This is just how I am".... . His words proved to be very important to me. I think that we always have certain ideas about acting that we carry with us that we think are necessary to express certain emotions. I started to realize that he had something very special. His actions may be slow, but why do I always have to get him to hurry up? Why can't I slow down to wait for him?... . I had to readjust the way I looked at performance. Later I realized that it is not at all a matter of fast or slow, as long as the performance is real and convincing.
>
> (M. Berry 2005: 379)

Lesley Stern and George Kouvaros suggest that the particularity of a performance 'emerges out of, and against, a backdrop of generalized performance and filmic conventions' (1999: 14). The particularity of Lee's being before the screen, the 'something very special' that Tsai gradually discovers in Lee, emerges in this instance *against* filmic conventions, the director's 'ideas about acting' and the way he 'looked at performance' (M. Berry 2005: 378–9). Lee himself has suggested that prior to this moment Tsai 'was probably working with the notion that there's some kind of standard motion for someone who turns his head', but since Lee did not have 'these traditional notions of acting' he 'disrupted that way of thinking' (Hummel 2004).

Lee's irregular or non-standard motion, his natural rhythm, influenced the pace of Tsai's films after *Vive L'Amour*. The length of individual shots was gradually increased from film to film, whereas the amount of dialogue was decreased. In their most recent work, dialogue is almost completely absent, resulting in a singularly contemplative cinematic. Tsai suggests that his films 'adopted' the actor's natural rhythm as their own; furthermore, that 'Hsiao Kang is not required to perform' (M. Berry 2005: 380). In other words, according to Tsai, calling Lee's screen presence the result of a performance no longer seems appropriate since the screen time in which his body is enclosed is determined in a particular way by Lee's own original, primary, natural being as a body in the time of the profilmic event.

One scene in particular epitomizes how Tsai's *durational aesthetic* is determined by Lee's physical capacities. Tellingly, this scene depicts filmmaking. In *The River*, Hsiao Kang is approached by a film director (played by the Hong Kong director Ann Hui) to help her shoot a scene in the film she is making. He agrees to wade into a river and float face down in the water in place of a mannequin the director had been using to represent a dead body. Lee's ability to hold his breath determines the length of the take, for both the director in the film, for whom a

longer take produces a more truthful and convincing representation of a corpse, and for the director of *The River*, for whom a longer take produces a distinctly eerie and unsettling representation of a character acting or playing dead. If, as Jean-Pierre Rehm has suggested, one can see this scene as 'a *mise en abyme*, a self-reflexive representation of acting', it is not simply that Hsiao Kang's role requires 'the most passive acting possible' (1999: 14) in ways that correspond to Lee's own work with Tsai. The representation of this dead body, indeed any film body, requires a real body, an actor's body, within whose physical being the representation slowly emerges. For Tsai, Lee's 'mere presence' moves him. This 'mere presence', and its affective impact on Tsai, are what his films seek to offer audiences.

The films of Lee Kang-sheng and Tsai Ming-liang, then, demonstrate a remarkable and intimate continuum between an actor's performances and a director's aesthetic maturation. Here the particular physical characteristics of the former have determined the distinct durational character of the latter, producing what Chris Berry has called an 'excessive' or 'hyperbolic' kind of cinematic realism (1999: 148). Together, Tsai and Lee are responsible for creating films that explore loneliness and longing with an uncompromising attention to (and interest in) an individual's temporal experience of these emotional states, the ways loneliness or longing are lived in and through everyday time, and necessarily take (up) time. The affective force, the felt power of these films, similarly takes (our) time. Ironically, this creative collaboration has resulted in these profoundly moving representations of solitude and of the difficulty of connecting with others. This partnership, and Tsai's trust in and adoption of, or deference to, Lee's natural rhythms, is repeatedly described in their interviews and increasingly acknowledged by critics. Their collaboration presents a kind of counter-thesis to the films' focus on the failure of relationships.

Towards non-professional performance

In *What Time Is It There?*, Hsiao Kang rents a DVD of François Truffaut's *Les Quatre Cents Coups* (*The 400 Blows*, 1959) and is shown smoking, wrapped in a grey duvet, watching the sequence in which Antoine Doinel (Jean-Pierre Léaud) pushes himself upside down on the fairground ride, with his left leg bent at the knee in the same position as the sitting Lee. As his long-term collaboration with Truffaut developed during the making of the Antoine Doinel cycle, Léaud's characterization of Doinel was increasingly influenced by, and thus intimately connected to, his own real self. Léaud/Doinel's presence in Tsai's film invites us to consider how not only European art cinema but also Léaud's performance in particular, and his professional relationship with Truffaut, may help us to understand Lee's work with Tsai.

As James Monaco has argued, 'the ultimate portrait we have of Antoine Doinel may owe as much to Léaud as to its ostensible model, Truffaut' (Monaco 1976: 19). Furthermore, Léaud's development of the Doinel character was due to the 'remarkable freedom' Truffaut gave his actor (Insdorf 1995: 71). Truffaut's films with

Léaud epitomize art cinema's regular preference for the depiction of ordinary lives, and thus for performances whose neorealist authenticity blurs distinctions between character and actor. Lee's performances, and his status as a transnational art-house star, need to be understood in this context.

Understanding his performances as non-professional (in the neorealist manner) challenges our ideas concerning the film star and star performance. Jared Rapfogel (2002) suggests that Lee is 'not called upon to act, exactly, but simply to be and to behave'. By foregrounding being and behaving (rather than conventional acting), Lee's performances seem barely to be performances at all, and so seem to provide access to the real Lee in ways that star performances rarely manage. Instead, the model for this kind of performance is *neorealist* or non-professional, in which the distinction between the role and the real is diminished or even denied altogether.

Tsai's films develop neorealism's interest in the convincing depiction of ordinary, everyday behaviour. 'In a very corporal sense', Pin-chia Feng (2003: 6) has claimed, 'Tsai's film narrative is almost always somatized'. The narrative foregrounds what Kent Jones (2003: 46) has called 'time-swallowing activities'. Bodies in Tsai's films, and Lee's body most of all, relocate the authenticity of neorealist performance – the truthful performing of concrete actions – into more ambiguous and allegorical contexts. According to Meiling Wu (2005: 85), '[each] of Tsai's limited dialogue films falls into a pattern of eating, sleeping, defecating, and having sex'; the lives of the characters are 'dominated by basic bodily functions'. Similarly, Rey Chow (2004: 126) suggests, 'It is human bodies (their basic physical needs, automatized movements, and weird behaviours) rather than human minds that become the primary sites of drama'.

Describing Lee's performances in this way often involves cataloguing seemingly mundane or apparently meaningless behaviour as 'the primary site of drama'. The mesmerizing quality of Lee's performances seems particularly difficult to pin down by simply recounting what happens on the screen: he walks, waits, follows, hides, cooks, eats, drinks, urinates, showers, smokes, rides a scooter, feeds a cat. The extraordinary actions that from time to time punctuate these films have a greater impact on the viewer since they appear alongside more familiar and routine behaviour. Lee holds a watermelon in his hands, gently throws it in the air, catching it like a basketball, then holds it still, in his outstretched arms. He looks at a man sleeping on a bed, lies down beside him, slowly slides across the bed, freezes, then edges even closer, and plants a kiss on the sleeping man's face. He takes a bath in an empty flat, and slides slowly beneath the water's surface. He sits on the bed, drinks from a plastic bottle of water, takes a knife and cuts his wrist and breathes in and out.

Noël Carroll (1990: 199) noted of Buster Keaton (1895–1966), whom Tsai admires, that his film acting is 'rooted in action' as opposed to the 'pretences' and 'mannerisms' that come to mind when we think of film acting. With Keaton, Carroll (1990: 199) advised, we must consider 'a much more basic sense of "acting"', namely 'acting as being involved in a process of doing'. Tsai presents Lee primarily as a body engaged in a 'process of doing', and it is as such a body that the

image of Lee circulates in a global film culture. The foregrounding of doing, as well as of being, in these performances, rather than more visible modes of dramatic characterization, makes Lee's status as a star complex. Through the disappearance of more obvious acting, these films seem to document and deliver to the audience intimate material details of Lee's own physical being more than of a fictive character.

Discussions of stardom repeatedly insist on the complex interaction between the actor, his or her public persona and their performances as characters in films. But actors' existence as stars depends on their relationship to viewers who perceive and respond to them as stars. Richard Dyer (1979, 1986) and Christine Gledhill (1991) understand stardom as involving complex and often contradictory processes surrounding the manufacture and reception of a star's image as well as the star's performances in particular films.

The characters played by a star contribute to his or her persona, but this persona often then restricts the kinds of characters that the star can play convincingly. There is something alchemical about the composition of the star persona, the contribution made by the star's 'real' self and that made by various characters the star plays. The non-professional performer, on the other hand, traditionally appears in a single film, such as Carlo Battisti in *Umberto D.* (Vittorio de Sica, 1952) or Nadine Nortier in *Mouchette* (Robert Bresson, 1967), and is chosen due to their particular consonance with the character they are to play, such as Lamberto Maggiorani in *Bicycle Thieves* (*Ladri di biciclette*, Vittorio de Sica, 1948) or Franco Citti (*Accattone*, Pasolini, 1961). André Bazin, discussing neorealist cinema, welcomed 'the disappearance of the concept of the actor into a transparency seemingly as natural as life itself' (1971: 57).

The 'readjustment' of Tsai's 'ideas about acting', which emerged in relation to Lee's physical peculiarities, represents a process by which conventional concepts of acting and thus 'the concept of the actor' are jettisoned for the 'transparent' representation of Lee, of (his) 'life itself'. The 'neorealist non-professional', the 'real person picked off the streets', 'becomes identified with the character he or she plays. With a movie star it is the other way around: each character he or she plays becomes identified with the movie star' (Perez 1998: 342, 37). The star 'from movie to movie remains by and large a constant presence, an icon that is primarily "Greta Garbo" or "John Wayne" and only secondarily a particular character played by Greta Garbo or John Wayne' (Perez 1998: 342).

In his films with Tsai, Lee plays characters called Hsiao Kang or who remain nameless. We are invited to consider the relationship between these characters and Lee in ways that we would not were the characters (otherwise) named. Furthermore, the films invite us to follow or track, to connect 'each' Hsiao Kang, from one film to the next. He is often shown in familial circumstances that are the same in different films (*Rebels*, *The River* and *What Time Is It There?*) or pursuing the same professional interests across films (*The Sidewalk I Gone* and *The Wayward Cloud*). Lee's work with Tsai therefore challenges the distinction Perez makes between non-professionals and stars. Lee is 'identified with the character he … plays' (in a neorealist non-professional manner) but that character (and this actor)

'from movie to movie remains', and remains in a particular way that foregrounds a 'primary' bodily being rather than a manufactured star persona.

The Bressonian connection: non-professional as model

Tsai has said he hopes Lee never becomes a 'professional' actor, qualifying his remarks by referring to the non-professionals in the films of the French director Robert Bresson. These are non-professionals whose 'acting skills are never discussed' yet Tsai finds these actors 'both persuasive and touching in their roles' (Tsai 2002). By comparing Lee's non-professional performances with the affective authenticity of characters in Bresson's films, Tsai invites us to consider his foregrounding of Lee's bodily being in relation to Bresson's own approach to performers.

Darren Hughes (2003) has discerned in Tsai's cinema something similar to 'Bresson's precise attention to the bodies of his non-professional actors', and Bert Cardullo (2004: 231) has described Tsai's actors as his 'performative instruments in the Bressonian sense'. Gilberto Perez (1998: 342) has described how the 'non-actors' in Bresson's films '[act] by sheer presence', a way of being that is affective on-screen by avoiding recognizable dramatic conventions, just as Lee's 'mere presence' is what 'moves' Tsai. Doug Tomlinson (2004: 90) has discussed how Bresson's methods '[force] us to reassess our cinematic aesthetic, specifically our spectatorial needs' and '[force] us to forestall our habitual reliance on performance'. Bresson's 'aesthetics of denial' sought to reveal rather than construct character, to present physiognomy rather than represent psychology (Tomlinson 2004: 73). Similarly, in Tsai's cinema, human bodies rather than minds are the primary sites of the drama.

In *Notes on the Cinematographer*, Bresson provides a series of elliptical statements, many of which are concerned with elucidating the difference between actors and 'models' (his name for non-professional performers), and the relationship between the film director and their models. With the traditional actor, '[the] "to and fro of the character in front of his nature" forces the public to look for talent on his face, instead of the enigma peculiar to each living creature' (Bresson 1975: 43). With models, on the other hand, '[their] way of being the people in your film is by being themselves, by remaining what they are. (*Even in contradiction to what you had imagined*)' (Bresson 1975: 86; original emphasis). For Bresson, the individual performer's enigmatic peculiarity is revealed only when character (characterization) no longer overlays and obscures the performer's nature, in much the same way that 'life itself' is presented transparently in the neorealist performance Bazin described when welcoming 'the disappearance of the concept of the actor'. By 'remaining what they are', by 'being themselves', the models may 'contradict' the way the director imagined them 'being the people in [the] film'.

It is clear how these remarks, these recommendations for the disappearance of conscious characterization in favour of revealing authentic being, evoke the

working relationship between Lee and Tsai described above. Bresson advises directors to be '[on] the watch for the most imperceptible, the most inward movements' and to draw from models 'the proof that they exist with their oddities and their enigmas' (1975: 45, 31). Again, the patient watchfulness Bresson recommends reminds us of Tsai's decision to 'slow down to wait for [Lee]'. The desire to privilege in the relationship with the model/actor the (mere but remarkable) 'proof that they exist' is also consonant with Tsai's interest in and attention to Lee's physical being.

There is, however, a key difference between Tsai's and Bresson's approaches to their performers. Bresson recommended using 'models' only once (1975: 90). Comparing his working methods with Bresson's, Tsai describes his relationship with actors as long term; only by understanding an actor's 'daily life', their 'real life', can he make films according to his desire for audiences to believe that the character 'is a real person and not just an actor' (Anderson 2002). Lee's stardom, therefore, is the result of an unusually ambiguous and alchemical interplay between his 'real life' and his performances on-screen.

Conclusion

Lee Kang-sheng's collaboration with Tsai Ming-liang has made Lee a particularly significant Chinese actor. His stardom rests to an unusual degree on these films' presentation of his body – of his physical, bodily being. In contrast to traditional star bodies, Lee Kang-sheng's is, paradoxically, extraordinary in and by its ordinariness. As a contemporary Chinese film star, he is an intriguing antidote to the dominant transnational images of the martial arts or fast-paced action body. Lee's movement, stillness, particular material and bodily being, as documented in Tsai's 'body of work which is in fact Lee's body' (Hu 2005), embodies the everyday, and allegorizes existential malaise. It does so in a manner comparable with certain bodies in European neorealism and art cinema of the 1950s and 1960s. The precise presentation (the detailed documentation) in Tsai's films of this bodily being in time – *this* body acting in *this* way – makes Lee Kang-sheng's presence unusual and significant as a contemporary Chinese star in a global film culture.

Lee Kang-sheng is a star because of, not despite, his explicitly non-professional style of performance. Stardom involves complex processes surrounding the manufacture and reception of a star's image as well as the star's performances in particular films. But Lee's on-screen characters remain, from film to film, and in a particularly embodied way, Lee himself. Lee is therefore perhaps the most *authentic* of contemporary Chinese action stars. His performances insistently present 'film action *as* acting', as Noël Carroll discerned of Buster Keaton (Carroll 1990: 199; added emphasis). Through his foregrounding of physical action and being, Lee is simultaneously ordinary and extraordinary. This makes him an actor 'in the way any human being is' (Cavell 1979: 153) and, just as significantly, a Chinese 'action' star in a particular and peculiar way that is very much his own.

Works cited

Anderson, Jeffrey M. (2002), 'Softly Tsai: Interview with Tsai Ming-liang'. http://www.combustiblecelluloid.com/interviews/tsai.shtml. Accessed 20 January 2008.

Bazin, André (1971), *'Bicycle Thief'*, in *What is Cinema?* Vol. 2, trans. Hugh Gray, Berkeley CA: University of California Press, pp. 47–60.

Berry, Chris (1999), 'Where is the Love? The Paradox of Performing Loneliness in Ts'ai Ming-Liang's *Vive L'Amour*', in *Falling For You: Essays on Cinema and Performance* (eds Lesley Stern and George Kouvaros), Sydney: Power Publications, pp. 147–75.

Berry, Michael (ed.) (2005), *Speaking in Images: Interviews with Contemporary Chinese Filmmakers*, New York: Columbia University Press.

Bresson, Robert (1975; 1997), *Notes on the Cinematographer*, trans. Jonathan Griffin, København: Green Integer.

Cardullo, Bert (2004), *In Search of Cinema: Writings on International Film Art*, Montreal: McGill-Queen's University Press.

Carroll, Noël (1990), 'Keaton: Film Acting as Action', in *Making Visible the Invisible: An Anthology of Original Essays on Film Acting* (ed. Carole Zucker), London: Scarecrow, pp. 198–223.

Cavell, Stanley (1979), *The World Viewed: Reflections on the Ontology of Film*, Cambridge, MA: Harvard University Press.

Chow, Rey (2004), 'A Pain in the Neck, a Scene of "Incest," and Other Enigmas of an Allegorical Cinema', *New Centennial Review*, 4: 1, pp. 123–42.

Dyer, Richard (1979), *Stars*, London: British Film Institute.

Dyer, Richard (1986), *Heavenly Bodies*, London: British Film Institute.

Feng, Pin-chia (2003), 'Desiring Bodies: Tsai Ming-liang's Representation of Urban Femininity', *Tamkang Review*, 34: 2, Winter, pp. 1–22.

Gledhill, Christine (ed.) (1991), *Stardom, Industry of Desire*. London: Routledge.

Hu, Brian (2005), 'The Unprofessional: An Interview with Lee Kang-sheng'. http://www.asiaarts.ucla.edu/article.asp?parentid=27006. Accessed 20 January 2008.

Hughes, Darren (2003), 'Tsai Ming-liang'. http://www.sensesofcinema.com/contents/directors/03/tsai.html. Accessed 20 January 2008.

Hummel, Volker (2004), 'An Interview with Lee Kang-sheng', *Senses of Cinema*, 32 (July–September). http://www.sensesofcinema.com/contents/04/32/leekangsheng.html. Accessed 20 January 2008.

Insdorf, Annette (1995), *François Truffaut*, New York: Cambridge University Press.

Jones, Kent (2003), 'Here and There: The Films of Tsai Ming-liang', in *Movie Mutations: The Changing Face of World Cinephilia* (eds Jonathan Rosenbaum and Adrian Martin), London: British Film Institute, pp. 44–51.

Kraicer, Shelly (2000), 'Interview with Tsai Ming-liang', *Positions*, 8: 2, pp. 579–88.

Lee, Vivian (2007), 'Pornography, Musical, Drag and the Art Film: Performing "Queer" in Tsai Ming-liang's *The Wayward Cloud*', *Journal of Chinese Cinemas*, 1: 2, pp. 117–37.

Martin, Fran (2003), *Situating Sexualities: Queer Representation in Taiwanese Fiction, Film and Public Culture*, Hong Kong: Hong Kong University Press.

Martin, Fran (2007), 'Introduction: Tsai Ming-liang's Intimate Public Worlds', *Journal of Chinese Cinemas*, 1: 2, pp. 83–8.

Monaco, James (1976), *The New Wave: Truffaut, Godard, Chabrol, Rohmer, Rivette*, New York: Oxford University Press.

Perez, Gilberto (1998), *The Material Ghost: Films and their Medium*, Baltimore: Johns Hopkins University Press.

Rapfogel, Jared (2002), 'Tsai Ming-liang: Cinematic Painter'. http://www.sensesofcinema. com/contents/02/20/tsai_painter.html. Accessed 20 January 2008.

Rehm, Jean-Pierre (1999), 'Bringing in the Rain', trans. James Hodges, in *Tsai Ming-liang* (eds Jean-Pierre Rehm, Olivier Joyard and Danièl Rivière), Paris: Dis Voir, pp. 9–40.

Reynaud, Bérénice (2004), 'Dancing About Architecture: Sundance Film Festival 2004'. http://www.sensesofcinema.com/contents/festivals/04/31/sund-ance_2004.html. Accessed 20 January 2008.

Stern, Lesley and George Kouvaros (1999), 'Introduction: Descriptive Acts', in *Falling For You: Essays on Cinema and Performance* (eds Lesley Stern and George Kouvaros), Sydney: Power Publications, pp. 1–35.

Tomlinson, Doug (2004), 'Performance in the Films of Robert Bresson: The Aesthetics of Denial', in *More Than a Method: Trends and Traditions in Contemporary Film Performance* (eds Cynthia Baron, Diane Carson and Frank P. Tomasulo), Detroit: Wayne State University Press, pp. 71–93.

Tsai Ming-liang (2002), 'Director's Notes', *What Time Is It There?*, DVD, Wellspring Media.

Wu, Meiling (2005), 'Postsadness Taiwan New Cinema: Eat, Drink, Everyman, Everywoman', in *Chinese Language Film: Historiography, Poetics, Politics* (eds Sheldon H. Lu and Emilie Yueh-Yu Yeh), Honolulu: University of Hawaii Press, pp. 76–95.

Filmography

Accattone, d. Pier Paolo Pasolini, Italy: Arco Film, Cino del Duca, 1961.

All the Corners of the World (Haijiao tianya 海角天涯), d. Tsai Ming-liang 蔡明亮, Taipei, 1989.

Bicycle Thieves (Ladri di biciclette), d. Vittorio De Sica, Italy: Produzioni De Sica, 1948.

Boys (Xiaohai 小孩), d. Tsai Ming-liang, Taipei, 1991.

Crouching Tiger, Hidden Dragon (Wohu canglong 卧虎藏龙), d. Ang Lee 李安, Taipei/Hong Kong/USA/Beijing: China Film Co-Production Corporation, 2000.

The Curse of the Golden Flower (Mancheng jindai huangjinjia 满城尽带黄金甲), d. Zhang Yimou, Beijing: New Picture Film, 2006.

Goodbye, Dragon Inn (Busan 不散), d. Tsai Ming-liang, Taipei: Homegreen Films, 2003.

Help Me Eros (Bangbang wo aishen 傍傍我爱神), d. Lee Kang-sheng, Taipei: Homegreen Films, 2007.

Hero (Yingxiong 英雄), d. Zhang Yimou 张艺谋, Beijing: New Picture Film, 2002.

The Hole (Dong 洞), d. Tsai Ming-liang, Taipei: Arc Light Films, Central Motion Pictures Corporation, 1998.

House of Flying Daggers (Shimian maifu 十面埋伏), d. Zhang Yimou, Beijing: New Picture Film, 2004.

I Don't Want to Sleep Alone (Hei yanquan 黑眼圈), d. Tsai Ming-liang, Taipei: Homegreen Films / France: Soudaine Compagnie, 2006.

The Missing (Bujian 不见), d. Lee Kang-sheng 李康生, Taipei: Homegreen Films, 2003.

Mouchette, d. Robert Bresson, France: Argos Films, Parc Film, 1967.

Quatre cents coups, Les (The 400 Blows), d. François Truffaut, France: Les Films du Carrosse, Sédif Productions, 1959.

Rebels of the Neon God (Qingshaonian nezha 青少年哪吒), d. Tsai Ming-liang, Taipei: Central Motion Pictures Corporation, 1992.

The River (Heliu 河流), d. Tsai Ming-liang, Taipei: Central Motion Picture Corporation, 1997.

162 *Michael Lawrence*

Seven Swords (Qijian 七剑), d. Tsui Hark 徐克, Hong Kong: Film Workshop, 2005.

The Sidewalk I Gone (Tianqiao bujian le 天桥不见了), d. Tsai Ming-liang, France: Le Fresnoy Studio National des Arts Contemporains, 2002.

Umberto D., d. Vittorio De Sica, Italy: Amato Film, De Sica, Rizzoli Film, 1952.

Vive L'Amour (Aiqing wansui 爱情万岁), d. Tsai Ming-liang, Taipei: Central Motion Picture Corporation, 1994.

The Wayward Cloud (Tianbian yiduo yun 天边一朵云), d. Tsai Ming-liang, France: Arena Films/Taipei: Homegreen Films, 2005.

What Time Is It There? (Ni neibian jidian 你那边几点), d. Tsai Ming-liang, France: Arena Films/Taipei: Homegreen Films, 2001.

Hong Kong and transnational cinema

Action, gender, emotion

12 'Bruce Lee' after Bruce Lee

A life in conjectures

Brian Hu

More has been written about Bruce Lee (Li Xiaolong, 1940–73) than about any other Chinese star. In popular culture, he is the subject of biographies, philosophical texts, websites, wall calendars, posters and even folk songs. In film studies, Bruce Lee and his films have been the subject of many excellent studies that typically take as their object of analysis Lee's masculinity and/or his Chineseness (Chiao 1981; Kaminsky 1982; Tasker 1997; Teo 1997: 110–21; Chan 2001; Berry and Farquhar 2006: 197–204). These studies of the Chinese male body have provided valuable insights into issues of Hong Kong identity, diaspora and cultural nationalism as manifested in the 1970s. An alternative approach is proposed by Melanie Morrissette, who calls for scholars to pay more attention to Bruce Lee's fight choreography (2005: 58–9) and M.T. Kato (2007) has more than answered that call.

But these existing studies fail to account for Lee's tremendously malleable, enduring and global star persona as it evolved from Lee's first international appearance in 1971, and beyond his premature death in 1973. This is because scholars and critics have limited their study to the five martial arts films Lee made between 1971 and 1973: *The Big Boss* (Lo Wei, 1971), *Fist of Fury* (Lo Wei, 1972), *The Way of the Dragon* (Bruce Lee, 1972), *Enter the Dragon* (Robert Clouse, 1973) and *The Game of Death* (Robert Clouse, released 1978). Because of the small number (and relative availability) of titles in Lee's canon of mature films, his martial arts films are convenient for study. And because the films were produced within a short window of history, his films and performances are easily generalizable. Rarely is anything mentioned of Lee's early career as a child star, except as biographical background.

More importantly, little is ever mentioned of the countless Bruce Lee imitators who followed after his death, significantly transforming the Lee persona while further commodifying and refining it. The exception is Leon Hunt's valuable 'Exit the Dragon, Enter the "Shadow"', which is to date the best resource on the history of the phenomenon and its many incarnations (2003: 76–98).[1] In this chapter, I argue that if we are to understand Bruce Lee's star persona, we must consider 'Bruce Lee' not only as an individual who starred in a discrete number of films but also as a star discourse that lived on, though the actor did not. 'Bruce Lee' after

Bruce Lee is constructed by an industry seeking to exploit Lee's cinematic persona, and by fans who refused to let go of the memory of Bruce Lee. In this chapter I focus on the discursive operations of the industry: the scattered, heterogeneous film producers who produced internationally distributed 'Bruce Lee' films starring such actors as Bruce Li, Bruce Le, Dragon Lee, Bruce Leong, Bruce Thai and others.

The impetus for this chapter is the question of why Bruce Lee, once the most empowering of all Chinese screen figures and the world's most idolized star, devolved through the decades into a clown, a shtick figure, a racial epithet hurled against Asian Americans. Surely there are still those who hail Bruce Lee as a cult hero, but there are just as many (in Asia and the West alike) who view Bruce Lee as a cheap stereotype of Chineseness on a par with other 'heroes' like Charlie Chan. Provocative but idealistic studies such as Vijay Prashad's 'Bruce Lee and the Anti-imperialism of Kung Fu' (2003) and M.T. Kato's *From Kung Fu to Hip Hop* (2007), and to a lesser extent the studies listed above, prefer to conceptualize Bruce Lee and his myth as eternal: frozen in immortality like the fetishized freeze-frame of Lee's character at the close of *Fist of Fury*. Analysing the 'Bruceploitation' films that were made in the decade after Lee's death allows us to consider how the industry's aggressive appropriation and re-narrativization of the Lee persona diluted the Lee myth these film scholars hold on to so dearly as inviolable.

This re-conceptualization of stardom – from a discrete person to a discourse spanning multiple human bodies – can be better understood as a 'star-function'. Celia Lury has adapted 'star-function' from Michel Foucault's notion of the 'author-function' in her discussion of stardom as an ownable (and thus copy-rightable) commodity (1993: 58). Here, however, I want to emphasize not ownership, but extensibility. In his classic essay 'What is an Author?', Foucault (1977: 131) argues that the term author 'does not refer, purely and simply, to an actual individual', but rather 'it simultaneously gives rise to a variety of egos and to a series of subjective positions that individuals of any class may come to occupy'. Certain authors of special influence can indeed 'speak' beyond their own texts and into future discourse as they are re-interpreted, re-mobilized or even negated. For Foucault, such thinkers as Marx and Freud are authors because they are 'initiators of discursive practices', not simply because they physically penned books which bear their names (Foucault 1977: 132). Thus, they remain authors even after they have stopped writing, and indeed, after they have passed away.

Similarly, certain stars 'speak' from beyond the grave. Elvis Presley lives on (and is repurposed and re-coded) through his impersonators.[2] Tupac Shakur's music is unearthed and remixed posthumously. Actors who appropriate aspects of James Dean and Marilyn Monroe still denote 1950s cool, albeit in new contexts. In Chinese cinema, a similar case can be made for Ruan Lingyu, Zhou Xuan (1920–57), Linda Lin Dai (1934–64) and of course, Bruce Lee. For Foucault, the importance of the author is their 'function' in society – for instance, to give a text a legal owner, to justify a text's authority, and so forth. An obvious, but important, function of the film star is branding. A film about Chinese resistance through martial arts to 1930s Japanese imperialism is simply an average martial arts film, but a film about Chinese resistance starring a fast-moving, yelping man

in a yellow jumpsuit is branded a *Bruce Lee* martial arts film. These visual and aural qualities (wardrobe, movement, voice) are key cinematic ways in which the star 'speaks' within the star-function. Such qualities can be disassociated from the specific human body of Bruce Lee and spoken through his imitators.

The artificial creation of a 'Bruce Lee' brand is precisely why fans and critics have used the term 'Bruceploitation' to describe films starring Bruce Li, Bruce Le, Dragon Lee, and others, explicitly imitating actor Bruce Lee. Qualities deemed specific to Bruce Lee's star-persona are estranged from their rightful owner and exploited through wannabes and their makers to ostensibly 'trick' consumers into imagining they are watching a Bruce Lee film. As a result, the subsequent Bruces are frequently labelled Bruce Lee 'clones', in part fuelled by one of the most self-reflexive Bruceploitation films of all, *The Clones of Bruce Lee* (Joseph Kong Hung, 1977). However, the word 'clone' fails to capture the logic through which Bruce Lee's image has been repurposed cinematically after his death. First, producers did not hide the fact that these were imitators, not the real Bruce Lee. With the exceptions of the Golden Harvest-owned *Game of Death* and *Tower of Death*, aka *Game of Death 2* (Ng See-yuen, 1981), these films were advertised with the name of the imitator as lead actor.

Furthermore, articles in fan magazines on both sides of the Pacific discussed the impersonators as actors with distinct personalities and abilities (*Jinri Dianying* 1976; Scura 1976). In an interview in one such fan magazine, a Bruce look-alike, Alex Kwon, discusses his own distinctiveness: 'I don't intend to copy [Bruce Lee] to very fine points ... because once I try to do that I look very unnatural' (Scura 1976: 41). Many Bruceploitation films even make the story of the 'Bruce Lee successor' their main narrative. *The Real Bruce Lee* (Jim Markovic, 1979) is a biography of Bruce Lee, but also an announcement that of all the Bruce Lee imitators, Dragon Lee is 'by far the greatest'. And as its title suggests, *Exit the Dragon, Enter the Tiger*, aka *Bruce Lee: Star of All Stars* (Lee Tso Nan, 1976) is about the death of Bruce Lee and the rise of the student, 'Tiger' (played by Bruce Li), destined to replace him.

Financial incentive spurs active differentiation between the 'real Bruce Lee' and the 'greatest of imitators': there is money to be made through activating the Bruce Lee brand to create a new brand that can be further exploited. But even without the industry actively highlighting the imitator as Bruce Lee imitator, viewers would have quickly noticed the double signification of somebody like Dragon Lee. As Jane Gaines has shown in relation to the photographed celebrity 'look-alike', the cinematic medium is distinct from literature and painting in that the visible celebrity 'look-alike' on film denotes simultaneously the image of a celebrity and the transparent image of an actor pretending to be that celebrity. That the viewer sees both 'Bruce Lee' and 'Dragon Lee as Bruce Lee' is, as Gaines (1992: 235) put it, 'the perversity of the look-alike phenomenon'. In other words, a 'clone' is impossible in cinema because the viewer can always see the indexical representation of the imitator.

Second, the word 'clone' conceals what I take to be the key characteristic of the Bruceploitation industry: differentiating product through differentiating

Figure 12.1 Conjectural villains: Bruce Lee fights a lion in *Tower of Death.*

narrative. The goal of these films was not simply to replicate *Fist of Fury*, *The Way of the Dragon* and *The Big Boss*. It was to preserve the Bruce Lee image and make profits by presenting something familiar but new. So instead of the term 'Bruce Lee clone', I prefer 'conjectural Bruce Lee'. After his death, the Bruce Lee star persona functioned by becoming flexible and sticky, providing Bruce with new narrative scenarios. Bruceploitation films took Bruce to new locations. *Fist of Fury* took Bruce to Thailand, *Way of the Dragon* took him to Italy and *Enter the Dragon* to a mysterious island; what would be next if Bruce were still alive? How about the streets of Manila (*Bruce Lee's Fists of Vengeance*, Bill James, 1984) or the exotic 'Snake Worship Island' (*Bruce Li in New Guinea*, C.Y. Yang, 1978)?

The films also endowed Bruce Lee with new villains to fight. How would Bruce Lee fare against deadly animals? Conjectured battles raged against giant gorillas (*Bruce Lee the Invincible*, Law Kai-shuk, 1978), deadly bulls (*Challenge of the Tiger*, Bruce Le, 1980) and vicious lions (*Tower of Death*) (see Figure 12.1). The films also pit Bruce against characters from other popular films, part of the industry trend of cross-pollination to reinvigorate existing film franchises (for instance *Zatoichi Meets the One Armed Swordsman*, Kimiyashi Yasuda, 1971). *Bruce and the Shaolin Bronzemen* (Joseph Kong Hung, 1982) pits Bruce against the bronzemen made famous in Joseph Kuo Nan-hung's 1976 film. In *Jackie vs. Bruce to the Rescue* (Wu Chia-chun, 1982), Bruce is up against a Jackie Chan imitator. *Bruce Lee Against Supermen* (C.C. Wu, 1975) sets Bruce against a clan of caped Chinese superheroes. Godfrey Ho's 1982 film *Secret Ninja Roaring Tiger* has Bruce battling ninjas. *The Clones of Bruce Lee* offers the attraction of watching Bruce Lee fight himself, a tradition resurrected later by both Jackie Chan in *Twin Dragons* (Ringo Lam and Tsui Hark, 1992) and Jet Li in *The One* (James Wong, 2001).

The most audacious example of these tendencies is director Lo Ke's 1977 comedy *Dragon Lives Again*. In the film's bizarre opening credits sequence, we see, against a hellish-red background, a series of encounters. First, the film presents

a James Bond look-alike crossing paths with a feet-shuffling Bruce Lee, played by Bruce Leong. Seconds later, we see Bruce in a different outfit – torn white shirt and black pants reminiscent of his character in *The Big Boss*. This time, he's fighting a clan of shadow-like demons dressed in black. In the next set-up, we hear Nino Rota's theme from *The Godfather* (Francis Ford Coppola, 1972) as we watch another man wearing a slick scarf (making him ... the Godfather?), fighting the same clan of demons. Bruce returns in the fourth set-up, this time battling a Zatoichi look-alike. Next, Bruce dressed as Kato from *The Green Hornet* takes on The Man with No Name, as a Morricone-esque spaghetti Western theme plays. Next to take on Bruce (now dressed in Republican-era garb, as in *Fist of Fury*) are two popular horror characters: Dracula and the Exorcist. Next, Bruce (now with nunchucks) fights a Chinese *wuxia* villain in traditional dress. The credits sequence ends with Bruce (back in his *Big Boss* outfit) fighting the shadowy demons once more. The narrative then begins with the corpse of Bruce Lee, dead after 'misadventure', awaiting judgement in the looniest chamber of hell.

The opening credits sequence immediately establishes that the spectacle of *Dragon Lives Again* is the thrill of seeing Bruce in his many incarnations, taking on the entire corpus of 1960s and 1970s action stars. In the rest of the film's wacky 87 minutes, Bruce fights with or against the One-Armed Swordsman, Caine (from *Kung Fu*), Emmanuelle, Yang Guifei, the cops from *House of 72 Tenants* (Chor Yuen, 1973), Popeye (played by future Hong Kong star Eric Tsang), and more, in addition to the superstars of the opening credits sequence. The film's advertising anticipates the attraction of this extreme rendition of 'conjectural Bruce'. The American poster reads '12 Underworld Assassins Trained to Find and Kill Bruce!', accompanied by pictures of nine of the more Western-friendly faces. Similarly, a two-page spread in the December 1976 issue of Hong Kong fan magazine *Cinemart* highlights 24 celebrity 'cameos' from look-alike actors (see Figure 12.2). The layout of this ad, with the Chinese title 'Bruce Storms through the Gates of Hell', invites the viewer to experience a spectacle of Bruce Lee never seen before: the same suave hero, but new villains, new allies, new setting.

This narrative and marketing pattern can be seen as the industry's attempt to transform Bruce Lee's star image into a diverse and self-sustaining film genre, much in the way the massive James Bond, Wong Fei-hung and Zatoichi series can be viewed as genres with their own narrative principles and marketing image. Rick Altman (1998) theorized the pattern of genre development by studios ('genrification') from the perspective of marketing and product differentiation. Altman observed that genres are created into cycles, which are then made into new genres through a process of generic hybridization (Comedy spawns Romantic Comedy, for instance), with cycles publicly displaying their hybridity in advertising for the films. The objective of new cycles is economic: by hybridizing, the studios differentiate their product from the products of other studios working in the same genre. An important corollary of this model is that in striving to create genres (to create cycles), studios strive not for homogeneity but for constant difference from previous films.

Figure 12.2 Spectacles of conjecture: Bruce Lee, Emmanuelle, James Bond and others in an ad for *The Dragon Lives Again* in *Cinemart* (Yinse shijie), December 1976.

The 'Bruce Lee cycle' can be seen as a step in the evolution of the transnational martial arts film. The *gongfu* genre (in 1970s parlance also known as the 'boxing film') itself was a cycle resurrected from the standard *wuda* (martial action) film. Later in the 1970s, fans could detect aspects of the *gongfu* film as recognizably 'Bruce Lee' elements whether the film actually starred Bruce Lee or not, just as certain aspects of the Hollywood spy film are recognizable as 'James Bond' whether or not the film includes one of the official Bond actors. In constructing this cycle, the producers and distributors of Bruceploitation re-orient the Bruce Lee star-function, standardizing stock moves, outfits and narratives and re-deploying them in fresh configurations. As a cycle in search of a genre, the 'Bruce Lee film' was constantly subject to hybridization, mixing Lee's Jeet Kune Do style with other martial arts film traditions like Jackie Chan's action comedy and the 'blind warrior' trope, as in the 1979 comedy *Blind Fist of Bruce*. With or without Bruce Lee the actual person, studios would genrefy the cycle through hybridization. In fact, without the presence of Lee, who was famously authoritative in producing his own films, this process would be eased. Bruce look-alikes are by definition replaceable, and a pliant, conjectural Bruce can be extended in any number of creative directions.

How exactly was this narrative expanded in Bruceploitation? In the language of genre theory, I argue that these films varied the semantic elements (the easily identifiable building blocks of a genre) of the Bruce Lee film, while retaining the basic syntax (the meaningful organization of those building blocks) (Altman 1984). From Lee's five martial arts films, one can identify three main syntactical

functions of 'the fight' – what traditionally structures audiences' responses to Lee's films (Chiao 1981: 35). The first syntactical function of fighting is to assert Chinese strength in the face of imperialism or racism (*The Big Boss, Fist of Fury, Way of the Dragon*). The second is to help uncover a mystery (*Enter the Dragon*). The third is to 'reach the next level' (Lee's unfinished *Game of Death*). We see these basic syntactical operations maintained in Bruceploitation. Examples of the first are those films set in the diaspora. *The Big Boss* was set in Thailand and *Way of the Dragon* in Rome. *Bruce Lee's Secret* (Chang Ki and Chen Hua, 1976) retains the basic Chinese-versus-Other syntax, but varies the semantic location, setting the film in San Francisco. Similarly, *Bruce Lee's Fists of Vengeance* has Bruce fighting the Japanese and Spanish in the Manila underworld and Lee Doo-yong's *Bruce Lee Fights Back from the Grave* (1976) takes Bruce (and his cultural nationalism) to Los Angeles, where he fights white, black and Mexican villains. The varying locations also reflect the fact that Bruceploitation films were made by production companies from throughout the world.

The second syntactical operation is common in an important subgenre of Bruceploitation: the 'vengeance for Bruce' film. These films typically begin with the death of the actor Bruce Lee (complete with footage from Lee's actual funeral). *Exit the Dragon, Enter the Tiger* construes a scenario in which 'Tiger' must seek revenge for Lee against a cartel of drug traffickers possibly involved with Betty Chen (a barely veiled reference to actress Betty Ting Pei, in whose apartment Lee died). *Tower of Death* is about the brother of Billy Lo (the Bruce Lee character from *Game of Death*) seeking revenge for the death of Billy/Bruce within the underworld of transnational crime.

The third syntax strings the semantic element of 'the fight' into a series of challenges of increasing difficulty. In the few scenes shot for *Game of Death*, we see Bruce Lee ascend the stairs of a building, each floor containing an increasingly powerful enemy. Each enemy has his own attributes. The three filmed for *Game of Death* are Dan Inosanto (a Filipino), Ji Han Jae (a master of the Korean Hapkido) and Kareem Abdul-Jabbar (the popular African American basketball player). The most obvious examples of the use of this semantic function are the many *Game of Death* variations that followed Bruce Lee's death. Since *Game of Death* was an unfinished film, the legend of its existing footage inspired filmmakers to produce entire feature-length narratives around the known scenes.

These films sought to thrill audiences by parading the many fight combinations possible within the 'reach the next level' syntax. For instance, each floor in *The New Game of Death* (Lin Bin, 1975), 3 years before Golden Harvest's official *Game of Death*, pits Bruce against a fighter of a different ethnicity or weapon: the first floor features a Chinese duo, the second floor a Japanese with a samurai sword, the third floor a Chinese black belt with a staff, the fourth floor a white Chuck Norris look-alike, the fifth floor an exotic Indian mystic with nunchucks, the sixth floor a tall shirtless black man, and the top floor the big boss with a big whip. *Enter the Game of Death* (Joseph Velasco, 1981) features a monk, a snake charmer, a nunchaku expert and others on each floor. *Tower of Death* retains the basic structure but changes the location. Instead of going up a tower, Bruce travels

down into the depths of an underground castle, where he fights a monk with a long spear, a man in a leopard-skin outfit and a pack of fighters wearing futuristic, metal-coloured jumpsuits.

Building on a *Vibe* magazine article by Jeff Yang, M.T. Kato provocatively compares Bruce Lee's Jeet Kune Do with the remix in hip hop, with the famous *Game of Death* footage being the most vibrant of 'samples' (2007: 178). To extend the hip hop analogy further, I would describe the re-filming of the *Game of Death* narrative in Bruceploitation not as 'remix' but as 'replay', the process by which the hip hop producer takes an old sample, and then 'replays' it with new instruments, before mixing it into a track.

It appears that the central semantic element – the character of 'Bruce' himself – should remain unchanged. Yet to differentiate product and produce new action stars, even 'Bruce' was varied from film to film. As long as core Bruce cues were present (some combination of a yellow jumpsuit, a bloody gash across the chest, a helmet-like haircut, the tendency to flick one's nose with the thumb while fighting, the agile use of nunchaku, the ability to shuffle one's feet quickly, the tendency to taste one's blood before finishing off one's enemy, the preference for fighting shirtless, and most importantly, loud yelping), the Bruces were free to assume different personalities and qualities. Some Bruces were even light-hearted: *Blind Fist of Bruce* (Kam Bo, 1979); *Storming Attacks* (Yueng Kuen, 1978). *The Clones of Bruce Lee* even highlights differences between various Bruce look-alike actors after a mad scientist decides to create three Bruce Lee clones. Given this scenario, Jane Gaines' comments on the look-alikes' double signification become especially important. Held next to each other, each look-alike's differences become even more evident, and part of the fun of the film is to notice that there is a muscular Bruce, a nimble Bruce and so forth (Hunt 2003: 80).

Another important variation on the Bruce Lee persona – one with important ramifications for understanding Lee's masculinity – is that unlike the sexually reserved characters of Bruce Lee's four completed martial arts films, Bruceploitation allowed Bruce to be sexually adventurous – even promiscuous. Chris Berry and Mary Farquhar astutely note that as Lee's career progressed, his characters were increasingly allowed to appropriate American codes of masculinity (2006: 201), which might reflect the increasingly transnational nature of Lee's cinema. Berry and Farquhar anticipate the seemingly limitless transnational explosion of Lee's image after his death, and with it, the transnationalization of Lee's masculinity.

However, compared to that of Bruce's first four martial arts films, the transnationality of Bruceploitation films is even more complex, heterogeneous and slippery, and cannot be explained in terms of the simple fluctuation between 'American' and 'Chinese' masculinity. Therefore, I do not read the Bruceploitation romances in terms of hybridized cultural codes. Instead, I prefer to interpret them in terms of hybridized romantic genre conventions. *Dragon Lives Again* appropriates European and Hollywood sexuality (from *Emmanuelle* (Just Jaeckin, 1974) and James Bond, for instance), while *Bruce Lee and I* (Lo Mar, 1976) appropriates the fleshy lust popular in the soft-core pornography genre produced

in Hong Kong in the 1970s. Also, many Bruceploitation films (*Bruce Lee Against Supermen*; *Exit the Dragon, Enter the Tiger*; *The New Game of Death*) appropriate tropes from Taiwan's romantic melodrama genre of the 1970s (most famously, the 'Qiong Yao films'). These tropes include the walk on the beach during sunset, the Mandarin love ballad and the extended music montage of lovers holding hands as they stroll about the city.

Semantic variability and generic hybridization created opportunities for producers to differentiate their products from others within the Bruce Lee cycle. But this cycle never became a genre, as is possible in Altman's model. One possibility is that initiating a discourse in the Foucauldian sense is not sufficient in creating a genre. Part of the 'genius of the system' is its ability to maintain order despite the necessary variability. Wong Fei-hung is the longest-lasting series in cinema history in part because of the presence of a constant actor (Kwan Tak-hing, 1906–96) and Zatoichi because of actor Shintaro Katsu, even as the series fused with other franchises: *Zatoichi Meets Yojimbo* (Kihachi Okamoto, 1970) and *Zatoichi Meets the One-Armed Swordsman* (Kimiyoshi Yasuda, 1971).

On the other hand, Bruceploitation films loudly flaunted the variability of their look-alikes. Furthermore, Bruceploitation films weren't managed by a single company; thus, there were multiple sequels to the same Bruce Lee movies and drastic reinterpretations of the Bruce persona. The many biopics of Bruce Lee also confused matters. The mysterious nature of Lee's death allowed film producers to playfully conjecture plots regarding Lee's passing. *The Legend of Bruce Lee* (Lin Bin, 1976) supports the 'Vibrating Palm theory' that Bruce Lee died after being attacked by a fatal martial arts move. *Exit the Tiger, Enter the Dragon* suspects that Bruce Lee died as a result of the violent drug trade surrounding Betty Ting Pei. *Bruce Lee and I*, produced by and starring Betty Ting Pei herself, prefers the theory that Bruce died of an old brain disease, compounded by drug use. There are even variations within the same film. *Bruce Lee – True Story*, aka *Bruce Lee: The Man, the Myth* (Ng See-yuen, 1976) presents three alternate endings, each with a different explanation for Lee's death: he was beat up by a local gang; and he suffered from a chronic brain disease; and he faked his death to retreat into spiritual reclusion. This tendency toward speculative biopics resulted in multiple, contradicting mythologies that may be amusing in their creativity, but ultimately make Lee's death spectacularly frivolous. Without a dominant mythologizing presence like Golden Harvest or Bruce Lee himself, the 'Bruce Lee' films that followed Lee's death failed to congeal into a sustainable generic structure.

A second possibility for the fizzling out of the cycle was its inability to sustain Bruce Lee's political credibility. Like Wong Fei-hung, James Bond, Zatoichi and other major film franchises, Bruceploitation films have what TV scholars have called 'series' narratives. In a series, the story concludes at the end of each episode, and the next episode introduces a new, independent story. There is little space for character development across episodes. This differs from a 'serial' narrative, where subsequent episodes pick off from the story of the previous episode (Kozloff 1992: 90–1). As Jeffrey Sconce (2004) has shown, TV series sometimes create interest by providing stunt episodes (the musical episode, the black and white

episode, the 'What if?' episode), which might also include episodes from guest directors.

Much of the appeal of Bruceploitation is exactly this stunting. How would Hong Kong B-movie king Godfrey Ho handle a Bruce Lee film? Or Korean taekwondo auteur Lee Doo-yong? Anybody who ever wondered how Yuen Woo-ping would have choreographed *Fist of Fury* should look no further than the *Fist of Fury* scene in *Bruce Lee and I*. However, though these conjectural combinations sustained interest in the series, they diluted a specific and important aspect of the Bruce Lee persona: his rebelliousness. Because the series format requires that the character remains relatively unchanged at the end of the film (ready for the next adventure in San Francisco, Manila, or New Guinea), Bruce cannot die. Except for the biopics, the films typically end happily: Bruce solves the crime, gets the girl. However, as Hsiung-ping Chiao (1981: 38–9) has noted, films like *The Big Boss* and *Fist of Fury* are perceived as subversive because Bruce Lee is either arrested as a hero who stands up against authority, or is killed and becomes a martyr. These endings give Lee credibility as a political agent who sacrifices for the communities he represents. But because Bruceploitation films seek above all to make money by keeping him alive (some variant of 'Bruce lives!' is their usual tagline), death – and consequently Lee's specific brand of politics – is kept out of the narrative.

Thus, because its primary function is differentiation, Bruce Lee's star image lost much of its political and narrative coherence as it was subjected to revision and competition between film producers in Hong Kong, Taiwan, the United States, South Korea, the Philippines, Italy and elsewhere. Furthermore, the logic of the Bruce Lee look-alike is that Bruce Lee is not a person, but a readily-assumable attitude and style. If even these C-grade actors could be Bruce Lee, in theory, anybody could be Bruce Lee. In fact, this was the attitude taken by much of the fan discourse following Lee's death. Though nobody would claim that Lee could be replaced, articles and advertisements in martial arts magazines suggested that anybody could learn to be Bruce. There were ads for nunchucks, books on Bruce's philosophies and training courses. One article in the American magazine *Fighting Stars* teaches 'Bruce Lee's fighting method self-defense techniques', with special attention on Lee's distinctive footwork (Lee and Uyehara 1981).

Just as the star-function of the Bruce Lee character in Bruceploitation films was flexible and sticky, connecting Bruce to everyone from Superman to *The 18 Bronzemen* (Joseph Kuo Nan-hung, 1976) to Dracula, the star-function of Bruce Lee in everyday life was also increasingly sticky. Bruce look-alikes could feel at home anywhere in the world, be it Hong Kong (*High Risk*, Wong Jing, 1995), Singapore (*Forever Fever*, Glen Goei, 1998), South Korea (*Once Upon a Time in High School*, Yu Ha, 2004), Germany (*Kebab Connection*, Anno Saul, 2005), or the United States (*No Retreat, No Surrender*, Corey Yuen, 1986).[3] Anybody who could yelp and make a fist could be Bruce Lee.

In the United States, 'Bruce Lee' stuck especially to many Asian American males. Just as 'Bruce Lee' in Bruceploitation was no longer the muscular hero of *Fist of Fury* and *Way of the Dragon*, having fallen into the depths of parody hell

in films like *Dragon Lives Again*, the association of 'Bruce Lee' placed on Asian Americans is anything but heroic. As Asian American activist Phil Yu blogs in response to a 2007 incident in which a California employer was sued for racially harassing his Asian worker with 'Bruce Lee' taunts:

> … what Asian guy in America can't relate to being called Bruce Lee or Jackie Chan or some other kind of martial arts nonsense (and not in a good way) during some point in their lives? [...] You know, some dude yelling 'Bruce Leeeeeeee!' out of a passing car? Or some idiot making kung fu noises while you're waiting in line at Burger King? That's right, it happens.
>
> (Yu 2007)

Chinese American director Justin Lin concurs: 'Every Asian American has been called Bruce or have [sic] had the Bruce yell thrown at them. It's a dichotomy of pride and anger. At once powerful, but also stereotypical. You can't escape it'. These words come from the press kit for Lin's 2007 farce *Finishing the Game* (Justin Lin, 2007), a parody of Bruceploitation that conjectures the casting process for Lee's unfinished *Game of Death*. In this film, Lin expands the stickiness of the Bruce Lee persona to comedic limits beyond even *Dragon Lives Again*. Infiltrating the casting sessions are a South Asian Bruce Lee, a Caucasian Bruce Lee, a shell-shocked Vietnam War refugee Bruce Lee and others who collectively lampoon the joke that 'all Asians look the same'. On a more general level, *Finishing the Game* sees the discursive flexibility of Bruce Lee as an opportunity, wresting control of the Bruce Lee persona away from the white film industry in Hollywood and the Asian film industry in Hong Kong, and toward the Asian American populace which has historically suffered as a result of the industries' exploitations in the 1970s.

Another example of the Asian American hijacking of Bruceploitation is Elliott Hong's 1982 comedy *They Call Me Bruce*, about a Chinese immigrant who is constantly referred to as 'Bruce', even though he is nothing more than a noodle cook and, more importantly, does not know Kung Fu. Zaniness ensues when the cook is mistaken in a newspaper as 'Bruce Lee reincarnated!' and is then unknowingly led on a nationwide drug-smuggling operation. The cook learns to use the 'Bruce' stereotype to his advantage, deflecting violent encounters and attracting women in the process. Like so much of Bruceploitation, *They Call Me Bruce* uses the 'reach the next level' syntax from *Game of Death*, structuring fights into a string of increasingly important villains to overcome. Now the 'death tower' isn't a metaphysical tournament of fight techniques, but America itself. The film is structured as a road movie, taking 'Bruce' from state to state, fighting (in gratuitous stereotypes worthy of Bruceploitation) Italians, Jews, cowboys, Poles and blacks to assert the cook's rightful place in America. His (and the film's) comedic assumption of the Bruce persona culminates in a grandiose shot of the cook arriving in New York at the heels of the Statue of Liberty.

In Hong's hands, the Bruce Lee look-alike is no longer a stooge but an agent: an impersonator who combats stereotypes by playfully assuming them. Tina Chen

(2005: 10–11) has theorized the act of impersonation in Asian American cultural production as 'the deliberate confounding of both visible difference and visible sameness', an act that is effective in 'both critiquing the impositions placed upon Asian American subjects via the roles in the US imaginary that they have been historically asked to perform and foregrounding the ways in which these very roles might be utilized to disrupt the codes of conduct they ostensibly uphold'. Thus we witness another operation of the Bruce Lee star-function in Bruceploitation. Deliberate difference here does not simply create marketable differences between products, but foregrounds gaps in the epistemology of Asian-ness in America, as well as gaps within our conception of the 'Bruce Lee' star itself.

Notes

1 Another excellent resource is the website 'Bruceploitation is a crime': http://www. geocities.com/many_bruces/.
2 For instance, the lesbian community has famously appropriated Elvis' persona in its gender-bending variation on the Elvis impersonator (Brittan 2006: 179–86).
3 For a discussion of the discourse of Bruce Lee as mentor in recent kung fu films, see Morris (2001).

Works cited

Altman, Rick (1984), 'A Semantic/Syntactic Approach to Film Genre', *Cinema Journal*, 23: 3, pp. 6–18.
Altman, Rick (1998), 'Reusable Packaging: Generic Products and the Recycling Process', in *Refiguring American Film Genres: History and Theory* (ed. Nick Browne), Berkeley, CA: University of California Press, pp. 1–41.
Berry, Chris and Mary Farquhar (2006), *China on Screen: Cinema and Nation*, New York: Columbia University Press.
Brittan, Francesca (2006), 'Women Who "Do Elvis": Authenticity, Masculinity and Masquerade', *Journal of Popular Music Studies*, 18: 2, pp. 167–90.
Chan, Jachinson (2001), *Chinese American Masculinities: From Fu Manchu to Bruce Lee*, London: Routledge.
Chen, Tina (2005), *Double Agency: Acts of Impersonation in Asian American Literature and Culture*, Stanford, CA: Stanford University Press.
Chiao, Hsiung-Ping (1981), 'Bruce Lee: His Influence on the Evolution of the Kung Fu Genre', *Journal of Popular Film and Television*, 9: 1, pp. 30–42.
'*Duoming jiequandao: Li Xiaolong gushi*' '夺命截拳道：李小龙的故事' ('Deadly Jeet Kune Do: The Bruce Lee Story'), *Jinri Dianying* 今日电影 (Today Movie) (15 July 1976), pp. 6–7.
Foucault, Michel (1977), 'What is an Author?', in *Language, Counter-Memory, Practice: Selected Essays and Interviews* (ed. Donald Bouchard), Ithaca, NY: Cornell University Press, pp. 113–38.
Gaines, Jane (1992), 'Dead Ringer: Jacqueline Onassis and the Look-alike', in *Classical Hollywood Narrative: The Paradigm Wars* (ed. Jane Gaines), Durham, NC: Duke University Press, pp. 227–52.
Hunt, Leon (2003), *Kung Fu Cult Masters: From Bruce Lee to Crouching Tiger*, London: Wallflower Press.

Kaminsky, Stuart M. (1982), 'Kung Fu Film as Ghetto Myth', in *Movies as Artifacts: Cultural Criticism of Popular Film* (eds Michael Marsden, Sam Grogg and John Nachbar), Chicago, IL: Nelson-Hall, pp. 137–45.

Kato, M.T. (2007), *From Kung Fu to Hip Hop: Globalization, Revolution and Popular Culture*, Albany, NY: State University of New York Press.

Kozloff, Sarah (1992), 'Narrative Theory and Television', *Channels of Discourse, Reassembled: Television and Contemporary Criticism* (ed. Richard C. Allen), 2nd edn, Chapel Hill, NC: University of North Carolina Press, pp. 67–100.

Lee, Bruce and Mitoshi Uyehara (1981), 'Bruce Lee's Fighting Method Self-Defense Techniques', *Fighting Stars*, 8: 1, pp. 50–7.

Lury, Celia (1993), *Cultural Rights: Technology, Legality and Personality*, London: Routledge.

Morris, Meaghan (2001), 'Learning from Bruce Lee: Pedagogy and Political Correctness in Martial Arts Cinema', in *Keyframes: Popular Cinema and Cultural Studies* (eds Matthew Tinkcom and Amy Villarejo), London: Routledge, pp. 171–86.

Morrissette, Melanie (2005), '*Cong wushu zhidao kan gongfu dianying*' 从武术指导看功夫电影 ('Watching kung-fu films through martial arts choreography'), in *Zhama shidai: wenhua shenfen, xingbie, richang shenghuo shijian yu xianggang dianying 1970s* 杂嗳时代：文化身份、性别、日常生活实践与香港电影 1970s (Age of hybridity: cultural identity, gender, everyday life practices and Hong Kong cinema of the 1970s) (eds Luo Guixiang 罗贵祥 and Wen Jiehua 文洁华), Hong Kong: Oxford University Press, pp. 50–62.

Prashad, Vijay (2003), 'Bruce Lee and the Anti-imperialism of Kung Fu', *Positions*, 11: 1, pp. 51–90.

Sconce, Jeffrey (2004), 'What If?: Charting Television's New Textual Boundaries', in *Television After TV: Essays on a Medium in Transition* (eds Lynn Spigel and Jan Olsson), Durham, NC: Duke University Press, pp. 93–112.

Scura, John (1976), 'What's So Hard About Playing Bruce Lee?', *Fighting Stars*, 3: 1, pp. 38–42.

Tasker, Yvonne (1997), 'Fists of Fury: Discourses of Race and Masculinity in the Martial Arts Cinema', in *Race and the Subject of Masculinities* (eds Harry Stecopoulos and Michael Uebel), Durham, NC: Duke University Press, pp. 315–36.

Teo, Stephen (1997), *Hong Kong: The Extra Dimensions*, London: British Film Institute.

Yu, Phil (2007), 'Auto Body Shop Settles Harassment Suit', *Angry Asian Man*. http://www.angryasianman.com/2007/09/auto-body-shop-settles-harrassment-suit.html. Accessed 20 January 2008.

Filmography

The 18 Bronzemen (Shaolin si shiba tongren 少林寺十八铜人), d. Joseph Kuo Nan-hung 郭南宏, Taiwan: Hong Hwa, 1976.

The Big Boss (Tangshan daxiong 唐山大兄), d. Lo Wei 罗维, Hong Kong: Golden Harvest, 1971.

Blind Fist of Bruce (Mangquan guishou 盲拳鬼手), d. Kam Bo 金宝, Hong Kong: Kam Bo, 1979.

Bruce and the Shaolin Bronzemen (Shenlong menghu 神龙猛虎), d. Joseph Kong Hung 江洪, Hong Kong, 1982.

Bruce Lee – True Story, aka *Bruce Lee: The Man, the Myth* (Li Xiaolong chuanqi 李小龙传奇), d. Ng See-yuen 吴思远, Hong Kong: Eternal, 1976.

Bruce Lee Against Supermen (Menglong zhengdong 猛龙征东), d. C.C. Wu 吴家骧, Hong Kong: Alpha, 1975.

Bruce Lee and I (Li Xiaolong yu wo 李小龙与我), d. Lo Mar 罗马, Hong Kong: B&B Film, 1976.

Bruce Lee Fights Back from the Grave, d. Lee Doo-yong, South Korea: Habdong and Hong Kong: Yangtze, 1976.

Bruce Lee the Invincible (Nanyang tangren jie南洋唐人街, aka Weizhen tiannan 威震天南), d. Law Kai-shuk 罗基石, Hong Kong: Hai Hua, 1978.

Bruce Lee's Secret (Yongchun yu jiequan 咏春与截拳), d. Chang Ki 张麒 and Chen Hua 陈华, Taiwan/USA/HK: Golden Sun, 1976.

Bruce Li in New Guinea (Shenü yuchao 神女欲潮), d. C.Y. Yang 杨吉爻, Hong Kong: Hai Hua, 1978.

Bruce's Fist of Vengeance, d. Bill James, Philippines, 1984.

Challenge of the Tiger (Shenlong mengtan 神龙猛探), d. Bruce Le 吕小龙, Hong Kong : Dragon Films, 1980.

The Clones of Bruce Lee (Shenwei san menglong 神威三猛龙), d. Joseph Kong Hung, Hong Kong: Wei Ling, 1977.

The Dragon Lives Again (Li Sanjiao weizhen diyu men 李三脚威震地狱门), d. Lo Ke 罗棋, Hong Kong: Goldig, 1977.

Emmanuelle, d. Just Jaeckin, France: Trinarca, 1974.

Enter the Dragon (Longzheng hudou 龙争虎斗), d. Robert Clouse, Hong Kong: Golden Harvest and USA: Warner Bros, 1973.

Enter the Game of Death (Siwang mota 死亡魔塔), d. Joseph Velasco, Hong Kong: Ying Shan, 1981.

Exit the Dragon, Enter the Tiger, aka *Bruce Lee: Star of All Stars* (Tianhuang juxing 天皇巨星), d. Lee Tso Nan 李作楠, Hong Kong: Alpha, 1976.

Finishing the Game, d. Justin Lin 林詣彬 USA: Trailing Johnson, 2007.

Fist of Fury (Jingwu men 精武门), d. Lo Wei, Hong Kong: Golden Harvest, 1972.

Forever Fever, d. Glen Goei, Singapore: Chinarunn, 1998.

The Game of Death (Siwang youxi 死亡游戏), d. Robert Clouse, Hong Kong: Golden Harvest/USA: Columbia, 1978.

The Godfather, d. Francis Ford Coppola, USA: Paramount, 1972.

High Risk (Shudan longwei 鼠胆龙威), d. Wong Jing 王晶, Hong Kong: Wong Jing's Workshop, 1995.

House of 72 Tenants (Qishier jia fangke 七十二家房客), d. Chor Yuen 楚原, Hong Kong: Shaw Brothers, 1973.

Jackie vs. Bruce to the Rescue (Shuangbei 双辈), d. Wu Chia-chun 吴家骏, South Korea/Hong Kong, 1982.

Kebab Connection, d. Anno Saul, Germany: Wüste, 2005.

The Legend of Bruce Lee (Tangshan jiequan dao 唐山截拳道), d. Lin Bin 林兵, Hong Kong: Artist Film, 1976.

The New Game of Death (Xin siwang youxi 新死亡游戏), d. Lin Bin, Taiwan/Hong Kong: Yu-yun, 1975.

No Retreat, No Surrender, d. Corey Yuen 元奎, USA/Hong Kong: Seasonal, 1986.

Once Upon a Time in High School, d. Yu Ha, South Korea: Sidus, 2004.

The One, d. James Wong 黄毅瑜, USA: Revolution, 2001.

The Real Bruce Lee, d. Jim Markovic, USA: Spectacular, 1979.

Secret Ninja Roaring Tiger, d. Godfrey Ho 何志强, HK/South Korea: Asso Asia, 1982.

Storming Attacks (Mengnan da yanzhi hu 猛男大胭脂虎), d. Yueng Kuen 杨权, Hong Kong: Goldig, 1978.

They Call Me Bruce, d. Elliott Hong, USA: Goldpine, 1982.

Tower of Death, aka *Game of Death 2* (Siwang ta 死亡塔), d. Ng See-yuen 吴思远, Hong Kong: Golden Harvest, 1981.

The Twin Dragons (Shuanglong hui 双龙会), d. Ringo Lam 林岭东 and Tsui Hark 徐克, Hong Kong: Golden Harvest, 1992.

The Way of the Dragon (Menglong guojiang 猛龙过江), d. Bruce Lee 李小龙, Hong Kong: Golden Harvest, 1972.

Zatoichi Meets the One Armed Swordsman, d. Kimiyoshi Yasuda, Japan: Daiei/Hong Kong: Golden Harvest, 1971.

Zatoichi Meets Yojimbo, d. Kihachi Okamoto, Japan: Toho, 1970.

13 Jackie Chan

Star work as pain and triumph

Mary Farquhar

I was a useless child
A ragged boy
A reckless teen.
And now—
Look who I am now!
 (Chan 1998: 315)

Introduction

Jackie Chan is a superstar, or dragon, of the Hong Kong cinema. In becoming a
dragon, certain life experiences mould his star image as a narrative of work, pain
and triumph, such as his childhood operatic training, his knock-about brand of
kung fu comedy and the high-risk on-screen stunts that he performs himself. But
star images are made, not born. They are made of everything we know or think
we know about a star and this knowledge has a complex, changing and sometimes
controversial history that projects a particular star's style, persona and context
(Dyer 1986: 2–3; Dyer 1998: 33–86).[1] As an actor, however, Chan's star image
has been remarkably stable for three decades. It relies on a high-octane physical
performance that is excessive, painful and often painfully funny – even though he
always triumphs in the end.

 This chapter looks at Jackie Chan's rise to stardom as a rite-of-passage and
rags-to-riches story that defines him on and off the screen. The discussion delves
behind well-known aspects of his earliest image in two key texts: his star vehicle
Drunken Master (Yuen Wo-ping, 1978) and his English-language autobiography,
I Am Jackie Chan (1998). The argument is that Chan's transition from 'useless' kid
to superstar is embedded in his operatic training, translated into martial arts training
on-screen. This training is performed and remembered as a painful rite-of-passage
from boy to man and it constitutes a major element in Chan's comic performances.
In his autobiography, Chan acknowledges these aspects of his image when he sees
his training – 10 years of hell – as the foundation of his stardom. He writes that his
blood father is 'the father of Chan Kong-sang' but his opera Master is 'the father
of Jackie Chan' (Chan 1998: 57).

In approaching Chan's stardom as narratives of pain and triumph, this chapter extends the theoretical perspectives in Richard Dyer's pioneering work, *Stars* (1979; 1998), which focuses on the star image. In a second edition of *Stars* and subsequent publications, Paul McDonald (1998; 2008) reviews new directions in star studies since then, including stardom as labour that involves 'images of star work'. As McDonald (1998: 195) points out, 'the image of star work is that it is all play and no work'. Conversely, Chan's earliest on- and off-screen persona projects an image of both work and play because his training involves moments of vicarious farce springing from bodily contortions, humiliation, outrageous stunts, cheekiness and pain. Indeed, his autobiography begins by recalling 'the world's most dangerous stunt': his own 60-foot leap from the sixteenth floor of a skyscraper in Rotterdam. He remembers leaping – his body screaming, his heart pounding and his stomach churning – to create 'a few more seconds of excitement' and 'a few more screams' from the audience. His autobiography ends with a 'ghoulish' catalogue of serious injuries caused by performing such stunts over four decades (1998: 1–2; 325–6). In short, Chan's fame rests on extreme bodily performances that play with pain, which is diluted through burlesque and happy endings to make it all worthwhile.

Narratives of pain and triumph are consistent elements of Chan's star image and a foundational element of his comic persona. This chapter turns first to his autobiography in retrospectively setting up Chan's personal story of his rise to stardom, noting that debates on modern autobiography as a construct of the self are similar in a way to debates on star construction. The second section then compares this story with the fictional story 20 years earlier in his star vehicle, *Drunken Master*, to show how public performance and private life are consciously negotiated over time to construct Chan's stardom as the outcome of hard work. The emphasis is on merging this aspect of his life and work in his star persona. The final section focuses on his early comic performance that transforms work into farce and pain into triumph. I suggest here that Chan's star performance is heavily grounded in operatic traditions, which are emphasized as training but downplayed as filmic performance in his autobiography. First published in English and then translated into Chinese in 1998, this work documents Chan's rise as a martial arts star during the rise of cinema and demise of opera in Hong Kong. The perspective, then, is on the early and remembered construction of Jackie Chan's star persona, emphasizing what stardom *does* as well as what stardom *means* (McDonald 1998: 200).

I Am Jackie Chan

Why did Chan write his autobiography in 1998? And why, as a dragon of the Hong Kong cinema, did he (co)write it in English? The obvious reason was to transfer his Hong Kong star persona to a global audience as he transitioned from Hong Kong to Hollywood in the 1990s. His breakthrough 'international Hong Kong film' was *Rumble in the Bronx* (Stanley Tong, 1994), backed by the entire publicity

machine of his American distributors. Chan explained the marketing strategy as follows:

> *Rumble in the Bronx* would be the film that would show audiences in the U.S. the *real* Jackie Chan. And New Line's publicity push would put me on the covers of magazines, in newspapers, on talk-shows. Not as some kind of strange animal, or Bruce Lee clone, or one-hit wonder who'd just gotten off the boat from Hong Kong. As the biggest star in the world.
>
> (Chan 1998: 312)

Rumble was followed internationally by his first commercially successful Hollywood film, *Rush Hour* (Brett Ratner, 1998). Hence, the 'real' Jackie Chan onscreen in *Rumble* and *Rush Hour* was complemented (in English) by the 'real' Jackie Chan off-screen in his autobiography. *I Am Jackie Chan* is integral to the construction of Chan's global star persona, fortuitously in the very same year as his first Hollywood blockbuster.

Autobiography and, more recently, personal websites are therefore ways in which stars and their publicists may negotiate their own distinctive space within a particular star system. Autobiography used to be seen as a truthful representation of the author's life, held together by a proper name and a theme, as distinct from fictional film, held together by character and plot. In the 1970s, however, star studies and autobiographical studies emerged separately as parts of new literary criticism. Since then, both star and author are seen as not 'real'. Authors are constructs that collapse 'the factuality of autobiography and the fabulation of fiction' (Spicer 2005: 393). Without going into debates on authorship that have spilled over into the literature on autobiography, it is clear that an author is not synonymous with either the narrator or main character in an autobiography any more than a star is synonymous with his or her on-screen characters. They do, however, share a common identity as 'the primary figure of the individual who centres and makes sense of the narrative' and star image as a referent within and beyond the text (Dyer 1986: 8–12; Spicer 2005: 398). This is the case with Chan's autobiography, which is so obviously self-centred: *I Am Jackie Chan*. Yet the apparently coherent self brought to the autobiographical text is immediately subverted by a co-author, Jeff Yang, a necessary addition given Chan's poor English-language ability.

The proper name 'Jackie Chan' seems to impose an apparent unity on this life story. But even this is illusory. The title of the Chinese translation is *Wo shi Cheng Long* or *I am Cheng Long*. Both Jackie Chan and Cheng Long are screen names. His third name is his birth name: Chan Shenggang (Chan Kong-sang, b. 1954). The unity in Chan's autobiography is therefore not supplied by a proper name but by his personal success story: from kid to dragon through pain and triumph.

Indeed, Chan's various names chart his career from 'useless' kid to dragon. His birth name, Chan Shenggang, means 'Chan, born in Hong Kong', then a British colony. His father, originally from Shandong, worked as an embassy cook in Hong Kong and then in Australia, leaving his 6-year-old son in the colony as a

child apprentice to a Peking opera school. Chan moved from opera apprentice to stuntman to labourer to celebrity. His autobiography conjures up Hong Kong's opera and film world so that Chan becomes a geographical subject as well as an historical subject in his memoirs. And geography is essential to his star image. From an abandoned child, he became an icon of the Hong Kong cinema and then a global star, perhaps even the world's 'most popular actor' (Zhang and Xiao 1998: 111).

The screen name 'Jackie' has a separate history but is embedded in the same narrative. It was earned in his youth as a labourer on an Australian construction site. Out of work and desperate after he left the opera school for casual work in Hong Kong's exuberant film industry, he moved to his parents' house in Canberra where he says he was an 'embarrassment'. So his father's friend found him a job shifting bricks. Australians make language short and simple, including names. The friend was Big Jack so Chan was Little Jack and then the diminutive, Jackie: 'and that's how Jackie Chan was born' (Chan 1998: 191–2). This name reflects more than his early vulnerability and outsider status, roles he plays again and again on-screen. The back-breaking work outdoors under a fierce Australian sun is just one instance of Chan's capacity for persistent and painful routine, which he learned at the opera school and enacted in *Drunken Master*. While leavened by comedy and outrageous stunts, all his films enact work, combat and, indeed, life as pain, repeated in his now famous outtakes of stunts-gone-wrong at the end of his films. As mentioned earlier, Chan even lists his serious injuries from head to toe in a final chapter of his autobiography called 'It only hurts when I'm not laughing: my aches and pains' (Chan 1998: 325–6).

If 'Jackie' suggests vulnerability, his Chinese screen name, Cheng Long (Sing Lung), anticipates triumph: the grand finale. The name was chosen in 1976, with studio boss Lo Wei and a friend Willie Chan, after he returned to Hong Kong from Australia. Cheng Long means 'already a dragon' and, in contrast to his English name, evokes a symbol of great power. Chan recalls this moment as 'inventing the dragon':

'How about *Zi Lung*?' I said. *Zi Lung* means 'child of the dragon'.
'Forget it,' said Lo. 'You're a hero, not a kid, kid. We don't want people to think you'll grow up to be a dragon *someday*, we want people to say, "Hey, this guy's *already* a dragon".'
Finally, Willie chimed in. 'How about *Sing Lung*?' he said.
Sing Lung means 'already a dragon'.
… And that's how I got the name by which I've been known ever since:
Jackie Chan Sing Lung –
A new dragon for a new generation.
<div align="right">(Chan 1998: 173; 204–5) [original emphasis]</div>

For over 30 years, Chan has played on-screen the invincible hero – but not until the climactic finale – in China's best-known film genre: martial arts. He is one of the two dragons of Chinese cinema. Chan shares 'dragon' (*long*) in his screen

name with Bruce Lee or Li Xiaolong (1940–73): 'Lee, little dragon'. The character *long* in Chan's name consciously recuperates Lee's power as a martial arts actor while the character *cheng* transcends Lee, the cult star who preceded Chan in the 1970s. In a chapter of his autobiography titled 'Enter the Dragon', Chan talks of Bruce Lee's breakthrough film, *The Big Boss* (Lo Wei, 1971) as a revelation 'and if I got the chance, I'd show the Little Dragon what a Shandong boy could do' (Chan 1998: 167).

His screen name was prophetic; Chan was not 'already' a dragon in 1976. His films under Lo had flopped. And Lo still called him a 'kid'. David Bordwell (2000: 55) aptly translates Chan's name with the infinitive 'to become a dragon' and, indeed, Chan had to earn this fame. He became a dragon in 1978 when he changed studios, starring first in *Snake in the Eagle's Shadow* (Yuen Wo-ping, 1978) and then *Drunken Master*, which earned more at the Hong Kong box office than any Bruce Lee movie. While *Snake* is the earlier film that made him a name, *Drunken Master* made him a celebrity. Chen Mo (2005: 196), for example, claims the latter film launched 'the Jackie Chan era'. Martial arts film historian, Jia Leilei (2005: 98), calls it a 'classic' in martial arts film history. While earlier kung fu comedies had box office success, the film confirmed this new sub-genre as a major turning point in martial arts movies. Chan (1998: 222) sees the film as crucial to his own star story: it changed 'everything for me forever', transforming him from a 'kid' into 'a new dragon for a new generation'. This story of personal triumph is variously replayed in film after film.

From kung fu kid to dragon

At 24 years of age, Chan inaugurated his trademark comic role as the 'kung fu kid' in *Snake* and *Drunken Master*. His performance synthesized operatic mime, acrobatics, adolescent slapstick and martial arts into a kung fu sub-genre: kung fu comedy.

> The actor created a character type that was a cross between a human livewire and a boy next door, mostly mischievous but also capable of great sensitivity. The two films form a diptych through the presence of Chan [the naughty boy] and his co-star Yuan Xiaotian [Simon Yuen, the sadistic and oft-drunken *shifu* or master], who in both films played the role of an old master to Chan's kung fu kid.
>
> (Teo 1997: 123)

The rites-of-passage narratives in these early films intersect at many points with Chan's personal reminiscences at 45 years of age where he details his long and painful training, alleviated by boyhood cheekiness and camaraderie in the opera school. In these films, Chan's boyhood character is either fatherless (*Snake*) or abandoned (*Drunken Master*), reciting the actor's own abandonment by his father to Master Yu Jim Yuen of the China Drama Academy where he spent 10 years of tortuous training (Chan 1998: 57). *Drunken Master* anticipates the

boy's eventual triumph. Chan reinvents a martial arts icon as a naughty boy who wins in the end. Here, Chan plays a young Wong Fei-hung (Huang Feihong, 1847–1924), the historical folk hero who featured in a string of earlier Cantonese martial arts movies. The popular black-and-white film series from 1949 onwards featured Kwan Tak-hing (Guan Dexing, 1906–96) as a mature Wong who exemplified Confucian moral conduct and paternal virtue.

Drunken Master sends up Wong's stature and seriousness. In an oft-quoted passage, its producer said Wong 'had always been so serious. I wondered what he was like before he became this Chinese superhero. Maybe he was just another naughty boy!' (Ng in Logan 1995: 63). By privileging juvenile mischief over heroic virtue, the film opened up possibilities for farce, satire, buffoonery and slap stick. But it also opened genuinely new terrain onto the screen: a depiction of a juvenile world full of bullying, beatings, pain and schooling that borders on the sadistic. Chan fights viscerally, using his entire body and anything else that comes to hand or foot, even if it is a cucumber. The growing up in *Drunken Master* is therefore not mundane. It is a drunken, humiliating, painful, riotous romp with every boy's fantasy ending: he defeats his enemies and saves both his father and the local village.

The early scenes set up the first stage of the rite-of-passage plot, which moves from bodily and mental debasement, through a process of brutal lessons under a master, to triumph against evil in a climactic combat suite in the third stage. In a variety of locations in this first stage – a martial arts school run by his father, village market, home, courtyard, restaurant and countryside – the young but likeable Wong Fei-hung cheats, fights and ridicules all who are around him. As retaliation, he is punished and beaten by his father, aunt, an inn keeper, street swindlers, his teacher, and his evil nemesis, Thunderleg.

Wong suffers severe physical pain in the film through a repertoire of torture that includes head locks and beatings, an incense stick in the anus, hot chilli in the mouth, extended 'foot work' better called foot torture, a twisted nose, bitten fingers, and even a big toe tied and pulled in full close-up! Wong runs away from home early on when his father hires the kung fu master, Beggar Su, to discipline him. Su saves Wong in the restaurant only to abduct, imprison and train him in his rural hovel. Again, Wong runs away until he meets Thunderleg who thrashes him and, smiling, forces Wong to crawl between his legs. This is simultaneously Wong's deepest moment of both debasement and enlightenment, recalled through flashbacks. He returns for more training under Beggar Su, the second stage of the rite-of-passage plot. In the third stage, he finally defeats Thunderleg. But the comic timing, vaudevillian music, bodily gymnastics and facial gestures are played with an exquisite operatic excess that lets the audience laugh to Wong's groans and grimaces.

Some of the training in *Drunken Master* mimics actual lessons that Chan endured as a child at the opera school and recorded later in his autobiography. These lessons include cracking open walnuts bare-handed, chilli punishment where the Master Yu's hot caning metamorphizes into a mouthful of real chilli in the film, and hours in agonizing positions that constitute the frozen poses called *liangxiang* in

Figure 13.1 Wong Fei-hung trains quite literally under Beggar Su.

Peking opera. As punishment in his father's school in the film, Wong is made to squat unsupported with bowls of boiling water on knees, shoulders and legs. This scene exaggerates his school lessons, which Chan (1998: 76) recalls:

> I gritted my teeth and remained immobile, my heart pounding and my muscles stiffening … 'Bring me the teapot, Yuen Lung' [Master] said … . I could feel my stomach beginning to buckle, and my left leg, the one on which I was balancing, was a mass of pain.
> Master poured himself a cup of tea, and sipped it, relaxing as his face was framed by steam.
> I wanted to scream … .
> He then leaned over and carefully balanced the cup of tea on my leg.

Chan's reminiscences in his autobiography are selective but gain credibility through similar stories from the opera world, which operated within a broader Confucian system of education based on strict discipline, corporal punishment, rote learning and hierarchy. Colin Mackerras (1997: 6) states that opera train- ing involved 'savage thrashings for even minor offences … so that the art of Peking opera was literally beaten into these boys'. As much as Chan retrospectively

acknowledges his opera training as essential to his stardom, he deeply resented it at the time. His difficult boyhood on and off the screen recalls a transitional Hong Kong world, moving between tradition and modernity in terms of education, class, culture and consumerism. The adolescent plot in *Drunken Master* is therefore ambivalent even if the ending is triumphant. It subverts a bygone era immersed in pain. At the same time, perhaps with a hint of nostalgia, there is a vicarious pleasure in the riotous antics that both Wong and Beggar Su deliver with such *joie de vivre*.

Chan's adolescent image is also transitional but less ambivalent. *Drunken Master* is a period piece. His character survives and triumphs in a world peopled by authoritarian fathers, sadistic teachers and killer villains. He triumphs with a youthful bravado that is irreverent, individual and empowered. His irreverence begins with a blow to filial piety. He hits his teacher, a father-substitute, in school. As he says of his own schooling, hitting the Master was as unthinkable as hitting God (Chan 1998: 45). Whereas irreverence is always punished, it is also justified in the larger abandonment narrative and is crucial to his hero's success. The father-master as paternal power is both present and absent as a moral force. The boy is therefore on his own as he faces his enemies, peers and authority figures on and off the screen. Beggar Su saves Wong in the restaurant only to imprison him; his real-life opera Master beats Chan to teach him. In the pain-drenched learning process, both Wong and Chan create their own agency that acknowledges, resents and surpasses their fictional and blood fathers. In terms of fantasy power, the son is the new Father. He is the 'new dragon' who represents 'a new generation'.

Chan's film and autobiographical coming-of-age stories therefore converge on and off the screen. Both are 'fantasies', in the sense that Chan's autobiography is also a reconstruction of the self, but ones that touch audiences around the world. Clearly, Wong's boyhood played by Chan in *Drunken Master* is fabulation, albeit fun and subversive. But his autobiography is fantasy too, narrated according to a modernist template of individual success through hard work. As Mary Evans demonstrates in *Missing Persons: The Impossibility of Auto/biography* (1999: 76, 105), reminiscences of boyhood in Western autobiography from the nineteenth century onward document a 'masculinist project' as 'the achievement of autonomy and individualism' in which school and military skills shaped the man-to-be.

Chan similarly uses training and martial arts to define his passage to masculine empowerment. Comedy may dilute and confront prescribed patriarchal hierarchies and, in this context, Chan's comic performance undermines traditional demands of filial piety and asserts a newly discovered autonomy in adolescence. Autonomy requires separation from the father, which, in Chan's case on and off the screen, is partially achieved through narratives of abandonment by the blood father to the brutal care of the master. In short, his identity negotiates its own space between two fathers just as his early starring roles negotiate between boyhood and manhood. For filmgoers, then, Chan's stardom is iconic not only of Hong Kong but also of modernity's insistence on individual agency and capitalism's promise of success through work. Chan's early stardom is a twentieth-century boy's own fantasy. *Drunken Master* and *I Am Jackie Chan* begin with humiliation, pain and

abandonment but end on the same triumphant note: 'and now – look who I am now!' (Chan 1998: 315).

Drunken immortals

Without comedy, Chan's early public and private stories would be ones of clearcut teenage rebellion, followed by submission, discipline and triumph through combat. Such stories would reinforce the *status quo*. Comedy, however, makes Chan's masculine persona more ambivalent about patriarchy and gender. The Chinese title of *Drunken Master* is *Zuiquan* (literally, 'drunken fist') and it refers to unarmed combat that conceals lethal power in a series of drunken moves (staggering, swaying, (almost) falling and tumbling), reinvented again and again in martial arts films. Leon Hunt (2003: 31) claims its apotheosis is found in Chan's performance in *Drunken Master*. Chan had to grow from kid to dragon in the film world by inventing his own style of kung fu or unarmed combat. Similarly, his character, Wong, moves from apprentice to Master by defeating Thunderleg in a combat finale, using drunken techniques that are both male *and* female, learned from Beggar Su. Wong intercedes on the way home just as Thunderleg is about to kill Wong's father. Su then wanders into the fray. Wong triumphs in the film by creating his own gender-crossing combat techniques and so both inherits and surpasses the martial arts skills of father, master and enemy in the film. Chan triumphed as a film star, had his first taste of celebrity life, and became a new dragon.

This final scene of *Drunken Master* showcases the 'exaggeration and humour' (*kuazhang he youmo*) that Chan designates, 30 years on, as his signature style (Wang *et al.* 2007). He said that, at the time, he and his colleagues wanted to reinvent the martial arts genre in *Snake* by introducing humour and humanity. The hero in the final fight scene of *Snake* uses all his training with the addition of Chan's own Cat's Claw technique. He wrote:

> Cat's Claw mostly involves me leaping around and making meowing noises; it's not a real kung fu style. But the acrobatics and tumbling that we incorporated into the style looked wonderful, and the fight was just as exciting as any of Bruce's [Lee] battles – yet completely unique in look, feeling and tone.
>
> (Chan 1998: 221)

Drunken Master, he went on, would be 'faster, funnier, and it would throw an even more hallowed tradition (i.e. Wong Fei-hung) to the loop'. The filmmakers invented a new set of kung fu styles based on drunken combat as Wong's 'secret weapon' and added in 'wild acrobatics, slapstick antics, comic mime, and even some real drama' (Chan 1998: 222). Chan's performance is both excessive and subversive, of gender and sobriety as well as generation.

Drunken fighting is, in fact, a marvellous medium for carnival, excess and subversion, whether on stage or on screen. In the film, the original techniques come from Su's manual of the Eight Drunken Immortals (*ba zui xian*). Only one is a woman, Miss Ho (Ho Sen-ku). The young Wong in the film studied the seven male

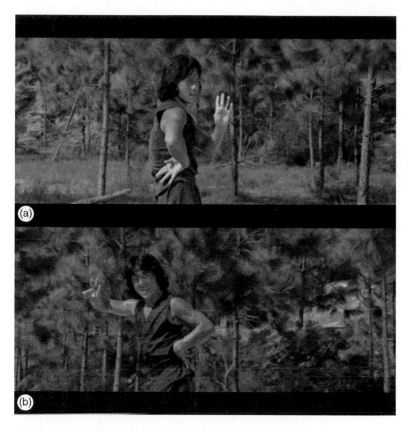

Figure 13.2 Wong's interpretation of Miss Ho in *Drunken Master*.

techniques but threw away the manual on Miss Ho as sissy and useless; initially, the masculinist project relies on a clear rejection of the feminine. When Wong is out of moves against Thunderleg in the finale, however, he invents his own version of the immortal Miss Ho. He combines his invention with merged techniques of the male immortals to win. Miss Ho is the equivalent of the Cat's Claw technique in *Snake*, the 'secret' in Wong's 'secret weapon' because her deadly coquetry completely outfoxes Thunderleg and liberates Wong from submission to male hierarchy and its rules of combat. In breaking the rules, he invents his own style. Indeed, Chan's performance brings exquisite humour to Wong's characterization by combining male with female personas, operatic excess with martial arts farce, and youthful irreverence with killer filiality. He sends up Wong, the eight immortals and Thunderleg (if not the entire film genre) in the primarily male pantheon of martial arts heroes and villains.

A focus on Miss Ho emphasizes the crucial role of Chan's operatic training in his 'exaggerated and humorous' brand of kung fu comedy. Portrayal of her,

I suggest, offers a key to both the burlesque and combat choreography in the final scene. These two points are discussed in turn.

Chan plays Miss Ho as a heroine (almost) straight out of Peking opera. As apprentices, children were usually trained into a specific role but Chan was trained in a range of roles, including the female roles (*dan*) that were traditionally played by men: the filial and virtuous lady or *qingyi*, the flirtatious 'flower female' or *huadan*, and the warrior woman or *wudan*. Chan plays Miss Ho primarily as a *huadan* who metamorphizes back and forth into a *wudan*. Having exhausted his repertoire of drunken male techniques, Wong spoofs the high falsetto voice, swaying hips, sideways glance and graceful hand gestures of the *dan* character as a last resort against his enemy. Moments of fast acrobatic fighting are interspersed with close-ups, medium and long shots of 'Miss Ho' in typical female (almost) frozen poses or *liangxiang* from opera Wong both freezes and sways seductively – he is after all supposed to be drunk – naming moves such as 'sexy girl's fist', 'twisting my arse', 'putting on cheek blush' and 'facing the mirror' as he dances around and pummels his surprised enemy. In the end, female and male immortal techniques combine in Wong's transition from an aggressive male scream to a softer female simper, saying in falsetto that the goddess wants another drink. He drinks and, in a final fast move, leaps on Thunderleg's back and kills him with a head crunch and lock. Brief flashbacks link crunch and lock to moments of training. All ends happily – indeed triumphantly – ever after for Wong and his ilk.

This is not to suggest that Chan's Miss Ho is simply a transplant from opera. Peking opera is a stylized performance, which abstracts and simplifies action and character types on a bare stage through mime, song, costume, painted faces, martial arts and acrobatics. The stylization includes exaggerated movements as conventions that denote character and plot. Chan's genius is to reinvent this exaggeration in a film replete with period landscapes, modern plot and comic characters in every-day dress. His reinvention invests distinctive characters with physical content, bodily contact and realistic sound effects. Chan's Miss Ho is not cross-dressing, so common in Chinese opera although Hong Kong audiences would be familiar with these conventions – that assume male superiority even in playing the female (Li 2003: 212) – and their comic transgression in the portrayal of Miss Ho. This is, however, gender-crossing and it relies heavily on mime and the female fighting that is crucial for victory. His impersonation of the male immortals, whether One-legged Li or Throat-lock Tso, is more obviously from the realistic kung fu lineage of Bruce Lee, whose combat was a revelation to the young Chan: 'street brawling' as 'quick and lethal as a cobra strike, pared down to bare essentials' (Chan 1998: 165). Yet even Chan's male personas mix Lee's aggressive brawling and 'cobra strikes' with Chan's drunken mime, defensive somersaults and evasive tumbling that are so common to opera but are not, as he said himself, 'real kung fu'.

A second operatic aspect of this final combat sequence (indeed, of all the fight sequences) is the choreography. Like *Snake*, the film was directed by another legend of the Hong Kong cinema, Yuen Wo-ping (Yuan Heping, b. 1945), who was also trained in Peking opera. Beggar Su was played by Yuen's father, Simon Yuen (Yuen Siu-tin), another opera actor and veteran of Shaw Brothers movies.

As many observers have noted, Hong Kong martial arts film inaugurated dance-like fight sequences that alternate stillness and slowness with fast and furious fighting. This tempo is operatic in origin and Yuen Wo-ping is not only a master fight choreographer but also the founder of kung fu comedy (e.g. Jia 1998: 69). Whatever the significance of Yuen's role, Chan is the star. In the finale, Chan as Wong announces each successive adoption of the eight different drunken techniques and so brings a rhythmic punctuation to the sequence. Miss Ho brings a change to this rhythm as Wong merges male and female before his deadly strikes at eyes and throat. Thunderleg's high-flying and high-kicking *tae kwon do* is a counterpoint to Chan's drunken, evasive, tumbling moves. Martial arts fans have favourite scenes and this 18-minute finale is deservedly one of the most famous in the business.

Jackie Chan and his colleagues in *Snake* and *Drunken Master* invented their own brand of kung fu comedy that made Chan a superstar and made the films box-office hits. The filmmakers appropriated various conventions, from kung fu, cinema and opera, to consciously reinvent and revitalize martial arts film. In this sense, Chan's physical comedy has been compared to that of the great comedians of the silent film era, especially the legendary Buster Keaton whom Chan much admired. Keaton left vaudeville for film. In their shift from stage to screen, both actors preserved and modified older and declining theatrical forms that involved arduous if not abusive training, physical feats and slapstick. Film technology, according to Sydney Duncan (2007: 352–67), 'offered new opportunities for staging and altering their old routines on the grand scale for which they are known'. But, as Duncan also insists, the comparisons are 'sloppy' outside the rich context of their respective performing traditions, film industries and social milieux.

Chan's brand of kung fu comedy therefore appropriates, integrates and trans-forms a range of theatrical forms and performance styles. By emphasizing operatic movement, comic plots and bodily farce in martial arts films, kung fu comedy added laughter as a counterpoint to the chivalry, blood, revenge and tears that pre-viously saturated the on-screen martial arts world (Jia 1998: 68–9). Importantly, the young martial arts hero also plays with prescribed gender and generational roles to bring ambivalence to the masculine autonomy so painfully achieved through training and fighting. In this sense, Jackie Chan enacted the complexities of becom-ing male for 'a new generation' in the late 1970s, including a new generation of martial arts films and filmmakers.

Conclusion

Jackie Chan is now an older dragon performing for generations of fans. 30 years ago *Drunken Master* launched him as a star. *Drunken Master II* (*Zuiquan 2*, Lau Kar-leung, 1994) was a remake of his 1978 super hit, which now featured a 40-year-old Chan as the young and naughty Wong Fei-hung. Again, the formula worked, setting a new record at the Hong Kong box office, but in this version female farce is supplied by Anita Mui (Mei Yanfang, 1963–2003) as Wong's anarchic mother (Berry and Farquhar 2006: 144–52). By the 1980s, however, Chan had already

shifted from period films to Hong Kong urban comedy as his primary vehicle, followed in the 1990s by Hollywood action cinema. His star image is not static. In the process, the outrageous stunts for which he is famous in the West have replaced the obvious operatic excesses of his earliest starring roles. His props, wielded as weapons, have transmogrified from cucumbers and wine jugs to urban machinery – buildings, buses and careering cars – and then to virtual worlds that fill the frame. Can a 50-something Hong Kong–Hollywood star, whose image relies on extremes of actual bodily performance, keep going as a star?

This question may seem superfluous in an essay on Chan's earliest star image. However, Chan returned to a period kung fu film, *Forbidden Kingdom* (Rob Minkoff, 2008), alongside Beijing-born Jet Li (Li Lianjie). Fred Topel (2007) calls the pairing of the two superstars a fan's 'wet dream'. The pair is really a trio because the film features Yuen Wo-ping as the action choreographer. This film is again a teen-pic, a rite-of-passage plot, in which Chinese legends played by Jackie and Jet – J&J to their Western fans – educate a naïve American, not Chinese, boy. They are the masters; a Western teen is the novice. In this sense, the film reprises, reverses and internationalizes the adolescent roles that respectively made Chan and Li famous as Wong in *Drunken Master* and Jueyuan in *Shaolin Temple* (Zhang Xinyan, 1980).[2] In *Forbidden Kingdom*, Chan plays a dealer in old junk in twenty-first century Boston as well as a drunken master in ancient China. He therefore replays his comic drunken persona 30 years after it first made him famous, while continuing the diverse cosmopolitanism that Chen Zhiling (2006: 11–12) considers to be Chan's filmmaking future into the twenty-first century. And perhaps Chan has regained some of the 'freshness and warmth' that Stephen Teo (2000) found so lacking in his Hollywood persona.

Jackie Chan has worked at becoming a star and being a star over many decades. Part of his star persona is to foreground and, indeed, perform stardom as work. As an ageing Hong Kong–Hollywood superstar he is still working, sparring on-screen with a mainland-born Hong Kong–Hollywood superstar. But he is now much more circumspect. He says that Jet Li's kung fu skills are higher than the 'exaggerated and comic' operatic style that he brings to the film (Wang *et al.* 2007). However, Chan is the comic star in *Forbidden Kingdom*, which, despite mixed reviews, immediately topped the box office upon its release in America, China and Hong Kong (Lee 2008). Fans in a new China and globally in a new century still want to see an older dragon triumphing over villains (and demons) that inflict pain not only on him but also potentially on China and the world. Just look at him now. He has certainly shown Bruce Lee 'what a Shandong boy' can do!'.

Acknowledgements

Thanks to Colin Mackerras of Griffith University for discussions on Peking opera in general and on Chan's final scene in *Drunken Master* in particular; to Liu Xian also of Griffith University for research assistance on recent online articles about Jackie Chan; to Maureen Todhunter for her highly constructive commentary on this chapter; to Jose Da Silva of the Australian Cinémathèque, Queensland Gallery

of Modern Art for help with stills from the film; and, finally, to Kathryn Weir and her team at the Australian Cinémathèque for a one-month film programme and video installation of Jackie Chan movies at the 5th Asia Pacific Triennial of Contemporary Art in 2007.

Notes

1 Thus, for example, Jackie Chan (along with celebrity filmmaker and Olympic impresario Zhang Yimou) was voted China's Most Loved Celebrity in a 2008 mainland survey (N.A. 2008). In contrast, Chan received 'a verbal thrashing across the Chinese-speaking world' in 2009 for suggesting at an elite gathering on Hainan island that 'Chinese people need to be controlled' (*Zhongguoren haishi xuyao bei guande*), presumably by government. He pointed to the alleged freedom and consequent 'chaos' (*hunluan*) of Hong Kong and Taiwan. Hong Kong and Taiwan newspapers retaliated, describing Chan as 'a knave', an idiot and an ignoramus. And almost 10,000 people on *Facebook* cheekily suggested that Chan be exiled to North Korea (Jacobs 2009)!
2 This chapter is a companion piece to a different chapter on Jet Li's adolescent stardom in his first film, *Shaolin Temple* (Farquhar 2009).

Works cited

Berry, Chris and Mary Farquhar (2006), *China on Screen: Cinema and Nation*, New York: Columbia University Press.

Bordwell, David (2000), *Planet Hong Kong: Popular Cinema and the Art of Entertainment*, Cambridge, MA: Harvard University Press.

Chan, Jackie (1998), *I Am Jackie Chan: My Life in Action* (with Jeff Yang), Basingstoke, UK: Pan Books. Translated as Cheng Long 成龙 (1998), *Wo shi Cheng Long* 我是成龙 (I Am Jackie Chan), Taipei: Shibao wenhua gongsi (China Times).

Chen, Mo 陈墨(2005), *Zhongguo wuxia dianying shi* 中国武侠电影史 (A history of Chinese martial arts film), Beijing: Zhongguo dianying chubanshe.

Chen, Zhiling 陈志凌 (2006), 'Duoyuan dingwei shiqi de Cheng Long gongfu dianying chulu sikao' 多元定位时期的成龙功夫电影出路思考 (New directions for Jackie Chan's kungfu films in an age of cosmopolitan pluralism), *Dianying ingjia* 电影评价 (Movie Review), 10: pp. 11–12.

Duncan, Sydney (2007), 'Contextual Perspectives on Buster Keaton and Jackie Chan', *New Review of Film and Television*, 5: 3 (3 December), pp. 353–67.

Dyer, Richard (1986), *Heavenly Bodies: Film Stars and Society*, New York: St. Martin's Press.

Dyer, Richard (1998), *Stars*, Supplementary chapter by Paul McDonald, 2nd edn, London: British Film Institute. First edition 1979.

Evans, Mary (1999), *Missing Persons: The Impossibility of Auto/biography*, London: Routledge.

Farquhar, Mary (2009), 'Jet Li: "Wushu Master" in Sport and Film', in *Celebrity China* (eds Louise Edwards and Elaine Jeffreys), Hong Kong: University of Hong Kong Press.

Hunt, Leon (2003), *Kung Fu Cult Masters: From Bruce Lee to Crouching Tiger*, London: Wallflower Press.

Jacobs, Andrew (2009), 'Jackie Chan Strikes a Chinese Nerve', *The New York Times* (23 April). http://www.nytimes.com/2009/04/24/world/asia/24jackie.html. Accessed 21 June 2009.

Jia, Leilei (1998), *Wu zhi wu – Zhongguo wuxia dianyingde xingtai yu shenhun* 武之舞-中国武侠电影的形态与神魂 (The dance of martial arts: form and meaning in Chinese martial arts films). Zhengzhou: Henan renmin chubanshe.

Jia, Leilei 贾磊磊 (2005), *Zhongguo wuxia dianying shi* 中国武侠电影史 (A history of Chinese martial arts film). Beijing: Wenhua yishu chubanshe.

Lee, Min (2008), 'Kung fu Film "The Forbidden Kingdom" is a Hit in China', Associated Press (8 May). http://www.film.com/news/story/kung-fu-film-forbidden-kingdom/20747590. Accessed 11 May 2008.

Li, Siu Leung (2003), *Cross-dressing in Chinese Opera*, Hong Kong: Hong Kong University Press.

Logan, Bey (1995), *Hong Kong Action Cinema*, London: Titan Books.

McDonald, Paul (1998), 'Supplementary Chapter, Reconceptualising Stardom', in Richard Dyer, *Stars*, 2nd edn, London: British Film Institute, pp. 175–200.

McDonald, Paul (2008), 'The Star System: The Production System of Hollywood Stardom in the Post-Studio Era', in *The Contemporary Hollywood Film Industry* (eds Paul McDonald and Janet Wasko), Malden: Blackwell, pp. 167–81.

Mackerras, Colin (1997), *Peking Opera*, Hong Kong, Oxford: Oxford University Press.

N.A. (2008) 'Zhang Yimou, Jackie Chan: China's Most Loved Celebrities,' *People's Daily Online* (28 December). http://english1.peopledaily.com.cn/90001/90782/92901/6563222.html. Accessed 21 June 2009.

Spicer, Jakki (2005), 'The Author is Dead, Long Live the Author: Autobiography and the Fantasy of the Individual', *Criticism*, 47: 3 (Summer), pp 387–403.

Teo, Stephen (1997), *Hong Kong Cinema: The Extra Dimensions*, London: British Film Institute.

Teo, Stephen (2000), 'Local and Global Identity: Whither Hong Kong Cinema?' *Senses of Cinema* (June). http://www.sensesofcinema.com/contents/00/7/hongkong.html. Accessed 15 January 2008.

Topel, Fred (2007), 'Gongfu zhi Wang 功夫之王 (Kung fu kings): Jackie Chan vs. Jet Li in *Forbidden Kingdom*' (10 August). http://au.rottentomatoes.com/m/forbidden_kingdom/news/1660697/. Accessed 14 January 2008.

Wang, A. 阿旺, Eric Lu and Zhang Liang 张亮 (2007), 'Gaoshou guozhao: Cheng Long Li Lianjie shouci jiaoshou' 高手过招: 成龙李连杰首次交手 (Grand masters spar: Jackie Chan and Jet Li meet in combat), *Mingri fengshang* 明日风尚, 娱乐名人 (Ming: entertainment and celebrities), 7, page unnumbered.

Zhang, Yingjin and Zhiwei Xiao (1998), *Encyclopaedia of Chinese Film*, London: Routledge.

Filmography

The Big Boss (Tangshan daxiong 唐山大兄) d. Lo Wei 罗维, Hong Kong: Golden Harvest, 1971.

Drunken Master (Zuiquan 醉拳), d. Yuen Wo-ping 袁和平, Hong Kong: Seasonal Films, 1978.

*Drunken Master II (*Zuiquan 2 醉拳 2), d. Lau Kar-leung 刘家良, Hong Kong: Golden Harvest, 1994.

Forbidden Kingdom, d. Rob Minkoff (action choreographer Yuen Wo-ping), USA: Lionsgate and Weinstein Company, 2008. This is a Hollywood film with the Chinese title Gongfu zhi wang 功夫之王 (*Kung fu King(s)*).

Rumble in the Bronx (Hong fan qu 红番区), d. Stanley Tong 唐季礼, Hong Kong: Golden Harvest, 1994.

Rush Hour, d. Brett Ratner, USA: New Line Cinema, 1998.

Shaolin Temple (Shaolinsi 少林寺), d. Zhang Xinyan 张鑫炎, Hong Kong: Chung Yuen Motion Pictures and SYS Entertainment, 1982.

Snake in the Eagle's Shadow (Shexing diaoshou 蛇形刁手), d. Yuen Wo-ping, Hong Kong: Seasonal Films, 1978.

14 Chow Yun-fat

Hong Kong's modern TV *xiaosheng*

Lin Feng

Introduction

The principal paradox of stardom is its combination of the ordinary and the extraordinary. As John Ellis explains, a star shares the simple desires of the common citizen, such as love and home, while impersonating the possession of extraordinary qualities such as success, talent and charisma (1991: 313). Ellis acknowledges that a star's presence in films brings the star close to their audience, but emphasizes that a star's charisma comes from their absence from ordinary people's daily life. Using the extraordinary–ordinary as a framework for identifying stardom, Ellis claims that cinematic narrative is essential for an actor to be considered as a star, since it simultaneously connects and disconnects stars with their audience. Understanding television as a medium whose power and significance come from its strong link with everyday life, Ellis (1991: 314) argues that television performers 'bear a fairly minimal relationship to the desire of the spectator' because the audience knows TV actors through familiarity rather than remoteness.

However, while Ellis's extraordinary–ordinary framework is a valuable tool in helping us understand the differentiation between a celebrity/personality and star, his argument that television reduces the star phenomenon by removing the extraordinariness of its performers (1991: 313) simplifies the implications of cross-media stardom as well as the connections between these two industries. Roberta E. Pearson (2004: 67) points out that the domestic nature of television viewing, the close affinity of the celebrity with the image consumer, and the continuity and integrity of character and actor do not necessarily expel the star charisma from TV performers. In a similar vein, I demonstrate in this chapter how in the circumstances of Hong Kong in the 1970s and early 1980s, the closeness and familiarity between the TV actor and audience created a sense of reality, which, instead of reducing the desire of spectators, enhanced it along with the star's extraordinariness. In this chapter, I discuss Chow Yun-fat (Zhou Runfa, b. 1955) as a modern *xiaosheng*, a widely understood term in traditional Chinese opera that refers to a young man who is usually good looking and has a romance with a *huadan*, the young female character.

In the Chinese-language TV and film industry, Chow Yun-fat has managed to maintain his stardom for nearly three decades. From a school dropout to glamorous star, he has been celebrated as a symbol of Hong Kong success. Having graduated from the third actors' training class organized by Television Broadcast Ltd (hereafter TVB) in 1973, Chow Yun-fat started his acting career in the TV industry as a walk-on actor and achieved initial stardom in 1976 through his performance in TVB's first long-length *shizhuang ju* (modern drama) *Hotel* (1976). In the following 10 years, Chow acted in nearly 1,000 TV episodes, which brought him the reputation 'king of TVB serials' (Pang and Zheng 2005) in the early 1980s. In 1985, Chow subsequently moved his acting career to the film industry entirely and has remained popular ever since. However, unlike many other Hong Kong actors, such as Jackie Chan, Tony Leung Chiu-Wai and Andy Lau (Liu Dehua, b. 1961), who also achieved their stardom during the period of the 1970s and 1980s, Chow rarely (although not exclusively) appeared in TV serials or films set in an ancient background before he moved to Hollywood. Thus, the study of Chow's early career has become particularly important in order to understand his star personae, as well as the social changes in Hong Kong during the 1970s and early 1980s.

Modern *xiaosheng*: A romantic, good-looking young man

In the 1970s, the Hong Kong film industry was largely stagnant, due to oversupply in the 1960s (Zhong 2004: 177–80; 232–6). In contrast, at this time the local TV industry experienced rapid growth. With lower price for television sets, more Hong Kong working-class families could afford their own TV set during the 1970s. The rate of domestic TV ownership soared from 3 per cent in 1957 to 90 per cent in 1976 (Wong 1978: 3). The popularity and availability of television created demand for local TV studios to provide not only more Chinese-language programmes but also more programmes concerning local life. However, during the early period of Hong Kong TV history, the majority of programmes were imported from countries such as the United States, Japan and Britain; only a few locally produced programmes were hosted by, or starred actors from, the Cantonese film industry or traditional Cantonese opera theatre.[1] TV studios had to broadcast old Cantonese films, many already adaptations of theatrical dramas from traditional Cantonese opera, to meet public demand for local programmes.

To attract more audiences and compete with each other, local TV studios not only recruited Cantonese filmmakers and Cantonese opera actors but also expanded their production of new TV dramas and organized their own actors' training classes to secure the talent resources. With the owner of Shaw Brothers (Hong Kong's biggest film studio in the 1960s), Run Run Shaw, gradually moving his business to TVB in the 1970s, the local TV industry took over the star system from the film studio (Zhong 2004: 247). TVB had adopted the same star system as Shaw Brothers in the 1960s and not only had its own contract actors but also controlled its stars' public image. Typecasting was, and probably still is, one of the main strategies to create and promote a new star through combining the

actor with a certain type of screen image. Lifted from the theatre, *xiaosheng* and *huadan* became the two most frequently employed character types in the film and TV industries, with a young man and woman often the main characters in the narrative.

However, although typecasting in the Hong Kong television and film industries reprised the formulaic character types of traditional Chinese opera, shifts were made in some of the character features. This was a response to the local perception of social change and the increasing demand for visible self-identity in the local media. An older generation of TV people, such as Cai Heping and Zhong Jinghui, who were in charge of TVB's production of general programmes and dramas, retired or resigned and the production team was gradually replaced by young people (including many who would later be called New Wave directors). These new young talents brought their concerns with local life and society to TV production, modernizing the contents of local TV dramas. While TVB continued to produce traditional popular genres such as martial arts series/serials, modern drama became another popular genre seen on local TV screens from the mid-1970s. Under these circumstances, Chow was gradually promoted as a new local icon.

In his review of the Cantonese TV serial *Man in the Net* (1979), Leslie Fong (1980) described Chow as 'tall, elegant and with dark eyes so smoldering they can melt a girl's heart at 20 paces'. Fong's comments on Chow's appearance and heterosexual appeal reflected TVB's intention to promote Chow as a typical *xiaosheng*. The booklet of *The Fate* (1981), for example, presented an interview between Ngai Chun, the character played by Chow, and a so-called journalist. In this pseudo interview, the journalist frequently used 'handsome', 'smart' and 'attractive' to emphasize the character's as well as the star's charisma. It is noticeable that the emphasis on male appearance is a typical discourse in the traditional Chinese theatre, and it often functions as an indicator of the character's personality and sexual appeal. Although, unlike the theatre *xiaosheng*, the film and TV *xiaosheng* did not need to put on strong face-paint; the attention given to his appearance remained in the shift from stage to screen. Instead of emphasizing the actor's acting skill and his personification of the character, TVB's promotion of Chow's physical attributes not only presented a typical *xiaosheng* image to the public but also reinforced the myth of the 'star look' – that only a few beautiful actors have the potential to become a *xiaosheng*-type star.

However, while Chow was generally considered a good-looking young man in modern dramas, his look was often criticized as unsuitable for playing pre-modern characters (Qiao 1991: 23; Zhong 2004: 253), such as Liu Chi in *The Lone Ranger/The Maverick* (1982) or Linghu Chong in *The Smiling Proud Wanderer* (1984). In terms of the criticism that Chow is 'too modern' and has 'no classical feeling', one of Chow's fans Chengzhen Zhou (1982: 82) questioned the legitimacy of differentiating man's modern and pre-modern looks in his letter to the local magazine *City Entertainment*. Zhou argues that local critics did not like Chow's pre-modern image because the local perception of a pre-modern *xiaosheng* was largely influenced by the traditional Chinese opera theatre. However, everyone has a different appreciation of beauty. Since there is no supplementary make-up

to formulate the character's appearance, the depiction of TV and film *xiaosheng*'s appearance relies, to a greater extent, on the actor's own look. Zhou's argument therefore does not completely explain why Chow's pre-modern look becomes problematic when he is generally seen as a good-looking young man and a *xiaosheng*-type actor. While I agree with Zhou's argument that there are no specific criteria for judging a man's modern or pre-modern looks, I would like to question why a character's historical background impacts on audience perceptions of the actor's look.

A pre-modern *xiaosheng* is a fictional figure representing the double myths of extraordinary good looks and a remote historical period. It is often adapted from characters in classic Chinese novels and folk stories. In contrast, a modern *xiaosheng*'s story often takes place in a contemporary space with which Hong Kong audiences are familiar. These TV serials tell stories of local people and local life, often taking a local young man as the archetype for their protagonists. Since a modern *xiaosheng* was often portrayed as an urban character with clear Hong Kong citizenship, he becomes a member of the local community. The modern *xiaosheng* consequently often possesses two ambivalent features. Along with pre-modern *xiaosheng* and many glamorous film stars, he is considered an extraordinary man in terms of his charisma and sexual appeal. Yet he represents an ordinary local young man. The appearance of a modern *xiaosheng*, as an explicit sign of the character's social and cultural identity, thus indicates simultaneously both extraordinariness/ordinariness and remoteness/closeness.

Pamela Robertson Wojcik (2004: 166) argues that '[t]ypecasting contributes to narrative economy, allowing audiences to quickly and easily recognize a character by associating him or her with an actor's previous roles'. As mentioned above, TVB recruited many film and Cantonese opera actors in the late 1960s and early 1970s, and many of these actors had already established their image as pre-modern *xiaosheng* before they moved into the TV industry. For example, TVB's top pre-modern *xiaosheng*, Adam Cheng, trained as a Cantonese opera actor before he joined TVB. Even the *xiaosheng*-type actors who graduated from TVB's actors training class, such as Wong Wan Choi and Lawrence Wu Wei-kuo, built up their star image as pre-modern *xiaosheng*, through the domination of historical drama and martial arts serials on local TV screens during this early period.

In contrast, far fewer actors were known by local audiences for their modern image before the mid-1970s. Local audiences in this context called for a new local icon that could represent Hong Kong's modern metropolitan identity. Chow had performed a few walk-on parts and minor characters, but did not act any important pre-modern character roles before he starred in his first TV serial. Thus, in his first memorable character role, any deep inscription of a pre-modern *xiaosheng* image simply did not exist. After Chow obtained initial popularity for his urban and Westernized image, TVB recognized the appeal of modern *xiaosheng* to local audiences. The modern drama soon became another main genre on local screens and Chow was frequently cast as a modern young man in TVB's serials. Needless to say, in serials set in contemporary Hong Kong and even in the serials set

in the 1930s and 1940s, Chow was always cast as a modern young man who dressed in Western clothing, such as Hui Man Keung in *The Bund* (1980) and Ouyang Han in *Good Old Times (1981)*. These early TV works served to integrate an urban and Westernized image into his star personae. Given the increasing popularity of the Western lifestyle after the war, local people identified more easily with an urban character with a Westernized lifestyle. As a result, when Chow was cast as a pre-modern *xiaosheng* in 1982, his already strongly established modern personae disrupted association of his pre-modern look with his modern star image. In some sense, criticism of Chow's pre-modern looks suggested local audiences' refusal to accept Chow's image moving from closeness to remoteness.

The relationship between *xiaosheng* and *huadan* should also not be overlooked. As another typical (or even stereotypical) feature of a *xiaosheng*, sexual appeal often suggests that romance is one of the traditional narratives in the Hong Kong media. TVB's promotion of Chow as a new *xiaosheng*-type star not only cast him as a romantic lead but also emphasized his heterosexual appeal to audiences. For instance, the cover of a 1980 TV booklet *Family Feelings* features a photograph of Chow Yun-fat cuddling female star Dodo Cheng from behind, with their faces close to each other. The booklet not only suggested romance between the two stars but also focused on their image as screen lovers. Since Chow and Cheng had starred together twice in a serial involving a romantic relationship, the booklet asked directly whether Chow and Cheng would become a real couple. Here TVB not only followed the typical discourse of the romantic relationship between *xiaosheng* and *huadan* but also responded to the public's curiosity about the stars' private romantic lives.

Romance between the *xiaosheng* and the *huadan* was rarely absent from Chow's TV characters. Yet the extraordinariness of Chow's heterosexual charisma also came from the narratives of female characters. The narratives of the modern *huadan* in Chow's TV serials were quite different from those of pre-modern female characters. The typical narration of a pre-modern *xiaosheng* romance depicts the *huadan* as a dependent, passive, beautiful woman, Chow's modern *xiaosheng*, however, often falls in love with 'new women' who are 'independent' and 'brave' (TVB 1980), 'smart' and 'intelligent' (TVB 1981a) and 'rebellious' (TVB 1981b). In contrast to the pre-modern *xiaosheng* who often find females who share their traditional patriarchal values (i.e. a woman's domain is the family) attractive, Chow's modern *xiaosheng* often devotes his love to career women who challenge the traditional male professional domain, such as the magazine editor and business woman in *Man in the Net*, the solicitor in *The Fate*, the factory worker in *Family Feelings* and so forth. Choosing these women as his ideal partner, Chow's modern *xiaosheng* displays his appreciation of talent rather than physical beauty.

The portrayal of Chow's romantic image was informed by rapid social changes in gender roles. Along with industrialization in Hong Kong, perceptions of gender and gender relationships started to shift in the 1960s as more women joined the workforce and even became family breadwinners. Ling Song's reviews (2004)

revealed that TVB, under public pressure, rewrote the ending of *Man in the Net* to reunite Ching Wai (Chow Yun-fat) and Fong Hei-man (Dodo Cheng). Similarly, the initial plot of *Family Feelings*, in which Chow and Cheng were separated, dissatisfied the public, causing complaint letters to pile up at TVB. As a result, TVB re-shot the ending and added a scene in which Shi Hui (Chow Yun-fat) confesses his love to Chow Tong (Dodo Cheng) in front of her grave. The collective creation of these characters and the popularity of Chow's modern *xiaosheng* image in the local media indicate that local audiences not only celebrated those female stars who represented the new career woman, such as Connie Chan Po-chu (Chen Baozhu, b. 1949) and Josephine Siao Fong-Fong (Xiao Fangfang, b. 1947), but also called for a male icon who valued career women and shared the perception of new gender relationships.

Local *xiaosheng*: A role model of Hong Kong success

In the 1970s, rapid economic growth turned Hong Kong into one of 'Asia's Four Little Dragons'.[2] As Kuan Liang (2002: 123) and Yao Yao (2002: 16) claim, the urbanization and modernization of Hong Kong quickly changed the public's taste in media content. National glory and heroic behaviour were no longer the key concerns in Hong Kong TV programmes of the 1970s. Instead, local audiences started to show a preference for stories telling how a person strives for upward social mobility. As Michael Curtin (2003: 250) points out, modern on-screen *xiaosheng* often depict a local young man who 'works his way up the ladder' by his determination and diligence. In his study of *Man in the Net*, Curtin argues that Wai (Chow Yun-fat) achieves success through his meritorious labour rather than through favours or advantages from friends or family. As a mirror of Ah Chian,[3] Wai's younger brother who immigrated from mainland China to Hong Kong illegally, Wai legitimized local citizens' self-pride in the rapid growth of its economy and feelings of superiority over mainland Chinese. According to Curtin (2002: 182), Wai provided a site for local people to see themselves portrayed as 'diligent, educated, and law-abiding citizens'. Chow, as the star who impersonates the Wai character, was thus recognized as a role model for local young men.

Chow's image as a Hong Kong role model is produced not only through the characters he played but also through his own experience in both TV and film industries. After Chow established his stardom and popularity in the TV industry, he began to seek a breakthrough for his acting career in the film industry. Offered a role in Ann Hui's *The Story of Woo Viet* (Ann Hui, 1981), Chow was determined to accept the opportunity regardless of TVB's objections. He hoped to make an impact on the film industry and extend his acting career.[4] Threatening to sue TVB over his contract, Chow finally obtained the chance to star in the film. However, the issue ultimately brought him to a career crisis during the first half of the 1980s.[5]

Chow's top *xiaosheng* status at TVB was soon replaced by new actors – the 'TVB Five Tigers'[6] in particular – in the mid-1980s (Zhong 2004: 319). After the

dispute Chow starred in far fewer TV serials than in the earlier period, and in these serials he was now cast more often as a middle-aged man or supporting character, such as Triad leader Lok Chong Hing in *The Battle among the Clans* (1985). Here Chow's character was aged around 50, requiring Chow to have his hair streaked grey. In *Police Cadet '85* (1985), Chow was cast as support character Ging Shing, the uncle of the lead *xiaosheng* Cheung Wai-Kit (Tony Leung Chiu-Wai). In his last TVB serial, *The Yangs' Saga* (1985), which starred the 'TVB Five Tigers', he played the minor role of Lü Dongbin, a middle-aged-looking character of the Eight Immortals in traditional Chinese Daoist mythology.

These middle-aged and supporting characters seemed to indicate the fading of Chow's *xiaosheng* personae. By then, however, Chow was increasingly accepted as a serious film actor. After winning Best Actor award twice – at Taiwan's Golden Horse Awards and at the Asian Pacific Film Festival – for his performance in the film *Hong Kong 1941* (Leong Po-Chih, 1984), Chow was seen as a role model by young Hong Kong TV actors. As Ma Hui (1985: 19) observes:

> During the last 12 years, Chow ... transformed himself from an 'everyman' to today's best actor winner. He represents a dream, a dream to change fate. Recently, television studios have introduced many new actors, and Chow has become their older brother who has been imitated.

In keeping with his modern *xiaosheng* image on the screen, Chow became another example of a local young man making a successful career move and rising in social class through his hard work and talent.

Chow's experience in the TV industry and his cross-media career in some sense exemplified an aura of credibility and reality: the message that extraordinariness is achievable. Hong Kong citizens of the 1970s did not want an imaginary hero; they wanted a real model whose success they too could achieve. As Qiao (1991: 22) argues, by comparison with film stars like Jackie Chan who have not worked in the Hong Kong TV industry, Chow is seen by local people in terms of the 'aspiration', rather than 'imagination', of achieving success. Jackie Chan, who is known for his working-class image, is celebrated as a larger-than-life hero whose success is attributed to his extraordinary physical stunts. In contrast, Chow shows local audiences the process and possibility of transforming himself from an ordinary local young man to an extraordinarily glamorous star.

Chow's TV experiences further facilitated the intimacy between the star and the local community. As local film critic Kei Shu claims:

> The strongest attraction about Chow is that he belongs totally to Hong Kong. He is a star but he has at the same time a down-to-earth quality that enables the audience to identify with him ... The closeness we feel about him comes in part from his television career and in part from his total accessibility. We know about his history ... as he worked his way up step by step, we were there to witness the process.
>
> (Sek Kei *et al.* 2000: 108–9)

Watching TV was one of the most popular forms of entertainment in Hong Kong during the 1970s and early 1980s; other entertainments such as karaoke and video games did not become popular until the late 1980s. As a pre-eminent TV star during that period, Chow appeared frequently in this domestic medium. TV screens shortened the distance between the actor and local audience. Although Chow created many memorable heroic screen characters after he moved to the film industry, his real charisma, as Qiao (1991: 24) claims, probably comes from the perception that Chow lives a local citizen's everyday life.

This was particularly important during the period of transition, when Hong Kong citizens began to question their own identity more than ever. Rapid economic progress had transformed Hong Kong into a metropolis by the 1970s, but mainland China still suffered from poor infrastructure, lack of public services, and a chaotic financial system in the wake of 10 years of Cultural Revolution. Material life in Hong Kong was far more advanced than in mainland China, despite the beginning of economic reforms in the People's Republic of China (PRC) in 1978. With a feeling of superiority over their mainland counterparts, Hong Kong citizens began to question their Chinese identity, especially when rumours of negotiation between the PRC and British governments regarding the return of Hong Kong sovereignty became public in the late 1970s. The divergent political ideologies of capitalist Hong Kong and communist mainland China also challenged locals' perception of Hong Kong as 'Chinese'. Yet rumour about sovereignty return also served to remind Hong Kong citizens of their colonial identity. When the people of Hong Kong discovered they were unable to join in the Sino–British negotiations begun in 1982, they realized the weakness of their political voice as colonial citizens. The ambivalence of Hong Kong's political and economic status and concern about its future urged local people to see themselves as a unique community. The local audience chose Chow, a local young man who had managed his acting career successfully across media, as a new Hong Kong icon whose *xiaosheng* image represented their desire to control their own fate.

Conclusion

Chow's popularity in Hong Kong is inseparable from his early TV career and Hong Kong citizens' awareness of their own identity. The search for a new local icon facilitated the connection of Chow's modern *xiaosheng* image with Hong Kong's own local identity. While typecasting in the Hong Kong TV industry still emphasized a leading man's appearance and heterosexual attraction, the shifting features of Chow's *xiaosheng* images indicate the social changes at work during a period when Hong Kong experienced rapid economic growth and increasing awareness of political change. While Chow's TV experiences de-glorified the star image as an extraordinary public icon, his career move provided local citizens with a window through which to view the process of a young man changing his fate. The popularity of his *xiaosheng* image not only met local people's desire for success but also, more importantly, fulfilled local citizens' perceptions of themselves and their local society.

Notes

1 Traditional Chinese opera is a form of stage performance combining story narrative, music performance, dance, acrobatics, and sometimes martial arts. It is a general term covering hundreds of different regional operas featuring different dialects, with some (such as Beijing opera, Shaoxing/Yue opera and Cantonese opera) more popular and influential than others. The narrative of Chinese opera is often taken from traditional Chinese novels and local folk lore. Cantonese opera is one of the regional operas, which is popular in Cantonese-speaking areas in South China, such as Guangdong (formerly know as Canton) province and Hong Kong.

2 The term refers to Hong Kong, Singapore, South Korea and Taiwan, which achieved high economic growth rates and rapid industrialization between the early 1960s and the 1990s.

3 With the popularity of the serial, 'Ah Chian' became a popular term referring to those mainland Chinese who (very often illegally) immigrated to Hong Kong. For a detailed study on the image of Ah Chian, see Curtin (2003) and Cheng (2002).

4 *Xiaosheng*-type actor Adam Cheng had moved to Taiwan, Huang Yuanshen and Lau Songren had both moved to another local TV studio (RTV) and Patrick Tse had reached middle-age in the late 1970s. Hence there were not enough male stars in TVB to play the *xiaosheng*-type characters in its drama productions. Under these circumstances, TVB was trying to stop Chow from acting in films.

5 Although TVB has never officially admitted to the practice, rumours abound of TVB 'freezing' its contracts with actors who brought 'trouble' to the studio. As punishment, the 'frozen' actor would not be promoted or even cast in any of the studio's programmes during their 'frozen' period. An exclusive contract usually prevents the actor working for other studios during the contract period, which means 'freezing' usually creates a hard time for the actor. 'Frozen' actors receiving only a basic salary, and excluded from public promotion, have not only financial pressure but also the prospect of being forgotten by audiences due to long absence from, or at least far fewer, public appearances. It is widely believed that Chow experienced a 'frozen period' in TVB for several years in the early 1980s, although he was still allowed to act in some films and appear in some TVB programmes.

6 'Five Tigers' was a term used in TVB All Star Challenge, a programme in the 1983 TVB annual jamboree shows. The term was popularly used to refer to five TVB contract actors who attended this show – Andy Lau, Tony Leung Chui-Wai, Felix Wong, Michael Miu Kiu Wai and Kent Tong – who were all selected and promoted as *xiaosheng*-type actors by the studio in the 1980s.

Works cited

Cheng, Yu 澄雨 (2002) first published 1988, 'Busu zhi Ke—Bashi Niandai Xianggang Dianying de Dalu Laike Xingxiang Chu Tan 不速之客—八十年代香港电影的大陆来客形象初探' in Junxiong Wu and Zhiwei Zhang (eds.), Reading Hong Kong Popular Cultures 1970–2000 (Yuedu Xianggang Puji Wenhua 1970–2000 阅读香港普及文化 1970–2000), Hong Kong: Oxford University Press<China> Ltd., pp. 181–6.

Curtin, Michael (2003), 'Television and Trustworthiness in Hong Kong', in *Planet TV – A Global Television Reader* (eds Lisa Parks and Shanti Kumar), New York: New York University Press, pp. 243–61.

Ellis, John (1991), 'Stars as a Cinematic Phenomenon', in *Star Texts, Image and Performance in Film and Television* (ed. Jeremy G. Butler), Detroit, MI: Wayne State University Press, pp. 300–15.

Fong, Leslie (1980), 'Man in the Net, Catch this Splendid Act', *The Strait Times* (9 August). http://www.templeofchow.com/tvb/gall_mannet01.html. Accessed 18 February 2007.

Liang, Kuan 梁宽 (2002), 'Xiao xiangzi de gushi – kan kan dianshi changpianju' 小箱子的故事 – 看看电视长篇剧 (The story of the small box: watching the long-length TV serials), in *Yuedu Xianggang puji wenhua 1970–2000* (eds Junxiong Wu and Zhiwei Zhang), Hong Kong: Oxford University Press, pp. 120–7.

Ma, Hui 玛辉(1985), 'Renwu zhuanfang: yinxiang Zhou Yun Fa' 人物专访: 印象周润发 (Special interview: impression on Chow Yun-fat), *Dianying shuangzhou kan* 电影双周刊 (City entertainment), 177 (12 December), pp. 19–20.

Pang, Bei 庞贝and Zheng Xiang 正翔 (2005), *Langman yingxiong ouxiang: Zhou Yun Fa sijia huace* 浪漫英雄偶像: 周润发私家画册 (Romantic heroic icon: Chow Yun-fat's album). http://book.sina.com.cn/nzt/ent/zhourenfasijiaxiangce.shtml. Accessed 5 May 2006.

Pearson, Roberta E. (2004), '"Bright Particular Star": Patrick Stewart, Jean-Luc Picard and Cult Television', in *Cult Television* (eds Sara Gwenllian-Jones and Roberta E. Pearson), Minneapolis, MN: University of Minnesota Press, pp. 61–80.

Qiao, Chu 乔楚 (1991), 'Shining Star: Xianggang ren de yiduan lishi – Zhou Run Fa' 香港人的一段历史—周润发 (Shining star: a history of Hong Kong people – Chow Yun-fat), *Dianying shuangzhou kan*, 310 (11 February), pp. 18–24.

Sek, Kei *et al.* (2000), 'Review of the 1987 Hong Kong Cinema', in *The 24th HK International Film Festival* (ed. Lo Tak-Sing), Hong Kong: Urban Council, pp. 107–11. First published 1988.

Shu, Gua 舒寡 (2002), 'Dianshi buzai shenmi' 电视不再神秘 (TV, no longer mysterious), in *Yuedu Xianggang puji wenhua 1970–2000* (eds Junxiong Wu and Zhiwei Zhang), Hong Kong: Oxford University Press, pp. 113–19.

Song, Ling 宋玲, (2004), 'Dang Zhou Run Fa yudao Zheng Yu Ling: *Wang zhong ren*' 当周润发遇到郑裕玲: 《网中人》 (When Chow Yun-fat meets Dodo Cheng: *Man in the Net*), *CRI Online*. http://gb.cri.cn/6851/2004/12/20/113@397001.htm. Accessed 26 February 2007.

TVB (1980): 'Qinqing' 亲情 (Family feelings), Hong Kong: TVB. http://www.templeofchow.com/tvb/gall_familycover.html. Accessed 16 January 2007.

TVB (1981a), 'Huo fenghuang' 火凤凰 (The fate), Hong Kong: TVB. http://www.templeofchow.com/tvb/gall_fatecover.html. Accessed 16 January 2007.

TVB (1981b), 'Eyu tan' 鳄鱼潭 (The good old times), Hong Kong: TVB. http://www.templeofchow.com/tvb/gall_goodoldcover.html. Accessed 18 February 2007.

Wojcik, Pamela Robertson (ed.) (2004), *Movie Acting: The Film Reader*, London: Routledge.

Wong, Wai-chung (1978), *Television News and Television Industry in Hong Kong*, Hong Kong: Communications Studies, Chinese University of Hong Kong.

Yao, Yao (2002), 'Sheng, se, yi – Huigu Xianggang dazhong wenhua de fazhan' 声色艺 – 回顾香港大众文化的发展 (Sound, vision, art: review on the development of Hong Kong mass culture), in *Yuedu Xianggang puji wenhua 1970–2000* (eds Junxiong Wu and Zhiwei Zhang), Hong Kong: Oxford University Press, pp. 9–18.

Zhong, Baoxian 钟宝贤 (2004), *Xianggang yingshiye bainian* 香港影视业百年 (100 Years of Hong Kong Film and Television Industries), Hong Kong: Joint Publishing.

Zhou, Chengzhen 周诚真 'Review on *Man in the Net* (1979)'. http://www.dodocheng.com/index/dodoworks/maninnet.htm. Accessed 6 February 2007.

Zhou, Chengzhen 周诚真 'Review on *Family Feelings* (1980)'. http://www.dodocheng. com/index/dodoworks/feeling.htm. Accessed 6 February 2007.
Zhou, Chengzhen 周诚真 (1982), 'Pinglun yanji de biaozhun' 评论演技的标准 (Criteria for judging acting skills), *Dianying shuangzhou kan*, 98 (4 November), pp. 38–9.

Filmography and TV

The Battle Among the Clans (Da Xianggang 大香港), TVB, Hong Kong, 1985.
The Bund/Shanghai Beach (Shanghai tan 上海滩), TVB, Hong Kong, 1980.
Family Feelings (Qinqing 亲情), TVB, Hong Kong, 1980.
The Fate/Flaming Phoenix (Huo fenghuang 火凤凰), TVB, Hong Kong, 1981.
Good Old Times (Eyu tan 鳄鱼潭), TVB, Hong Kong, 1981.
Hong Kong 1941 (Xianggang 1941 香港1941), d. Leong Po-Chih 梁普智, Hong Kong: D & B Films, 1984.
Hotel (Kuangchao 狂潮), TVB, Hong Kong, 1976.
The Lone Ranger/The Maverick (Gucheng ke 孤城客), TVB, Hong Kong, 1982.
Man in the Net (Wang zhong ren 网中人), TVB, Hong Kong, 1979.
Police Cadet '85 (Xin zha shixiong II 新扎师兄续集), TVB, Hong Kong, 1985.
The Smiling Proud Wanderer (Xiao ao Jianghu 笑傲江湖), TVB, Hong Kong, 1984.
The Story of Woo Viet (Hu Yue de gushi 胡越的故事), d. Ann Hui 许鞍华, Hong Kong: Pearl City Film, 1981.
The Yangs' Saga (Yangjia jiang 杨家将), TVB, Hong Kong, 1985.

15 Leslie Cheung

Star as autosexual

Julian Stringer

> There is something so sad in the spectacle of someone trying to give pleasure to others and not succeeding. Ironically, there are those who by deliberately choosing to please themselves, give a lot of pleasure to others.
>
> (Kenneth Williams in Davies 1994: 356)

Introduction

Leslie Cheung (Zhang Guorong, 1956–2003) more than deserves his place in any collection of scholarly writings on film stars and stardom. By the time he jumped to his death from the twenty-fourth floor of the Mandarin Oriental Hotel, Hong Kong, on 1 April 2003, Cheung had been acting in movies for a quarter of a century and was one of the city's most experienced, respected and wealthiest media celebrities. He had also attained international fame through remarkable performances in a series of important gangster, fantasy and art-house films that helped establish Chinese cinema's global reputation in the 1980s and 1990s.[1] Cheung had won acting awards along with the loyalty of a legion of devoted fans. Moreover, death proved to be on his side as well. While news of the star's suicide shocked and saddened a grieving public, it also catapulted Leslie Cheung to legendary status. As Yiman Wang points out, since 2003 'Gor Gor' (the elder brother) has accrued '*increased* charisma after his death' (Wang 2007: 327; original emphasis), in part because internet fandom allows the star's iconic presence to be extended and savoured in myriad ways across multiple media formats. Clearly, not only are Leslie Cheung's achievements on the silver screen impressive and memorable but also his digital after-life possesses ongoing resonance.

Ironically, Leslie Cheung's premature death also sparked belated recognition of the fact that he was a talented actor who took on a diverse range of roles in varied film genres. Cheung may remain best known among international cinema *aficionado*s for scene-stealing performances in the famous movies cited in Note 1, but such titles only constitute a minority of his output. Starting his cinema career in Hong Kong in the soft-core costume romp *Erotic Dream of the Red Chamber* (Kam Kam, 1978), the youthful Cheung soon found an early niche for himself playing

moody and sensitive teenagers.[2] He went on to appear in almost 60 other titles, from action films, cop dramas and gangster sagas to comedy and parody, from comic and non-comic dramas and romances to fantasy and horror.[3] In addition, in 2000 Cheung helmed his first and last film as director, when the RTHK mini-feature *From Ashes to Ashes* (Leslie Cheung, 2000) reunited him in front of the cameras with fellow superstar Anita Mui.[4]

Given the extent of the accomplishments sketched only very briefly above, it is impossible in a chapter of this length to do anything resembling critical justice to the quantity and quality of Cheung's work in the medium of film. Equally, it is impossible to do more than gesture towards his contributions in other kinds of media as well. Simply put, any accurate assessment of Cheung's status as film star would also need to acknowledge his existence as more than just a cinema idol. As the Hong Kong postal service recognized in 2005 when issuing memorial stamps to commemorate a select band of distinguished local singers, Leslie Cheung was an all-round public entertainer and perennial media presence, 'a glamorous star in music, films and television, affectionately loved by his fans because of his irresistible charm' (Hong Kong Post 2005: n.p.).

It is therefore important to remember that Cheung's work in television simi-larly stretches back to the late 1970s and early 1980s, with appearances in ATV, RTHK and TVB dramas as well as numerous variety shows and advertisements for companies such as Pepsi Cola.[5] In music, meanwhile, Cheung was an ear-catching vocal talent.[6] Early recordings for Polydor and Capital Artists included hits like 'The Wind Blows On' (1983), 'Monica' (1984) and 'Love in Those Years' (1986), together with albums such as *Lover's Arrow* (1979), *For Your Love Only* (1985) and *Leslie Cheung: Allure Me* (1986). Dozens of other vinyl and CD releases followed, including *Summer Romance* (1987), *Beloved* (1995), *Red* (1996) and *Crossover* (2002), as did worldwide concert tours featuring cel-ebrated stage performances. Such activities, among others, underpin the claim made on numerous occasions that Cheung's significance lies in his status as a symbolist who 'represents the '80s [Hong Kong] generation ... identified as an idol of the teeny-bopper, giggling school-girl set who cheers him on as a romantic male lover' (Teo 1997: 203).

However, in line with many international celebrities who sustain images as popular entertainers in multiple channels of communication across decades, Cheung may more properly be described as a star who means many different things to many different people. For example, Yiman Wang is not alone in argu-ing that he was and remains a 'transgressive "entertainment" figure' whose 'stellar popularity, and ability to connect with a diverse audience, was in part based upon his androgynous identity and ambivalent or "queer" sexuality' (Wang 2007: 326, 327). In her reading, the 'structured polysemy' (Dyer 1998: 63) of Cheung's star persona speaks to a variety of different fans who project their own dreams and desires on to its fascinatingly indeterminate aspects.

Certainly, across his films, television appearances, songs, concerts and fashion shoots, Cheung performed a range of gender roles with confidence and conviction, oscillating between the tough and the vulnerable, the assertive and the passive,

the butch and the femme. The commercially and culturally profitable outcome of this long-term media strategy was the ongoing popularity of a public image that synthesized contradictory gender traits into something resembling a masculine ideal while simultaneously hinting at the 'complexity of transgender experience and the agency of transgender subjects' (Leung 2005: 98).[7] This chapter analyses one important yet hitherto neglected aspect of what may therefore be characterized as Leslie Cheung's 'polysemic polysexuality'.

Autosexuality

Of the many millions of words written and spoken about Leslie Cheung, one of the most compelling meditations on his androgynous identity and ambivalent sexuality comes from the lips of the man himself. Interviewed for Stanley Kwan's documentary, *Yang ± Yin: Gender in Chinese Cinema* (1996), Cheung talks with charm and grace about his perceptions of his own work.

In a segment of *Yang ± Yin* entitled 'Feminine and Masculine Face and Body', Cheung responds to historical distinctions drawn by Kwan between the emphasis on the body to be found in the martial arts film (a type of movie in which Cheung seldom appeared) and the emphasis on the face to be found in such 'perverse' genres as horror (e.g. *Song at Midnight* (Maxu Weibang, 1937), remade with Cheung as *The Phantom Lover* in 1995). Following a discussion of repression, sexual undercurrents and Freudian implications – in short, everything that is hidden or bubbling away under the surface in these kinds of works – the topic of conversation turns to the question of narcissism. Kwan's narration states that 'Leslie Cheung has played more than his share of narcissistic characters … many directors tend to offer him parts as rather feminine men' while three graphically similar shots from *A Better Tomorrow*, *Rouge* and *Farewell My Concubine* are visually juxtaposed so as to present a composite illustration of Cheung's narcissism for the viewer. Cheung elaborates, 'I have some quality which is unique. Something the audience identifies with. Maybe it's a kind of sensitivity. Especially in affairs of the heart … Something soft'.

In another section of the documentary, 'Transvestites and Transsexuals', rumours of Cheung's off-screen homosexuality are addressed through discussion of the actor's celebrated on-screen exercises in cross-dressing. Comparing his work with that of female actor Lin Ching Hsia – famous for cross-dressing as men in films like *Peking Opera Blues* (Tsui Hark, 1986) and *Swordsman II* (Ching Siu-tung, 1992) – Cheung reflects upon his public persona's distinctly epicene qualities:

> The characters I play mostly project an image of delicacy. And so there have been many rumours about me from the very start. But times have changed. These things matter less than they used to. People don't care so much any more. They pay to see you look handsome on screen. And that's enough. But it should be more fair. If they can accept a woman playing men [i.e. Lin] then a man playing women should be OK too.

The cumulative effect of the star's appearance in *Yang ± Yin*, as well as of Stanley Kwan's subtle use of him, is to foreground two linked concepts of habitual importance to discussions of Leslie Cheung: namely, narcissism and ambisexuality. Narcissism may be defined in this context as a tendency towards self-worship (Bettinson 2005) while ambisexuality may be defined as the possession of a fluid sexuality of indeterminate origin and identity. In the case of Cheung, each concept plays a powerful part in confirming the fundamental truth of Vito Russo's apt observation that 'love is a many-gendered thing' (1981: 146).

Cheung's narcissism and sexual ambivalence point to key reasons why he is perceived to be not just a transgressive figure, but also one of the most socially significant of all Chinese film stars. As a 'male diva of the 1980s and 1990s' (Guo 2004),[8] Cheung represents gender trouble. He is an actor whose image straddles boundaries of gender and sexual identity, extending in the process the range of permitted public expressions of love and eroticism. Much has been made of Cheung's historical importance as 'the only major star in Hong Kong to have confirmed being in a same-sex relationship' (Tsui 2007), and it is to be hoped that in future academic commentators will consider this fact in light of shifting discourses of Chinese morality upon which the present chapter unfortunately does not have space to dwell.[9]

For now, though, it is enough to suggest that Leslie Cheung's narcissistic and ambisexual image may also be identified with yet another 'perversion' redolent of the transgressive and the queer: autosexuality. This third concept is much less likely to be familiar to the reader as it has yet to find its way into the lexicon of Star Studies or Film Studies more generally. Yet its meaning and connotations are easily comprehensible.

An autosexual is someone who finds sexual gratification in his or her own body via the pleasuring of oneself, the loving of oneself, masturbation, or – in the argot of British vernacular slang – wanking.[10] Autosexuality is thus the seeking of erotic fulfilment through a reciprocal arrangement whereby the pleasure taken from sexual activity exists in precise relation to the amount of pleasure given. The imaginative world of the autosexual revolves around self-help. Individuals of this tendency think about themselves and dream about themselves because they alone are capable of providing all the love and stimulation needed for the attainment of sexual satisfaction.

In probing the suggestion that Cheung's persona is an autosexual one, it is clearly necessary at this stage to draw a distinction between the private sexual practices of a specific individual and the complex meanings associated with a cross-media and highly indeterminate public image. It is therefore important to distinguish between what may be termed literal autosexuality and symbolic autosexuality.

As a way of illustrating the differences between these two key terms, a brief comparison may prove helpful. In his published diaries, British actor Kenneth Williams presents himself as a literal autosexual through graphic reports on his indulgence in what he calls 'the auto-erotic function' (Davies 1994: 277).[11] 'Masturbation is a physical manifestation of self-love', writes Williams (Davies 1994: 97), 'or perhaps self-satisfaction is the better expression. Anyway, it is gratifying one-self,

as far as I am concerned'; 'I hoovered the carpet in the lounge dressing only in bathing trunks. It was v. daring and the atmosphere was charged with sex. If any-one had walked in, they would have been irresistibly attracted' (Davies 1994: 230). 'By the time I'd bathed, washed the hair (Selsun) etc., and done the fingernails etc. and sloshed Monsieur Givenchy all over meself, I looked in the mirror and marvelled – I may be going to pot completely, but no one would know it! – all so lovely. I had the barclays' (Davies 1994: 404).[12]

As Russell Davies explains in his introduction to the Williams diaries:

> [Williams] seems to have treated masturbation as a considerable play-acting performance In the imaginative passion of the moment he even caused him-self superficial injuries on more than one occasion. His moments of extreme narcissism, too, will surprise and enlighten those who have always found diffi-culty in understanding why a synonym for masturbation should be 'self-love'. In Williams we see someone who – and this is in middle age – is capable of being so captivated by his own image in the mirror that he must resort at once to 'the barclays'. This is self-regard of a rare order; but the strangeness and the charm of it, within the diaries, is that Williams can be overcome by a sense of his own beauty one day, and disgusted the next by his bad complexion, erupting pustules, baggy eyes, and so forth. The aesthetic sensitivity worked both ways.
>
> (Davies 1994: xxii)

Conversely, Leslie Cheung left behind no autobiographical writings document-ing his preferred sexual practices, and the question of whether or not he was in any sense a literal autosexual is therefore entirely irrelevant. Instead, it is as a manu-factured media image that Cheung's persona circulates in what may be described as an autosexual manner. After all, as Lo Chi-leung reminds us, 'Leslie Cheung [is] a star and it is very difficult to strip him of his star persona' (quoted in Shin 1997: 30).[13]

As I will now go on to illustrate, Leslie Cheung's symbolic autosexuality encom-passes his narcissistic and ambisexual identities, but is not reducible to them. Moreover, I would like to argue that Cheung's suicide at the age of 46 worked to consolidate and magnify the various aspects of his autosexual image.

All alone

Three dimensions of Cheung's persona transcend narcissism and androgyny by taking these qualities into the self-enclosed world of the autosexual. First and foremost amongst these is the emphasis placed throughout his career on the impor-tance of notions of privacy. This aspect of Cheung's star image encompasses two distinct yet closely related elements. On the one hand, it includes the regularly repeated observation that in real life the entertainer wished to keep details of his personal life hidden from public view. On the other hand, the corresponding impression that as a consequence of Cheung's protection of his own privacy the

precise nature and character of his individual sexual peccadilloes never could fully be penetrated.

In the 1980s and 1990s, the decision not to disclose details of Cheung's sexual orientation certainly cushioned the star from the career repercussions faced by openly gay entertainers in Hong Kong. Yet the fascinatingly indeterminate resonances of that policy carried the additional effect of feeding a concomitant sense of mystery into every aspect of his star persona. Across all popular media forms, Cheung's cloaked and enigmatic sexual identity generated compelling dramas of gender intrigue. What is he hiding? What does he like to do? Is he or isn't he? In emphasizing his inexplicability and unattainability, Cheung's image circulated associations of solitariness and secrecy that serve as prerequisites for the presence of the autosexual sensibility.

As just one example of this specific dynamic, consider Cheung's role in the RTHK television production *Crossroad: Woman at 33* (1983). For this drama of marital breakdown and romance across the genders and generations, Cheung plays a young film composer called Michael who may or may not be about to start up a relationship with a recently divorced middle-aged woman named Jenny (Cheng Pei Pei). In one particularly suggestive scene, the two friends go to a cinema to watch a movie about ballet dancers, *Nijinsky* (Herbert Ross, 1980). When Michael greets Jenny with the words 'You're on time, for a woman', Jenny responds with the question, 'So your girlfriends are never on time?', whereupon Michael matter-of-factly replies 'I've never had a girlfriend'. One of Jenny's female friends then telephones her later that day to get news of how the 'date' went. 'Those young guys do fancy mature women like us', the friend states, before adding, 'Or they like men' – and thus casting doubt on the origin and identity of Michael's sexuality.

It is difficult to pinpoint with any degree of certainty exactly what is going on in these particular scenes. *Crossroad: Woman at 33* ostensibly explores the taboo subject of a middle-aged divorcée's potential liaison with a young boy, but the ultimate meaning of all this beating around the bush is never resolved. While the encounters described above undeniably engage with discourses of both heterosexuality and homosexuality, they also draw upon the drama of mystery and privacy surrounding Cheung to suggest that Michael's fluid sexual identity may be otherwise virginal or else simply a blank or maybe even empty surface impossible to fathom.

Another way of putting this is to say that in *Crossroad: Woman at 33,* it is unclear whether the focus of Michael's erotic attention is directed outwards (i.e. towards women or men or both) or inwards (i.e. towards the private self-satisfaction of his own needs). Furthermore, it is also worth noting in this context that Michael is elsewhere referred to as a 'kid', a description that, while entirely in keeping with the youthful Cheung's teen image at this time, is also used to structure the narrative of the feature film, *The Kid*, produced 16 years later. Here Cheung plays a successful adult executive who lives alone contentedly on a houseboat until the titular diminutive turns up and messes his life about. However, it soon becomes obvious that this is a story about more than just one kind of 'kid'. Cheung's

character is before too long also revealed to be self-oriented and inner-directed, fixated upon the attainment of self-gratification in exactly the same manner that very small children frequently are.

In music, too, connotations of privacy, secrecy and solitariness may be traced back to the very start of Cheung's singing career. Contemplate his 1977 album *Daydreamin'*, the cover of which features a photograph of a relaxed Leslie in casual morning attire leisurely sipping tea by himself. The songs collected on *Daydreamin'* are all about the pleasures as well as the pain of being alone or with other people, but it is the inclusion of a cover version of Boz Scaggs' famous 1976 song, 'We're All Alone', that is most suggestive of Cheung's symbolic autosexuality.

Sung at this stage of his artistic development inexpertly, but with an excess of youthful spunk all the same, Cheung's adaptation of 'We're All Alone' captures the veiled ambiguity of the song as originally written:

> Close your eyes and dream, and you can be with me ...
> Close the window calm the light
> And it will be alright ...
> Let it out, let it all begin.
> Learn how to pretend ...
> My love
> Hold me Dear
> All's forgotten now my love
> We're all alone.

On first hearing, Scaggs' song may strike the listener as resolutely outer-directed. That is to say, many will intuitively interpret its scenario as outlining that of two people alone with each other, or else alone while nevertheless in each others' company. Leslie Cheung's version, however, layers a more inner-directed sensibility onto the same material. In his hands, 'We're All Alone' resembles a hymn to the state of existing by oneself. Seeming to adopt the usage of 'we' so beloved of royal persons (for whom 'we' really means 'I'), Cheung sings this song for himself and to himself in a way that – through conjuring alternative scenarios of self-solace and self-seduction – details the pleasurable expectations of self-satisfaction. In this light, it is ironic to recall that one of Cheung's most famous film roles required him to play one half of a couple in a movie entitled *Happy Together*. For one of the effects of this song's inclusion on the *Daydreamin'* album is to highlight Cheung's talent for conveying the perverse romanticism of being (Un)Happy Alone.

The second dimension of Cheung's star image suggestive of the self-enclosed world of the autosexual is its highly sexualized nature. At the same time as Cheung's persona has across the years connoted indeterminacy and solitariness, it has placed these qualities in a self-oriented domain that is relentlessly erotic. However, while commentators are quick to characterize this realm as narcissis-tic, such ascetic terminology arguably downplays precisely what makes it most interesting. In bringing together in one physical body manifestations of gendered

love that are as inner-directed as they are outer-directed, Cheung's image repeatedly emphasizes overtly sexualizing tendencies while also enmeshing these in discourses of secrecy and privacy.

Let us therefore be mindful first of all of the sheer number of times Leslie Cheung has grunted and groaned his way through a sex scene in a movie. Indeed, from *Erotic Dream of the Red Chamber* and *Nomad* to *Viva Erotica* and *Happy Together*, it is possible to chart the course of his audiovisual career solely by concentrating on the abundance of such moments. Often presenting him nude and usually depicting him seized in the throes of orgasmic abandon, such scenes work to emphasize Cheung's sexuality at every turn.

However, the presence of diverse forms of one-on-one sexual activity in Cheung's filmography enhances rather than precludes his autosexual image. No matter where his characters' erotic energies originate from, or to whom they are directed, the self-regarding qualities of his polysemic polysexuality remain ever-present. This is to say that the cumulative effect of Cheung's sex scenes is to intensify the erotic force of his image's duplicitous sides. They effect an oscillation between object choices that directs attention to the one person who may always be relied upon to give and take reciprocal amounts of sexual pleasure – Cheung himself.

Curiously, for all the energetic bonking sessions Cheung has stripped off for in front of the cameras, it remains a mark of his acting ability that he is still perceived to convey a fundamental lack of interest in other people. In the words of Richard Corliss (2003):

> Inside these varied characters was the irreducible, enigmatic 'Leslie': a beautiful man whose sexuality is a gift or a plague to those who fall under his spell. They loved him and he left them; he must have said, 'I don't love you' more times than anyone else in movies …. Seeming not to care, he got audiences to care.

What quotation better suggests Cheung's talent effortlessly to embody the autoerotic function while also masquerading in the guise of great screen lover? Push the logic of Corliss' argument one step further and a new conclusion comes into view: if Leslie Cheung's characters do not love other people, then surely he must love himself. Giving the impression of remaining aloof and of not wishing to sully his secret and private domain by getting involved in the mess that is other peoples' lives, Cheung's persona retains its self-loving connotations. There is thus no contradiction between the star's capacity to perform numerous acts of heterosexual, homosexual and queer coupling in film and his ability simultaneously to signify the more solitary values of symbolic autosexuality.

As further evidence in support of this statement it is worth pondering the implications of Yiman Wang's (2007: 333) remark that during his international *Passion* tour of 2000 and 2001, Cheung's 'seductive body postures (such as self-caressing and changing clothes in front of the audience)' caused 'a furor in the Hong Kong media'. Similarly, earlier pop videos and CD publicity accompanying the release

of the 1988 *Printemps* album depict Leslie waking up in the morning alone and half-naked or else bathing in water in closed-eyed ecstasy. At moments such as this Cheung achieves a level of self-regard truly rare among popular entertainers: few media stars have ever produced images more directly suggestive of the masturbatory. They speak of an erotic sensibility once articulated by Andrew Holleran (1995: 388) in his description of one of the characters in his 1979 novel of gay American life, *Dancer from the Dance*: 'he wanted to keep this life in the realm of the perfect, the ideal. He wanted to be desired, not possessed, for in remaining desired he remained, like the figure on the Grecian urn, forever pursued. He knew quite well that once possessed he would no longer be enchanted'.

It is doubtless significant that the self-regarding nature of Cheung's sexualized star image cannot always adequately be captured through use of existing terminology. While holding on to words such as narcissism and ambisexuality, some commentators – myself included, clearly – have grasped for new notions through which to describe and understand his power and appeal. For example, in a newspaper report on the television contest *My Hero*, organized by Shanghai Media Group and broadcast on the Shanghai Satellite Station in 2006, Raymond Zhou (2006) writes of how:

> *My Hero* is presenting a corps of men remarkable for their delicate looks, soft voices and accessorizing skills …. These young men are marching to the drum of diminishing sexual identity. They are beyond gay or straight. Truth is, the object of their love is themselves. In other words, they are China's first generation of self-conscious metrosexuals, even though the word does not have a Chinese equivalent yet and the concept is still making its rounds in glossy magazines … metrosexual idols have long been touted by Chinese entertainment editors, who post photos of male celebrities in self-obsessed poses from Rudolf [sic] Valentino to Leslie Cheung.

The term 'metrosexual' originated in Britain in the 1990s to describe the emergence of a new class of moneyed and style-conscious young consumers. Although it carries slightly different connotations (e.g. metropolitan living) than the term 'autosexual' as I deploy it here, the two words are similarly suggestive of a shift in cultures of masculinity in both Western societies and the capitalist and fashion centres of East Asia such as Shanghai and Hong Kong. Whether metrosexual and/or autosexual idols have long been touted by the Chinese entertainment media is a subject worthy of detailed historical research. Yet at this point one may say with certainty that the addition of words such as metrosexual to the language used to describe Cheung's fascinating indeterminacy merely underlines the star's overtly sexualizing aspects. More than this, the ongoing resonance of Cheung's digital after-life may in future further extend the range of permitted public discourses of love and eroticism in the Chinese context. Given the habitual erotic tendencies of his image, who is to say that Leslie Cheung's media persona will not one day be given other strange baptismal names and made to do other kinds of cultural and intellectual work?

The third and final dimension of Cheung's symbolic autosexuality is provided by the link between his star image and theatricality. It is a truism of life that great actors need to be great exhibitionists, and among Cheung's varied film roles it is the ones in which he adopts a highly mannered veneer – for example, *Farewell My Concubine*, *The Phantom Lover*, and *Rouge* – that are often singled out for attention and utilized by others (e.g. Stanley Kwan) to explain who Cheung is and what it is he does. Theatricality defines Cheung's career not just because he is an all-round public entertainer but also because it conveys the impression that he has been granted some mysterious licence to deliver particularly egregious dramatic performances. Here is a man who acts as if the whole world revolves around him.

Cheung's theatricality constitutes the public face of his persona's more private and secret qualities. In *A Time to Remember*, his character is described as 'thin, average Chinese', deepening the impression reproduced across all media that this entertainer's boy-next-door good looks coexist with hints of uncloaked gender preoccupations and a complex or inexplicable sexual agency. Theatricality and privacy thus constitute twin sides of an indeterminate yet everywhere highly sexualized star image. Cheung's self-applauding moments of high drama throw into stark relief the self-absorbed and self-obsessed aspects of his autosexual persona.

The important point to highlight here though is the skill and authority with which Leslie Cheung projected his star image's theatrical nature. Always confident and convincing, his professional performances hid the inner self through enacting a range of impeccable and often highly stylized exterior roles. To be sure, this was facilitated on the one hand by Cheung's delicate skin, soft voice and accessorizing skills; as an actor he was unusually well aware of the fact that he only had one body and as a result had to look after it. On the other hand, however, Cheung also carried off the popular entertainer's requisite public standing with magnificent aplomb. The intense and ongoing success he enjoyed across decades in music, films and television suggests something of the strength of an audience's desire to submit to the will of a charismatic, self-possessed and sexy actor. In other terms, while a literal autosexual like Kenneth Williams may be said to treat masturbation as a considerable play-acting performance, symbolic autosexuals such as Leslie Cheung may be said to treat play-acting as a spectacular form of public wanking.

The three dimensions of Cheung's media persona discussed above were consolidated and magnified at the precise moment in 2003 when the star was called upon tragically to go whither we know not hence. Corliss (2003) claims that Cheung's suicidal leap from a Hong Kong hotel terrace provided him with his greatest role: 'I imagine he felt an artist's grim pleasure as he determined the form of his suicide … . Instead of riding out the inevitable decline, he made the most sumptuous gesture possible: a swan dive from a swan diva'. With this one dramatic gesture, the 'most widely adored and admired male diva of the late twentieth century … the cinema's greatest man-woman' resisted the certainties of pitiless decay and protected his face from the hieroglyphics of age. 'Any visitor to Hong Kong',

continues Corliss, 'who mentioned his name to a local film maven would hear the same refrain: a conspiratorial "Guess how old he is". As if Leslie kept a rotting portrait of himself in the attic ... [he] will forever stay that age, no older ... he chose a drastic method of staving off wrinkles, a pot belly, the whims of a fickle public'. As Grady Hendrix goes on to speculate, Cheung's aesthetic sensitivity worked both ways:

> [But] when Leslie Cheung killed himself he was just a guy ... a guy who was looking in the mirror and seeing a receding hairline, an expanding waistline, a lack of options. He didn't see the hopes and dreams we had all projected onto him, he was seeing lines around his eyes that he had never seen before And he was lonely, so lonely that he couldn't bear the thought of being alive for even one more minute.
>
> (Quoted in Corliss 2003)

In the mirror of death

Cheung's suicide generated lively posthumous internet fandom, but it carries other meanings as well. For instance, initial press reports from Hong Kong elaborate on all the possible reasons why an international celebrity and multi-millionaire secure in the arms of a real-life long-term personal relationship may wish to end it all.

One suggested answer to the question of why Cheung chose to kill himself lies in the intimations of depression unravelled in a suicide note left behind by the star. Following news of his death, a widespread public discussion emerged around this subject, which served to intensify the connotations of privacy, secrecy, solitariness and inexplicability contained in Cheung's star image. Among the flurry of articles attempting to diagnose and make visible the hidden causes of mental health problems, some used Cheung's suicide to advocate for the promotion of psychological health among *tongzhi* (literally 'comrade', but a term used by activists to cover gays, lesbians, bisexuals and transgender subjects) as well as socially isolated individuals more widely. Explicitly connecting with key dimensions of Cheung's autosexual image, one report informed readers that a '17-year-old girl has not left home since her idol' committed suicide: 'Xiao Min became a recluse and quit school towards the end of 2003. She spends her days at home in Chongqing listening to Cheung's songs' ('Hermit Fan').[14]

In addition, commentators writing subsequent to Cheung's suicide articulated not just a new-found awareness of his diverse acting talents, but also heightened sensitivity towards his role as performer *tout court*. The sudden realization that Cheung effectively kept details of his acutely shakeable frame of mind hidden from public view disturbed but nonetheless impressed many. In this light, the murderous theatricality of Cheung's final swan dive magnified his image's private dimensions while also reconfirming his ability to startle through acts of unparalleled drama.

The phenomenon of Cheung's suicide therefore exacerbates his symbolic autosexuality as it confirms that a momentous performance requires momentous privacy. Because for a delicate and sensitive actor violation of the self-oriented

domain represents the most terrifying invasion of privacy, the best way to guarantee protection from intrusion is to retain opportunities for intimacy with oneself. Clinging to privacy helps sustain a rejection of a potentially hostile world at the same time as it intensifies any hint of inner-directed erotic activity.

Finally, Cheung's suicide also prompted fans and commentators alike to confront the sheer number of times in his career when Cheung had already kept company on screen with death. It encouraged retrospective re-readings of his back catalogue in hopes of finding conclusive evidence of death before life. Certainly, since 1 April 2003, watching Leslie Cheung act out scenes of suicide and self-harm (as in *Farewell My Concubine, Inner Senses, Rouge*) can, for those who like him and for those who care for him, feel like a hammer blow.

The poignant *From Ashes to Ashes* provides one example of this revaluation in recent years of death-themed Leslie Cheung film narratives. Initially designed to help bolster public awareness of the anti-smoking cause, it concerns the trials and tribulations of a middle-aged couple whose son, Chris, catches and subsequently dies of acute leukaemia. In the face of the fact that the film represents Cheung's sole attempt at directing, one is struck by how many of its more ostentatious stylistic choices appear wilfully 'motivated' by death.[15] In particular, there is the horrible irony of Leslie Cheung's address straight to camera during the final scene, wherein the star announces that as a fortieth birthday present to himself he is giving the gift of health; he will stop smoking because he now appreciates that his own health is more important than anything else. It is difficult to hear these words while in possession of the knowledge that Cheung eventually died not by smoking too many cigarettes, but by electing to jump off a high building.

The link between Leslie Cheung and death was underscored by other unhappy events that also occurred in Hong Kong in 2003. In December, *From Ashes to Ashes* co-star Anita Mui died of cervical cancer. The two stars had first met in the early 1980s when both were pursuing Cantopop singing careers: their lives intersected from that point on, both on stage and in films such as *Rouge*. Funeral preparations for Mui proceeded along the lines of those arranged for Leslie Cheung just 8 months previously: whereas the portrait chosen to adorn Cheung's funeral was taken from *He's a Woman, She's a Man*, the 'picture chosen to mark Mui's last journey' (Chan 2004) was from its sequel, *Who's the Woman, Who's the Man*. Moreover, the mortal demise of Cheung and Mui – alongside the deaths of 'Cantopop godfather' Roman Tam Pak-sin in October 2002, lyricist Richard Lam Tsun-keung in November 2003, and Cantopop writer and movie actor James Wong Jim in December 2004 – were interpreted by many as marking the passing of a 'golden era' of Hong Kong popular entertainment (Chow 2004). Coinciding with the aftermath of the SARS crisis, as well as with other fatal and unfortunate events in the city, the timing of Cheung's death was enough to transform him into a symbolist of an altogether different kind – of 2003, a tough time for Hong Kong, 'the year we'd like to forget' (Wong 2004).

Leslie Cheung's symbolic autosexuality now lies preserved forevermore in the catacombs of death, and it is therefore worth turning our attention to the question of how he should ultimately be remembered. In 2005, the Hong Kong postal service

placed him in a group of 'five pop stars who have left their marks on Cantopop music history' (Hong Kong Post 2005: n.p.) – the other four being Wong Ka Kui, Danny Chan, Roman Tam and Anita Mui. Others may wish to position Cheung in the context of a roster of talented Hong Kong stars who made their names in a series of internationally successful films of the 1980s and 1990s, for example Maggie Cheung, Chow Yun-Fat, Andy Lau, Tony Leung Chiu-Wai and Tony Leung Kai-fei (Liang Jiahui, b. 1958). Corliss (2003) links him ethnically with 'a grand tradition' of Chinese (female) stars who have over the years all killed themselves for one sad reason or another – most famously silent screen legend Ruan Lingyu, but also Lin Dai, Betty Loh Tih, Kitty Ting Hao, Margaret Du Juan and Pauline Chan.

However, taking an even more expansive historical perspective, Cheung may also be enshrined amongst an entirely different throng of rarefied company. For it is worth advancing the hypothesis that symbolic autosexuality underpins the entire film star phenomenon, and that star systems correspondingly reserve a special place in their hearts for performers able to express themselves in just such a manner. Nowhere is this truer than in the case of what remains historically the most important star system of them all: Hollywood. In life, Leslie Cheung proclaimed that as an Asian superstar he could find no earthly reason why he should deign to insert himself into the US movie industry. Yet let it be said that Leslie Cheung more than deserves his place in any collection of scholarly writings on film stars and stardom because he sits alongside other timeless international legends vividly able to project autosexual images with confidence and conviction. These figures include Hollywood icons such as James Dean, Marlene Dietrich, Greta Garbo and Rudolph Valentino (whose 'autoerotic' aspects Miriam Hansen (1991: 245–94) has gestured towards). Lovely to look at but not to be touched, existing as works of art in themselves, such stars remain as elusive as they are alluring.

Fernando Pessoa once wrote:

> We never love anyone. What we love is the idea we have of someone. It's our own concept – our own selves – that we love.

> This is true in the whole gamut of love. In sexual love we seek our own pleasure via another body. In non-sexual love, we seek our own pleasure via our own idea. The masturbator may be abject, but in point of fact he's [sic] the perfect logical expression of the lover. He's the only one who doesn't feign and doesn't fool himself.

> (Pessoa 2002: 104)

A true idol of cinema resembles this perfect logical expression of the lover. She or he thrills our eyes and ears by conjuring an imaginative domain of self-help, a self-enclosed world wherein the enjoyment taken from sexual activity exists in precise relation to the amount of satisfaction given. Leslie Cheung possesses exactly this quality. By appearing to deliberately choose to please himself, he gave and will continue to give a lot of pleasure to others.

Acknowledgement

Thanks to staff at the Hong Kong Film Archive for their help in locating research materials. Page references for newspaper reports sourced at the HKFA are provided where available.

Notes

1 These films include *A Better Tomorrow* (John Woo, 1986), *A Chinese Ghost Story* (Ching Siu-tung, 1987), *Rouge* (Stanley Kwan, 1987), *Days of Being Wild* (Wong Kar-Wai, 1991), *Farewell My Concubine* (Chen Kaige, 1993), *Ashes of Time* (Wong Kar-Wai, 1994), *Temptress Moon* (Chen Kaige, 1996) and *Happy Together* (Wong Kar-Wai, 1997).

2 These early titles include *Encore* (Clifford Choi, 1980), *Energetic 21* (Chuen Chan, 1982), *Nomad* (Patrick Tam, 1982) and *Teenage Dreamers* (Clifford Choi, 1982).

3 Examples of action films, cop dramas and gangster sagas are *A Better Tomorrow II* (John Woo, 1987), *Once a Thief* (John Woo, 1991), *Arrest the Restless* (Lawrence Ah Mon, 1992), *Shanghai Grand* (Man Kit Poon, 1996) and *Double Tap* (Lo Chiu-leung, 2000). Examples of comedy and parody are *Aces Go Places V* (Lau Kar-leung, 1989), *All's Well Ends Well* (Clifton Ko, 1992), *The Eagle Shooting Heroes* (Jeffrey Lau, 1993), *It's a Wonderful Life* (Clifton Ko, 1994), *The Chinese Feast* (Tsui Hark, 1995), *Tri-Star* (Tsui Hark, 1996) and *Okinawa Rendezvous* (Gordon Chan, 2000). Examples of comic and non-comic dramas and romances are *Behind the Yellow Line* (Taylor Wong, 1984), *He's a Woman, She's a Man* (Peter Chan, 1994), *Long and Winding Road* (Gordon Chan, 1994), *Viva Erotica* (Derek Yee and Lo Chiu-leung, 1996), *A Time to Remember* (Ye Daying, 1998), *Anna Magdalena* (Chung Man Yee, 1998), *The Kid* (Jacob Cheung, 1999) and *Moonlight Express* (Daniel Lee, 1999). Examples of fantasy and horror are *A Chinese Ghost Story II* (Ching Siu-tung, 1990), *The Bride With White Hair* (Ronny Yu, 1993), *The Phantom Lover* (Ronny Yu, 1995) and *Inner Senses* (Lo Chiu-leung, 2002).

4 Leslie Cheung and Anita Mui co-star in such films as *Rouge*, *He's a Woman, She's a Man* and *Who's the Woman, Who's the Man* (Peter Chan, 1996).

5 Leslie Cheung's television dramas include *Under the Same Roof: Teenagers* (RTHK, 1978), *Crocodile Tear* (ATV, 1978), *Agency 24* (ATV, 1979), *Heritage: The Young Concubine* (RTHK, 1980), *The Spirit of the Sword* (ATV, 1980), *Pairing* (ATV, 1981), *Cheap Detective* (ATV, 1982), *Once Upon an Ordinary Girl* (TVB, 1984) and *The Fallen Family* (TVB, 1985).

6 Cheung was first discovered after appearing in a televised music talent show in Hong Kong in May 1977. He once described himself as 'a perfect tenor, but I'm not a soprano' (Dannen and Long 1997: 76).

7 While Cheung's cross-dressing performance in *Farewell My Concubine* remains arguably his single most renowned role, he also excelled when appearing in civilian drag. For example, he plays two such roles in *Moonlight Express* – one character sweet and naïve, the other character tough and world-weary – thus bringing together in one film opposing aspects of the complex totality (Dyer 1998: 63) of his star image.

8 Definition of 'diva': great woman singer, prima donna.

9 Cheung 'declared his long-term gay relationship' at the 'Crossing 1997' Hong Kong concert where he also 'wore red lipstick and red heels, and performed a male–male tango, in addition to singing several songs dedicated to his male lover' (Wang 2007: 333).

10 The etymology of the word 'autosexual' remains uncertain. However, Foucault (1990: 43) alludes to the concept in his list of 'minor perverts whom nineteenth-century [European] psychiatrists entomologized by giving them strange baptismal names: there were Krafft-Ebing's zoophiles and zooerasts, Rohleder's auto-monosexualists;

and later, mixoscopophiles, gynecomasts, presbyophiles, sexoesthetic inverts, and dyspareunist women'.

11 Kenneth Williams is best known as one of the stars of the long-running *Carry On* series of post-World War II popular British comedies. A gay man who lived alone for virtually all of his adult life, Williams died in 1988 at the age of 62. He is thought to have committed suicide.

12 British rhyming slang for masturbation; Barclays = Barclay's Bank = wank.

13 Lo made this statement in the context of co-directing Cheung in *Viva Erotica* (1996). He later went on to direct Cheung again in *Double Tap* (2000) and *Inner Senses* (2001).

14 'I'm one of ten children', Cheung told *Time*'s Stephen Short in early 2001. 'I'm the youngest and the loneliest. The one closest to me is 8 years older. My brothers would be dating girls and I was left alone in the corner, playing GI Joe or with my Barbie Doll' (Corliss 2003).

15 For example, when Chris dies in hospital, hand-held camerawork, rapid tracking shots rushing towards medical equipment, use of slow-motion and manipulation of key sound elements all graphically represent the distress and disorientation experienced at this moment.

Works cited

Bettinson, Gary (2005), 'Reflections on a Screen Narcissist: Leslie Cheung's Star Persona in the Films of Wong Kar-Wai', *Asian Cinema*, 16.1 (Spring), pp. 220–38.

Chan, Carrie (2004), 'Friends in Life, Stars United in Death', *South China Morning Post* (1 December).

Chow, Vivienne (2004), 'Deaths Mark Passing of Golden Era', *South China Morning Post* (25 November).

Corliss, Richard (2003), 'That Old Feeling: Days of Being Leslie', *Time* (3 April). Online. http://www.time.com/time/arts/article/0,8599,440214,00.html.

Dannen, Fredric and Barry Long (1997), *Hong Kong Babylon: An Insider's Guide to the Hollywood of the East*, London: Faber and Faber.

Davies, Russell (ed.) (1994), *The Kenneth Williams Diaries*, London: HarperCollins.

Dyer, Richard (1998), *Stars*, 2nd edition, London: British Film Institute. First edition 1979.

Foucault, Michel (1990), *The History of Sexuality: Volume 1: An Introduction*, 2nd edition, New York: Vintage Books. First edition 1976.

Guo, Flora (2004), 'Remembering Leslie', *Shanghai Daily* (13 March).

Hansen, Miriam (1991), *Babel and Babylon: Spectatorship in American Silent Film*, Cambridge; MA: Harvard University Press.

'Hermit Fan Has Not Stepped Outside For Years', *China Daily Hong Kong Edition* (16 February 2006).

Holleran, Andrew (1995), 'The Twelfth Floor', in *The Faber Book of Pop* (eds Hanif Kureishi and Jon Savage), London: Faber and Faber, pp. 384–91. Extracted from the novel *Dancer from the Dance* originally published in 1979.

Hong Kong Post (2005), *Hong Kong Pop Singers*. First day cover of memorial stamp set.

Leung, Helen Hok-sze (2005), 'Unsung Heroes: Reading Transgender Subjectivities in Hong Kong Action Cinema', in *Masculinities and Hong Kong Cinema* (eds Laikwan Pang and Day Wong), Hong Kong: Hong Kong University Press, pp. 81–98.

Pessoa, Fernando (2002), *The Book of Disquiet*, 2nd edition, London: Penguin. First edition 1998.

Russo, Vito (1981), *The Celluloid Closet: Homosexuality in the Movies*, New York: Harper and Row.

Shin, Thomas (1997), 'Lo Chi-leung and Derek Yee on *Viva Erotica*', in *Hong Kong Panorama 96–97* (21st Hong Kong International Film Festival), Hong Kong: Urban Council, pp. 30–31.

Teo, Stephen (1997), '*He's a Woman, She's a Man*', in *Hong Kong Cinema Retrospective: 50 Years of Electric Shadows* (21st Hong Kong International Film Festival), Hong Kong: Urban Council, p. 203.

Tsui, Clarence (2007), 'Pride and Prejudice', *South China Morning Post*, 22 February.

Wang, Yiman (2007), 'A Star is Dead: A Legend is Born: Practising Leslie Cheung's Posthumous Fandom', in *Stardom and Celebrity: A Reader* (eds Sean Redmond and Su Holmes), London: SAGE, pp. 326–52.

Wong, Martin (2004), 'Thousands Say Farewell to the Year We'd Like to Forget. While 2003 was Tough for Hong Kong, the Sun Rose Today Over a Changed City', *South China Morning Post* (1 December).

Zhou, Raymond (2006), 'Sexual Politics No Longer the Same', *China Daily Hong Kong Edition* (7 August).

Filmography (including television series)

Aces Go Places V (Zhuijia paidang V 最佳拍档 5:兵马俑风云, 别名: 新最佳拍档), d. Lau Kar-leung 刘家良, Hong Kong: Cinema City, 1989.

Agency 24 (Tiantian ershisi wei, 甜甜廿四味, 21 集电视连续剧), TV, Hong Kong: ATV, 1979.

All's Well Ends Well (Jia you xishi 家有喜事), d. Clifton Ko 高志森, Hong Kong: Regal Films /Mandarin Films, 1992.

Anna Magdalena (Anna Madelianna 安娜玛德莲娜), d. Chung Man Yee 奚仲文, Hong Kong: Amuse Hong Kong Ltd, 1998.

Arrest the Restless (Lanjiang zhuan zhi fanfeizu feng yun 蓝江传之反飞组风云), d. Lawrence Ah Mon 刘国昌, Hong Kong: Win's Movie Production, 1992.

Ashes of Time (Dongxie xidu 东邪西毒), d. Wong Kar-Wai 王家卫, Hong Kong: Jet Tone /Scholar Films, 1994.

Behind the Yellow Line (Yuanfen 缘份), d. Taylor Wong 黄泰来, Hong Kong: Shaw Brothers, 1984.

A Better Tomorrow (Yingxiong bense 英雄本色), d. John Woo 吴宇森, Hong Kong: Film Workshop, 1986.

A Better Tomorrow II (Yingxiong bense 2 英雄本色 2), d. John Woo 吴宇森, Hong Kong: Cinema City Company Ltd, 1987.

The Bride With White Hair (Baifa monü zhuan 白发魔女传), d. Ronny Yu 于仁泰, Hong Kong Mandarin Films/Yes Pictures, 1993.

Cheap Detective (Aotu shentan 凹凸神探, 电视剧), TV, Hong Kong: ATV, 1982.

The Chinese Feast (Manhan quanxi 满汉全席, 别名: Jinyu mantang 金玉满堂), d. Tsui Hark 徐克, Hong Kong: Mandarin Films/Film Workshop, 1995.

A Chinese Ghost Story (Qiannü youhun 倩女幽魂), d. Ching Siu-tung 程小东, Hong Kong: Film Workshop/Cinema City, 1987.

A Chinese Ghost Story II (Qiannü youhun zhi renjian dao 倩女幽魂 2: 人间道), d. Ching Siu-tung 程小东, Hong Kong: Film Workshop/Cinema City, 1990.

Crocodile Tear (Eyu lei 鳄鱼泪, 电视剧), TV, Hong Kong: ATV, 1978.

Crossroad: Woman at 33 (Linqi: nüren 33 临歧: 女人三十三, 电视剧), TV, Hong Kong: RTHK, 1983.

Days of Being Wild (A Fei zhengzhuan 阿飞正传), d. Wong Kar-Wai 王家卫, Hong Kong: In-Gear Film Production Company, 1991.

Double Tap (Qiangwang 枪王), d. Lo Chiu-leung 罗志良, Hong Kong: Golden Harvest/ GH Pictures/Film Unlimited, 2000.

The Eagle Shooting Heroes (Shediao yingxiong zhuan zhi dongcheng xijiu 射雕英雄传之东成西就), d. Jeffrey Lau 刘镇伟, Hong Kong: Jet Tone, 1993.

Encore (Hecai 喝彩), d. Clifford Choi 蔡继光, Hong Kong: Fu Shan, 1980.

Energetic 21 (Chongji 21 冲激 21), d. Chuen Chan 陈全, Hong Kong: Lo Wei Motion Picture, 1982.

Erotic Dream of the Red Chamber (Honglou chun shang chun 红楼春上春), d. Kam Kam 金鑫, Hong Kong: Seasonal Film, 1978.

The Fallen Family (Wulin shijia 武林世家, 电视剧), TV, Hong Kong: TVB, 1985.

Farewell My Concubine (Bawang bieji 霸王别姬), d. Chen Kaige 陈凯歌, Hong Kong: Thomson Film, 1993.

From Ashes to Ashes (Yanfei yanmie 烟飞烟灭), d. Leslie Cheung 张国荣, TV, Hong Kong: RTHK, 2000.

Happy Together (Chunguang zhaxie 春光乍泄), d. Wong Kar-Wai 王家卫, Hong Kong: Jet Tone, 1997.

He's a Woman, She's a Man (Jinzhi yuye 金枝玉叶), d. Peter Chan 陈可辛, Hong Kong: United Filmmakers Organization, 1994.

Heritage: The Young Concubine (Suiyue heshan: Wojia de nüren 岁月河山: 我家的女人, 电视剧), TV, Hong Kong: RTHK, 1980.

Inner Senses (Yidu kongjian 异度空间), d. Lo Chiu-leung 罗志良, Hong Kong: Filmko, 2002.

It's a Wonderful Life (Dafu zhi jia 大富之家), d. Clifton Ko 高志森, Hong Kong: Mandarin Films, 1994.

The Kid (Liuxing yu 流星语), d. Jacob Cheung 张之亮, Hong Kong: Mei Ha Films, 1999.

Long and Winding Road (Jinxiu qiancheng 锦绣前程), d. Gordon Chan 陈嘉上, Hong Kong: Win's Movie Production, 1994.

Moonlight Express (Xingyue tonghua 星月童话), d. Daniel Lee 李仁港, Hong Kong: Mei Ha Films, 1999.

Nijinsky, d. Herbert Ross, USA: Paramount/Hera, 1980.

Nomad (Liehuo qingchun 烈火青春), d. Patrick Tam 谭家明, Hong Kong: Century, 1982.

Okinawa Rendez-vous (Lianzhan Chongsheng 恋战冲纵), d. Gordon Chan 陈嘉上, Hong Kong: China Star Entertainment/100 Years of Film Company/ People's Productions, 2000.

Once a Thief (Zongheng sihai 纵横四海), d. John Woo 吴宇森, Hong Kong: Golden Princess/John Woo Film /Milestone Pictures, 1991.

Once Upon an Ordinary Girl (Nongben duoqing 侬本多情, 电视剧), TV, Hong Kong: TVB, 1984.

Pairing (Duidui hu 对对胡, 电视剧), TV, Hong Kong: ATV, 1981.

Peking Opera Blues (Daoma dan 刀马旦), d. *Tsui Hark,* Hong Kong: Cinema City/Film Workshop, 1986.

The Phantom Lover (Yeban gesheng 夜半歌声), d. Ronny Yu 于仁泰, Hong Kong: Mandarin Films, 1995.

Rouge (Yanzhi kou 胭脂扣), d. Stanley Kwan 关锦鹏, Hong Kong: Golden Way/Golden Harvest, 1987.

Shanghai Grand (Xin Shanghai tan 新上海滩), d. Man Kit Poon 潘文杰, Hong Kong: Win's Entertainment /Film Workshop, 1996.

Song at Midnight (Yeban gesheng 夜半歌声), d. Maxu Weibang 马徐维邦, Shanghai: Xinhua, 1937.

The Spirit of the Sword (Huanhua xijian lu 浣花洗剑录, 电视剧), TV, Hong Kong: ATV, 1980.

Swordsman II (Xiao ao jianghu zhi dongfang bubai 笑傲江湖之东方不败), d. Ching Siu-tung 程小东, Hong Kong: Film Workshop, 1992.

Teenage Dreamers (Ningmeng kele 柠檬可乐), d. Clifford Choi 蔡继光, Hong Kong: Shaw Brothers, 1982.

Temptress Moon (Fengyue 风月), d. Chen Kaige 陈凯歌, Hong Kong: Thomson, 1996.

A Time to Remember (Hongse lianren 红色恋人), d. Ye Daying 叶大鹰, China: Forbidden City Films/ Nathansan Kwok Entertainment, 1998.

Tri-Star (Da sanyuan 大三元), d. Tsui Hark 徐克, Hong Kong: Cinema City, 1996.

Under the Same Roof: Teenagers (Wuyan xia: Shiwu shiliu 屋檐下: 十五十, 电视剧), TV, Hong Kong: RTHK, 1978.

Viva Erotica (Seqing nannü 色情男女), d. Derek Yee 尔东升, Hong Kong: Film Unlimited, 1996.

Who's the Woman, Who's the Man (Jinzhi yuye 2 金枝玉叶 2), d. Peter Chan 陈可辛, Hong Kong: Golden Harvest/United Filmmakers, 1996.

Yang ± Yin: Gender in Chinese Cinema (Nansheng nüxiang: Zhongguo dianying zhi xingbie 男生 女相: 中国电影之性别), d. Stanley Kwan 关锦鹏, UK/Hong Kong: British Film Institute/Kwan's Creation Workshop, 1996.

16 Jet Li

Star construction and fan discourse on the internet

Sabrina Qiong Yu

Introduction

On the complicated map of Chinese-language cinema, Jet Li (Li Lianjie, b. 1963) is a conspicuous and celebrated figure. He has crossed numerous cultural and geographic boundaries and stands as one of the most flexible and adaptable contemporary Chinese stars. After earning an overnight reputation through Shaolin temple films made in mainland China in the early 1980s, Li became a kung fu superstar in Hong Kong in the early 1990s and maintained huge popularity in East and Southeast Asia throughout the first half of the 1990s. After 1998, he transferred to the West and ever since has made action films in the USA and France, establishing himself as a reliable action star in Hollywood. In recent years, he has periodically returned to Chinese film studios to make transnational art-house martial arts blockbusters such as *Hero* (Zhang Yimou, 2002), *Fearless* (Ronny Yu, 2006) and *The Warlords* (Peter Chan, 2007). The last one reportedly made Li the most expensive actor in Asia at the time (BBC News, 26 November 2007).

Despite his remarkably successful career and long-term star appeal, Li receives very little critical attention (Major 2000; Hunt 2003; Stringer 2005). In this chapter, I examine the construction of Li's star persona through his publicity at *The Official Jet Li Website* and the ways in which his fans make sense of this publicity, thereby effectively participating in the process of star-making.

The duality of star image

As many academic writings elaborate (Dyer 1979; Allen and Gomery 1985; Geraghty 2000), it is the duality of image that makes a star, a duality composed of on-screen performance and off-screen existence, publicized through gossip columns, celebrity interviews, fan magazines/sites/clubs and so forth. According to Christine Gledhill (1991: xiv), 'Actors become stars when their off-screen life styles and personalities equal or surpass acting ability in importance'. For Christine Geraghty (2000: 189), the circulation of information on the star's 'real' life should not be seen as secondary to the film itself, since this information plays a crucial role in understanding the meanings of the star.

In terms of the construction of the star image, two kinds of industry strategies have been identified – one emphasizing conflict, and the other coherence, between

the glamorous screen presence and the private life of the star. In his seminal book *Stars*, Richard Dyer (1979) proposes that there are always contradictions and tension between the screen image and the star's personal life. Judith Mayne (1993: 138) takes this argument further – that the very appeal of stardom comes from 'constant reinvention, the dissolution of contraries, the embrace of wildly opposing terms'. Some critics, however, discern another strategy of constructing the star persona; i.e. to highlight integration, consistency and mutual support between the screen persona and the private life. Exploring the early years of the film star system in America, Richard deCordova (1991: 27) observes that a performer's off-screen life was mostly represented as a reflection of his or her on-screen roles. Combining the above two viewpoints, Paul McDonald (1995: 83) suggests that the public image of on-screen appearances and the publicized private image of the star's off-screen image either 'seamlessly correspond to one another, or antagonistically conflict'.

Both strategies of juxtaposing the picture personality with the off-stage image take effect only when they work on the audience. As Geraghty (2000: 189) puts it, in construction of the celebrity, 'It is the audience's access to and celebration of intimate information from a variety of texts and sources which are important here'. This audience is best typified by the fan. As a special category of audience that is equally interested in the star's on-screen and off-screen presence, the role of fans in the complex process of forming and transforming the star's persona should not be underestimated. However, while many writers analyse how the star's off-screen personality is contrived and controlled by the industry through various publicity methods, little attention has been paid to fans' active participation in star-making. Fans form their own networks of communication, such as fan magazines and fan clubs, to circulate star discourses. Nowadays, the popularization of the internet seems to have replaced the fan magazine with the fan site, making it a central location for fans to engage with the star and rework materials as a basis for their own social identification and cultural exchange.

Among numerous fan sites, the star's official website deserves particular attention. Stars' official websites may appear to be different from each other, yet they share a common function of satisfying fans' curiosity by feeding the fans with anecdotes from behind the scenes or related to the star's personal life, which are supposedly more authoritative than information in the entertainment press or other unofficial fan sites. Another important function of the official website is to communicate with fans directly and help to maintain the fanbase. In short, the official website serves as another effective arena within which stars can build up their images. *The Official Jet Li Website* (www.jetli.com) is such an arena where rich discourses of stardom and fandom emerge constantly.

Everybody can get close to Jet: an introduction to *The Official Jet Li Website*

Jet Li is notorious for his low-profile off-screen life,[1] especially compared with his Hong Kong or Hollywood counterparts. During his screen career across three decades Li's name has hardly ever appeared in gossip columns. What Li says in

interviews always focuses on his films, his experience in martial arts and recently his Buddhist beliefs and charity work. The personal image constructed of him in the media seems wholly stable, yet mysterious. Probably on this basis, Leon Hunt (2003: 141) sees Li as a 'diffident celebrity', 'as though "Jet Li" does not exist outside his films and martial arts'. Li's low-key public presence predictably increases the appeal of his official website to his fans, in that it offers Li's own remarks about his life, films and outlook, as he promises in his on-site greeting. Given the lack of similar information in other media such as the press or television, *The Official Jet Li Website* stands out as an important place for Li to construct his off-screen image and for his fans to engage with this construction.

Initiated by a team from Design Reactor,[2] *The Official Jet Li Website* is divided into two general categories: 'Jet Li' and 'Fans'. Under 'Jet Li', five sections – 'life', 'body', 'work', 'spirit' and 'mind' – respectively address Li's personal life, identity as a martial artist, film career, identity as a Buddhist and the website itself. Each section roughly consists of 'essays', 'articles', 'biography/wushu-ography/ filmography', 'questions' and 'media'. While the 'essays' are allegedly written by Li himself, the 'articles' and 'media' reflect Li's media exposure. In the 'questions' section, Li answers questions put to him in fan mails or chats during the period 1999–2002 (restarted in July 2007). The original website was presented solely in English but a Chinese version, which is simply the translation of its English version, has been added since mid-2007 to accommodate the increasing flow of Chinese-speaking visitors. A bilingual official website nicely reflects Li's status as a transnational Chinese star.

The other part of the website, 'Fans', is the most lively section and the one to which I pay main attention. It comprises a long-running fan forum and the star's blog established in December 2006. On 26 March 2007 (the day I researched the site for this study), the site had 176,936 registered users, a much larger number of guests, and 138,096 published postings. The forum was divided into nine sub-forums in nine different languages to accommodate the diverse language backgrounds of fans. This indicates Li's far-ranging fanbase, although nearly 90 per cent of the postings were in the English forum. The current forum is divided by three languages (English, Chinese and Japanese) but English is still the main language used. Webmaster Mark (23 December 2006) reported that 75 per cent of the traffic on jetli.com came from North America. A poll entitled 'First Jet Li experience' (FongSaiYuk319, 31 March 2005) shows that many became Jet Li fans because of the appeal of his roles in Western films, not his earlier Chinese work. Therefore, we can roughly identify Jet Li fans at his official website as a new generation of North American fans, distinguishing them from the fans of the 1990s from Hong Kong, East Asia and Southeast Asia who were enthralled by Li's new *wuxia* masterpieces in the early 1990s and also from the fans of the 1980s from mainland China who were impressed by Li's debut in *Shaolin Temple* (Zhang Xinyan, 1982).

What kind of off-screen image has been constructed through Li's publicity, in particular at *The Official Jet Li Website*? How do Jet Li fans make sense of this publicity? How does the interaction between Li and his fans help establish and reinforce his star persona? Emphasizing two-way responses and construction, this

research focuses on three sections of the website: namely, fan mails and answers; fan forum; and blog entries and discussions. Here it is important to point out the website's here-today-gone-tomorrow quality; i.e. content can be removed, changed, modified, deleted, from one day to the next, which can make it hard to track content. Reading through thousands of messages at Li's official website,[3] I observed that three key issues – authenticity, sexuality and cultural identity – which are often raised in the discussion of Li's on-screen image, continue to be noticeable in, and sometimes dominate, Li's off-screen construction.

I am a normal guy ...

The authenticity of martial arts skills is one of the main criteria to define a martial arts star. It is also the subject of a long-standing debate surrounding Li's screen persona, among (mainly Western) critics and fans alike. Andy Willis (2004: 182) points out: 'The idea that martial-arts performers can actually perform the actions we see them do on screen is their mark of authenticity'. Yet the intervention of cinematic technology and application of stunt doubles in martial arts films make it difficult to judge the authenticity of on-screen fighting. Therefore, 'a great deal of effort is spent in the creation of an authentic persona through other related media texts' (Willis 2004: 183). This observation is true in terms of the off-screen constructions of Bruce Lee, Jackie Chan, or Steven Seagal, who all try to deliver the same message – that the star can do as well in reality as on-screen, if not better. But Li's case is certainly more complicated. While Li's status as a five-time national martial arts champion provides undeniable proof of his authentic martial arts skills, Li shows less interest in authenticating his hero image through publicity. Moreover, he often adopts an opposite strategy of deconstructing the authenticity of the martial arts star by distancing himself from the on-screen superhero image and instead emphasizing his ordinariness in real life.

It is almost a cliché for Li to confess in interviews, 'I am not a hero', 'I am just a regular guy, boring ...', 'He is a lot stronger than me', and so on. Similar statements can be found easily in his replies to fan letters at his official website. For example, concerning a fan's question 'What do you think is the biggest misconception the public has about you?' (Dragonfly Dreams, 13 October 2001), Li answered, 'Most people think that I'm this tough, strong martial artist but in reality I'm just a normal guy who likes to stay at home (whenever I have a chance)'. Unlike Bruce Lee, a martial arts superstar who is narcissistic towards his own body, Li always undermines the significance of his physical prowess. To a fan's curiosity about a specific reason for his unwillingness to 'expose' himself (literally, to take off his shirt) (Marc A, 12 August 2002), Li attributed this to purely physical reasons: 'I'm short, only 5'7″ and my muscles don't really look that great. I think that if you looked at 10 people walking down the street, probably half of them have a better physique than mine'.

Li tries to dismiss both the fetishism of his body/physical capability and the worship of his star status, by understating his identity as a 'real' martial artist and highlighting his drawbacks as a normal guy in off-screen life. How do the fans

react to Li's refusal to authenticate his star persona? First, compare the following postings. 'I like Jet because of the sense of integrity and honour he seems to project both on and off screen' (Taiji Kid, 5 September 2006); 'He's humble, respectful and honest' (AJ, 1 September 2006); 'JET's honest, wholesome and generous in a kick-ass sort of way ... JET doesn't let his ego get in the way, either' (JRS, 30 August 2006); 'His manner in all the interviews and speeches I've seen is so sincere and polite – attentive and focused, intense but not overbearing' (Flagday, 30 August 2006).

In the praise from these fans, 'honest', 'humble' and 'sincere' emerge as the key words characterizing Li's personality, which, to a large extent, results from his self-deprecating attitude in off screen publicity. On the one hand, given his established 'superhero' screen image and undoubted titles as martial arts champion, Li's self-assumed 'ordinariness' adds an unpretentious quality to his star persona and constructs Li as a sincere celebrity. On the other hand, while stars' private lives as disseminated in the media often seem to be beyond the imagination of ordinary people, Li's confessing to be a 'normal guy' who loves to stay at home whenever he can sets him apart from most stars and presents him to fans as more like a familiar person.

Although Li's off-screen 'normality' seemingly contradicts his screen image, it by no means denies it. The emphasis on the ordinariness of the celebrity is not the same as the ordinariness of what Jon Dovey (2000) calls the 'ordinary celebrity'. In the context of television docusoaps which make celebrities out of ordinary people, Dovey argues that celebrity has become accessible to anyone as the distance between the famous and the rest has diminished. The construction of Li's stardom clearly does not work in this way. Li takes the side of ordinary people, yet he stands as an ideal man incorporating the ordinary and the extraordinary at once and is a hero whom his fans look up to. As Dyer (1979: 49) proposes, the extreme ambiguity/contradiction of the phenomenon of stardom lies between the star-as-ordinary and the star-as-special, and the combination of ordinariness and specialness is always a key element of stardom.

Li's statement, 'I am a normal guy', therefore can be regarded as a clever strategy of building his star persona on the contrast of the glamorous film world and the ordinary domestic life of the star. Exactly through this strategy, the superhero and the humble man, two seemingly contradictory images, perfectly unify in Li's star personality. The responses of Jet Li's fans to this construction indicate precisely the mechanism of star discourses – that is, to preserve at once the accessibility and inaccessibility of the star. Put simply, he is normal while he is inaccessible. Li's 'superstar-next-door' image clearly reveals how the star persona is carefully constructed in relation to ordinariness and specialness, accessibility and inaccessibility.

Shy man vs sexy icon

Sexuality is always an intriguing topic in terms of Li's screen persona. Since Li's shy – or, from another viewpoint, sexless – screen presence seems unchangeable,

even a little mysterious for his audiences, both the media and his fans, in the West and East, take much interest. Hong Kong's entertainment reporters were keen to uncover why Li holds back in all romantic scenes since his breakthrough role as Wong Fei-hung in *Once Upon a Time in China* (Tsui Hark, 1991) (*Wen Hui*, 1994a, 1994b). And Western critics often complain about the lack of chemistry between Li and the female lead, viewing Li as 'sexually unattractive' (Floyd 2000; Leyland 2001). Thus, the task of handling this kind of curiosity and criticism becomes inevitable for Li in his off-screen publicity. Li's most notable strategy is to frankly admit that he is not good at expressing romantic feeling and to skilfully relate this to his introverted, shy personality. A few times in his blog, Li mentions his experiences in filming romantic scenes. One of them is in shooting *Swordsman II* (Ching Siu-tung, 1992), when Tsui Hark said to him, 'How come filming you in a romantic scene feels like you are being assaulted?' (5 February 2007).

While highlighting his 'discomfort' in filming romantic scenes, Li at the same time tries to attribute this discomfort to his 'real' personality: his shyness, which he explains as a result of his conservative, puritanical upbringing. For instance, to the question 'Why do your characters avoid physical intimacy?' (Cassandra Huskey, 3 April 2002), Li responded:

> To be honest, I'm not a very good actor – especially when it comes to romantic scenes. Even in my real life I'm not that familiar with these situations. I think the writers or directors know me and realize that it is a part of my personality and a limitation of my abilities. I think they create characters with that in mind.

Apart from foregrounding his off-screen image as a shy man who always feels nervous in front of women, Li also portrays himself as a traditional, responsible 'family man' by sharing some off-screen stories on his website. The most famous one is that he turned down the main role in *Crouching Tiger, Hidden Dragon* (Ang Lee, 2000), which proved a huge success later, because he had promised to stay with his pregnant wife, Nina.

How do Jet Li fans at his official website respond to Li's shy personality, con-structed as it is both on-screen and off-screen? Generally speaking, most fans regard it as part of Li's unique star persona and express their appreciation of it, as the following postings show: 'I love … his shyness as well. The way he behaves in front of a girl is cool' (Goodgoingish, 31 August 2006); 'It is very cute that a love scene is what makes Li uncomfortable' (Christicr4, 4 February 2007). For some fans, it is precisely the 'shyness' that makes Li attractive. JRS suggested that Li is such a babe-magnet 'for the simple reason that he's "forbidden fruit". You can see, but you can't have!' (12 September 2006). Elsewhere, JRS wrote, 'lack-of-kissing will always leave his fans longing!' (13 August 2006).

More intriguingly, in spite of his shy screen presence and complaint about his 'lack of sexuality' often heard in Western critical discourse, many fans see Li as a sexy icon. In 2006 a poll on 'What makes Jet so unique and compelling to you' was conducted in the forum (KL70, 30 August 2006). Stargazer 234 (female) admitted frankly, 'I'm very shallow, I just like JET's appearance. You know, eyes,

lips, smile, hair, etc.' (30 August 2006); GATSU (male) wrote, 'I'm saying this in a non-gay way, but his boyish charm combined with his resolute persona are what I find appealing' (30 August 2006); Flagday confessed that although she likes Jackie Chan very much, he just does not have the 'sex appeal' that she feels from Li (7 September 2006). While Li seems to appeal to both genders, female fans particularly find Li very sexy. Some female fans in the forum are keen on discussing Li's charismatic effect on women by talking about his killer smile, his artless but appealing demeanour towards women, and his unconsummated romantic venture.

Given that women are believed to be not particularly interested in action cinema, Li's popularity among female fans is worth noting. Moreover, why do his fans take views opposite to those of his Western critics of the same screen image? Even though critics are usually more fastidious and fans more devoted, another important reason may be that fans pay a similar amount of attention to Li's on-screen and off-screen presence while critics focus mainly on his screen persona. For critics, 'no kisses' is simply evidence of Li's 'asexual' screen image. But fans tend to conflate Li's screen character and his 'publicized' private life and interpret 'no kisses' as a manifestation of Li's 'real' personality. When Goodgoingish asked, 'I've never seen JET kissing a girl in any film I've watched. What do you think the reason is? Is he saving his kisses for NINA?' (13 August 2006), JRS replied, 'I think it goes against his grain ... goes against his beliefs' (13 August 2006). Obviously, the consistent construction of off-screen Li as a shy but reliable 'family man' contributes to his sexual appeal among many fans, especially female fans, as Daniels Girl's comment neatly summarizes: 'You definitely ARE SEXY, always have been and even more so in the future because of your ability to keep yourself dedicated to your family and friends. That is EXTREMELY SEXY' (25 April 2007).

Unlike the apparent contradiction of the superhero/normal guy construction, when it comes to sexuality, Li's publicized private image seamlessly corresponds to his on-screen persona, thereby effectively blurring the line between the cinematic world and reality, at least as far as the fan is concerned. This coherent construction of the star persona not only makes up for Li's weakness in performing romantic scenes but also successfully constructs the persona of the 'shy but reliable man' as Li's unique trademark, which has won him immense female loyalty all around the world.

Non-violence vs violence

If the two aspects of Li's publicity discussed above are more or less common strategies of star-making, another noticeable off-screen construction into which Li seems to have put much effort has more to do with his specific identity as a crossover Chinese action star; he strives to redeem his on-screen 'fighter' image by performing as an advocate of non-violence off-screen. Since a very early stage in his career, Li had declared that his aim in making films is to spread Chinese martial arts as a wholesome form of athletics (Yang 1991), thereby clearly locating himself

in the category of martial arts star. Yet, in recent years, this aim seems to have been slightly modified, in that Li has been trying to foreground the cultural rather than the physical side of the martial arts, and to promote the idea of 'violence is not the only solution'. For instance, in interviews and on his website, Li frequently claims that the deeper meaning of *wu* (martial or military) in Chinese is actually to stop fighting, and he often expresses his aversion to the violent characters he plays in Hollywood.

Other noticeable aspects in Li's recent publicity in relation to his advocacy of 'non-violence' are his confession that he is a pious Buddhist and his devotion to charitable work. In December 2006, Li announced the launching of the Jet Li One Foundation, an international relief agency. It is funded by the gift of one yuan/dollar from each person each month and aims at helping those affected by natural disasters. Since then, *The Official Jet Li Website* has become an ideal place for Li to pursue his philanthropic missions. On the website's homepage, the logo and the link of the Jet Li One Foundation are put in the foreground and half of the news headlines are about Li's charity activities. Soon after the inauguration of the One Foundation, Li started his blog and called on his fans to support this project. The One Foundation is undoubtedly a central topic in Li's blog, as he appears to relate everything else to it. For example, Li foregrounds his shy personality and enthusiasm for philanthropic work at the same time in the following blog entry written during the filming of *The Warlords*:

> At the start of every film production I really don't know how to break the ice with the lead actress. I'm more introverted and don't know how to communicate well with them. But for the sake of the foundation, I broke my 26-year-long habit and took the initiative myself to ask Jinglei to help spread news about the foundation on her blog. I hear that Jinglei has the most viewed blog in China.
>
> (December 29, 2006)

It is not difficult to sense that Li has been trying in all possible ways to distinguish himself from his screen character, who must often fight and kill. While his reasons for drawing this distinction, such as his Buddhist world views, are manifold, an important one may be that he is unhappy with the screen image built up for him in his English-language films since his crossover to the West – no longer a hero but a killer, not a martial artist but a fighting machine. In *Heavenly Bodies* (1986), Richard Dyer pays attention to the stars' revolt against the lack of control they felt within the Hollywood industry and under capitalism. He cites Robeson and Monroe as protesters encapsulating the situation of black people and women, respectively.

Similarly, Li's off-screen activities indicate Li's struggle and negotiation with Hollywood's racist discourse and commercial oppression. More specifically, unsatisfied that only his physical capability has been exploited and showcased on Western screens, and with being labelled as one among many martial arts

performers, Li tries to reclaim his cultural identity within a film industry that tends to blot out any stamp of culture or individuality, especially where crossover film talents are concerned. Thus, off-screen construction of himself as a tireless advocate of non-violence or a zealous philanthropist reveals to a large extent Li's intention to challenge Hollywood's stereotypical preconception that Chinese kung fu stars are people who know only how to fight. Again, how do Jet Li fans respond to Li's endeavours to mediate his star persona?

Corresponding with Li's publicized dissatisfaction with violence, fans often raise in the forum such topics as 'Jet Li in a movie without fighting', or 'should Jet try comedy/drama for a future movie?' Three typical attitudes can be discerned in fans' discussions: down-to-earth, sceptical and sympathetic. The fans with a down-to-earth attitude think it would be good to see Li in different types of roles, but it is unrealistic for Li to want to give up action films altogether. Sceptical fans see it as ironic or simply a promotional trick that while Li has always been an advocate of 'non-violence', he still participates in movies where violence is the only solution. Yet, most fans show sympathy for this contradiction embodied in Li's star persona, as seen from the following postings. 'As a martial artist who also embraces Buddhism etc., he no doubt feels strongly about the image of *wushu* and martial arts and that particular aspect of misrepresenting the spirit of the art' (Thatguymark, 24 September 2006). 'I feel like Jet is caught in the middle of his beliefs, philosophy and his career He wants people to know and understand the real meaning behind the Martial Arts and at the same time he has to feed his family ...' (Solar Stanze, 22 September 2006). In fan discourse, the contradiction of violence/non-violence in Li's personality is read as an inevitable consequence of the conflicts between marketability and the cultural significance of Chinese martial arts, between Li's two identities as a martial arts star and a Buddhist and between his unstable positions as a Chinese superstar and a minority actor in Hollywood.

As to Li's devotion to philanthropy (the One Foundation in particular), the fans respond ardently and unanimously. JRS (5 February 2007) commented, 'It is such a breath of fresh air to hear about celebrities who want to give back to society JET, you continue to nurture my belief that there is still some humanity left in our world!' Longhu (17 March 2007) wrote, 'Jet Li, you are my hero. In a world which lacks good role models, I admire you for starting the foundation and using your talent for good causes that serve all people!' Apart from paying compliments to Li's kindness and compassion, the fans show their support for him by donating to the One Foundation, helping to spread the One Foundation project in their own way, or offering suggestions for developing the project.

It is not rare for a martial artist to be a Buddhist – monks are often trained in fighting skills in temples (such as the famous Shaolin Temple) – but it is quite unusual for an established martial arts star like Li to openly challenge his own screen image with his off-screen activities. Similarly, it is nothing new to hear that a star is doing charity work, but it is a bit surprising that Li puts it at the centre of his life,[4] and that his fans are so zealously involved in his philanthropic endeavour. The case of the One Foundation proves yet again that the meanings of

the 'film star' have gone beyond the entertainment industry and entered the sphere of political and social life. This is especially noteworthy within the Chinese context as, throughout Chinese film history, a star (in film or theatre) has usually had a poor reputation in the domain of morality. For his fans, Li is certainly not merely a fighter or a killer as depicted on the Western screen, but also a martial artist, Buddhist, cultural defender and moral model. This multiple star persona is exactly built upon the construction of on-screen violence and off-screen non-violence. In the meantime the contradiction thus entailed has been neatly turned into part of Li's star appeal.

Conclusion

In preceding pages I have examined three key aspects of Li's off-screen star construction. While Li's superhero image on-screen is recognized widely, off-screen Li reveals himself as a normal guy who became a martial arts star by luck; while he is arguably the best on-screen fighter alive in both the East and the West, he tries his best to distance himself from his film roles by tirelessly advocating 'violence is not the only solution'; while shyness defines most of Li's screen characters, he always relates this trait to his 'real' personality as a shy man who devotes himself to his wife alone. As a consequence, in the eyes of Jet Li fans, Li stands as an 'ordinary hero', a 'moral model' and a 'sexy icon' (the last of these, mostly among female fans). This makes it possible to argue that Li's star persona is built upon both consistency and contradiction between his on-screen and off-screen images. Precisely through this correspondence and conflict, such opposed terms as 'superhero/normal guy', 'shy man/sexy idol' and 'fighter/preacher of non-violence' are perfectly reconciled in Li and help constitute his profuse meanings for a new generation of North American Jet Li fans.

Furthermore, I would like to suggest that, if film stars were mainly produced by the industry and media texts in the past, nowadays stars themselves and fans are playing increasingly significant roles in star-making, as my research on *The Official Jet Li Website* demonstrates. This change could be largely because the internet is becoming the most powerful medium in contemporary life. The internet (his official website in particular) provides Li with a new space, outside institutionally produced media, to construct his star image. Through essays, a personal blog and replies to fan mails, Li exposes his life and ideas to the public as he wants, thereby limiting industry intervention and media manipulation. In this sense, the internet empowers stars by giving them the opportunity to take more control over their own image.

Fans are similarly empowered as well. The official website and other internet sites offer fans access to information about the star's off-screen life to an extent not possible with previous channels of mass communication. They also encourage interplay between fans and the star, as well as communication among fans. By publishing postings on the forum, writing mail to the star and participating in fan activities, fans gain a more visible existence in forming and disseminating the star image. In his book on the star system, Paul McDonald (2000: 114) argues that the

World Wide Web has changed the star system through 'decentring the production of star discourses'. Indeed, besides the film industry and the media, with the help of the internet, the authorship of star discourses is more and more opened up to the stars themselves as well as to their fans. This undoubtedly challenges the commercial and legal control of star identities on which the system has always depended. However, as McDonald (2003: 43) insightfully points out elsewhere, 'Star discourse on the internet displays a continuing engagement with the stars as revered others and commercial identities'. In some ways, fans' readings of Li as an 'ordinary hero', 'sexy idol' and 'moral model' reveal that a new medium is still 'maintaining and perpetuating an old media realm of discourse' (McDonald 2003: 43).

Notes

1 This habit seems to have changed somewhat since Li announced the launching of the One Foundation at the end of 2006. He now appears on talk shows and press interviews much more frequently than before, mainly to promote the One Foundation.
2 A company based in Berkeley, California. It was later on taken over by *Rotten Tomatoes*.
3 All messages quoted in the following were accessed in January 2007.
4 Almost all publicity of Jet Li in recent few years is centred on his One Foundation project. Reportedly, Li turned down several film roles in 2008 in order to devote himself to philanthropy.

Works cited

Allen, Robert C. and Douglas, Gomery (1985), *Film History: Theory and Practice*, New York: Random House.
BBC News (2007), 'Jet Li breaks film salary record' (26 November). http://news.bbc.co.uk/2/hi/entertainment/7112639.stm.
DeCordova, Richard (1991), 'The Emergence of the Star System in America', in *Stardom: Industry of Desire* (ed. Christine Gledhill), London: Routledge, pp. 17–29.
Dovey, Jon (2000), *Freakshow: First Person Media and Factual Television*, London: Pluto Press.
Dyer, Richard (1979), *Stars*, London: British Film Institute.
Dyer, Richard (1986), *Heavenly Bodies: Film Stars and Society*. London: British Film Institute.
Floyd, Nigel (2000), 'Romeo Must Die', *Time Out* (11–18 October), p. 81.
Geraghty, Christine (2000), 'Re-examining Stardom', in *Reinventing Film Studies* (eds Christine Gledhill and Linda Williams), London: Arnold, pp. 221–43.
Gledhill, Christine (1991), 'Introduction', in *Stardom: Industry of Desire* (ed. Christine Gledhill), London: Routledge, pp. 79–97.
Hunt, Leon (2003), *Kung Fu Cult Masters: From Bruce Lee to Crouching Tiger*, London: Wallflower Press.
Leyland, Matthew (2001), 'Kiss of the Dragon', *Sight and Sound*, 11: 10, p. 51.
McDonald, Paul (1995), 'Star Studies', in *Approaches to Popular Film* (eds Joanne Hollows and Mark Jancovich),Manchester: Manchester University Press, pp. 79–97.
McDonald, Paul (2000), *The Star System: Hollywood's Production of Popular Identities,* London: Wallflower Press.

McDonald, Paul (2003), 'Stars in the Online Universe: Promotion, Nudity, Reverence', in *Contemporary Hollywood Stardom* (eds Thomas Austin and Martin Barker), London: Arnold, pp. 29–44.

Major, Wade (2000), 'The Afterburner', in *Hollywood East: Hong Kong Movies and the People Who Make Them* (ed. Stefan Hammond), Illinois: Contemporary Books, pp. 149–75.

Mayne, Judith (1993), *Cinema and Spectatorship*, London: Routledge.

Stringer, Julian (2005), 'Talking about Jet Li: Transnational Chinese Movie Stardom and Asian American Internet Reception', in *Political Communications in Greater China* (eds Gary D. Rawnsley and Ming-Yeh T. Rawnsley),London: Routledge Curzon, pp. 275–90.

Wen Hui 文汇 (1994a), 'Yinmu tan qing dian dao wei zhi, Li Lianjie wei xian chu wen' 银幕谈情点到即止, 李连杰未献初吻 (Understated Screen Romance: Li Lianjie's Unendured Virgin Kiss) (22 July).

Wen Hui 文汇 (1994b), 'Li Lianjie xingge haixiu, pai qinre xi nan touru' 李连杰性格害羞, 拍亲热戏难投入 (Shy Li Lianjie Feels Difficulty in Filming Love Scenes) (16 September).

Willis, Andy (2004), 'Cynthia Rothrock: From the Ghetto of Exploitation', in *Film Stars: Hollywood and Beyond* (ed. Andy Willis), Manchester: Manchester University Press.

Yang, Xiaowen 杨孝文 (1991), 'Li Lianjie yanzhong de Huang Feihung' 李连杰眼中的黄飞鸿 (Wong Feihung in the Eyes of Jet Li), *Dianying shuangzhou kan* 电影双周刊 (*City Entertainment*), 323, p. 23.

Filmography

Crouching Tiger, Hidden Dragon (Wohu canglong 卧虎藏龙), d. Ang Lee 李安, transnational: Asia Union Film & Entertainment Ltd, China Film Co-Production Corporation, Columbia Pictures, EDKO Film, Good Machine, Sony Pictures, United China Vision, and Zoom Hunt, 2000.

Fearless (Huo Yuanjia 霍元甲), d. Ronny Yu 于仁泰, Beijing: Beijing Film Studio, China Film Co-Production Corporation, China Film Group, Hero China International, Wide River Investments, 2006.

Hero (Yingxiong 英雄), d. Zhang Yimou 张艺谋, Beijing: Beijing New Picture Film, Elite Group Enterprises, 2002.

Once Upon a Time in China (Huang Feihong 黄飞鸿),d. Tsui Hark 徐克, Hong Kong: Golden Harvest , Film Workshop, 1991.

Shaolin Temple (Shaolin si 少林寺), d. Zhang Xinyan 张鑫炎, Hong Kong: Chung Yuen Motion Picture, Zhongyuan Film, 1982.

Swordsman II (Xiao ao jianghu zhi dongfang bubai 笑傲江湖之东方不败), d. Ching Siu-tung 程小东, Hong Kong: Film Workshop, 1992.

The Warlords (Touming zhuang 投名状), d. Peter Chan 陈可辛, Beijing; Hong Kong: Applause Pictures, Beijing Jinyinma Movie & TV, Beijing Poly-bona Film, Chengtian Entertainment, China Film Group, Media Asia, Morgan & Chan Films, Stellar Mega Film, Warner China Film HG Corporation, 2007.

Index